THE MUSEUM ESTABLISHMENT AND CONTEMPORARY ART

This book provides an in-depth account of the protests that shook France in 1968 and which served as a catalyst to a radical reconsideration of artistic practice that has shaped both art and museum exhibitions up to the present. Rebecca DeRoo examines how issues of historical and personal memory, the separation of public and private domains, and the ordinary objects of everyday life emerged as central concerns for museums and for artists, as both struggled to respond to the protests. She argues that the responses of the museums were only partially faithful to the aims of the activist movements. Museums, in fact, often misunderstood and misrepresented the work of artists that was exhibited as a means of addressing these concerns. Analyzing how museums and critics did and did not address the aims of the protests, DeRoo highlights the issues relevant to the politics of the public display of art that have been central to artistic representation in France, as well as in North America.

Rebecca J. DeRoo is an assistant professor of art history at Washington University in St. Louis. A scholar of contemporary art, she has contributed to *parallax* and the *Oxford Art Journal* and curated the exhibition *Beyond the Photographic Frame* at the Art Institute of Chicago, which was supported by a Rhoades Foundation Fellowship. She has also received fellowships from the Fulbright Commission and the Javits Foundation, as well as an award from the National Endowment for the Humanities.

THE MUSEUM ESTABLISHMENT AND CONTEMPORARY ART

The Politics of Artistic Display in France after 1968

Rebecca J. DeRoo

Washington University in St. Louis

CAMBRIDGE
UNIVERSITY PRESS

CAMBRIDGE UNIVERSITY PRESS
Cambridge, New York, Melbourne, Madrid, Cape Town, Singapore, São Paulo

Cambridge University Press
40 West 20th Street, New York, NY 10011-4211, USA

www.cambridge.org
Information on this title: www.cambridge.org/9780521841092

First published 2006

Printed in Hong Kong by Golden Cup

A catalog record for this publication is available from the British Library.

Library of Congress Cataloging in Publication Data

DeRoo, Rebecca J.
The museum establishment and contemporary art : the politics of artistic display in France after
1968 / Rebecca J. DeRoo.
 p. cm.
Includes bibliographical references and index.
ISBN-13: 978-0-521-84109-2 (hardback)
ISBN-10: 0-521-84109-7 (hardback)
1. Art museums – France – Management – Social aspects. 2. Art and society – France – History –
20th century. 3. Artists and museums – France – History – 20th century. 4. Boltanski, Christian,
1944 – Influence. 5. Messager, Annette, 1943 – Influence. 6. Centre Georges Pompidou.
7. General strike – France – 1968. 8. College students – France – Paris – Political activity. I. Title.
N2010.D47 2005
708.4–dc22 2005017945

ISBN-13 978-0-521-84109-2 hardback
ISBN-10 0-521-84109-7 hardback

For Joe

CONTENTS

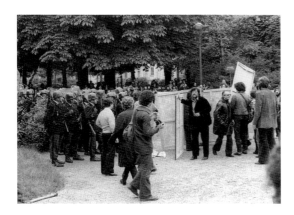

ILLUSTRATIONS

ACKNOWLEDGMENTS

Many outstanding individuals have helped me in the preparation of this work. My deepest thanks go to my mentors at the University of Chicago, Martha Ward, Joel Snyder, and Katie Trumpener. First and foremost, I am grateful to Martha Ward for her generous guidance and astute advice, and for being a model of critical intelligence. I warmly thank Joel Snyder for his continued support, intellectual engagement, and dedication to the teaching of photography. Katie Trumpener brought interdisciplinary insights that greatly improved the project. Daniel Soutif and Jean-Marc Poinsot advised me during research trips to France, graciously sharing their work and opening many doors to the French art world. Serge Guilbaut and Jill Carrick provided helpful comments and lively discussions during a postdoctoral year at the Center for the Study of Postwar French Art, University of British Columbia. For advice, encouragement, and help that has strengthened this project more than I can describe, I thank Aditya Adarkar, Saher Alam, Lara Bovilsky, Elizabeth Childs, Charles Harrison, Laura Letinsky, Joe Loewenstein, Angela Miller, Tom Mitchell, Linda Nicholson, Sylvie Penichon, Justine Price, Susan Rotroff, Lynne Tatlock, Sue Taylor, Alicia Walker, and William Wallace. For their insightful comments on my manuscript, I thank Julie Ault, Michèle Hannoosh, Herman Lebovics, Kristin Ross, and Mark Sandberg. I feel fortunate to have worked with such a knowledgeable editor, Beatrice Rehl, at Cambridge University Press, and am grateful for her enthusiasm and support for this project. I am indebted to the individuals at the Press responsible for the production of this book as well as to the anonymous readers whose suggestions were enormously helpful. My sincere thanks go to Aeron Hunt for critically reading the project in its various stages, offering fresh perspectives, elegant editorial suggestions, and moral support all along the way.

Thanks also go to Anne-Claude Morice, Sylvie Mokhtari, David Benzel, Cécile Merino, Philippe Lacour, and Anna Prat-Nida for their years of friendship and hospitality in France. I am grateful to my parents, Bill and Carlene DeRoo, for their constant love and encouragement. Their example and understanding have helped me in more ways than I can express. I dedicate this project to my husband, Joe Kury, whose support, companionship, and refreshing sense of humor have enriched my life.

I am deeply grateful to Christian Boltanski and Annette Messager, who for the past eight years have generously shared their time, thoughts, archives, and collections of artwork with me, making this project possible. I am indebted to Harald Szeeman, who accepted a series of interviews and gave me access to his personal archives. I thank Claire Legrand, Christopher Phillips, and Anne Rorimer for sharing their work and discussing ideas with me. I also thank Bob Calle, Jean-Dominique Carré, and Philippe Vermès for allowing me to consult their personal collections. I extend my gratitude to the following individuals who granted me interviews for my research: Jean Le Gac, Claire Burrus, Catherine Millet, Daniel Buren, Suzanne Pagé, Jean Clair, Pierre Restany, Alfred Pacquement, Jean-Hubert Martin, Didier Semin, Günter Metken, Nathalie Heinich, Serge Le Moine, Hélène Cixous,

Aline Dallier, Laurent Gervereau, Nancy Gillespie, Raymonde Moulin, Agnès de Gouvin Saint-Cyr, Antonio Homem, Pierre Cabanne, Gilbert Lascault, Ida Biard, and Daniel Templon.

I appreciate the kind efforts of Alfred Pacquement, Director of the Centre Pompidou, and of his staff, to facilitate my research there. For opening their collections to me, I thank the staffs of the Archives de la Critique d'Art, Bibliothèque Nationale de France, Bibliothèque de Documentation Internationale Contemporaine, Institut National de Recherche Pédagogique, Fonds National d'Art Contemporain, FRAC Bretagne, FRAC Bourgogne, FRAC Aquitaine, CAPC Bordeaux, Musée d'Art Moderne de Saint-Etienne, Musée d'Art Moderne de Strasbourg, FRAC Rhône-Alpes, Musée de Grenoble, Galerie Daniel Templon, Galerie Chantal Crousel, and Marian Goodman Gallery. At Washington University in St. Louis, art librarians Carmen Doering and Ellen Petraits provided valuable assistance; Nada Vaughn and the interlibrary loan staff went to great lengths to obtain rare publications. I also thank research assistants Sonia Fulop and Theresa Huntsman for their energy and attention to detail.

For generous funding of my project in its early stages, I am grateful to the Fulbright Commission, the Jacob Javits Fellowship Program, the Josephine de Karman Fellowship Trust, the University of Chicago Humanities Division, and the Department of Art History at the University of Chicago. A Killam Postdoctoral Fellowship and a Faculty Research Grant from Washington University in St. Louis enabled me to pursue additional archival research. Finally, I would like to thank Edward Macias, Executive Vice Chancellor and Dean of Arts and Sciences, and William Wallace, Chair of the Department of Art History at Washington University, for supporting the book's illustration program.

A NOTE ON TRANSLATIONS

Unless otherwise indicated, all translations are my own. When available, I have used English translations of French sources, parenthetically indicating the original publication dates in the bibliographic citations.

Material from Chapter 3 was published in "Christian Boltanski's Memory Images: Remaking French Museums in the Aftermath of '68," *Oxford Art Journal* 27.2 (2004) 219–38.

1 MUSEUMS AS POLITICAL CENTERS

■■

In 1989, Christian Boltanski's *Lessons of Darkness* exhibition toured North American museums to great critical acclaim. Works such as his *Archives* – composed of rusted tin biscuit boxes (suggestive of "memory containers" stored in attics) and faded family photographs lit by individual electric lamps – seemed to evoke the fragility and pathos of private efforts to preserve memories and received special critical attention and praise (Fig. 1). Here were forms and subjects so familiar, curators claimed, that they seemed to reach out to each individual viewer, triggering his or her own private memories and making a space for the uniqueness of personal experience within the institution of the museum.[1] Furthermore, Boltanski's evocative installations seemed to address another challenge. The catalog essay that accompanied the exhibition, written by Lynn Gumpert, stressed that Boltanski had recently revealed that his father was Jewish and had gone into hiding during the Second World War. The faded family photographs, therefore, were taken by critics and curators to represent not merely deeply personal memories, but also the numerous individuals who had passed from life into memory in the violence of the Holocaust.[2] In other words, Boltanski seemed to have provided new ways for museum audiences to access and emotionally respond to a previously suppressed history and to have permitted the museum to represent what had previously been suspected to be unrepresentable within its confines. His work was deemed to give such powerful new access to history that its signature images and forms were adopted in other works that dealt with this unspeakable horror, such as the *Tower of Life* installation of family photographs at the Washington, D.C. Holocaust Memorial Museum. Even the German government saw Boltanski as a figure who could generate an appropriate artistic response to its past, commissioning him for an installation in 1999 in the renovated Reichstag building in Berlin (Fig. 2).

Some years later, the curators of the 2002 Documenta 11 exhibition in Germany similarly felt the need to address the experiences of ordinary people following a decade that had seen its share of political and economic turmoil: the violence in the Persian Gulf and Rwanda, and in the more immediate European neighborhood with the wars in the former Yugoslavia; the attacks of September 11, 2001; and the disruptive

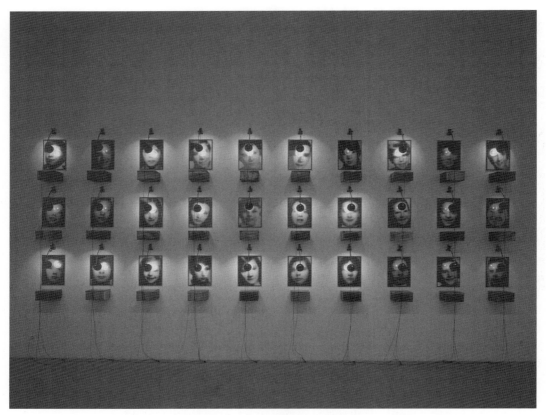

Figure 1. Christian Boltanski, *Archives*, 1988. © 2005 Artists Rights Society (ARS), New York/ADAGP, Paris. Photo courtesy of Bob Calle.

effects of economic globalization. The Documenta catalog explicitly for-
mulated the goal of the exhibition as bringing into the museum stories
of oppressed and marginalized groups that museums had not always had
the courage to confront. In this context, Annette Messager's *Articulés-
désarticulés (Articulated-Disarticulated)* (2002), soft sculptures composed
of fabric and parts severed from stuffed animals, created powerful evo-
cations of dismembered bodies and expressed the personal agony of
suffering and loss (Figs. 3–4). Critics and curators praised Messager's use
of ordinary materials to reference the larger human condition of oppres-
sion and provide ways for viewers to understand the effects of history
on the private lives of those who were usually overlooked.[3] Messager's
work was thus commended by curators and critics for making cultural
institutions face up to the everyday experiences of violence and suffering
that characterized the lives of many but that museums had not done a
good job of representing.

Figure 2.
Christian Boltanski, *Archiv der Deutschen Abgeordneten*, 1999. © 2005 Artists Rights Society (ARS), New York/ADAGP, Paris. Photo © Deutscher Bundestag.

The aims of these two exhibitions typify a broader cultural move in the last two decades to open up art and its institutions not only to histories that had been marginalized and previously suppressed but also to new audiences, who it was thought were likely to be engaged by these new images and stories. Since the 1980s, international museums have felt challenged to be engaged politically, as well as accessible to and broadly representative of a diverse population – a far cry from the isolated realms of art and culture that they had once seen themselves as. The prominence of Boltanski and Messager in these international contexts was perhaps not entirely unpredictable; this was not the first time their work arrived at an extraordinarily felicitous moment, when museums were seeking to respond to demands for greater inclusion and accessibility. Nor was it the first time that curators saw their work as making museums accessible by reaching out to viewers in new ways.

Boltanski and Messager had first exhibited to widespread critical acclaim in France in the aftermath of the May and June 1968 protests, the largest strikes and demonstrations in modern French history, when workers, artists, and sympathetic members of the public joined with students who had launched wide-ranging protests against the Vietnam War; the Gaullist state; capitalism and the society of consumption; and French social, political, and cultural institutions, particularly the educational system. All told, approximately nine million people went on strike in solidarity with the student protesters, forming a new kind of alliance between

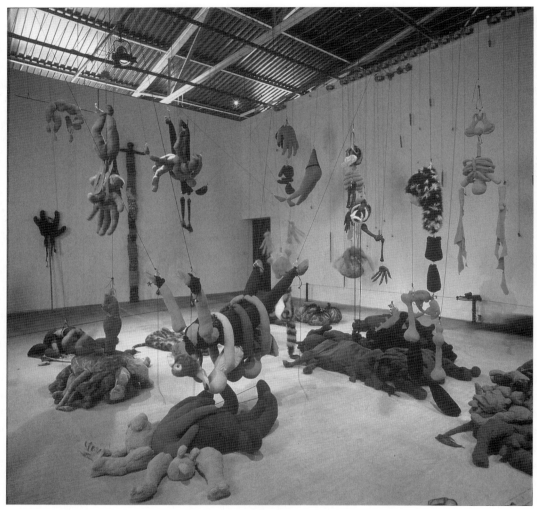

Figure 3. Annette Messager, *Articulés-désarticulés*, 2002. © 2005 Artists Rights Society (ARS), New York/ADAGP, Paris. Photo © Annette Messager and Galerie Marian Goodman, Paris/New York.

students and workers and paralyzing the country as banks, public transportation, the postal service, newspapers, gas stations, and department stores were shut down, and nearly precipitating the fall of Charles de Gaulle's Fifth Republic.[4] Unions were reluctant to strike, but workers did anyway, giving the protests the feel of a spontaneous popular movement sweeping the nation. Workers in both public and private sectors struck for better working conditions and self-determination in the workplace. Students demanded more open access to universities and schools along

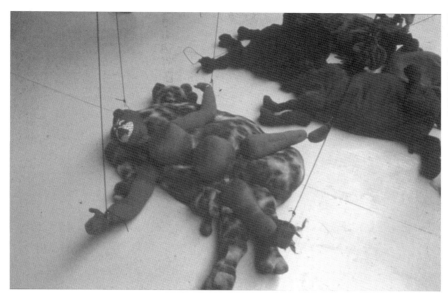

with the modernization of the curriculum.[5] The university, students argued, had become the place where canonized knowledge was dispensed to a privileged few; rather than serving to improve life for all citizens, the university functioned as a means of maintaining the social hierarchy.

These tumultuous political events of May and June 1968 generated a reassessment of the unified collective history and national identity that museums were seen to embody. Since 1793, when the French revolutionary government opened the royal palace at the Louvre to the citizens of France, redefining its treasures as belonging to the citizenry rather than to the king, French art and museums have been considered privileged national property.[6] Over the years, French museums came to be seen not merely as sites for the preservation and exhibition of art, but also as crucial symbols – what the historian Pierre Nora has called *lieux de mémoire*, repositories and embodiments of the nation's collective memory and identity.[7] The museum was to represent France to itself: its history, its culture, and its democratic aspirations. Because it has had such an important purpose, the museum has since been a battleground when the idea of the nation has been challenged. Although Nora locates the 1980s as the moment when the consensus that museums could adequately represent the nation's collective history breaks down, it is reasonable to suggest that these recent contestations began much earlier than that.[8] In the revolutionary fervor of 1968, this concept of museums as

representations of a unified national culture had come to appear elitist, outdated, and disconnected from the everyday, personal, and political experiences of the diverse groups that made up the French people. Thus, when artists, art students, and critics, along with striking workers and university students, took to the barricades in May of 1968 with the aim of transforming French society, art institutions of the time became a crucial site in the larger battle. Throughout the late 1960s and early 1970s, activists attacked museums, calling for more representative, accessible, up-to-date, and politically engaged art and cultural venues.[9]

Yet once the recognized models of art and museums were exploded, artists and curators were left with questions of how new forms for collective representation were to be found and new audiences reached. The debates sparked in 1968 continued to inform French cultural policy for the next decade, culminating in the construction of a new museum of modern art in the Pompidou Center in 1977 (see Fig. 72). Even though the French government took these concerns seriously and made ambitious attempts to respond to them in its construction of the new museum, the issues raised in the 1968 activism and its aftermath were so controversial and wide-ranging that they have not been well documented and therefore not fully addressed by curators and art historians, even in France. In essence, this is a decade lost to historians, and one of the first and extremely influential state efforts to respond in cultural policy to the new activism of the late twentieth century has been dramatically underexamined.[10]

In the 1980s, the artwork and issues developed in France in 1968 and the decade following came to international prominence in broader European and North American contexts. By that time, however, the issues raised by the 1968 protesters had become intertwined with the demands of the feminist and multicultural movements. Although in the 1980s and 1990s, as opposed to the decade after 1968, the demands on museums were different – voiced in terms of multiculturalism or a more highly elaborated discourse of feminism, in contrast to the emphasis in 1968 on social class and the newly emergent call for women's liberation in the early to mid-1970s – in both contexts, museums were recognized and challenged as symbols of collective memory and identity and their organizers felt forced to respond to calls for greater inclusion of social diversity. Despite these differences, curators and critics in both contexts seized similar solutions, deeming artists' displays of private images and everyday objects a powerful strategy to address the pressures facing the museum. Boltanski and Messager were not the only artists to work with these media, but they rapidly became two of the most celebrated, because their

personal images were seen to remake museums in innovative ways.[11] In the aftermath of 1968, when these artists began their careers, they created exhibitions that looked nothing like the work that had been displayed in French museums before. Instead of elite masterworks or abstract painting, audiences were faced with personal and everyday objects – family pictures, school notebooks, and childhood memorabilia – presented in museum formats, such as in ethnographic display cases. Curators and critics in post-1968 France saw the artists' exhibitions of private memorabilia and everyday objects as triggering viewers' individual memories and thus providing new ways to reach out to and include broader audiences.[12] In this way, they saw the artists' exhibitions of private images as creating an inclusive, responsive museum. These early critical responses established a pattern in the interpretation of Boltanski and Messager and of the display of private material in the museum that has remained prominent ever since.

It is a central contention of this book that museums' use and interpretation of the artwork of the private and everyday, of which Boltanski and Messager have become renowned practitioners, have from the start been compromised by a misunderstanding of both the artists' projects and the activism of 1968 from which it arose. Whereas curators and critics promoted the artists' display of personal and everyday objects as making art and museums more accessible and universally representative, it is argued here that the artists' work in fact raises questions about the ability of art and museums to be accessible to all or to represent the collective. For example, Boltanski's work from the 1970s, like his *Archives* in the 1980s and 1990s, incorporated personal memorabilia, such as objects from childhood and family photographs. In his 1970 *Vitrine de référence*, for example, Boltanski displayed childhood souvenirs, such as photographs, sugar cubes, balls of mud, and tool-like objects that resembled things he had made as a child (see Fig. 37). He presented his objects as an archive with factual labels that stated the type of object and the date of its creation, but he gave no indication of its personal significance. His vitrine thus illustrated both the ways museums traditionally presented history and the impossibility of preserving personal memories within these frameworks. Similarly, in his 1988 *Archives*, Boltanski's invocations of personal memory are anything but straightforward (see Fig. 1). The tin storage boxes contain debris or are empty; the family photographs are faded and barely recognizable, thus inhibiting viewers' attempts to retrieve the memories that they ostensibly preserve. His work appears to promise the preservation and communication of memories, yet simultaneously frustrates such objectives.

Like Boltanski's displays, Messager's exhibitions cast doubt on the accessibility and universality that critics have attributed to her work, challenging museums' objectives rather than resolving them.[13] In the early 1970s, for example, Messager exhibited diary-like collection albums (see Figs. 49–50). Although curators saw these albums as easily accessible representations of daily life, there is a challenging undercurrent to both the form and the content of the pieces. The albums were forms customarily considered feminine, and their content referenced the traditionally feminine preoccupations of housework and child rearing; their inclusion, therefore, underscored how such "women's work" had been traditionally excluded from the museum. Similarly, her 2002 installation at the Documenta 11 did not simply, as some critics and curators contended, depict universal human suffering; it could also be read as suggesting female figures and employing traditionally feminine materials to reference the oppression endured by women in particular.[14] In this way, her display of "feminine" materials and subjects challenged the idea that any representation in the museum could be universal in meaning.

If these tensions in Boltanski's and Messager's artwork are overlooked, the work seems to provide the solutions museums are seeking. However, when these conflicts are recognized, it becomes clear not only that the work does not solve museums' problems, but also that it offers a potentially destabilizing critique of their inadequate responses. Boltanski's and Messager's private images, in other words, do not provide straightforward access to previously excluded histories. Instead their private and everyday images emphasize the way the private histories, memories, and everyday experiences of marginalized groups are resistant to incorporation within museums' representations of national identity and public history.

This book argues, therefore, that museums were only partially faithful to activists' demands for more inclusive and representative museums. In fact, museums frequently misunderstood and misrepresented the work of some of the very artists they exhibited to address these concerns. By returning to the original manifestation of both these problems and their proposed solutions in 1968 France and the decade following, we may draw lessons for the situations contemporary museums now confront. My approach is twofold: first, to return to the moment when the demands for inclusive and representative museums originated in the protests of 1968 France, and to examine how, over the decade that followed, artists and museums attempted to resolve these demands with displays of the private and everyday. Second, I aim to bring to light the

ways in which the work of Boltanski and Messager, which came to be celebrated as emblematic of the new museum, actually challenged museums' aims. These challenges were sometimes perceived when the work first was shown, but they have since been lost from view because of the great possibilities the themes of the private and everyday seemed to offer the museum as it tried to render itself more democratic. Thus by examining key facets of the cultural politics of 1968 as they were exemplified in Boltanski's and Messager's work – the notion of the death of the author, which opposed what activists saw as the fetishization of artistic biography and genius, and the analysis of art institutions – my goal is not simply to reconsider the dominant interpretation of Boltanski and Messager. It is, rather, to bring back into view the politics of the artwork and the movement to which it belonged, Conceptual Art, especially the ways in which it advanced the activist agendas voiced in 1968, in particular, the critique of the museum.[15]

The protesters of 1968 who raged against the notion of the isolated genius and the ideal of the artist's biography as the key to the meaning of his or her work would be skeptical of the turn that Boltanski's recent critical reception has taken. The acclaimed 1988 and 1989 *Lessons of Darkness* exhibition and catalog essay by Gumpert, described previously, cemented Boltanski's prominence on an international level and simultaneously set in motion the biography-centered interpretation that his work revolved around an effort to address the legacy of the Holocaust. Drawing from her 1987 interview with Boltanski in which he revealed that his father was Jewish and had gone into hiding during the Second World War, Gumpert contended that the aging black-and-white family photographs in Boltanski's archives, and indeed much of his oeuvre, constituted an immediate way to access the memory of lives lost during the Holocaust. Gumpert's provocative essay is one of the most powerful examples of the tendency to treat Boltanski's work as autobiographical expression.

However, the inconsistencies that arose when I examined Boltanski's life as represented in published interviews, art criticism, and artwork, as well as in interviews that I conducted with the artist over the course of eight years, should make us rethink any straightforward interpretation of the biographic information he presents. The details of Boltanski's ethnic identity and his family connection to the tragedy of the Holocaust certainly permit a reading of his more recent work that ties it to the horrors of the Shoah. Boltanski himself at one point during the mid-1980s and early 1990s seemed to encourage such a reading and in fact created the works *Lycée Chases* (1988) and *La Maison manquante* (1991) (*Chases High School* and *The Missing House*), which specifically reference the period

of the Holocaust.[16] But significantly, since that time he has downplayed and even disavowed not only his Jewish identity but also interpretations that would ground his work in the biographical details he had recently put forth, in the same way that he disavowed earlier representations of his identity – the suicidal artist desperate for recognition and the nostalgic and sentimental collector of objects from times past.[17] This pattern of advancing an image of his life and then rejecting or turning away from it is part of a larger pattern in Boltanski's career. Although the identities he presents may inform and deepen our readings of his work, we should hesitate to accept any particular biographical presentation as the single key to Boltanski's work.

I first noticed these contradictions when tracing Boltanski's critical reception. After almost every new interpretation or interview was published, Boltanski advanced a different line about his life and work that conflicted with or contradicted previous ones.[18] Boltanski was clearly playing a game with his biography, one that extended to our conversations in Paris. When he telephoned me, simply announcing "*c'est moi*," I never knew which Boltanski I'd get; during our exchanges, he frequently shifted back and forth to inhabit the varied and contradictory selves that he had created in earlier interviews and autobiographical work. Boltanski continues this play with his identity in the present, alternately taking on the personae of a recluse, guru, or preacher. Given his pattern of advancing and withdrawing biographical interpretations, it would be dangerous to understand Boltanski's entire career through the lens of an identity that he offers at any single moment since it may be simply one in a series of identity games.

I read this dynamic as an instance *par excellence* of Boltanski's employment of the notion of the "death of the author," an idea which came to the fore in the 1968 protests and was used to address what protesters saw as the dangerous tendency of notions of artistic genius and biography to remove the artist from his or her social, political, or institutional circumstances. Roland Barthes, Michel Foucault, and critics writing for the *Cahiers du cinéma* also developed this idea in theoretical writings of the period.[19] Boltanski's approach, I believe, comes closest to Foucault's, who in "What Is an Author?" analyzed how authors were constructed by literary institutions such as literary criticism and copyright law, whose corollaries in the visual arts can be found in art criticism and museum and gallery exhibitions. Boltanski's work elaborated these ideas of the "death" of the artist in the years following 1968 when institutions were in flux. This early work set up a pattern he has maintained throughout his career in which he adopts and parodies clichés of the artist in order

to both highlight and undermine the significance traditionally attached to the artist's biography. In contrast, I believe that we need to examine this overall pattern of shifting identity as a strategy born out of the political desires and institutional situation after 1968. Taking Boltanski's self-presentation as straightforward and genuine has not only meant missing his works' sources in 1968 and the reconsideration of art institutions that emerged during that era, but has also provided a shaky foundation for a widely accepted interpretation of one of the most celebrated artists of our time.

Overlooking how Boltanski problematizes the biography of the artist has served to consolidate an interpretation of his art as achieving a means to represent stubbornly elusive private memories and experience. Whereas Boltanski's interviews created images of the artist in which fact and fiction are intentionally blended, his exhibitions of personal material in archival and museum forms of display (such as vitrines, file drawers, and tin boxes) purport to convey a self by representing intimate experiences (his own or those of others), but simultaneously draw attention to the fact that this content is never communicated. For example, the faded photographs, rusted tin storage boxes, and glowing electric lamps of his *Archives* do suggest memorials for lives lost (see Fig. 1). Yet what information can be gleaned about these particular individuals or the memories that the pictures were taken to depict? His use of personal material elicits viewers' emotional responses, identification with his images, or projection into them, but at the same time emphasizes the fading and irretrievability of memory. The consequences of this misunderstanding become even greater when we consider the way these evocations of personal memory have taken on a privileged role in museums' attempts to address the traumas of history.[20] Although Boltanski's work seems to promise access to an otherwise ephemeral, traumatic, or difficult-to-represent private past, in fact it just as strongly resists revealing this content. For this reason museums' seizing on these kinds of objects as a way to incorporate previously excluded histories may end up only acting as cover for the ways they still fall short of this goal. In fact, I would argue that the availability of Boltanski's work for national symbols, such as museums, or the recently reopened Reichstag building in Berlin, comes out of the works' ambivalence, which seems to acknowledge and preserve history while providing a means of avoiding or forgetting it. My account exposes these shortcomings in the ways museums have presented his work; instead, I see Boltanski revealing the limits of what can be retrieved from history and memory and challenging the role that representations of private experiences are expected to play in museums today.

If Boltanski developed the idea of the "death of the author" to examine biographically centered art criticism and exhibitions and the possibility of representing private memories in museums, Messager employed comparable strategies of representing multiple identities with personal and everyday materials to play with notions of artistic subjectivity. (Indeed, the two artists have been colleagues and romantic partners since 1971, and although they have sought to keep their public lives separate, their artwork clearly reflects their mutual exchange of ideas.) For example, in her diary-like notebooks and collection albums, created from 1971 to 1974, Messager described and illustrated fictional daily activities with handwritten texts, sketches, and clippings from magazines (see Figs. 49–50). In these albums, Messager adopted various models of femininity; at different moments she appeared to be a schoolgirl dutifully copying her lessons, a sentimental young woman reading magazines and fantasizing about romance, or an artist-mother caring for her children. She has continued this process of taking on different feminine roles throughout her career. Messager's work thus does not merely comment on the construction of the artist by art institutions, but also uncovers how broader social and political institutions, such as family upbringing, education, and the influence of the mass media, create conditions in which individuals form their identities as subjects. In this way, I see her work paralleling contemporary analyses of how institutions shape individuals' subjectivity, such as those by the sociologist Luc Boltanski (Christian Boltanski's brother), Louis Althusser, and, most famously, Michel Foucault.[21]

In the literature on Messager's work, however, this focus on institutions has been little recognized. Instead, the critical reception of Messager's work from the 1970s to the present has been organized around two poles: one which sees her work as a universal documentation of the way identity is shaped in daily life, which employed ordinary images to evoke common experiences, and a second in which feminist critics saw her work not as universal but as representing feminine subjects and experiences. These latter critics saw Messager's work as typifying a fluidity of identity that was deemed specifically feminine. Feminist critics and curators compared Messager's work with that of French feminist author Hélène Cixous, which celebrated the multiple and changeable aspects of feminine identity as offering strategic ways of sliding between (rather than being pinned down by) predetermined definitions and clichés of femininity.[22] Accordingly, these critics saw Messager's methods of mixing together and moving among clichés of femininity as a means for challenging feminine stereotypes.

Although these interpretations from the 1970s to the present are certainly correct to point out how Messager represented daily life and played with the formation of stable identities, another more historically and politically grounded interpretation is possible. After all, Messager's work describes neither a universal expression nor an essential femininity but rather insists on the ways that feminine identities are shaped by history and institutions. I have recovered her albums' sources, which reveal her interest in the specific institutions that shaped women's daily experiences in the 1960s and 1970s – girls' home economics lessons from primary and secondary school (now stored in the Institut National de Recherche Pédagogique in Rouen), as well as in those less official pedagogical tools, women's magazines such as *Elle* and *Marie Claire*. Messager depicted a range of subjects drawn from these sources – from cooking meals to caring for children to applying makeup – and portrayed different relations to them – from slavish imitation to insecurity to irony – exploring how the roles learned from schools and the media shaped women's subjectivity.

By recovering these sources, I interpret Messager's documentation of her daily activities as a specifically feminist commentary on the politics of everyday life, which had been discussed in the 1960s by philosophers, such as Henri Lefebvre, and became a powerful tenet for 1968 protesters.[23] For these activists and writers, everyday life was a site of political struggle and a place where broader social and institutional patterns of oppression could be perceived and resisted. Many members of the French women's movement, or *Mouvement de libération des femmes* (MLF), came to see everyday life as a place where women could observe and combat their oppression. This notion became particularly salient during the demonstrations of 1968 as women watched many revolutionaries try to marginalize their concerns, never questioning the fact that women tended to be relegated to the roles of secretary, babysitter, or cook. One of the many contributions of the women's liberation movement was an exploration of the ways social and educational institutions structured women's everyday life and trained them to do daily domestic tasks.[24] I use Messager's engagement with these issues of everyday life to demonstrate how the 1968 calls for a politicization of everyday life were developed and expanded in the French women's movement.

At the same time, I also pursue the way that these specific gender issues have dropped out of the discussion in criticism on Messager's work. In fact, some of Messager's biggest successes have been attended by a critical reception that downplayed the specific feminist content of her work and promoted an interpretation claiming her work as universal.[25]

I explore this oscillation between gendered and universalizing accounts of Messager's appeal as a manifestation of the challenge that gender posed to the contemporary project of conceiving a museum that fulfilled the dream of a national collective representation. The tensions between the desire for a universal and the demands of the particular that troubled the critical reception of Messager's work were a central problem for artists and curators who were seeking to create responsive, engaged art and cultural institutions throughout this period.

This kind of struggle on the part of artists and curators should not be underestimated; it demonstrates the way artists and curators in the 1960s and 1970s did see the museum as an important political site and did view the need to remake art and cultural institutions as a crucial revolutionary aim. This is a point that has not yet received due attention in several recent accounts of Conceptual Art and its submovement, institutional critique. A number of scholars have seen the Conceptual Art movement that emerged in the 1960s as an extremely significant attempt to have broad social impact; however, because artists interested in institutional critique came to focus their attention on the museum rather than joining the political movements outside it, these scholars have characterized their attempts as failures. However, this narrative should be reconsidered in light of the way museums were seen as highly contested and significant political spaces in the late 1960s. It was not only by circulating work outside the museum with practices such as land art or mail art that artists could challenge the power of the institution. Within the museum itself, artists' efforts at institutional critique could be politically charged in their own right.

In his influential account, *The Rise of the Sixties*, Tom Crow argues that the art of institutional critique was a falling away from the more politicized practices of the 1960s, such as the Paris *atelier populaire*, which produced graphic posters in support of demonstrations and workers' strikes during May and June 1968. Crow praised the posters as "the most visible and memorable accompaniment to political action in Paris." He lamented that the art of institutional critique that followed in the early 1970s, such as Daniel Buren's museum installations of repetitive stripes, "began to lose confidence in addressing any subject beyond the most proximate institutions of artistic display and consumption."[26]

Similarly, in his 1999 anthology *Conceptual Art*, coedited with Alexander Alberro, Blake Stimson provocatively rethinks Conceptual Art through the lens of '68 activism and also concludes that Conceptual Art ultimately distanced itself from the political movements of the 1960s. In Stimson's view, "for a critical moment" the ambitions of artists of the

late 1960s to have broad social and political impact were realized as they collaborated on work and developed alternate means for circulating it, challenging norms of artistic production and distributing work more democratically.[27] Stimson comes to see the promise of Conceptual Art compromised as artists turned to exhibit within the museum, retreating from these initial attempts to radically overhaul the production and distribution of art; he views the late 1960s and early 1970s as a moment when the possibility for creating a new social function and audience for art was lost.

Both Crow and Stimson advance the discussion of Conceptual Art by investigating the connections between the politics and artistic production of the period. For them, the problem at that moment was that the art of institutional critique became overly engrossed with museums and thus lost its engagement with broader political movements of the time. I would argue, however, that by treating politics as something that comes from and takes place beyond the walls of the museum, such accounts miss the actual politics of artists' institutional critiques within their historically and nationally specific contexts. Both Crow and Stimson tend to maintain the notion that politics come from outside the museum, from the wider world: politics are war, the operations of government, and social and political movements with announced agendas, such as the New Left. For them, work that retains its focus on cultural institutions risks remaining confined within the art world and cut off from the political movements outside.

It is certainly true that other artists in the late 1960s and early 1970s were more obviously political in the way Crow and Stimson describe. Boltanski and Messager did not partake of the most visible forms of political activism; they did not, for example, employ political iconography or slogans and did not take their work to the factories and streets.[28] However, although their work did not reflect the flat-out rejection of museums expressed in many protests of the time, the two artists' work engaged concerns with the political functions of cultural institutions that were crucial to the activism of '68 and its aftermath. To hold that art's engagement with institutions diminishes its political power would be to miss the centrality of cultural institutions to the 1968 protests in France. Artists' occupations and critiques of art institutions, like students' occupations and critiques of universities, were directed at institutions seen as primary instruments of government power and social order; they were not incidental, secondary arguments against sites seen as refuges from the forces of state and society. Boltanski's and Messager's complex explorations of the functions of museums as repositories of memory and symbols of

national identity thus extended and expanded a crucial political concern of 1968.

It is particularly the case in France that art institutions should have this political resonance, given the way their functions as symbols of the nation had come to the fore at moments of national political crisis since the French revolution. In France, museums were centralized, run by the state, and conceived as repositories for national patrimony, as well as representations of national culture, memory, and identity. One of the reasons why Crow's and Stimson's extraordinarily useful American histories of Conceptual Art are less applicable to the French scene may be that museums did not and do not have the same structures, social functions, and meanings in the United States as they do in France. In America, museums have tended to be closely associated with the cities in which they are located and are subsidized by a combination of city, state, national, and private funds, as opposed to France, where art museums have close bureaucratic ties to the national state (with most major museums belonging to a national network). As a result, art activism in the United States in the late 1960s and early 1970s generally had a more diffuse character and locally targeted focus. This is not to say that artists did not launch challenges to the way museum institutions functioned. In New York, for example, Women Artists in Revolution (WAR) protested the underrepresentation of women at the 1969 Whitney Annual exhibition; they were joined the following year by WSABAL (Women, Students, and Artists for Black Liberation) and the Ad Hoc Women Artists' Group in calling for equal representation of women artists.[29] In 1969, the newly formed Black Emergency Cultural Coalition (BECC) similarly contended that black artists were not receiving due representation and voice in museum management, criticizing in particular the Metropolitan Museum of Art.[30] Or, for example, in a 1969 anti–Vietnam War protest, the Guerilla Art Action Group called for the resignation of the Rockefellers from the Museum of Modern Art's board of trustees, because their companies had been linked to the production of chemical and military weapons.[31] But in the United States, this kind of institutional critique did not share the same centralized, national focus and concentration that it had in France, where within two months in 1968 Prime Minister Pompidou and President de Gaulle were forced to confront protesters' demands themselves. Individual groups in America pursued their agendas with local museums and establishments over a period of years beginning in the mid- to late 1960s; the responsibility to answer these protesters' challenges has devolved to particular museums, which have responded in

uneven ways. Within a year after the 1968 protests in France, in contrast, President Pompidou announced a plan to create a new kind of center for modern art. The French national response, though by no means able to satisfy these wide-ranging challenges, has no institutional equivalent in the United States.

In the following chapters, I proceed by exploring a series of conjunctures in which the politics of art and museums take center stage. Chapter 2 demonstrates how the 1968 activists' practices, ranging from closing museums to occupying art schools to taking artwork to the streets, converged around a critique of cultural institutions. This establishes a foundation for understanding the artwork that in the aftermath of 1968 comes to critically engage museums as a political practice. In subsequent chapters, I counter the view that museums are depoliticizing spaces, and instead strive to capture their shifting and contested political status as they come to the fore in moments of vivid intensity. In Chapter 3, I consider the Expo '72, the first large state-sponsored exhibition of contemporary art to follow the 1968 demonstrations. With this exhibition, the French government sought to respond to the protests and to solidify plans for a new museum of modern art in what would become the Pompidou Center. I focus specifically on Boltanski's work, which rose to national prominence through this exhibition because of the responsiveness and openness his art seemed to offer museum policymakers struggling with the aftermath of '68. I present a reinterpretation of his works that suggests, in contrast, that his art was only partially amenable to their aims, uncovering a strand of resistance to the institution that demonstrates continuity with 1968's critiques. The next moment I consider in Chapter 4 is the period between 1973 and 1975, when the growing feminist movement added gender concerns to 1968's largely class-based criticisms of how educational and cultural institutions perpetuated an exclusive model of culture and the nation. By examining the archival sources of Messager's work, I demonstrate how it engaged these contemporary feminist debates and resisted museums' universalizing interpretations. In Chapter 5, I discuss the opening of the Pompidou Center in 1977, which was the first major art museum to attempt to address the May '68 demands for access and inclusion. The center is generally considered to have incorporated the 1968 activists' objectives and has served as a prototype for contemporary museums over the last two decades; I examine its limits, as well as its achievements. The final chapter examines how the '68 agenda has informed much contemporary cultural policy, asking what challenges and possibilities remain, where museums have

succeeded, and where they are still falling short as they have sought to address the imperatives of inclusion and representation in the decades following 1968.

The readings presented in this book challenge commonly put forth interpretations of not only Boltanski and Messager, but also of other post-1968 activist artists who engage political subjects through representations of private and everyday materials. Such representations have been viewed in numerous ways by critics and curators: in isolation, making them seem introspective and apolitical; as representations of an authentic self; as a breath of fresh air from outside the fine arts tradition making the museums that contain them universally accessible and democratic; and finally, as a means of making a true connection between the individual viewer and the national collective. What I argue instead is that such readings inadequately recognize that rather than being about the private *per se*, artwork that puts the private and the everyday on display foregrounds the tension between its imagery and the public museum – and it is through this tension that political battles continue to be fought. My aim, in focusing on this tension between the private and public, the everyday and the institution, is to render museums as they are today – sites of political struggle.

2 DISMANTLING ART INSTITUTIONS

THE 1968 EXPLOSION OF SOCIAL AWARENESS

■■
■■

In March of 1968, student clashes with the administration erupted at the Nanterre campus of the University of Paris, spurred by anti–Vietnam War activism as well as dissatisfaction with university policies; by early May, when the Nanterre campus was closed by the administration, the student agitation spread to the Sorbonne and other branches of the University of Paris.[1] From this local beginning grew the largest protests and strikes in modern France and the largest insurrections in the modern West.[2] Within a few weeks, hundreds of thousands of university and high school students including art students across France joined the demonstrations, as well as Maoists, Trotskyists, Anarchists, Communists, and other leftist groups that also came to participate. The protesters' dissent took many, sometimes contradictory, forms, ranging from protests against the Vietnam War, the Gaullist state, capitalism, consumer society, and the mass media, to demands for the overhaul of the French school system by ending its class bias, abolishing examinations, and modernizing the outdated curriculum and overspecialized majors. With public speeches and poster slogans, demonstrators underscored the fact that although public universities were ostensibly accessible to any citizen, they were composed almost exclusively of students from the middle and upper classes and thus perpetuated social hierarchies; it was hoped that a revolution in the school system would lead to a revolution in society, as the banner reading "from the critique of the university to the critique of society" proclaimed (Fig. 5).[3] In the Latin Quarter of Paris, students marched in the streets and occupied public buildings, such as the Sorbonne, the Ecole des Beaux-Arts, and later, the Théâtre de l'Odéon (Fig. 6). In the buildings they occupied, students held public meetings, organized action committees, printed tracts, and even developed systems of meals, dormitories, and nurseries (the latter run mainly by women). The demonstrations and occupations were met with arrests of activists and increasing police violence (Fig. 7). Beginning on May 10, the famous "night of the barricades," students took paving stones from the streets and erected ramparts; they also threw fire bombs, clashing with police, who beat them with clubs and sprayed them with tear gas.

Figure 5.
May 6, 1968 demonstration in the Latin Quarter. The banner declares "from the critique of the university to the critique of society." © Elie Kagan. Photo courtesy of the Bibliothèque de Documentation Internationale Contemporaine (BDIC), Nanterre.

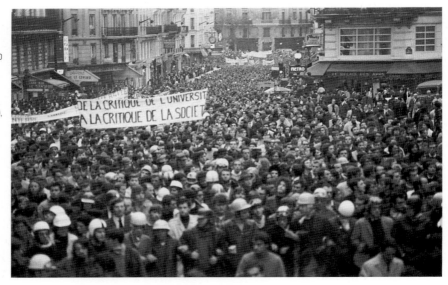

The broader public was shocked by the police violence and generally sympathetic to the students. On May 13, approximately 800,000 students and workers assembled in the streets of Paris, forming an alliance to protest the Gaullist government as an undemocratic instrument of repression, which they held responsible for unemployment and poverty, blaming the economic stabilization plan that it had pursued in recent years (Fig. 8). (The number of unemployed had nearly doubled between the fall of 1966 and the fall of 1967; nearly 40% of the unemployed were under 25.)[4] This demonstration was followed by widespread strikes by approximately nine million workers, who demanded not only reduced work hours, wage increases, and a voice in management, but also greater worker control and ability to make decisions about their own work lives. Like students, workers began occupying factories – in effect, seizing control from the owners.[5]

President Charles de Gaulle and Prime Minister Georges Pompidou were unwilling and unable to satisfy the demands of the protesters. On May 29, de Gaulle visited French military troops stationed in Germany, who assured him of their support. He returned to France the next day, portraying himself as a figure of stability, and gave a dramatic radio speech in which he announced the dissolution of the National Assembly and called for a general election at the end of June. As it witnessed gas shortages, the shutdown of public transportation, and the suspension of many public and private services due to the strikes, the general public was growing increasingly uneasy.[6] De Gaulle's speech was followed by

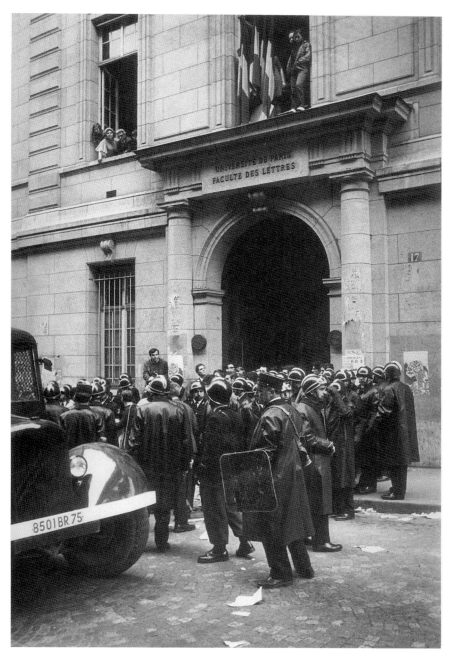

Figure 7.
May 6, 1968: Student protesters in the Latin Quarter are beaten by police. © Elie Kagan. Photo courtesy of the Bibliothèque de Documentation Internationale Contemporaine (BDIC), Nanterre.

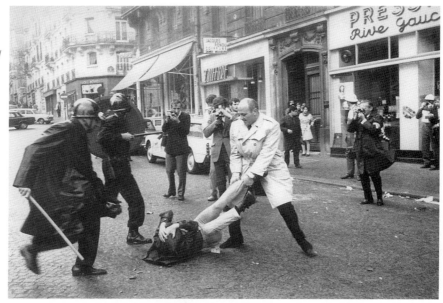

Figure 8.
May 13, 1968 demonstration headed by student leaders: (from left) Michel Recanati (the head of the CAL, the high school students' action committee), Alan Geismar (the national secretary of the SNE-Sup, the major lecturers' union), Daniel Cohn-Bendit (a student who led the Nanterre protests in March and was often considered the spokesperson for the May movement), and Jacques Sauvageot (the acting president of the UNEF, the national students' union). Behind Cohn-Bendit on the right is Daniel Bensaïd (a leader of the Jeunesse Communiste Révolutionnaire, a Trotskyist group). The banner proclaims: "students, teachers, workers, in solidarity." © Elie Kagan. Photo courtesy of the Bibliothèque de Documentation Internationale Contemporaine (BDIC), Nanterre.

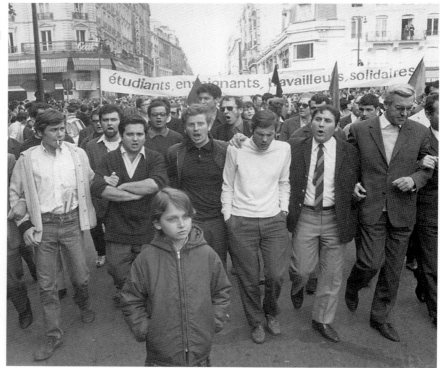

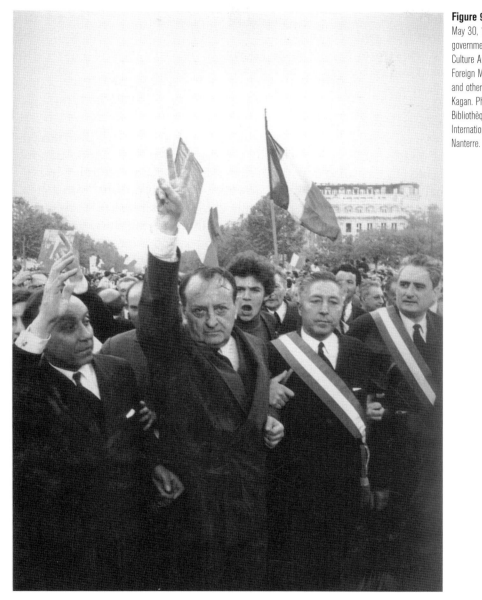

an immense, 300,000-person strong, demonstration of support for the
government led by the Minister of Culture, André Malraux, and other
prominent Gaullists at the Champs-Elysées (Fig. 9). In the days that fol-
lowed, the government ordered riot police to force workers to leave the
occupied factories. By mid-June, the government and laborers began to
reach agreements that provided increased wages and improved working

conditions, and workers returned to their jobs soon after. The govern-
ment also made concessions to students to decentralize, democratize,
and modernize the university system. In the election, which many stu-
dents and activists boycotted, de Gaulle's party and its allies won three-
quarters of the seats – a landslide victory. At the end of June, police
forced students to leave the occupied buildings, effectively ending the
student demonstrations.

Yet as the short-lived, but extraordinary, tumult subsided – even though
de Gaulle had been reelected, the student and worker demonstrations
seemed to have died down, and things appeared to be returning to nor-
mal – public trust had broken down, and this was coupled with a great
sense of disillusionment concerning the relations between workers and
management, students and university authorities, and the government's
jurisdiction over them. This anxious mood extended beyond the activists
into the wider public, which retained some sympathy for their causes. As
theorist Michel de Certeau evoked, "The rains of August seem to have
doused the fires of May and flushed their ashes down the sewers. With
Paris emptied, the streets, then the walls have been cleaned. . . . Even if
the waste . . . is thrown into the dumpsters, it still cannot be said that
the revolution has been forgotten. Something in us is caught up in it,
something we cannot eliminate so easily."[7] After such a broad-based and
vigorous questioning of the social, political, and economic order, what
was to come next? It was apparent that the system could not remain as it
was, yet it was unclear what measures could be taken to realize activists'
calls for change.

The art world, too, was left shaken by the events of May and June
1968. Practicing artists, art students, and critics, as well as some curators,
allied themselves with the larger social movements, and saw that the time
was ripe to contest the power structures of the art world. Before 1968,
the notion that art occupied an elevated, autonomous realm remained
widespread. In 1968, art world activists insisted that art was not a separate
sphere, but was integrated into broader political, social, and economic
structures through the institutions of museums, art education, and the
art market. They saw these institutions – and the aesthetic ideologies
and traditions that they created and depended upon – as instruments
of power for the ruling classes. Rejecting the idea of the autonomy of
art as a mystification of its politics, art world activists called for a rev-
olution in the creation, circulation, and study of art, with goals that
ranged from establishing a more democratic, egalitarian society to radi-
cal, utopian visions of unending pleasure and play. Art activists came to
the conclusion that it was not enough to politicize the content of art;

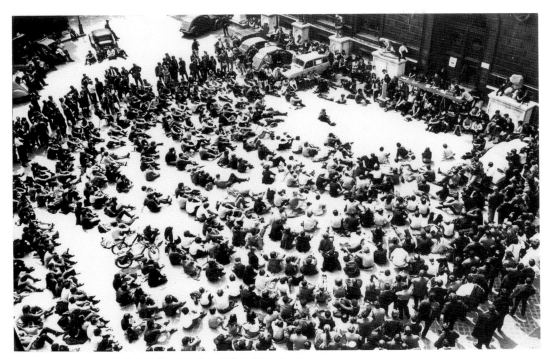

Figure 10. Student sit-in at the Ecole des Beaux-Arts, Paris, 1968. © Philippe Vermès.

they needed to transform the entire socio-economic structure in which it operated.

The aims of art world protests paralleled those of the broader demonstrations in that they opposed state institutions and the market, but because these institutions were manifested in the art world in particular ways, the art world protests took on distinct forms. Like university students, art students occupied their school buildings (most prominently at the Ecole des Arts Décoratifs in Paris and especially at the Ecole des Beaux-Arts, where occupying students hung a sign out front proclaiming the "Closure of the School until the [creation of a] new order" (Fig. 10).[8] Specifically, art students objected to an academy-driven education that encouraged emulation of a national artistic tradition rather than fostering individual creativity. Furthermore, like their comrades in the universities, many of the art students were motivated by a sense that the working class was largely shut out of art education. In addition, high failure rates in school and high unemployment upon graduation created a sense that the system as it existed was not even able to serve the needs of those who did participate in it. And artists in particular were frustrated by an educational system that did little to foster their work and exhibition

opportunities – especially given the limited venues for supporting contemporary art in the French art world.

Because museums and galleries also represented central power in the art world, groups of artists, art students, and critics boycotted galleries, closed the Musée National d'Art Moderne, and withdrew works from exhibitions. The Salon de la Jeune Peinture, for example, a forum for politically engaged young artists, never opened the *Red Room for Vietnam* exhibition that was due to begin at the Musée d'Art Moderne de la Ville de Paris that May; instead the artists chose to take their paintings to the factories and streets.[9] Some artists and students collaborated in solidarity with workers in collective works of art at *ateliers populaires* (popular studios), whereas other artists preferred more spontaneous forms of creative expression, turning to graffiti slogans and improvised tracts that they plastered on the walls of occupied university buildings and city streets.

In constructing their critique of cultural institutions, art world protesters renounced the museum policies in place at the time that had been established during the 1960s. These policies depended upon a humanist vision, in which art and culture constituted a separate, sacrosanct sphere and could communicate universal truths to the entire nation. Protesters, many of whom were influenced by Marxist analyses of culture in capitalist society, saw this vision as forcing a consensus and obscuring the actual experience of class conflict, transmitting the values of an elite as purportedly universal. Various responses emerged from this critique, ranging from calls to close museums to demands for reforms that would infuse museums with the vitality of everyday life, replacing the outdated and elitist collections with art that would render museums more democratic, accessible, and politically engaged.

The protesters' analyses of the operations of the art market were similarly motivated by the desire to eliminate the boundary that had been seen to separate the art world from the world of capitalist exploitation. As artists asked which classes were served by cultural production and who profited from artistic labor, they objected to the capitalist market that turned artworks into commodities, objects of alienated production and consumption, deprived of meaningful roles in society. Gallery owners and other "middlemen" who manipulated access to artists' work and gleaned profits from it were fiercely condemned in tracts and speeches. Artists demanded more control over the circulation of their works and sought new circuits for distribution that were not driven by profit. In addition, a movement grew among artists to undertake collaborative work as a refusal of market competition, which they saw as fostering one-upmanship between avant-garde groups.

In a further effort to escape or reduce the influence of market forces, as well as to challenge the traditional artistic education they had received, many artists and art students rejected specialization, which contributed to the valuation of art as the unique product of a trained and gifted individual. Their main objection was that this preference for specialization elevated the artist, creating a hierarchy that isolated him or her from other workers. In response, artists argued that the differences between mental, creative labor and manual labor were purely ideological. To call into question the elite, elevated position of the artist and the notion of the artist as the privileged source of creativity, many artists forged alliances with workers, for example, at the *ateliers populaires*. Moreover, many artists were influenced by the contemporary notions of the "death of the author," advocating collaborative creation or the circulation of anonymous artwork, which circumvented the notion of the gifted individual.

Documentation and analysis of art world activism in 1968 is sketchy at best. Few journals and venues for contemporary French art existed in the 1960s, and the publication of these, like many other journals and newspapers, was interrupted in 1968 by the widespread strikes. Much of the news of the activism was transmitted through short-wave radio, ephemeral posters, tracts, and wall newspapers.[10] Although particular slogans from these sources have been often repeated in commemorations of this period, these commemorations have not sought to understand the calls for change within the institutional and material contexts of the art world at the time. As a result, the specific politics of art world activism and its institutional targets have been overlooked in accounts of the period, and the texture it provides for our understanding of artistic practices has been sorely lacking.[11]

One specific consequence of this has been subsequent criticism's division of artists of the period into two broad camps: the explicitly political practitioners of the *ateliers populaires* and the street, and the less overtly political, loosely associated groups who were to become known as conceptual artists. Accounts written in the years following 1968, such as Jean Clair's landmark *Art en France: Une Nouvelle Génération*, have suppressed the politics of conceptual artists' practices, establishing a pattern of interpretation that has remained very influential up to the present.[12] For example, the cover of Clair's text presented a diagram of the contemporary French art world bisected down the middle (Fig. 11). This central division separated the use of "art as a critical instrument," exemplified by the *ateliers populaires* of May '68, from the conceptual work of artists such as Daniel Buren, Michel Parmentier, Gina Pane, Jean Le Gac, and Christian Boltanski. Significantly, the use of art as a critical and

political instrument is the only movement in the diagram represented by a backwards-facing arrow – portrayed as retrograde and moving against the grain of all the major artistic movements of the time and in direct opposition to the development of Conceptual Art as (purely) "aesthetic." The book's narrative also reinforces this image: although Clair briefly mentions artists' political contestation, as if a momentary aberration, he quickly moves to focus on the "aesthetic" practices that he sees defining the new French avant-garde.

But the group of young conceptual artists that Clair approvingly places on the apolitical side of his divide was by no means unconcerned with the political ferment around them. Although their artistic practices were not explicitly political in that they did not involve disruptive activities, such as demonstrations, or employ didactic slogans, they nonetheless advanced the broader institutional critiques of their contemporaries. By rejecting *beaux-arts* painting, which occupied the highest position in the aesthetic hierarchy, and working with nontraditional materials and venues, these young artists contested traditional academic and market definitions and valuations of art. Clair's text, like many subsequent accounts of the art of this period, considers conceptual artists in isolation from their political, institutional, and material contexts, and thus creates a picture of competing works, movements, and styles.[13] Yet this focus on isolated works of art misses a central component of 1968's artistic challenges, which, even across styles and movements, sought to examine and critique the institutional settings of art. Different artistic practices and forms of activism, in other words, converged around similar sets of concerns. This chapter locates members of the art world and their activism in relation to the institutional, economic, and political challenges they faced. Their critiques – which centered on debating the new role of the museum and even questioning the need for it, reviving the possibilities for art and exhibitions by incorporating the everyday, and exploring new avenues for production, distribution, and training – would be foundational for artists and museums in the years following '68 as they sought to re-imagine their roles in society.

CONTESTING HUMANISM AND CULTURAL DEMOCRACY

On May 18, at the height of the protests, a crowd of students, artists, and critics gathered outside the Musée National d'Art Moderne and went so far as to close it, charging that the museum was a "cemetery," and art, "a corpse," sealed off from "contemporary life."[14] For these demonstrators, as well as for a number of vocal factions on the left, the only way to

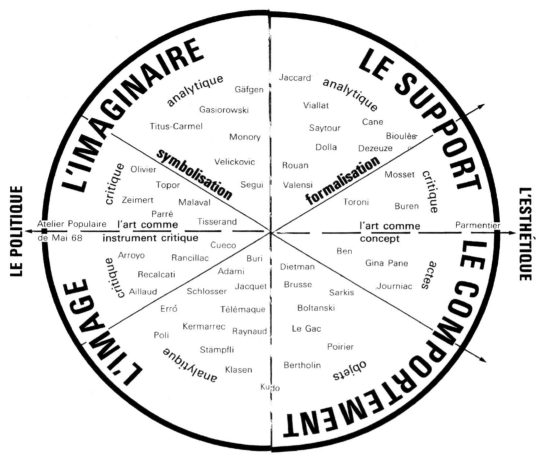

Figure 11. Jean Clair, Cover diagram for *Art en France: Une Nouvelle Génération* (Paris: Chêne, 1972). © Jean Clair.

improve the museum was to abolish it in order to demystify art and merge it with everyday life. Yet among other activists, critics, and curators at the time, there was also a real desire to determine how to reform the museum. Those who wanted to grapple with the roles of the museum sought to rethink the longstanding tradition of French patrimony and the more recent attempts at cultural democracy that had been developed by the Minister of Culture, André Malraux, whose cultural policy of the 1960s had focused on "democratizing" culture by making great artistic works – the best of a shared humanist heritage – available to as many people as possible. However, in the minds of many students, artists, critics, and curators, this project had not gone far enough towards reaching a broad public and exhibiting an art that engaged everyday life and

that responded to social inequalities. In their opinion, the museum's humanism was a cover for elitism.

When de Gaulle appointed Malraux in 1959, he already had made a mark in the field of cultural analysis through his celebrated 1954 text, *Le Musée imaginaire*, in which he asserted that every person could recognize the value of art from all times and all cultures, an experience which united people in their common humanity.[15] In aesthetic expression from across the ages, viewers could contemplate the essential issues that had always faced humanity: the questions of life and death. Great works of art, Malraux believed, helped viewers feel connected to other people, times, and places. Although photography was not itself a medium of art, photographic reproductions of great works of art extended the possibilities for aesthetic experience to viewers beyond the walls of the museum, creating new opportunities for broad audiences to share in the common heritage of humankind.[16] Photography thus brought together and united the great works of all civilizations in an immense, universal imaginary museum. Despite Malraux's pretensions to universality, his *musée imaginaire* was actually more suggestive of collective Western memory, a concept that was to be challenged in 1968 and further contested in the years following by artists turning to private, personal kinds of memory as well as ethnography, as the next chapters will discuss.

When Malraux began planning the state's new cultural agenda in 1959, he continued to employ the humanist language of universal accessibility and shared culture, but this time in the service of specifically national aims. Malraux favored the development of centers called *maisons de la culture* ("houses of culture") in major provincial cities as a means to make originals and reproductions of great works of art that were held in Paris available to audiences throughout France, who, Malraux contended, had been deprived of access to culture. Malraux thus intended the *maisons de la culture* to promote cultural cohesion, binding the nation together with the shared history and values embodied in art. In this way, the *maisons de la culture* would function as reservoirs of cultural memory and points of national identification.

The *maisons de la culture* were based on the humanist idea that viewers would have epiphanies before works of art, gaining immediate and complete comprehension of them. Furthermore, Malraux believed that contact with art in museums was crucial for maintaining the public's humanistic values in a modernizing society. Great works of art enriched individual viewers, developing their civic sense and aesthetic sensitivity, in contrast to mass cultural entertainment or "dream factories," such as movies, television, and radio that promoted vacuous fantasies and

distracted from culture of real value. Thus, the fundamental mission of the Ministry of Cultural Affairs under Malraux was "to make accessible the most important works of humanity and especially France to the largest possible number of French citizens and to assure the largest possible audience for cultural patrimony" so that "any sixteen-year-old child, however poor he may be, can have true contact with his national patrimony and with the glory of the spirit of humanity."[17] Malraux described the *maisons de la culture* as the "cathedrals of the twentieth century," public spaces that allowed visitors to transcend the concerns of their daily lives and enter into a "national communion," a collective celebration of the shared values represented in cultural patrimony. Malraux's vision of cultural democracy, then, was one of extension, in which an already agreed-upon set of masterworks was diffused more widely; it was an appropriate vision for a minister in a conservative government, which aimed to advance national unity rather than to transform the very notion of national culture itself.

The notions of democratic extension of culture on which Malraux had based his policy had not always been the tool of the Right, however. In fact, the policy of cultural democratization was grounded in concepts that had been advanced by the Popular Front of the 1930s, and developed by the popular education and popular culture movements, particularly during the postwar years.[18] The Popular Front and the popular culture movements asserted that members of the working class, who had been deprived of culture and excluded from its sacred sites, had a right to and even a "need" for culture. Thus, the movements' primary emphases were to help the members of the working class gain access to art and culture. Another strand of their politics argued for the development of a specifically working-class culture, based in people's daily experience: an expansion, in other words, of the notion of what counted as culture. However, Malraux adopted only the first of these approaches, focusing on the idea of providing access to high culture for all citizens, asserting that all social groups could come together and share in the common, national culture.

Malraux's goal that the *maisons de la culture* should perform a unifying function was a response to a very real sense of disintegration in the French community following the Second World War. As Herman Lebovics has argued, Malraux promoted national unity through a common French culture as a means to combat on the cultural front the growing factionalism of postwar French society. The factionalism had been intensified by the regionalism of the Vichy years; the decline of French political prestige; the colonial wars for independence; and the social dislocations attendant

upon economic modernization, urbanization, and an increasingly migratory population.[19] As Emile Biasini, Malraux's adviser, claimed, the cultural work of the nation could play a critical role in fostering national cohesion: "For, as varied and multiple in its diversity as it may be, deep down the country is solidly united; beyond doubt, its accumulated cultural capital has been the most binding cement of a community which appears so factious on the surface."[20]

In 1968, however, Malraux's conceptions of a unifying, democratic culture came under fire. Different constituencies, including artists, scholars, critics, and some museum administrators, rejected Malraux's idea of the universality of art and criticized the class biases of cultural institutions. Many feared that art was being used to maintain the status quo and set about to formulate ways to make the museum truly democratic. One of the foundational critiques of French cultural policy of the time was the sociologist Pierre Bourdieu's *The Love of Art*, which was first published in 1966 and was frequently cited in 1968 by critics, intellectuals, and other protesters as both evidence of the class bias of museums and an articulation of how it was perpetuated.[21] Bourdieu began by rejecting the idea of the viewer's spontaneous revelation before a work of art. Such an experience of "aesthetic grace," Bourdieu argued, was not available to all viewers, but only those with a culturally privileged upbringing. He renounced the conception of cultural democracy that Malraux had advanced, contending that the idea of a universally accessible national culture – transcending divisions and particularities – ignored the socio-economic and familial inequalities that conditioned audiences' abilities to approach art.

Bourdieu's research team surveyed visitors to French museums and found that although museums were supposed to be available to a broad public, the overwhelming majority of visitors came from the "cultivated classes"; the proportion of working-class, middle-class, and upper-class museum visitors was roughly 4%, 24%, and 75%, respectively, which was similar to the social profile of the university.[22] Furthermore, the museum-going public was highly educated, with 31% holding the baccalaureate and 24% holding a diploma or superior degree. Based on these surveys, Bourdieu concluded that although most schools did not teach art, they provided a "scholarly disposition" as well as historical and literary background that would aid the interpretation of works of art. Thus, students with a higher level of education were both more confident and better intellectually equipped when approaching works of art.

But the individuals with the greatest cultural advantages were those who had been exposed to art and culture by their families. Bourdieu

contended that schooling reached children of different social classes very unequally because schools presupposed general culture that was never formally taught. The occasional teaching of art in schools was much more effective when children had already been exposed to art and could fit the individual lessons into a general framework of artists, styles, or periods. Without consistent art education, Bourdieu explained, children from the lower classes were "condemned to a perception of a work of art which takes its categories from the experience of everyday life,"[23] seeing only its practical and functional criteria and unable to recognize the styles and aesthetic symbolism that were accessible to children of the upper classes. They were left with simply a "basic recognition of the object depicted."[24] But schools did not compensate for children's unequal preparation in the arts; moreover, when children with more culturally privileged backgrounds were more successful, schools attributed their success to individual merit. In reality, Bourdieu summed up: "The school is in fact the institution which . . . transforms socially conditioned inequalities in matters of culture into inequalities of success, interpreted as inequalities of talent."[25]

The individual preference for works of art, Bourdieu explained, was the epitome of cultural sensibility. Yet individual taste could only be achieved by absorbing academic culture so thoroughly that one could surpass it. The bourgeois appreciation of art, viewed as personal taste, thus obscured its connection to the educational system and appeared to be a "natural" means of distinction. Bourgeois individuals were able to perpetuate their distinction through their "innate ability" to understand culture:

> The heir of bourgeois privileges, not being able to invoke rights of birth . . . can call on cultivated nature and naturalized culture, what is sometimes called "*class*," . . . or "*distinction*," a grace which is merit and a merit which is grace, an unacquired merit which justifies unmerited attainments, namely heritage. . . . [B]y making a fact of nature everything which defines their "worth," their *distinction*, a mark of difference which . . . is separated from the vulgar "by a character of elegance, nobility, and good form" – the privileged classes of bourgeois society replace the difference between the two cultures, products of history reproduced by education, with the basic difference between two natures, one nature naturally cultivated, and another nature naturally natural.[26]

Bourdieu believed that the bourgeois justified their monopoly of culture by drawing "natural divisions" between themselves as "civilized" and

lower classes as "barbarians." Museums – by making groups that had been deprived of culture feel that they did not belong – helped to persuade the lower classes of their own "barbarity" and made them inclined to accept their own exclusion and subordination:

> The museum presents to all, as a public heritage, the monuments of past splendor, instruments for the extravagant glorification of great people of previous times: false generosity since free entry is also optional entry, reserved for those who, equipped with the ability to appropriate the works of art, have the privilege of making use of this freedom, and who thence find themselves legitimated in their privilege, that is, in their ownership of cultural goods, or to paraphrase Max Weber, in their *monopoly* of the manipulation of cultural goods and the institutional signs of cultural salvation.[27]

Although museums supposedly offered equal access to the national patrimony, in reality they remained the domain of highly educated, middle-class and upper-class visitors who had the background necessary to understand the artwork and who seemed to justify their monopoly of art by their "innate" talent for understanding it. This monopoly of the cultural field, Bourdieu contended, reinforced bourgeois domination in social and economic spheres. Even though educational aids, such as explanatory panels in museums, could help provide background for inexperienced viewers, and American-style cafés and bookshops might encourage a more welcoming atmosphere, Bourdieu believed that only comprehensive art education in schools would compensate for early familial disadvantages and produce large numbers of students competent in art, thereby breaking the cycle in which unequal access to culture reproduced the broader social hierarchy.

Activists in May and June 1968 frequently invoked Bourdieu's terms to describe the class biases of the museum and the *maisons de la culture*. For example, members of the *ateliers populaires* declared: "We ... denounce the system of cultural 'participation' proposed by Malraux and the Maisons de la Culture. . . . We should work towards the development of a truly popular culture ... in opposition to the oppression of bourgeois culture."[28] The Commission on Reforming Instruction in the Visual Arts at the occupied Ecole des Beaux-Arts likewise urged, "We must replace the culture that is only exercised by those who have been educated [about it] from a very early age."[29] But many of them went beyond Bourdieu's program – which, like Malraux's, held onto traditional notions of national culture, museums, and academic preparation – and

challenged the imposition of the culture of the elite on the public at large, arguing for an alternative view of art based on daily life that Malraux and Bourdieu had ignored. These targeted attacks in the form of tracts and texts as well as widespread protests against cultural institutions forced the directors of the *maisons de la culture* to confront their objections.

Beginning on May 20, 1968, the directors of the *maisons de la culture* as well as of the *théâtres populaires* (national theaters located in the provinces, another key element of Malraux's cultural policy) met in Villeurbanne (near Lyon) to respond to the criticisms of their institutions.[30] The document they produced is telling for the extent to which it summarizes and accepts the arguments of the activist students, artists, and critics. Like Bourdieu, the directors acknowledged that museum and theater audiences were largely middle and upper class, and recognized that they had not succeeded in enlarging the public for art. Yet the directors pushed beyond Bourdieu's ideas and sought to address protesters' demands, calling for new methods of art education for the museum and innovative forms of art based in daily life that would be instrumental in forming political self-consciousness in all sectors of the public.

Mindful of the new challenges that were emerging in the streets, the art schools, and the museums all around them, the directors produced a signed statement that described the problems in the current operations of their art institutions and drafted a resolution for fostering more democratic culture:

> The mere "diffusion" of works of art…has come to seem less and less capable of producing a real encounter between these works and the vast numbers of men and women who are struggling with all their might to survive in society, but who, in many respects, remain excluded from it. While obliged to participate in the production of material goods, they are deprived of the means of contributing to the way in which society is run.…
>
> Whatever the purity of our intentions, in reality our attitude appears to a considerable number of our fellow citizens to reflect the preference of a privileged few for a culture that is hereditary and particularist — that is to say, for a bourgeois culture.[31]

The directors renounced Malraux's humanist idea of the universality of culture and concluded that the art of the *maisons de la culture* was "hereditary" and "bourgeois." They rejected Malraux's plan for decentralizing art by "diffusion" – using museums and photography to bring works of art to large numbers of people. Merely making art physically accessible,

they recognized, did little to include those who "remained excluded" from authoritative roles in the political, economic, and cultural domains of society. They argued that a "non-public" existed, comprised of people who did not have the opportunity to understand or contribute to culture. By making groups who were unfamiliar with culture feel that they did not belong, museums made them inclined to accept their own exclusion and subordination.

Like Bourdieu, the directors saw art education as a means to diminish the exclusion of the economically disenfranchised from the cultural sphere, yet they went further, reconsidering how art and art education had been conceived and promoted by public institutions. Instead of a predetermined set of cultural objects and interpretations that would be simply transmitted to the public, as both Malraux and Bourdieu had advocated, one from a right-wing and one from a left-wing perspective, the directors drew on ideas that had been advanced beginning in the 1930s by champions of popular culture, arguing for a different form of cultural activity, one that derived from the public's interests and needs. New educational methods would be based on "an entirely different conception that does not *a priori* refer to certain pre-existing contents but waits for a meeting with the people for the progressive definition of a content that they can *recognize*."[32] Meaning would thus not be predetermined and imposed, but would derive from individuals' encounters with art, during which they would recognize content that was relevant to their daily lives. The directors believed that this process of discovering meaning in art would help the non-public out of its isolation, by helping people see themselves in a social and historical context and "liberate themselves better from the mystifications of all orders that tend to make them complicit in real situations that are inflicted upon them."[33] These individuals would no longer remain victims of social, economic, and cultural marginalization; seeing their lives and experiences reflected in art would help them understand what their situation held in common with that of others and empower them to improve it. Whereas Bourdieu focused on the educational system as the locus of his plan, the directors believed it was necessary to adapt art institutions to these new educational and cultural experiences. Although they pushed for innovative forms of cultural activity, their statement remained unclear as to what specific forms of art and education would be adopted and left the future of cultural programming uncertain.[34] As museums began to reconstruct themselves in the aftermath of '68, it was clear they would need to engage the challenges of daily life and incorporate individuals who previously had been excluded from cultural institutions. The ideal that came to

hold great appeal for many curators as a response to the demands of '68 was an interchange between artwork and viewer in which the artwork would invoke the viewer's experience, and the viewer would see himself in and read his own meaning into the work. This entailed not only a change in the institutional efforts to attract different viewers, but also allowed for a kind of transformation in the art that the museum came to promote.

For many critics sensitive to the challenges of '68, the ethnographic museum seemed to offer an attractive solution to the problem of the perceived elitism of the fine arts museum. As protesters called for leveling artistic hierarchies and turning to the everyday as a source for art, numerous artists, critics, and curators came to view the ordinary objects in ethnographic museums as an alternative to the masterworks of art museums. Ethnographic museums such as the influential Musée de l'Homme purported to represent collective culture through what were considered "*objets témoins*," a concept developed in the late 1920s and early 1930s by Paul Rivet, Director of the Trocadéro and Musée de l'Homme, and Georges Henri Rivière, the Deputy Director. Rivet and Rivière were not interested in the aesthetics or rarity of the ethnographic objects presented; they saw them as artisanal, revealing the traits and characteristics of the cultural system in which they were produced.[35] The concept of *objets témoins* also suggested that within the ethnographic museum all objects were equal in value and significance as representations of cultures. At the Musée de l'Homme, consequently, objects were arranged in two primary types of displays: vitrines, organized by ethnic groups and geographic locations, and synthetic vitrines, organized by social institutions across cultures, which used ethnographic objects for intercultural comparisons. This concept of *objets témoins* was very influential for the reinstallations of the museum galleries in the 1930s and beyond and was disseminated through the course that Rivière taught on the history of museology up into the 1960s. After the '68 protests, when the model of the masterwork came under fire, influential critics and curators, as well as a number of artists, saw the idea of making an art that could stand as a kind of *objet témoin*, representing the everyday life of a culture, as an opportunity for revitalizing the museum.

Although ethnographic museums represented the everyday objects of cultures, however, they were not politically benign. By taking an object as a representation of a culture, they obscured the potential for variations among objects and were liable to present a homogeneous view of the culture. Furthermore, the intellectual influence of humanism and structuralism in the 1960s, which transported the same Western categories from

place to place, rendering all cultures comparable, contributed to flatten-
ing out the representation of the exhibited cultures. Moreover, many
of the exhibited objects had been obtained through colonial exploits.
For these reasons, readers today more familiar with poststructuralist and
postcolonial critiques of ethnographic museums might be surprised that
ethnographic museums were rarely targeted by protesters in '68. Yet the
colonial heritage and implications of ethnographic museums were rarely
discussed as such at the time.[36]

In 1968, however, the emergence of such a critique was seen in the
writings of Michel de Certeau. In particular, de Certeau recognized as
problematic the type of humanist universal represented in ethnographic
museums. In *The Capture of Speech*, he contended that museums, like
universities, had perpetuated a singular view of culture that was suppos-
edly universal but had been achieved through censoring nonconformity,
suggesting that other cultures and peoples had been studied as objects
and examined within Western categories, rather than acknowledged as
subjects in their own right:

> Other peoples and other human beings have become the *objects* of
> ethnology; they have been captured in this equivocal region where the
> Western recuperation of the foreigner holds sway. Because they have
> neither known nor been able to defend their speech, they have seen the
> law of our own curiosity imposed upon themselves. Reduced to being
> nothing more than border dwellers frozen in a return to their primitive
> history…they exist in communication only by dint of what we say about
> them.[37]

In 1968, de Certeau saw people who had been treated as objects of knowl-
edge speaking out as subjects, demonstrating that their differences could
no longer be contained within the humanist categories of the museum
and the frameworks of knowledge that had been imposed upon them.
This "capture of speech" contested the monolithic culture represented in
museums and universities by revealing the presence of differences within
culture, ones which had to be understood in their own specificity.

In the 1960s, French museums, whether of fine arts or ethnography,
evoked the kind of transcendent categories that could not withstand the
force of 1968. Although the problems had been identified – assump-
tions of universality that were actually elitist, open access that remained
restricted – it was not yet clear what positive action would render the
museum more politically palatable. Whether the museum was reformable
or needed to be abolished remained unclear.

MUSEUMS IN THE LATE 1960S AND THE IDEA OF THE EVERYDAY

Although Malraux tried to rejuvenate museums during the 1960s by making art more accessible, he concentrated on the art of the past, and this emphasis on patrimony and traditional masterworks had simply reinforced the neglect of contemporary art in national art institutions. Cultural programs had expanded under his leadership, yet the national arts administration generally did not support the collection and exhibition of art created after the Second World War. Few French museums exhibited contemporary art, contributing to artists' alienation from them. As the political ferment and changes to the social fabric of everyday life erupted around them in 1968, the masterwork-based museum seemed increasingly out of touch.

A case in point, the Musée National d'Art Moderne (MNAM), the major modern art museum in France, showed little that had been produced after the Second World War (Fig. 12). Conceived as early as 1934, but not regularly functioning until 1947 because of the adversities of World War II, the museum had been created at the Palais de Tokyo to combine the collections of the overcrowded Musée du Luxembourg (which exhibited French artists) and the Galerie du Jeu de Paume (which displayed foreign artists). Jean Cassou, the director of the MNAM from 1940 to 1965, worked to continue the chronology of modern French art from the Luxembourg museum, which held mainly academic work and

had acquired few paintings between the world wars.[38] Cassou focused on collecting the work of painters who had gained recognition before the Second World War, rather than acquiring the work of young postwar painters, primarily collecting and exhibiting works of the Ecole de Paris or "School of Paris," which he promoted as a French tradition.[39]

Because the Musée National d'Art Moderne did not have its own acquisition budget, however, it was unable to collect twentieth-century works in a consistent manner. In fact, the museum received acquisitions from external sources that opposed or neglected modern art: the Conseil Artistique des Musées Nationaux, which generally did not purchase living artists' work, and the Direction des Arts Plastiques, which did purchase the work of living artists, but favored academic painters as its members were largely influenced by the Academy. Cassou obtained School of Paris works largely through donations from artists and their families because the MNAM did not have the administrative and financial independence to purchase them.

By the 1960s, the Musée National d'Art Moderne was still displaying Ecole de Paris paintings that had been produced prior to World War II and largely ignoring contemporary art. Cassou, discouraged, resigned in 1965. He was replaced by Bernard Dorival, who served as curator and director from 1965 to 1968, a period which Yve-Alain Bois has termed "the darkest years of the museum and its acquisition policy," during which "not a single work was bought for the MNAM by the Conseil Artistique des Musées Nationaux, and only a handful were purchased by the other committees."[40]

In response to this institutional neglect of contemporary art, the Centre National d'Art Contemporain (CNAC) was founded in 1967, providing a curatorial team and budget designed for acquiring contemporary art. The CNAC, however, was not affiliated with the Musée National d'Art Moderne, and had few exhibition venues for its collection. Although some works were displayed in official buildings and in regional cultural centers, many remained in storage.[41]

The Musée d'Art Moderne de la Ville de Paris was created to share the Palais de Tokyo with the MNAM, but did not open until 1955. The Musée d'Art Moderne exhibited works of artists living and working in Paris, especially those of the Ecole de Paris. By the mid-1960s, the museum began to show more contemporary art, but it had a very limited acquisition budget. The Musée des Arts Décoratifs, under the direction of François Mathey, displayed some contemporary art in the 1960s, and is generally acknowledged to have had the most innovative programming for contemporary art exhibitions. Due to the decorative arts mission of

the museum, however, it had no budget for acquiring contemporary artwork.[42]

The ARC, "Animation-Recherche-Confrontation," located within the building of the Musée d'Art Moderne de la Ville de Paris, was created in 1967 to develop "*animation*" – educational programming to make Paris museums more accessible.[43] The ARC was also developed in response to the perceived provincialism of Paris, which had little space for traveling exhibitions or for young artists to display work. Although drastically underfunded, the ARC provided a rare space for young artists and experimental work. Pierre Gaudibert, the first director, sought out work in non-traditional media that was created by individuals and groups, and by French and foreign artists, who often did not have galleries or public exhibition spaces available to them.

The charge by the radical students, artists, and critics of 1968 that the modern art museums of France were merely "cemeteries" containing the "corpses" of art – and their closing of the Musée National d'Art Moderne as a symbol of this deadness – thus grew out of the fact that most city and state museums (with the exceptions of the ARC, the Musée d'Art Moderne de la Ville de Paris, and the Musée des Arts Décoratifs) were closed to the generation of artists who were beginning their careers in the 1960s. And the exclusion of contemporary artists was seen as particularly egregious as the revolution of 1968 escalated, ushering in a transformation of everyday reality that made the masterwork-based museum look increasingly outdated and removed. At a revolutionary time, the museum needed to be revolutionized as well. The museum had to be made responsive to the life of the streets, of the workplace, of the media, of the home – in short, to the everyday life of France and its citizens – in order to have any contemporary relevance or progressive political effects.

In turning to everyday life as a site for revitalizing an institution that many had come to see as dead, critics, students, and artists joined in a broader theoretical movement that saw the everyday as a primary locus for social change. This broader tendency was by no means monolithic, however, and the idea of the everyday held a range of meaning in both theory and practice. Theories that saw everyday life as having an important political resonance had existed in various forms for decades.[44] However, perhaps the most influential conception of everyday life for the revolutionaries of 1968 was that of the philosopher and social theorist Henri Lefebvre, a professor of sociology at the Nanterre campus of the University of Paris, whose *Everyday Life in the Modern World* was published in the turbulent spring of 1968 and was widely considered to have sparked the

student demonstrations. (Lefebvre himself had published two previous volumes on everyday life, in 1947 and 1961.) Lefebvre explored everyday life because he saw it as the place for understanding the new routines of life and patterns of consumption that had been brought about by the influx of American commodities and the increasingly bureaucratic organization of work and social institutions in rapidly modernizing postwar France. Lefebvre sought to go beyond a traditional Marxist emphasis on sites of work and the social relations implicated in them, which he felt had constructed a false dichotomy between the public sphere of alienated labor and the private sphere that tended to be seen as untouched by alienation's reach.[45] Lefebvre widened his focus to include all of the individual's daily lived experience in the traditionally public world of work and the private worlds of recreation and consumption in order to show how both were permeated by the same broader economic and institutional structures.

Everyday life in this new world, Lefebvre contended, had been structured by the "bureaucratic society of controlled consumption," making people into passive consumers. In the cultural sphere, even high art had become just another product to be consumed, leaving no place for true creativity. Yet banal and routinized everyday life contained the possibilities for political transformation, because it was there that the contradictions caused by larger institutions, bureaucracies, and patterns of consumption were lived and could thus be understood and challenged. Lefebvre envisioned people coming together in city streets in utopian festivals or "*fêtes*," spontaneous outpourings of games and creativity that would transform everyday life. Although Lefebvre did not describe the particular forms of revolutionary creativity, his concept of the everyday as a site of both oppression and political transformation, which had been circulating in the years before 1968, greatly influenced not only political movements that predated and came to be active in 1968, such as the Situationist International, but also more broadly a range of '68 protesters.[46]

The Situationist International was a group of artists and writers established in 1957 to promote revolutionary politics and cultural intervention.[47] The Situationists, who counted among their number Guy Debord, Michèle Bernstein, and Raoul Vaneigem (who associated with Lefebvre for a time), shared his view that the structuring of daily life increased the passivity of a potentially active and engaged population. For example, they sought to transform everyday life by encouraging people to break out of stultifying routines through what they called a *dérive*: instead of commuting to and from work, individuals were to wander through the city, following their desires. The Situationists hoped to

inspire each individual to interact with others in a spirit of play and games, jolting him out of his passivity and "provoking his capacities to revolutionize his own life."[48]

In the aesthetic sphere, the Situationists opposed traditional, "moribund" culture as well as the superficial pleasures of consumption and the mass media, which drained individuals' creativity and lured them into complacency. These views were embodied in Situationist-inspired graffiti of May and June 1968. In the Latin Quarter, graffiti was written on the walls of the Sorbonne and the city, challenging the cultural authority represented by university buildings and the commercial messages on posters and ads that were typically plastered in the streets. For example, graffiti on city walls commanded, "never work." Inside a Sorbonne stairwell, anti-consumerist graffiti demanded, "hide yourself, object." Graffiti near the Sorbonne amphitheater proclaimed, "I take my desires for reality because I believe in the reality of my desires," advocating love and desire as a way to break out of the boredom and passivity cultivated by traditional culture, work routines, and consumption.[49]

The idea of turning to everyday life as a site of potential creativity was very influential for the members of GRAV, another politically engaged group that predated the May revolts and that collaborated on projects between 1960 and 1968. For GRAV, whose membership included the artists Julio Le Parc, François Morellet, Francesco Sobrino, Horacio Garcia-Rossi, Joel Stein, and Jean-Pierre Yvaral, creating an art of the everyday meant taking to the street and engaging the public in collective games and festivities. The group strove to "eliminate the category of the work of art" and designed projects that would involve the public in "spontaneous creation."[50] GRAV was best known for the project *Une Journée dans la rue*, which took place on April 19, 1966, from 8 A.M. to 11 P.M. For this "day in the street," the group gradually moved from the Champs-Elysées to the Latin Quarter, meeting the public and sharing objects from their van, such as a giant kaleidoscope and a sculpture that was to be assembled and disassembled. A photograph documented their installation of mobile pedestals on the sidewalk in front of the café La Coupole (Fig. 13). Passersby tried to balance on the pedestals, a practice that GRAV promoted as "revalorizing everyday gestures" and "giving new meaning to the behavior of the group."[51]

GRAV believed that such spontaneous acts of creativity in everyday life – although conveying no specific political content – had the power to revolutionize society.[52] Taking the public from passive spectatorship to active participation was expected to spill over into broader social and political spheres. But GRAV's projects limited their participants to

predefined roles and activities, rather than encouraging a truly transformative expression of personal creativity. Members of the Situationist International were very critical of the ways in which GRAV's projects prescribed certain roles for spectators and saw them contributing to the organized passivity that was part of people's work and leisure routines.[53] Members of GRAV came to accept such criticisms, and the group disbanded in late 1968.

As controlled experiments, such as those of GRAV, were seen as inadequate, a view developed that the true artistic happening was the organic explosion of popular protest of May 1968 itself. For example, Michel Ragon, a historian and critic, viewed the activism of '68 as the embodiment of a creative transformation of the everyday. In "The Artist and Society," Ragon described the May events as a "permanent happening," in which artists abandoned the production of art and radically altered daily life. He saw protests, public activities, and occupations of public buildings as creative, playful expressions, transforming the everyday life of the city into the truest form of art:

> During the May Revolution, the city once again became a center of games, it rediscovered its creative quality; there instinctively arose a socialization of art — the great permanent theater of the Odéon, the poster studio of the ex-Ecole des Beaux-Arts, the bloody ballets of the C.R.S. [riot police] and students, the open-air demonstrations and meetings, the public poetry of wall slogans, the dramatic reports by Europe No. 1 and Radio Luxembourg, the entire nation in a state of tension, intensive participation, and, in the highest sense of the word, poetry. All this meant a dismissal of culture and art.[54]

The occupation of the national Odéon theater and the Ecole des Beaux-Arts, the violent confrontations between the C.R.S. riot police and students, the outdoor demonstrations, wall graffiti, and so forth: all these engaged the population at large in creative, if violent, expression (Figs. 5–8, 10). Ragon praised banners that were displayed in the streets and posters that were pasted on public walls as an art for all people, which transformed the city itself into a kind of living museum. In his eyes Paris had become as vibrant as Havana, where murals inspired by the Cuban revolution were "permanently on exhibition": "There the museum is the city. Nor is the city a museum-city. This is the true diffusion of art — an art to bathe in, to live with."[55] In this idealized view, everyday art arose from political and social life, surrounded all people in an urban environment, and used a common language to represent political goals.

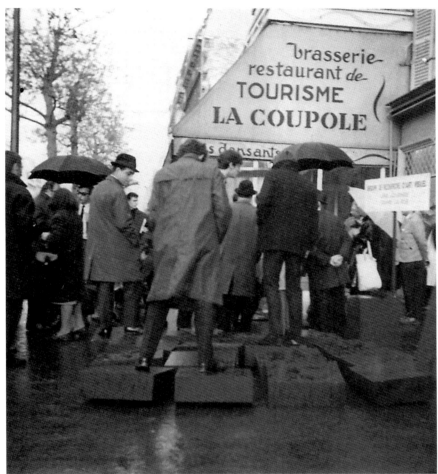

Figure 13.
GRAV, *Une Journée dans la rue*,
1966. Photo © GRAV, courtesy of
Julio Le Parc.

Where groups such as the Situationist International and writers such as Lefebvre and Ragon advocated a radical melding of art, life, and politics that refused to see art as a separate category and that even militated against the existence of art as such, other movements took somewhat more playful stances (that nonetheless often wound up preserving a special position for art). One of the most influential art movements in the years that led up to 1968 was Fluxus, a diverse group of artists from Japan, Europe, and North America, whose members included, among others, Yoko Ono, George Brecht, Ray Johnson, Nam June Paik, Robert Filliou, and Ben Vautier. For Fluxus, making art a part of life meant taking art outside the usual circuits and expanding its audiences, materials, and practices through musical performances and happenings. A manifesto

written by George Maciunas, an aspiring composer and organizer of Fluxus performances, highlights the way Fluxus challenged not only art's separation from everyday life but also the idea of the status of the artist himself:

ART

To justify [the] artist's professional, parasitic and elite status in society,
he must demonstrate [the] artist's indispensability and exclusiveness,
he must demonstrate the dependability of [the] audience upon him,
he must demonstrate that no one but the artist can do art.

Therefore, art must appear to be complex, pretentious, profound, serious, intellectual, inspired, skillful, significant, theatrical, it must appear to be valuable as [a] commodity so as to provide the artist with an income.

To raise its value (artist's income and patron's profit), art is made to appear rare, limited in quantity and therefore obtainable and accessible only to the social elite and institutions.

FLUXUS ART-AMUSEMENT

To establish [the] artist's nonprofessional status in society,
he must demonstrate [the] artist's dispensability and inclusiveness,
he must demonstrate the self-sufficiency of the audience,
he must demonstrate that anything can be art and anyone can do it.

Therefore, art-amusement must be simple, amusing, unpretentious, concerned with insignificances, require no skill or countless rehearsals, have no commodity or institutional value. The value of art-amusement must be lowered by making it unlimited, mass-produced, obtainable by all and eventually produced by all. Fluxus art-amusement is the rear-guard without any pretension or urge to participate in the competition of "one-upmanship" with the avant-garde. It strives for the monostructural and nontheatrical qualities of [a] simple natural event, a game or a gag. It is the fusion of Spike Jones, Vaudeville, gag, children's games, and Duchamp.[56]

Fluxus challenged the professional and elite status of the artist by holding performances that audiences could carry out themselves. In lieu of competition for prestige, recognition, and high prices for their work – the

"one-upmanship" of the avant-garde – Fluxus favored egalitarian relations among artists and audience members. Fluxus artists endeavored to undermine the economic value and institutional aura surrounding works of art by mass-producing objects, using mundane materials, or holding ephemeral events. Certain members of the group, including Ray Johnson, Ben Vautier, and Robert Filliou, avoided traditional circuits for diffusing art by sending mail art through the post, calling it a new means for circulating art in daily life.[57] These Fluxus practices inspired a number of young French artists, who shortly after 1968 used collaborative practices, mundane materials, and mail art to question the status of the artist and the circuits for art's distribution.

Another prominent group of artists in the early to mid-1960s, the *nouveaux réalistes*, or new realists, joined GRAV and Fluxus in advocating the transformation of daily life through artistic practice. The *nouveaux réalistes* differed from GRAV and Fluxus in that they did not aim to create an art of the streets or even to reject traditional artistic venues; in fact, the *nouveaux réalistes* were very successful in the art market, and their work was shown in galleries internationally. But they resemble these other groups in the way their art engaged the materials and subjects of contemporary everyday life. The term "*nouveau réalisme*" was coined by the critic Pierre Restany in 1960 to describe a group of predominantly French artists who used ordinary objects, technological materials, and the detritus of contemporary consumer society as source material for their work and as a means to oppose the "timeless" abstraction of the School of Paris.[58] Restany, a market-savvy art critic who was the principal proponent of the group (and who in May 1968 led the protest that closed the MNAM), described the artists' work as a utopian celebration of daily life, enabling a "new reality." Yet the artworks themselves suggested a more cynical view of modern, consumer society and the possibilities for art within it. For example, Niki de Saint-Phalle shot through canvases with a rifle, Arman displayed piles of trash, and Yves Klein exhibited the empty rooms of the Galerie Iris Clert.[59] Although the *nouveaux réalistes* were given little support from Paris museums during the 1960s, they were immensely successful on the art market with exhibitions at major galleries in Paris, Milan, and New York. The *nouveaux réalistes* provided a dramatic example of a group of young artists who found a way to work outside the *beaux-arts* tradition by drawing upon the everyday bustle that surrounded them and who rapidly achieved international recognition and market success that seemed out of reach for most young artists working in Paris. Some of their contemporaries, however, saw the *nouveaux réalistes*' commercial success as a result of Restany's labeling of the group and promotion of the artists

as members of an easily identifiable movement. This kind of critical labeling of artists as an organized movement was largely rejected in 1968 by artists who opposed ideas of market competition between avant-garde groups and sought more informal and egalitarian collaboration.

The example of an art of the everyday that has come to hold iconic status as the paramount artistic practice of '68 was the *atelier populaire* at the occupied Ecole des Beaux-Arts, a popular studio organized to make posters for the strikes and demonstrations, which attracted members of GRAV and the Salon de la Jeune Peinture, as well as communists, anarchists, and other leftist activists.[60] For members of the *atelier*, the goal was an art grounded in the daily life of workers who had been long ignored in national cultural policy. The Ecole des Beaux-Arts had been on strike since May 8th; on May 16th the students set up an *atelier populaire* in the painting studios and began to make silk-screen posters for the streets of Paris (Fig. 14). The *atelier* created approximately 350 different posters in May and June, producing up to two thousand copies of each. Gérard Fromanger, a participant in the *ateliers*, has said that young artists, workers, and students from the universities, art schools, and high schools collaborated on the design and execution of the posters; members who had more technical training shared their knowledge of silk-screening with the workers and the *beaux-arts* students whose backgrounds had not included it.[61]

In opposition to the art housed in museums and the *maisons de la culture*, the members of the *atelier populaire* wanted to bring art into the city and the everyday life of its people, and to encourage the "development of a popular culture...issuing from the people and at the service of the people."[62] In this way, the *atelier populaire's* idea of the everyday was different from the notions espoused by the Situationists, GRAV, and Lefebvre: rather than spontaneous outpourings of creativity to bring about individual liberation, the *atelier populaire* promoted a more structured and didactic form of politics in the service of the workers' struggle. For example, a text posted on the Maison des Beaux-Arts urged artists to

> escape from the condition of the isolated Artist, who remains on the periphery of the realities of the street, the city, and everyday surroundings, creating images that are never integrated because they are destined for the museum and the apartments of the rich, because they are articles of mercantile value or items for archives...Let us put an end to this age-old definition of the artist that is handed down by dealers, schools, and institutes....Let us infiltrate the community with the plastic means at our disposal and create activities on a human scale.[63]

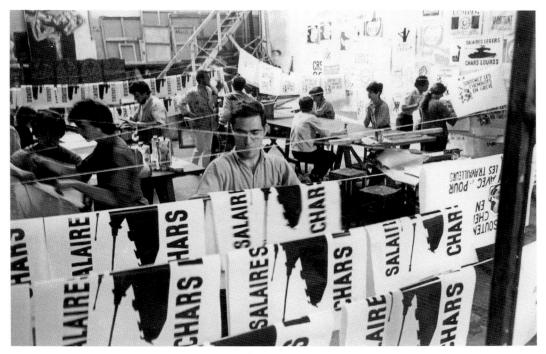

Figure 14. The Atelier Populaire at the Ecole des Beaux-Arts, Paris, 1968. © Philippe Vermès.

Seeking an everyday, popular culture that was physically available, accessible to all, and engaged with contemporary events, members of the *ateliers* pasted their posters on city walls throughout Paris, so that the images were visible to the public at large. In addition, they used an easily legible iconography that required no art training to understand. These posters were designed to engage "the reality of the street, the city, and everyday surroundings" by supporting the workers' demonstrations and strikes that were happening around them in the city. For example, the May 22 poster "French and immigrant workers united" was made in collaboration with striking Citroën workers (Fig. 15).[64] A poster of June 5, made to support striking Renault workers who had occupied the Renault factory in Flins (which was subsequently seized by the C.R.S. state security police), depicted a worker's wrench in the jaws of a C.R.S. officer (Fig. 16).[65]

The *atelier* posters also represented concerns similar to those expressed by Lefebvre and the Situationists that the mass media were numbing the minds of the masses, as, for instance, in one poster that depicted the logos of French newspapers with "poison" stamped across the center. The *atelier* posters, however, were particularly critical of state censorship

Figure 15.
The Atelier Populaire at the Ecole des
Beaux-Arts, Paris, *Affiche*, 1968.
Courtesy of Philippe Vermès.

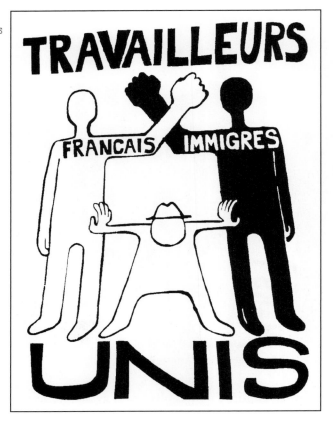

Figure 16.
The Atelier Populaire at the Ecole des
Beaux-Arts, Paris, *Affiche*, 1968.
Courtesy of Philippe Vermès.

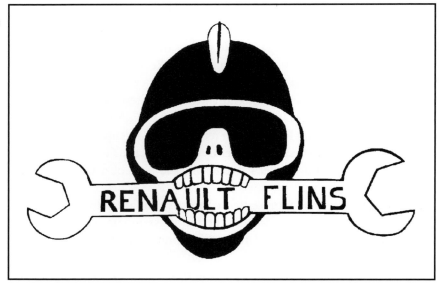

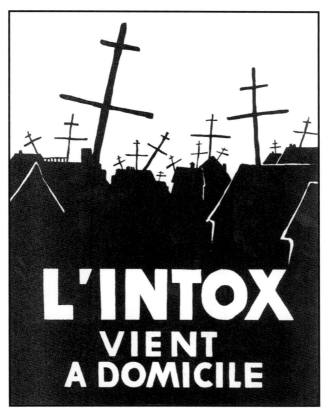

Figure 17.
The Atelier Populaire at the Ecole des Beaux-Arts, Paris, *Affiche*, 1968. Courtesy of Philippe Vermès.

of press and television through the Ministry of Information.[66] For example, a poster that represented rooftops cluttered with TV antennae shaped in the symbol of de Gaulle's political party declared "intoxication comes to your home" (Fig. 17).[67] Another poster represented a C.R.S. officer speaking into a microphone labeled O.R.T.F. (Office de Radio Diffusion-Télévision Française), the French broadcasting service (Fig. 18). It was captioned "the police speak to you every evening at 8 P.M.," implying that the French news hour was regulated by the police and state.[68]

Posters also represented censorship of expression in the student rebellion. A poster that displayed a caricature silhouette of de Gaulle covering the mouth of a student was captioned "act young and be quiet," referencing the traditional notion that children should be seen and not heard (Fig. 19).[69] Another poster, alluding to police violence, depicted a young person with his head bandaged and with his mouth fastened shut by a safety pin. On June 27, hours after C.R.S. officers seized the Ecole des Beaux-Arts building and forced the *atelier populaire* to disband, members

Figure 18.
The Atelier Populaire at the Ecole des
Beaux-Arts, Paris, *Affiche*, 1968.
Courtesy of Philippe Vermès.

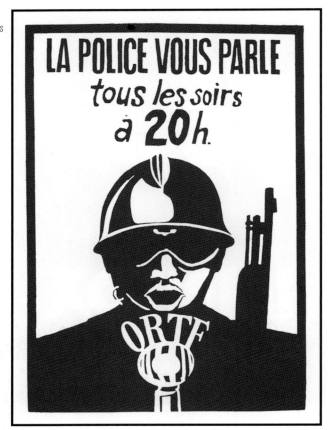

of the *atelier* printed a poster with a monstrous C.R.S. officer grinding a paintbrush in his teeth (Fig. 20). The poster proclaimed "the police flaunt themselves at the [Ecole des] Beaux-Arts, *beaux-arts* exhibits in the streets."[70] Such posters, as they entered the everyday life of French citizens, stood as strong symbols of opposition to police repression.

In the art world of the late 1960s, the idea of the everyday took on such importance because it was believed to be in opposition to artistic conventions and traditional art institutions. The *nouveaux réalistes* saw the everyday as providing a contemporary artistic vocabulary that stood as an alternative to outmoded *beaux-arts* painting. Members of the *atelier populaire* viewed the everyday as the space of working-class traditions, experiences, and politics as opposed to the bourgeois values represented in high art. For Lefebvre and the Situationists, the everyday was conceived more as a space of commodification and bureaucratic control that was potentially transformable through spontaneous creativity.

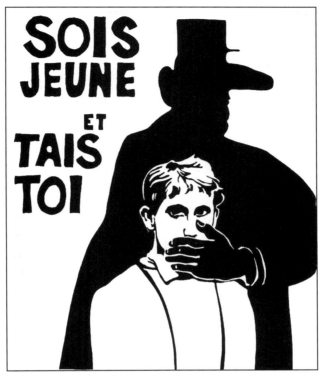

Figure 19.
The Atelier Populaire at the Ecole des Beaux-Arts, Paris, *Affiche*, 1968. Courtesy of Philippe Vermès.

For members of GRAV and Fluxus, working in the everyday meant using alternative sites and means for circulating their work, thereby enlarging art's public. But despite these differences, all these groups held out hope for the everyday as a source for creativity and a site of political struggle.

ARTISTIC TRAINING AND THE ART MARKET: CHALLENGES TO TRADITION, SPECIALIZATION, AND AUTHORSHIP

As various groups of artists and activists sought to render art's subjects and spaces more responsive to the tumultuous changes of their times, others sought to revolutionize the techniques and training of art in order to make it relevant and engaged. Artists' and students' discontent with the traditional and academic nature of art education had been increasing over the course of the 1960s. Scholars have generally taken the 1964 Venice Biennial – when American Pop artist Robert Rauschenberg was awarded the grand prize and the French academic painter Roger Bissière went without mention – to be a widespread acknowledgment of the

outdatedness of the French academic tradition.[71] Clearly, the authority of the Academy had waned in the international art scene and art market, which in the 1960s was dominated by American Pop Art and, later, American Minimalist Art. Nevertheless, the Academy maintained enormous influence over contemporary French art by overseeing art education, prizes awarded at salon exhibitions, the Prix de Rome scholarship competition, and national arts budgets. Many artists, students, and critics in France believed that art schools and exhibitions were missing vital movements in the art world by perpetuating the models and traditions of the past. In addition, Rauschenberg's victory at the Venice Biennial represented a high degree of market success that was unobtainable for most French artists. For those who sought alternatives to the academic tradition, the French art market offered little support and the international market generally remained beyond their reach.

The outdated structure of French art education in the late 1960s has been well pictured in Pierre Gaudibert's article "The Cultural World and Art Education." Artistic training was grounded in emulating traditional drawing techniques and genres:

> We all know the importance attached to casts, the antique, copying, perspective, and compositions based on still lifes; these have haunted the scholarly memories of several generations. The result is a huge time-lag between contemporary art and the school system, which does not contribute to the development either of those who are engaged in modern art or its public.[72]

As the director of the ARC contemporary art venue, Gaudibert was alarmed that academic lessons were not training students in contemporary art techniques or creating a public that could understand recent art trends. Students of art, art history, and art education all followed the academic sequence that neglected the art of the twentieth century:

> Elements that are taught in the framework of traditional drawing instruction (thus in the training of future art specialists, producers, teachers, and researchers) are almost completely cut off from the profound change in the entire system of the language of forms which began with the turn of the century....Drawing instructors, who are themselves victims of entrance examinations and programs and of their outmoded training, are for the most part indifferent or hostile to modern art and give evidence of a conservative attitude.[73]

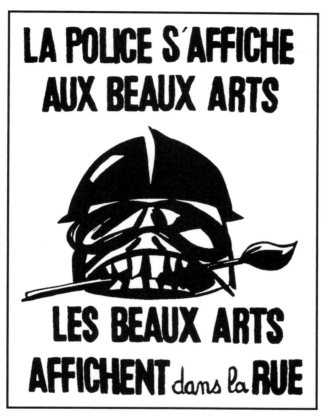

Figure 20.
The Atelier Populaire at the Ecole des Beaux-Arts, Paris, *Affiche*, 1968. Courtesy of Philippe Vermès.

Because current art instructors had academic training and the system of exams and competitions had remained essentially the same, academic traditionalism continued to dominate art education.

It was these traditional techniques and the institutional structures that perpetuated them that students sought to change in 1968. In fact, when students occupied the Ecole des Beaux-Arts in May, they repudiated their training and set out to develop more modern methods of art education and creation. During May and June, student committees at the occupied Ecole des Beaux-Arts and the Institut d'Art et Archéologie debated educational issues and called for reforms in art education.[74] Their central criticism was that art education was overspecialized, training students to emulate their professors and the academic tradition, rather than encouraging their creativity. In place of specialization and traditional art history, the student committees called for more general and interdisciplinary studies that would increase their understanding of the modern world. The examinations and prize competitions that

were used to continue academic techniques and hierarchies were to be abolished.

For artists who rejected the academic tradition, the market might have seemed to provide an alternative space for gaining recognition and distribution. In fact, Gaudibert believed that "the entire [market] system . . . which assures the promotion and diffusion of contemporary art, is outside and in opposition to school models, practices, and methods."[75] But for most young artists, the French art market was not a viable option. In the late 1960s, a recession made selling contemporary art difficult. The booming contemporary art market of the 1950s and early 1960s had come to an end. As the sociologist Raymonde Moulin described:

> In the fifties, the art trade saw exceptional prosperity, and the support given to the avant-garde by part of the buying public led to the belief that a new golden age was opening for artists. . . . The general economic situation (growth accompanied by inflation), speculation encouraged by the absence of a capital gains tax, and the special prestige conferred on bourgeois art collectors, who sought to acquire an aristocratic image by the possession of works of art, all acted in the market's favor. The spread of the monopoly contract has exercised an influence in the same direction. . . . The speculative fever of the fifties, plus financial publicity techniques, assured the promotion of the most recent art styles and led people to believe that a work of art could be treated as ordinary merchandise. The most representative dealers at this privileged moment in the history of the market exploited their opportunities to the hilt. By bulling the market, they awakened a keen interest in contemporary art, assured their impatient artists (who were often their accomplices) of a quick commercial success, and brought considerable profit to those collectors who thought of pictures as stocks and shares. During these same years the prosperity of the market gave artists a relative security, while some made sizable fortunes. . . .

> [T]he sickness that hit the Bourse after 1963 profoundly changed the speculative sector of the art market which deals in recent works. . . . When the Bourse drops, the dynamic army of speculative collectors adopts a position of retreat. Finally, the Americans who used to be the great buyers on the French art market not only have begun to buy American works but even to impose the New York School on Europeans.[76]

Moulin's enthusiastic portrayal of the French art market of the 1950s needs to be put in perspective, however, and the number of

players – dealers and buyers – active in the market at this time should not be overestimated. For example, the prominent contemporary art dealer Daniel Cordier offered a more modest assessment, explaining that during this period when the market was supposedly operating at a "fever pitch," a "couple of dozen speculators . . . had been reinvesting their stock-market earnings in pictures."[77] In the mid- to late 1960s this group of contemporary collectors became reluctant to purchase new work due to the market recession.[78] Those who were buying increasingly turned to American work. Moreover, American collectors who had been important patrons of modern French art before it had gained widespread recognition in France were now taking greater interest in American artists. These circumstances made it extremely difficult for young French artists to support themselves by selling their work on the market.

While the stagnation of the contemporary art market frustrated artists, they were also discontented with the way the market system gave little control over how their work was circulated. A student tract of May 20 titled "The Job Market in Painting" explained:

1. THE SUPPLY: comes from the artist
2. THE DEMAND: is controlled by the aesthetic criteria of the art object and by a speculative criterion which consists of betting on the good horse, the value of the artist being established by the following process:
 a. dealers stockpiling the entire production of certain artists
 b. some of these works are presented in museums until they take on value. The supply is thus sold progressively sold (*sic*) to collectors.
 c. the collectors resell these works in public sales. The value of the artist is thus established according to the principle of supply and demand.

The art market is comparable to the stock market (fear of increases [in numbers of works], collapsing prices . . .)

Thus the artist is subjected to the effects of a system against which he is powerless to act and in which the quality of his work cannot intervene

BECAUSE HE IS IN THE HANDS OF SPECULATORS.

3. MECHANISMS OF THE MARKET:
 a. The contract
 – exclusivity over all works in exchange for a low, fixed salary plus a percentage of sales
 b. "first choice"
 – priority over all production. Artist-dealer relations are not always perfect but:
 – contracts are oral

> – [dealers' practices include] blackmail and collapsing prices with the brutal sale of all stock
> – complicity in fiscal fraud, [which] prevents all legal procedures
>
> However, these contracts are restricted to 1% of professional artists
>
> b. (*sic*) <u>Brokers</u>
>
> Intermediaries that deduct a comfortable commission between the artist and points of sale.
>
> The "continuing rights," [which are] legal, at the rate of 3% cannot be claimed by the artist due to the secrecy of most sales.
>
> It appears that the exploited artist cannot integrate himself within society because of the market.
>
> HOW CAN THE ARTIST REACT?
> – With contempt
> – With the isolation and downward spiral of the "cursed artist"
> – By fleeing the system and seeking other means[79]

These artists felt that success on the market did not derive from the quality of the artwork; art was simply treated like shares of stock. Dealers and brokers used techniques ranging from stockpiling works to reselling works on the market to raise prices and profit from artists' products. The artists believed that the dealers had little concern for the artists themselves and paid artists a small percentage of the profits. The artists' description of "a system against which they were powerless to act" expressed the extent to which they felt their works, reputations, and incomes were vulnerable in a market that afforded them little control.

In the regular operations of the art market, artists' struggle for recognition bred competition among different constituencies. Artists, dealers, critics, and collectors promoted their own work or the work they supported so that it would be recognized as dominant. Awards, exhibitions, critical acclaim, and other forms of validation by experts increased the value of artists' work, enabling them to move up the art world hierarchy. In Moulin's words, this competition among artists made the art market a "Darwinian jungle in which each artist offers, or believes he offers, a universe that is incompatible with those of his fellows."[80]

The depression of the art market, however, may have encouraged artists to reject market competition in 1968.[81] Numerous artists believed that by collaborating with other artists they could counter the competitive organization of the market. Rather than working in isolation, members of the *atelier populaire*, for example, sought collaboration and solidarity in

the service of a politically engaged art. A manifesto titled "Popular Studio 'Yes,' Bourgeois Studio 'No'" that was posted on the doors of the Ecole des Beaux-Arts (and issued as a leaflet several days later) attacked "bourgeois culture" as "the instrument whereby the ruling class's power of oppression accords artists a privileged status so as to separate and isolate them from all other workers. This privilege locks the artist in an invisible prison."[82] The artists renounced their status as "creators" and affirmed themselves as collaborative workers making collective products. Any person, with or without artistic training, could work for the studio; poster production, as this manifesto argued, was "not a job for specialists."[83] Members of the *atelier* collaborated on poster designs, and every evening attended the "*assemblées générales de contrôle*" where they developed new slogans and voted on which images to print. Representatives from striking workers' groups attended these meetings, explained the challenges they faced, and often came up with slogans for the posters. The *atelier* also set up a demonstration room to teach other student groups and striking workers the silk-screen technique so that they could make posters based on their needs and agendas. The artists felt that collaborative participation at the studio avoided the "bourgeois individualistic creation" that had been fostered by the market. Indeed, in working to extend their knowledge of production techniques and to downplay the role of the individual in creative decisions, the *atelier populaire* challenged the notion of the lone artistic genius. Echoing the critiques of individual creative production and reception that were circulating widely during the 1960s with the notion of the "death of the author," the manifesto criticized the ways in which the economic and cultural authority of the artwork was "conditioned by the cult of the personality and the signature." By countering the preeminence of the single artistic producer, the *atelier populaire* contested a central component not only of aesthetic valuation but also of the market valuation of art.

The *atelier populaire's* efforts to undermine the art market extended beyond their attack on individual authorship to attempts to eliminate the value of artwork itself. Their manifesto opposed the idea of the art object as "something totally unique whose value is permanent and above historical reality."[84] Instead, the *atelier* produced multiple posters that were meant to be ephemeral, to engage the events of the day and disappear. In order to avoid the social and economic value that was attached to the artist's name, they worked anonymously and simply stamped the posters with an *atelier populaire* logo.

This generic stamp, however, proved difficult to manage in practice and made the posters more, rather than less, susceptible to being collected

on the market. Furthermore, at least some of the members recognized that selling the posters on the art market was the only option available for generating income. The first poster printed at the *atelier*, proclaiming "factories, universities, united," was created as a limited edition lithograph that a group of participants planned to sell through galleries to raise money for the revolutionary cause.[85] Although these posters were subsequently displayed in the streets and the *atelier* began mass printing and posting, some posters were sold to collectors to raise money for supplies. These seemingly contradictory practices of posting free, ephemeral posters in the streets and simultaneously selling them as limited edition prints reveal the difficulties artists faced in trying to oppose the practices of the market while depending on market sales for their subsistence.

CONCEPTUAL ARTISTS AND ACTIVISM

The *atelier populaire* in the occupied Ecole des Beaux-Arts was the most visible manifestation of art activism in 1968. Other groups of artists working at the same time may not have announced their politics with didactic slogans and imagery like the *atelier populaire* posters, but they shared many elements with 1968 art world activists, most particularly an awareness of the ways in which art education, museums, and the art market perpetuated and shaped the structures of social authority. Among these was a group of young artists who were atypical for artists working in France in the late 1960s in that they had already begun to distance themselves from the outdated *beaux-arts* training and abstract painting styles favored by the school system and art museums. French institutions had held onto painting as the predominant medium in the aesthetic hierarchy well into the late 1960s, while the international art scene had moved away from painting in movements, such as Pop Art, Minimalism, and Conceptual Art. As 1968 proved a turning point for French art as aesthetic hierarchies were challenged, these young artists ushered in the more experimental media and practices aligned with Conceptual Art. The Conceptual Art movement sought to move away from the traditional notion of art as objects of visual beauty and monetary value by reconceiving art as ideas that could be expressed in a variety of nontraditional physical forms, such as events, sketches, and documents. This group of artists working in France participated in the practices of this international movement, but would increasingly target their work towards a critique of French art institutions. In this regard, they shared the 1968 protesters' goals of dismantling art institutions, and their work can be seen as an extension of these aims.

This section examines the response to '68 of a group of conceptual artists, including Jean Le Gac, Gina Pane, Daniel Buren, Christian Boltanski, and Annette Messager, who were to rise to prominence in the years following. All of these artists, aged from their mid-twenties to mid-thirties in 1968, were at the beginning of their careers, and thus little documentation exists of their work from this time. Many of them had participated in small group exhibitions in Paris and in the provinces, but had not yet had international or solo shows. Soon after 1968, these artists began associating and exhibiting their work together in nontraditional spaces when art institutions and galleries were not available to them. (Buren, whose work had already begun to be shown in prominent galleries and exhibitions by 1968, was an exception to this.) As they began their careers, they had to negotiate the numerous challenges posed by outdated educational and institutional structures and the depression in the art market. The events of May and June intensified these challenges and complicated the pressures on the artists. With the exception of Annette Messager, these artists generally did not participate in the demonstrations, sit-ins, or *ateliers populaires* of 1968. Yet the currents leading up to '68, as well as the events themselves, had a major impact on the artists, prompting reorientations of their artistic practices.

Like their contemporaries in the *ateliers populaires*, and like other experimental art movements of the 1960s such as Fluxus and GRAV, Le Gac, Pane, Buren, Boltanski, and Messager were interested in challenging the conventional ways that art was produced and circulated. They, too, rejected the traditional methods of making and showing art. For example, they utilized ephemeral materials and events, collaborated to undermine the status of the artist and his or her implied specialization, and used alternative spaces in an effort to work outside traditional museums and galleries. These young artists' challenges to artistic conventions and contexts were part of the wider attempts to transform the entire social and economic system in which art operated. However, each would adopt different techniques and emphasize different elements in his or her critique of art institutions and the art market.

Jean Le Gac quit painting in 1967 despite achieving earlier successes with this genre. Born in 1936 in Tamaris, Le Gac had developed a background in academic painting when training to become a secondary school art teacher. He later recalled that his training had been very traditional; he learned how to draw by studying anatomy and perspective techniques. For the first Paris Biennial, he had submitted a drawing influenced by Modigliani, but it was not selected for the exhibition.[86] His paintings did, however, come to be exhibited in the subsequent Biennials in 1961,

1963, and 1965 and at the Salon de la Jeune Peinture in 1965. When he renounced painting, Le Gac began to carry out activities in nature, during which he rearranged objects such as rocks and sticks. For example, a photograph from April 1968 documented a circle of stones and several vertical sticks that he had arranged during a trip to the beach. This photograph provided the basis for the image on a later mail art work, *Le Campement projet* (1969), which also included two short texts describing his activity (Fig. 21). For these activities in nature, Le Gac sought out what he called "neutral" places and made interventions in the landscape that were almost imperceptible. With this basic, almost "primitive" practice and simple record of his activity, Le Gac sought to avoid creating a refined work of art that would demonstrate his specialized training and would acquire traditional cultural and economic value. The decision to carry out his project in nature also marks his efforts to work outside the museum and market system.[87]

Le Gac's interest in projects in the landscape was also shared by Gina Pane, with whom Le Gac and Boltanski would come to collaborate. Pane had studied at the Ecole des Beaux-Arts in Paris and the Atelier d'Art Sacré from 1961 to 1963. During the mid-1960s her work largely consisted of geometric structures, and in 1967 she started making simple interventions in the environment. For example, in July 1968, when walking in the northern part of the Orco valley, Pane discovered a small group of rocks that were embedded in the ground and covered with moss, completely shielded from the sunlight.[88] She transported the rocks to a sunnier location that she discovered in the southern part of the valley and documented the experience in a series of photographs and a short text (Fig. 22). Like Le Gac, Pane made her landscape interventions outside of traditional art circuits. Furthermore, both artists sought to avoid the prestige of the art object by producing ephemeral works and activities. Pane and Le Gac photographed their acts, intending the images to serve as generic documents that resisted the cultural authority and market value of expressive art objects. The works themselves – the arrangements of stone, sticks, mosses – were produced without conventional *beaux-arts* languages in circumstances that did not readily translate into market modes of circulation.

Daniel Buren was twenty-nine in 1967 when he started exhibiting with artists Olivier Mosset, Michel Parmentier, and Niele Toroni. (Although critics often designated the artists as a group with the initials "B.M.P.T.," they never formed a formal association, refusing traditional notions of artistic schools and movements.) Each of the artists adopted repetitive motifs: Buren, uniform blue and white vertical stripes (in part as a

Figure 22. Gina Pane, *Pierres déplacées, Vallée de l'Orco (Italie) Juillet 1968.* The images were accompanied with the following text: "au cours d'une promenade dans la vallée de l'Orco (Italie), au pied des montagnes, la vue d'un amas de pierres de petite taille allant de 0,15 m. à 0,20 m. exposées au nord, recouvertes de mousse et encastrées dans une terre humide, m'a fait réaliser qu'elles ne recevaient jamais de rayon de soleil, donc de chaleur. C'est alors que j'ai pris la décision de les déplacer en les prenant une à une pour les déposer dans un endroit découvert et au sud." © 2005 Artists Rights Society (ARS), New York/ADAGP, Paris. Photo © Anne Marchand, courtesy of the Fonds National d'Art Contemporain.

rejection of the academic painting he had learned at the Ecole Nationale Supérieure des Métiers d'Art in Paris); Mosset, a black circle in the center of a white painting; Parmentier, horizontal bands; and Toroni, small, square brushstrokes placed at thirty centimeter intervals (Fig. 23). The artists' repetitive, mechanical marks were intended to counter the idea of the creative gesture that was so highly valued in art education, museums, and galleries. Moreover, in a December 1967 exhibition at the Galerie J, Buren, Mosset, and Toroni all presented work but played with the attribution so it was difficult to tell which of the works had been produced by each artist. In manipulating the attributions, these artists sought to undermine the concept of style as the trademark of the individual artist and the basis for the financial value of the artwork. These projects, too, shared in the reaction against artistic specialization, portraying the artist not as an individual genius but as a worker performing routine, repetitive labor.

Christian Boltanski was born and raised in Paris, and started painting in the 1960s, although he did not have a formal artistic education. In 1965, when he was twenty-one, he began to exhibit paintings at the Paris Biennial, the Salon de la Jeune Peinture, and the Musée d'Art Moderne de la Ville de Paris. In 1967, he displayed his work in a group exhibition at the Maison des Jeunes, Charençon (a community youth center), and

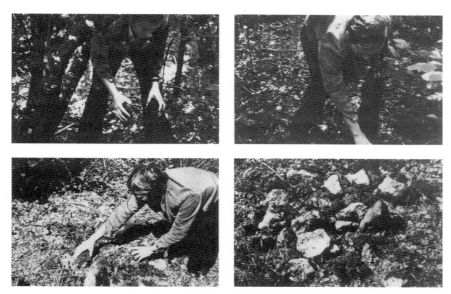

Figure 22 (*continued*).

at the Maison de la Culture in Caen. In these exhibitions, he presented paintings such as *La Chambre ovale*, an image of a nondescript figure in an empty room (Fig. 24). In early 1968, however, Boltanski gave up painting and turned to experimental media, making mannequins and films that he exhibited in May.

On May 13, when nearly 800,000 demonstrators assembled in the streets surrounding the Latin quarter, Boltanski opened his first individual exhibition at the Ranelagh theater, located in the comparatively quiet sixteenth *arrondissement*. He displayed several paintings from previous years and in small "chambers" staged mannequins that he had dressed with old clothing and masks. Spectators were able to enter one chamber in which he projected a twelve-minute super-8 film *La Vie impossible de Christian Boltanski*, for which the exhibition was named.[89] Although little work or documentation from the exhibition remains, the exhibit nonetheless manifests several practices that would take on increasing importance in Boltanski's work: a turn away from painting to experimental media; a use of non-traditional exhibition spaces, one that was not only determined by the fact that as a young artist his access to art institutions was uncertain but also as a deliberate attempt to find a critical alternative to them; and an interest in fictional portrayals of the life and work of the artist. Like members of the *atelier populaire* and Fluxus, and like his generational contemporary Buren, Boltanski was working out concerns about the role and status of the artist that were preoccupying many in the revolutionary years of the late 1960s.

Figure 23.
Daniel Buren, Olivier Mosset, Michel Parmentier, and Niele Toroni, *Photo-souvenir: Buren, Mosset, Parmentier, Toroni, Manifestation no.3, travail in situ, Salle de spectacle du Musée des Arts Décoratifs, Paris le 2 Juin 1967.* © 2005 Artists Rights Society (ARS), New York/ADAGP, Paris. Photo courtesy of Daniel Buren.

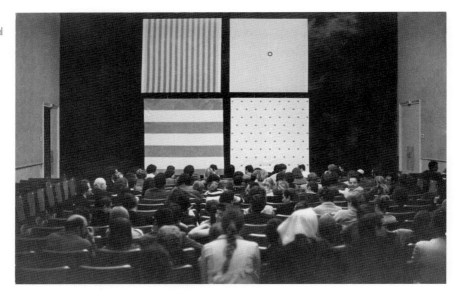

Figure 24.
Christian Boltanski, *La Chambre ovale*, 1966. © 2005 Artists Rights Society (ARS), New York/ADAGP, Paris. Photo courtesy of Bob Calle.

Another artist with whom Boltanski would come to exhibit was Annette Messager, who was born in Berck sur Mer in 1943. She completed her baccalaureate in philosophy and studied art at the Ecole des Arts Décoratifs in Paris from 1962 to 1966, but she left the school before receiving her degree. She participated in group exhibitions in Barbizon

in 1965, in Le Touquet and Berck sur Mer in 1966, and at the Musée d'Art Moderne de la Ville de Paris in 1968.

Messager was active in the events of May and June. She participated in the barricades and street demonstrations, later explaining: "Everyone who was in Paris...we were in the streets....Of course I was in the streets all the time, at the barricades. At least [I was there] often."[90] But in addition to the students' activism, the events of May also marked for Messager the start of a feminist movement: "It was the beginning of feminism. It was truly a new awareness for women, that they weren't always behind men. Women organized a lot in '68 for children, babies, child care facilities. It was really important for that [reason]."[91] Although Messager would not publicly affiliate herself with feminist movements, she believed that the events of '68 marked a turning point for women of her generation, when they began to speak openly about social inequalities and assert their specific needs.

Messager's work from 1968 includes a pen and ink drawing of a C.R.S. officer, which has attached, moveable arms that swing back and forth to club the "innocent" youth below (Fig. 25). With its cliché characters, the image provides a humorous look at the "generational conflict" of 1968 and the police repression of the student movement.[92] Even though Messager's 1968 drawing was not a mark of what was to come – within the next few years, her work would take up the complex politics of everyday life, as opposed to such commentaries on contemporary incidents – the events of May and June precipitated Messager's definitive break with her artistic training, especially painting. She described: "I think that [the revolution of '68] truly changed the orientations of artists in France. Because for me at least, I hadn't been painting – at school I had painted – but it was clear that I no longer wanted to paint."[93] In rejecting the tradition of painting, Messager turned to the ordinary and everyday: "Grand paintings, all the pictures in the Louvre – we were ready to burn them. All that was zip....I wanted to work on the everyday, the ordinary, things from the street, from magazines. That was my '68."[94]

The conceptual work of Le Gac, Pane, Buren, Boltanski, and Messager shared many elements of the broader art world activism, from GRAV to the *ateliers populaires*, in its critiques of art institutions and the art market. Their practices too, expressed the desire to create and display work outside traditional artistic circuits or to challenge them from within; questioned the role of the author and the value assigned to his or her "specialized" products; and attempted to level the cultural hierarchy by portraying the painter as routine laborer or rejecting painting entirely, working with ordinary materials. All of these practices participated in the critiques of

art institutions and their role in shaping the broader society that were widespread in the late 1960s.

The events of 1968 intensified and multiplied the demands that artists had to negotiate. For young artists, the negotiation was particularly challenging: while they struggled to bring their work before the public and continue to practice as artists, they were confronted with questions of how to be responsible to the criticisms of the structure of the art world and the role of the artist that were voiced in the May and June protests. At the same time, government art administrators and museum curators felt extreme pressure to respond to the critiques of art institutions that had been put forth. By the following year at the behest of no lesser figure than the new president, Georges Pompidou, the government would begin formulating a new museum and contemporary cultural center that would dramatically alter the cultural policy and art market in France. While curators tried to balance administrative responsibilities and public pressure, artists strove to critically engage their evolving circumstances.

The efforts of artists to work outside the institutional and market structures available in France were serious, but they faced an uphill battle. In countries such as the United States, despite the difficulties of working outside the established channels, a variety of nontraditional venues for the encouragement of art existed, such as artist-run centers, scholarships and public funds for sponsoring new art, and artist residency programs. In France, by contrast, few alternatives to the galleries and heavily centralized museum and school networks developed, so that refusing to work with or within these art institutions tended to mean a nonexistent career. Some French artists found the negotiation of political critique and pragmatic material needs impossible and dropped out of the art world. Boltanski and Messager are two artists who developed practices that enabled them to engage the issues raised in '68 and to critique museums and other institutions while participating in them. Rather than replacing objectionable elements of the system with their opposites (for example, instead of individual production, collaboration; instead of exhibiting in institutions, working outdoors) Boltanski and Messager would propose more complex and nuanced critiques, reworking museums from within, with artworks expressing a sophisticated understanding of how museums create cultural meaning through their displays. The two artists combined museum forms of exhibition with unexpectedly private and everyday objects as a way of challenging museums by highlighting how their modes of presentation routinely operated and exposing their inherent limitations. And both artists pursued questions that had played prominent roles in 1968, Boltanski investigating the role and status of

Figure 25. Annette Messager, Untitled Drawing, 1968. © 2005 Artists Rights Society (ARS), New York/ADAGP, Paris.

the artist after the proclamation of the death of the author, and Messager exploring the intersections between institutions and everyday life. Their success at negotiating political critique, changing institutional circumstances and ideals, and the demands and desires of careers in art make Boltanski and Messager particularly compelling cases in the years that followed 1968. Furthermore, tracing the trajectories of their careers (and their promotion and reception as they rose from relative anonymity to national prominence) reveals the new priorities of the art administration as it attempted to respond to and reconstruct itself after the challenges of 1968.

But in the autumn of 1968, after the demonstrations and strikes had subsided, it was not yet clear how to proceed. Once the tensions between artists and museums had come to a head, both sides recognized the need to re-envision their practices — a process of negotiation that is still ongoing. The problem they faced was how to re-imagine art and its venues when nothing could remain as it was.

3 CHRISTIAN BOLTANSKI'S PERSONAL MEMORABILIA

REMAKING MUSEUMS IN THE WAKE OF 1968

The art world is going through a stage of individualistic creation in which the artist is deified....

[T]he charismatic ideology of the artist, which came into being with Renaissance humanism, to be confirmed and sublimated by romanticism and carried to its logical extreme by the theoreticians of art for art's sake, has at last been repudiated. Artists are no longer the quasi-gods who exist outside the norms of the community. They have been seized by an almost mystical fever of renunciation: "I renounce my status as an artist"; "the artist must melt into anonymity...." Like the Trappist who forgets himself to become engulfed in God, the artist denied himself so as to melt into collectivity, to become one with the people by working for society as a whole.[1]

<div align="right">Raymonde Moulin, "Living without Selling" (1968)</div>

We can easily imagine a culture where discourse would circulate without any need for an author. Discourses, whatever their status, form, or value, and regardless of our manner of handling them, would unfold in a pervasive anonymity. No longer the tiresome repetitions:
"Who is the real author?"
"Have we proof of his authenticity and originality?"
"What has he revealed of his most profound self in his language?"[2]

<div align="right">Michel Foucault, "What Is an Author?" (1969)</div>

As early as a year after the demonstrations of 1968, a new kind of artwork started appearing on the Parisian scene. Christian Boltanski, a young conceptual artist, began to exhibit images and materials that did not reference the struggles of striking workers and rebellious students but rather seemed to suggest an introspective concern with the self. With family photographs and childhood memorabilia, Boltanski seemed to be returning to a focus on the life of the individual artist that had been attacked as outmoded and elitist in the protests of a few months before. Was this a turn away from the political demands of 1968, as some critics suggested? Certainly something had changed. Yet this new emphasis on the personal life of the artist did not necessarily indicate Boltanski's abandonment of politics.

To decipher the significance of this shift in focus in Boltanski's work, it is important to consider the context within which artists were working after 1968 – that is, the logistical difficulties, material pressures, and

conflicting demands of their newly revived political roles as authors or artists in society at large. Two scholars of the late 1960s, Raymonde Moulin, a sociologist of art, and, more famously, Michel Foucault, a philosopher and historian, examined the ways in which the author or artist was integrated within broader social, political, and economic structures and provided an index of the challenges to authorship that had been brought forward in 1968 but not fully realized. Moulin, in "Living without Selling," offered a contemporary account of the plight of the artist faced with the commercial and political dynamics of the art world following the events of May. In "What Is an Author?" Foucault addressed the relation between an author and his text, which was then a widespread area of investigation in intellectual circles, having been taken up by, among others, Roland Barthes in "The Death of the Author" (1968) and debated in the *Cahiers du cinéma* in the 1960s.[3] Although Moulin and Foucault may appear to have discussed different domains, both examined how an artwork's success in the museum and market and a text's literary reception revolved around the notion of the author. Both scholars promoted the "death" of the author, believing that the processes through which works were associated with authors and artists served to mystify how they actually circulated, were interpreted, and took on cultural and economic value. Moulin saw contemporary artists facing a paradox: in 1968 activist artists rejected the museum's and market's promotion of the individual artist – instead collaborating with others on anonymous artwork – yet in the aftermath of '68, the operations of the museum and market remained largely unchanged, and artists who wanted to continue to practice had little alternative but to try to work within this system. For Moulin, the "death of the artist" would enable new possibilities for creative activities that engaged broad audiences, beyond those of the art market and the museum. While she focused on the artist as a being in the art world, Foucault was interested in the construction of the author in literary reception. Foucault challenged the way that literary criticism produced an image of the author in order to frame a coherent interpretation of his work, isolating the work's meaning within individual biography rather than seeing its embeddedness in broader political and institutional situations. For Foucault, the "death of the author" would enable new modes of analyzing texts, modes based on discerning how discourses appear and circulate. Both Moulin and Foucault seem very representative of their time in seeking fresh methods of interpretation and a freer distribution of works beyond the contemporary cultural hierarchy that depended on the status of the author.

Taken together, these texts begin to suggest the difficulties of being an artist amid the intellectual, political, and economic conditions of 1968. If the author was dead, what role was the artist to take? If he shunned the museum and market on political or intellectual grounds, what new avenues could he use to bring work before the public? If the individual was no longer the source for the content of the work, then where were new forms for collective expression to be found, how were they to be made comprehensible, and how were new audiences to be reached?

Although Christian Boltanski did not participate in the demonstrations of 1968, he had to navigate the tumultuous changes in the French art world that they had precipitated. This chapter argues that Boltanski, by using private materials to create multiple and often fictional identities, was able to work out a new role for the artist that was based on the "death of the author" and was influenced by and responded to the rapidly changing political, intellectual, and economic circumstances. In reconstructing his early career, this chapter addresses an omission in his critical reception, which has been principally monographic and has tended to project retrospectively onto the whole of his career the interpretation that his work is concerned with the universality of the forms of the family photo album, and related themes of personal memory, childhood, and death.[4] Indeed, Boltanski's projects and exhibitions have not been analyzed historically in light of the political tumult of the time, thereby obscuring how the notions of his oeuvre, and with it a new identity for the artist, were formed out of the complex confluences and negotiations following May 1968. Ironically, out of the death of the author would come a highly successful form of authorship and what would become the dominant interpretation of Boltanski's work: a new universal art.

The perception of his art as universal stemmed from his use of types of personal memorabilia that were common in French culture. In fact, in the years following 1968, many critics and curators came to see Boltanski's work as a powerful solution to protesters' critiques of the museum. Instead of Malraux's emphasis on the great masterworks of high culture that embodied the national collective memory, Boltanski's personal souvenirs and humble materials seemed to provide new forms of identification and outreach – a new way for audiences to connect with and find themselves represented in the museum. At the same time, Boltanski's display of his self in this autobiographical work seemed to curators and critics to offer a new approach to the old model of artistic subjectivity,

one that provided a note of continuity with the traditional roles of the museum and the artist. These efforts on the part of curators to display this new artwork and respond to the demands of '68 were significant; however, in promoting Boltanski's work as an answer to museums' struggles to remain relevant after 1968, they distorted the complexities of Boltanski's work and oversimplified the political ideas expressed in the 1968 critiques of art institutions.

These distortions primarily involved a tendency to read Boltanski's presentations of personal memorabilia in a straightforward fashion – that is, as documentation of the artist's past rather than strategic commentary on the role of the artist in the institution. By investigating the different ways Boltanski played with notions of artistic identity and private memory through various stages of his early career, this chapter traces the continuities between this new work's focus on the private and the critiques of authorship and art institutions that were central components of the 1968 art world protests.

The subtlety in Boltanski's work that allowed him to carry forth the institutional critiques of '68 but simultaneously appear to be the answer to museums' needs was to be incredibly fruitful for his career. In examining the steps of his career from the earlier more overtly political work through the turn to the personal in several of his first major exhibitions, I demonstrate how elements of Boltanski's critique dropped out of the dominant interpretations of his work. By insisting on the continuities between the political artwork of 1968 and Boltanski's exhibitions of private memorabilia, I reveal the appeals but also the very real limits of his displays of the personal for the museum.

FROM COLLABORATION TO ASSEMBLY LINE: RE-IMAGINING THE ARTIST IN THE ART WORLD

In much contemporary art criticism, the label "political art," when applied to the productions of the period around May 1968, has tended to signal an artist's involvement in the political activism of that time; the best-known example was the *atelier populaire* at the Ecole des Beaux-Arts. In occupying the national art school and setting up an anonymous, collective studio to make silk-screened posters for street demonstrations, these politically engaged artists rejected the practices of the museum and the market and their elite audiences in favor of ephemeral works that reached out toward the broad audience of the streets.

The artistic explorations that had begun in May 1968 extended beyond the *ateliers populaires*, producing a spill-over of artistic activity that

continued to have political resonance, and late in 1968, Boltanski became involved with them. His early projects drew on rhetoric of revolutionary change that was circulating at that time, and produced, as one of their effects, critiques of the notion of the author. In various ways, Boltanski and his collaborators challenged the organization of art institutions that had endured up to that point: in collaborative works they sought to undermine the notion of the individual artist; with activities in alternative sites they sought to break out of the strictures of the museum and market; and by creating art as events rather than objects they resisted the cultural status and economic value of art. Although at first glance Boltanski's later work seems to turn away from these overtly oppositional practices, the complex examinations of institutions, markets, and artistic identity that marked his later projects were anticipated in his earlier work.

One of these early collaborative projects was the *Occupation des lieux*, which was held at the American Center for Students and Artists in Paris from December 4 to 21, 1968. The title evokes the sit-ins or occupations of May 1968, and the location itself suggests certain politics. The American Center, supported by private funds and the American Embassy, was a venue open to experimental art; it served as an important cultural site because it was neither a museum run by the French state nor a gallery with marketing intentions and was, therefore, seen by many young artists as an alternative to the more traditional venues of the French art world.[5]

The only extant documentation is the poster advertising the event; however, the poster provides many suggestive details that indicate the political aims of the project (Fig. 26). After listing the artists who would participate – Boltanski, Le Gac, Journiac, Kudo, Miralda, and Pane (all of whom were experimenting with nontraditional media or performance art) – the poster displayed a text by contemporary critic Jean-Jacques Lévêque to explain the concept of the show. The artists, the poster announced,

> will not only be physical presences, but an affirmation by acts and objects: that which we in former times called a work of art, is here, a living work. More than aesthetic speculations, they propose, in virtue of a new philosophy, mechanisms of public health. They invite one, through their action, to know oneself better, communicate better, dream better, love better, to be without false pretenses and without prevarication.... It's not about an exhibition, it's about communication, a collective gesture that doesn't have any reason for being except for participation, the continuity of living.

The traditional work of art is an object added to life; here life is…modified.…The urgency for such a modification of art has been felt by various isolated persons. This is a tentative meeting, without distinctions of style or genre, of those, who in France, have brought the most to this game of exchange, to this essential form of communication that will save man from corrosive, anemic, deadly anonymity, for which the society of consumption prepares him.[6]

The *Occupation des lieux* was to provide an antidote: a new ethic to revive the public health threatened by consumer society, a new form of communication that would free the individual to be true to himself and allow him to participate in a collective through openness, interaction, and sharing with others. By unleashing individual creativity, and thereby a collective force, the show would revolutionize society and allow the continuity of life.

The poster's emphasis on freeing individual creativity to combat the deadening effects of consumer society evokes concepts that were in wide circulation at the time and most notably described in Henri Lefebvre's influential 1968 text, *Everyday Life in the Modern World*.[7] People had become passive consumers and spectators, Lefebvre argued; even art or "high culture" had become a product of consumption, providing a means for the state to impose its ideology on a population that had lost its true creativity. Because the organization of both mass culture and high culture had left no place for originality or spontaneity, Lefebvre believed that it was necessary to look to everyday life for the space that could unleash individual expression and produce radical social transformation. Lefebvre believed that philosophers, as well as other groups that were implicated in and yet dissatisfied with the current avenues for cultural expression, needed to maintain a critical perspective that would allow these groups to rebel against the cultural channels and institutions available to them. But although he described their roles in this revolution, he did not define the actual forms that their revolutionary creativity would take.

The *Occupation des lieux* echoed Lefebvre's broad themes in identifying the society of consumption as its target. Rather than making an object to be consumed by the audience, the artists sought to jolt viewers from passive spectatorship by inviting them to participate in a new form of "collective gesture" that evoked Lefebvre's revolutionary "fête" – a spontaneous, playful, and creative uprising in which people would take over city spaces from capitalists and bureaucrats in order to transform the experience of the everyday. Furthermore, by "seizing" new spaces, the

AMERICAN CENTER for STUDENTS and ARTISTS

(Centre International de Paris)

261, Boulevard Raspail - Paris-14 - 033.99.92

OCCUPATION
DES LIEUX

VERNISSAGE LE 3 DÉCEMBRE 1968
A 20 HEURES

boltanski le gac
journiac miralda
kudo gina pane

Parce qu'ils sont des artistes (ce produit étrange d'une société qui, tour à tour, y découvre ses épigones, ses victimes et ses chantres) ils ne seront pas seulement une présence physique, mais une affirmation par des actes et des objets: ce qu'en d'autres temps on appellerait une œuvre d'art et qui, ici, est plutôt une œuvre à vivre. Plutôt que des spéculations esthétiques, ils proposent, en vertu d'une nouvelle morale, des mécanismes de santé publique. Ils invitent par leur action à mieux se pénétrer de soi, à mieux communiquer, à mieux rêver, à mieux aimer, à être sans faux semblants, sans faux fuyants, toutes les hypocrisies d'une société qui, en vingt siècles, en a tant accumulées que l'air est devenu irrespirable. Il ne s'agit pas d'une exposition, mais d'une communication, d'un geste collectif qui n'a de raison d'être que dans la participation, la continuité à vivre.
L'œuvre d'art traditionnelle est un objet ajouté à la vie; ici, c'est la vie qui est, en vertu d'une idée morale, modifiée, ainsi que le comportement permanent de celui qui en reçoit les effluves. L'état d'urgence d'une telle modification de l'art a été ressentie par quelques isolés. Ici, a été tentée la rencontre sans distinction de style, de genre, de quelques-uns de ceux qui en France, ont le plus apporté à ce jeu d'échanges, à cette forme essentielle de communication qui sauvera l'homme d'un anonymat corrosif, anémiant, mortel, que la société de consommation lui prépare.
Jean-Jacques LEVEQUE.

EXPOSITION DU 4 AU 21 DÉCEMBRE
DE 12 H A 22 H

Figure 26. Jean-Jacques Lévêque, Poster for the *Occupation des lieux* at the American Center for Students and Artists, Paris, December 1968.
© Jean-Jacques Lévêque, courtesy of the Archives de la Critique d'Art, Châteaugiron (fonds Pierre Restany).

artists sought to intervene more directly in the space of "life" – outside the walls of the traditional galleries and museums that enclosed and isolated their art. Like Lefebvre, they saw the liberation of individual expression as the source of a collective power that could transform life; they were vague, however, as to how these revolutionary changes would be enacted.

Although the poster drew on the revolutionary language of May 1968, its agenda was crucially different from that of the posters produced by the *atelier populaire*. Unlike the *atelier populaire* posters, which called for action with explicitly political graphics, such as calls for strikes and opposition to the police and government – no question in their posters of how the revolution would come about – the American Center poster aimed not only to encourage the audience to participate in the artists' activities but also to publicize the event itself. The revolutionary politics were thus counterbalanced by the rhetoric of advertising for an event. Moreover, the word "occupation" would have evoked the sit-ins of May, during which activists took over public institutions and obstructed their normal functioning in order to make political demands. In the *Occupation des lieux*, the artists did not seize control of the venue but did seek to use it in a non-traditional way. Indeed, the differences between the *atelier populaire* posters and the *Occupation des lieux* are marked enough that the fact that both could be considered political projects in 1968 demonstrates the importance of the intersection between art and politics at that moment.

As part of the intended transformation of society, the *Occupation des lieux* was to eliminate the authority of the individual artist genius by engaging a group of artists as well as the audience, with an equal distribution of power among them. In this way, the artists drew on the contemporary theories and practices that aimed to call into question the preeminence of the artist or author. Yet the artists' assault on authorship was inevitably compromised by the project itself. The call for the collective dispersion of the artist was undercut by the boldface list of artists' names on the poster. Furthermore, although the event did not promote the artist as a solitary creator, the artist's exceptionality was nonetheless reinforced by the suggestion that he could take on a messianic role with the stated mission to "save man." Moreover, whereas the artists implied that their choice of space was based on a rejection of the market and the museum, it was also the case that they were at the beginning of their careers and needed to show their work. Thus, they sought to use the limited options available to contemporary artists at the time to provide alternatives to the traditional system. In 1968, working at alternative sites

could serve as a protest against traditional structures, while also providing an important means to present work to the public; indeed, although many artists would have shunned the notion at the time, the new spaces and forms adopted by politically engaged artists may have eventually multiplied the ways of achieving an artistic career.

In October 1969, Boltanski shifted away from the kinds of explicitly political statements that the *Occupation des lieux* poster represented. He participated in the international movements of Land Art and Conceptual Art, both of which sought to avoid creating traditional art objects for display in institutions. While conceptual and land artwork in the United States and England sought to oppose the museum and the market, in France the critique of the museum had potentially higher political stakes, given the centralization and national administration of fine arts education and museums and the wide-ranging attacks on cultural institutions in 1968. Whereas in the United States, for example, the market functioned as the primary site where new artists were discovered, in France the contemporary art market was depressed and increasingly favored American work, so that many artists like Boltanski depended on city and state exhibitions to show their work before the public.[8]

Another artist, Daniel Buren, pursued themes similar to those we will see in some of Boltanski's early projects, yet unlike Boltanski, Buren explicitly voiced his political objectives in public statements. In his exhibitions, Buren consciously sought to make art consist of repetitive motifs: each of his installations consisted of uniform blue and white stripes and aimed at eliminating the trace of the artist's gesture from the piece. Thus, the "artist's work" resembled assembly-line labor; it was always the same product and was measured in quantitative, not qualitative, terms.[9] Furthermore, by showing the same work inside and outside institutions, Buren sought to interrogate the museum by investigating how different venues influenced the way the audience perceived the work. In addition to these projects, Buren was outspoken in his criticism, publishing letters and tracts that attacked the arts administration, as well as the commercial aspects of salons, biennials, and various museums.[10] At times, he boycotted shows when he opposed the politics and the management of the exhibitions.

Like Buren, Boltanski sought to engage in what was understood to be an oppositional artistic practice. But in contrast to Buren's outspoken political stance, Boltanski remained silent at the moments when exhibitions triggered political debate. Boltanski never boycotted exhibitions and instead launched his critique exclusively through his work and its relation to the institution. We can consider the range of Boltanski's early

exhibition activity and the political valences of his institutional critique by examining three exhibitions that explored a variety of venues: the quasi-institutional biennial run by the city of Paris, the more market-oriented promotional show *Jeunes Artistes à Paris*, and the exhibition at the ostensibly neutral American Center.

The 1969 Paris Biennial, supported by the national Ministry of Culture, provoked a number of different responses in the art world. Although many artists had boycotted the 1968 Venice Biennial exhibition in support of the spring's many strikes and sit-ins, the 1969 Paris Biennial was never boycotted.[11] Still, many artists continued to oppose the official application procedure and the selection of participants by the biennial jury, seeing them as processes intended to designate a restricted group of elite artists who were endorsed by the establishment. Nonetheless, the power of the organizational committee and the jury members did not seem to be an authority worthy of the strongest challenge because of the biennial's limited budget and outdated approach. In addition, numerous artists said that they desperately needed the visibility, exhibition space, and recognition.

For the Paris Biennial, Boltanski collaborated with Jean Le Gac and Gina Pane, who had been conducting interventions in the landscape since 1967. Their entry, *Concession à perpétuité* – an "activity in nature" that was partially reconstructed in the biennial exhibition – attempted to participate in the exhibit while maintaining a physical and thereby critical distance (Figs. 27–8). Like other British and American land artists at that time, Boltanski, Le Gac, and Pane sought to create ephemeral installations in an outdoor environment, rather than individual objects for museum display, in order to avoid the ways that the museum accorded authority and value to the unique art object. The project occurred on September 10, 1969, when Boltanski, Le Gac, and Pane took over a piece of land in Ecos, Eure, that they chose because it seemed neutral and had no particular character. During the day, each of the three artists made an installation, part of which was shown at the biennial to evoke the site-specific project. Pane made markers with prismatic signposts in a lacquered blue metal, which were placed as signs to mark their passage. Boltanski half-buried a life-sized mannequin. Le Gac created three *Containers d'images* or *Bâches*, clear plastic sheets upon which he depicted views of his interventions in nature. The installation at the biennial exhibition, which opened in October and ran for a month at the Musée d'Art Moderne de la Ville de Paris, won a prize; it consisted of Pane's metal stakes, Le Gac's *Bâches*, and Boltanski's four partially buried mannequins.

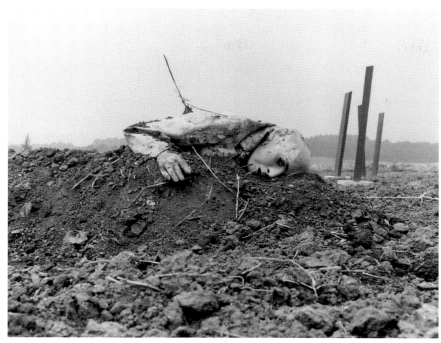

Figure 27.
Christian Boltanski, Jean Le Gac, and
Gina Pane, *Concession à perpétuité*,
1969. Ecos (Eure) installation, 1969.
© 2005 Artists Rights Society
(ARS), New York/ADAGP, Paris.
Photo: Michelle Vincenot, courtesy of
Bob Calle.

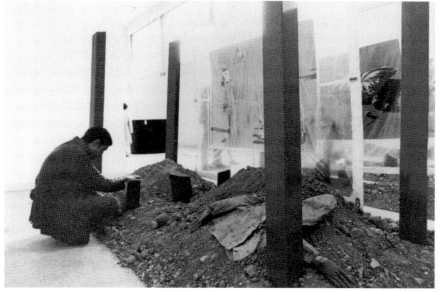

Figure 28.
Christian Boltanski, Jean Le Gac, and
Gina Pane, *Concession à perpétuité*,
1969. Installation at the Paris
Biennial (with Boltanski on left),
1969. © 2005 Artists Rights
Society (ARS), New York/ADAGP,
Paris. Photo courtesy of Bob Calle.

The project brought together two meanings evoked by the title *Concession à perpétuité*. The artists' statement proclaimed "this plot of land belonged to them." Thus, they surveyed the land and used Pane's posts to define its limits and to mark it as their own. Furthermore, the project suggested French burial practices: before the twentieth century *Concession à perpétuité* was a frequent inscription on French funerary monuments, which indicated that individual plots were owned in perpetuity. Here however, the half-buried mannequin suggested a decaying mortal body that was not resting complacently, but appeared to be crawling out of the grave.

The biennial project, suggesting the death and re-animation of a corpse, resembled films that Boltanski had recently made, which showed mannequins and masked characters acting out extreme mental and physical states (one character coughed up blood, a second had a mental breakdown, a third licked a life-size female mannequin, and a fourth beat a victim with a club). In a review of the *Concession à perpétuité*, the critic Gilbert Gatellier viewed Boltanski's half-burial of the mannequin in the broader context of his films:

> Boltanski's mannequin is evidence of his work from the last few years where the same types of characters, dressed in unbearable rags, were frozen in plastic, semi-transparent sorts of aquariums.... Now these static stagings have disappeared and the characters find themselves in the guise of masked actors in short, preferably foul films (a man who coughs up blood for two and a half minutes, with a soundtrack...).[12]

Even though the corpse in the *Concession à perpétuité* was obviously fake, it, like Boltanski's films, transgressed boundaries and taboos and elicited strong emotional responses. Boltanski's half dug up grave markedly contrasted with the affirmation of "*la vie*" in his previous work, indicating a shift to address explicitly sordid themes that were intended to disturb the complacency of the exhibition viewer without making an overtly political statement.

Gatellier also saw the project as a challenge to traditional forms of exhibition and artwork, describing the *Concession* as "without spatial limits or cultural specialization." His phrase "without spatial limits" implied that the artists' work existed beyond the confines of the institution; the artists' description of taking over a neutral space and making it their own reinforced this idea of independence from the museum.[13] Gatellier's phrase "without cultural specialization" suggested that the traditional hierarchy of art or role of the artist had been negated. In addition, he contended

that the *Concession* was an "attractive assemblage of three heterogeneous kinds of work that do not pretend to have the fixedness or synthetic purity of a work of art," indicating that at least part of the significance of the collaborative and multi-media project was to avoid producing a traditional art object.[14] Like many contemporary conceptual and land art works that sought to avoid the display of conventional art objects in institutional venues, however, this ambitious attempt at subverting the structures of the art world inevitably participated within them.[15] In the end, the artists' reconstruction was accorded value in the way that art objects traditionally had been by the prize it received from the biennial officials.

Concurrently with the biennial, an annex exhibition called *Jeunes Artistes à Paris* was held at the Palais Galliera. Here, Boltanski displayed *Repas*, composed of a sheet, a light bulb, numerous balls of mud, a bowl filled with clay, and a clump of hair in a screen casing (Fig. 29). Gatellier described: "Boltanski gives himself over to solitary, fanatic, useless work, such as making three or four thousand little balls of clay."[16] Boltanski's creation of the balls of mud had the effect of quantifying work in terms of time. One year after he made the balls, he recounted that they "only reflected the time he put into making them."[17] The balls evoked an

attempt to illustrate what a unit of time would look like in terms of material production. Boltanski's process conjured a vague analogy with alienated labor, which was measured and valued in temporal units for sale. The balls were roughly uniform in size and shape, recalling mass produced parts, and could have been made by anyone. While the intention of the exhibition was to spotlight young talent, Boltanski's practice seemed to counter this purpose: his mechanical gestures contradicted notions of the creative act.

That same month, the American Center offered its interior and exterior spaces to artists "seeking a new presentation of the artistic act," and twenty-one artists participated in the resulting exhibition *Work in Progress*. Whereas at the biennial the artist's work had to be submitted to a panel of judges for evaluation, the American Center allowed any interested artist to participate. Each artist was given control of the American Center space and the presentation of his work for one day. In the publicity for the event, the spectator was invited not to look at a finished object, but to watch process-based work, which transformed the site throughout each day. On October 9, 1969, for his part of the proceedings, Boltanski planted and dug up approximately 1,000 pink sticks (Fig. 30) in a project that combined the idea of burial and exhumation from the *Concession à perpétuité* with the repetitive acts seen in the making of the balls for *Repas*.

Work in Progress was an innovative project, yet aspects of the event nonetheless fell within the patterns of traditional exhibitions. Although Boltanski avoided creating objects, a catalog of the exhibition was printed and became a surrogate object embodying the participation of the artists in the exhibition. Furthermore, by featuring work by one artist per day, the show ended up reinforcing the notion of the individual artist as creator. While the exhibition provided good exposure for young artists and sought to provide a more egalitarian form of work and relation to the audience, critics lamented that the activities failed to attract the public's participation or attention.[18]

Boltanski's work from this period attempted, in varying degrees, to protest the dominance of museum and market structures by shunning them or by straightforwardly contradicting the ideas of the artist, the work, and the institution. His work was often collaborative instead of individual, an event instead of an art object, or an act in nature instead of in an institution. Yet these projects were inevitably compromised by their dependence upon the exhibition form and its apparatus, a quality that Raymonde Moulin had observed in much of the work of this period.[19] Boltanski's work proposed alternatives or substituted "opposites" rather than thoroughly examining and undermining how the

13 des I.000 petits batons roses plantés à l'american-
center le 9-I0-69 par christian boltanski. Les 987 autres
ont été laissés a dijon le 26-II-69.

entire system worked, and it was thus bound to continue to participate in the museum and market systems it sought to overturn. Despite his wide-ranging attempts to undermine the figure of the author – from the utopian formation of an artistic collectivity to his thematic explorations of death and repetition – traditional conceptions of authorship survived in art criticism, museum exhibitions, and even in his own work. Boltanski would soon abandon such attacks on generalized notions of authorship and focus on the presentation of a single author – himself – by exploring how an artist's biography was framed by museums.

BOLTANSKI'S *VITRINES*: THE LIFE – OR DEATH – OF THE ARTIST?

In mid-1969, a new kind of subject matter became evident in Boltanski's work, as he began to combine personal memorabilia with museum and gallery forms of display. It is unclear why Boltanski changed his practice at this point, but the effect of this change was both his entry into prominent galleries and museums, and the emergence of a more sophisticated

critique of these spaces. Boltanski framed personal, autobiographical material in museum display formats to show how the institutional setting imposed a coherence on a biography that ultimately could not be upheld; by role-playing various artistic personae he challenged the idea that any unity or consistent "Boltanski" could conceivably be found. Yet his insertion of unexpectedly private material into museum forms of presentation could be simultaneously seen as the candid expression of the artist – a sincere and straightforward expression of individuality. This interpretation hearkened back to museums' and art criticism's traditional mode of celebrating works of art as the highest form of individual expression and obscured the critique of artistic subjectivity that Boltanski's work presented.

From 1969 to 1971 Boltanski developed his play with artistic identity in pieces that would come to be re-presented in his *Vitrines*, display cases that gathered together prior projects. As his work shifted in subject matter and tone, critics moved from an awareness of its ironies to assertions of its sincerity. Throughout this period Boltanski gained increasing critical recognition that would lead to his taking a place on a national and international stage.

In May 1969, exactly one year after the revolutionary artists' protests, Boltanski published a booklet titled *Recherche et présentation de tout ce qui reste de mon enfance 1944–1950* and sent photocopies of the project as mail art to curators and critics (Figs. 31–3). This work manifested features that he continued to employ as he moved more fully into museum and gallery circuits: autobiographical subjects, form or content that suggested museum practices, and a statement to frame the project. And no less important, the *Recherche et présentation* – supposedly an attempt to reconstitute the first six years of Boltanski's life in their entirety – lent itself to opposing interpretations: an invitation to view the private life of the artist or a critique of trying to read Boltanski's life into the work. The cover of the booklet reproduced a school photograph with an "x" above Boltanski's head, indicating him in the photograph. The second page explained his presentation of this purportedly personal material:

> One never notices enough that death is a disgraceful thing. In the end, we never really try to struggle against it, doctors and scientists do nothing but compromise with it, struggling with details, putting it off by a couple of months or years, but all that's nothing. What's needed is to attack the root of the problem with a large collective effort, where each person works for his own survival and that of others. That's why, because

Figure 31.
Christian Boltanski, "Collège d'Hulst, Paris, 1950–1951," cover of *Recherche et présentation de tout ce qui reste de mon enfance 1944–1950*, 1969. Photocopied book of nine pages. (Paris: Givaudan, 1969) n.p. © 2005 Artists Rights Society (ARS), New York/ADAGP, Paris. Photo courtesy of Christian Boltanski.

it's necessary that one of us provides an example, I decided to take up a project that has been very important to me for a long time: conserving entirely, keeping a trace of those instants of our life, of all the objects that are close to us, of all that we have said and that was said around us, that was my goal. The task is immense and my means are meager. Should I have started sooner? Almost all of the things that I began trying to save from the period (6 September 1944–24 July 1950) were already lost, thrown away by guilty negligence. Only with great difficulty did I find the few elements presented here. Proving their authenticity, situating them exactly, was only possible by incessant questions and a meticulous investigation. But the task that remains to be done is large and how many years will be occupied with searching, studying, and classifying before my life will be secured, neatly arranged and labeled in a safe place, sheltered from theft, fire, and atomic war, before it will be possible to take it out and reconstitute my life at any moment and [before I], being assured of not dying, can finally rest.[20]

The rest of the booklet illustrated his personal belongings in the photographs with labels indicating a moment in archival time: Christian Boltanski playing with blocks in 1946, Christian Boltanski's blocks found again in 1969, Boltanski's bed from 1947 to 1950, his shirt in March 1949, a piece of a sweater worn by him in 1949, and tufts of his hair from 1949.

Figure 32.
Christian Boltanski, "Christian
Boltanski's Bed, 1947–1950,
Christian Boltanski's Shirt, March
1949," *Recherche et présentation de
tout ce qui reste de mon enfance
1944–1950* (detail), 1969.
Photocopied book of nine pages.
(Paris: Givaudan, 1969) n.p. ©
2005 Artists Rights Society (ARS),
New York/ADAGP, Paris. Photo
courtesy of Christian Boltanski.

Figure 33.
Christian Boltanski, "Piece of a sweater worn by Christian Boltanski in 1949, Christian Boltanski's hair, 1949," *Recherche et présentation de tout ce qui reste de mon enfance 1944–1950* (detail), 1969. Photocopied book of nine pages. (Paris: Givaudan, 1969) n.p. © 2005 Artists Rights Society (ARS), New York/ADAGP, Paris. Photo courtesy of Christian Boltanski.

Boltanski's project of collecting and classifying his life evokes not the presentation of an artist in an art museum, but the presentation of an individual in a culture of the sort encountered in an ethnographic museum. In fact, Gatellier remarked on the parallel, comparing Boltanski's images and materials to those objects representing "extinct cultures in the Musée de l'Homme." Moreover, Gatellier recognized the insufficiency of these images to the aims that Boltanski professed, describing the work as made up of "pathetic images," "little albums, where the mediocrity of the photocopied documents . . . emphasizes the poverty of the materials used as proof of [his] memories."[21]

Indeed, Boltanski's booklet suggests a representation of an individual, yet simultaneously frustrates the process of finding the personal meaning of the material, because of the work's strict adherence to museum modes of presentation. In the late 1960s, in an ethnographic museum such as the Musée de l'Homme, unlike in an art museum, utilitarian objects and photographs were understood to function as proof and as authentic presentations of the past. Objects and illustrations were accompanied by textual explanations so that they could be appreciated as exemplary of the culture. But when Boltanski presented his personal material as ethnographic documents, his childhood stories were hardly communicated. His presentation of the photograph of the bed or of the piece of the sweater as "evidence" seems ridiculous. What does the picture of the bed reveal beyond the fact that the object existed? The process of proving the authenticity of his objects, such as his childhood sweater and blocks, is represented with great hyperbole; such objects are given dates with the precision usually reserved for historical events. However, the objects' quotidian nature suggests that their use would have been ordinary and ongoing. Therefore, they are more difficult to date in this way.

Because Boltanski presents his personal objects in this impersonal, ethnographic format, it is difficult to create a picture of the individual who owned them. Part of the difficulty stems from the fact that in viewing ethnographic displays, audiences do not look for depictions of individuals but for exemplary representations of a culture. In order to access the private meaning of the objects, viewers would require biographical information gained either from personal familiarity or from knowledge of the career of an individual. Because such information about Boltanski's biography is not provided, the personal memories associated with his objects cannot be communicated in their given format. Moreover, his exaggerated account of storing and labeling the objects highlights the ridiculousness of the idea that one could simply fix pure moments and

later re-experience them, even as it puts forth an impassioned plea to do so. By presenting documents of his personal life within the museum's formats of preservation, Boltanski explored the limits of preserving personal memory within public museum frameworks. Furthermore, the tension between the ethnographic forms of display and the autobiographical mode serves to frustrate viewers' desires for a coherent picture of the artist's self.

Whereas Gatellier's review emphasized the *Recherche et présentation's* exposure of its inability to adequately represent Boltanski's memories, and although the work itself revealed the literal impossibility of the objectives it set, by the next year a different interpretation of the mailing began to emerge. Although neither was entirely convinced of the authenticity of his documentation, both Catherine Millet in early 1970 and Jean-Marc Poinsot in 1971 saw Boltanski crossing a line between the boundaries of public and private life by bringing elements from his personal life into the public sphere of the art world. Millet described the project in conjunction with Boltanski's lock of hair, which was sent as a mailing in October 1969, and his photo of his sister digging in the sand on the Granville beach, which was sent as a mailing a month later. She asked: "How can one react when one possesses from someone with whom one has had no personal contact, a tuft of hair sealed up like a relic, several photos of his little sister ... in order to bear witness to his activity and thereby mark the time of his life?"[22] Millet's reaction was to feel personally implicated, because Boltanski had shared private material with her. In 1971, Poinsot, a young critic interested in mail art, explained that Boltanski's works "come from his private life ... [which] would suffer if divulged to a large public."[23] Poinsot also described the mailed items as relics. In one mailing, Boltanski's hair was folded inside a small piece of white linen with two pins holding it closed. In the other, a blurry, grainy, and somewhat faded photograph of his sister was simply tucked inside the mailing envelope. Like relics, both the hair and the photograph were fragile materials, had packages to protect and preserve them, and appeared to be remnants of experiences of former times. These critics' comments suggest the strong emotional power that the objects held for viewers due to their humbleness and implied connection to the artist's past.

A particularly revealing event in early 1970 shows how Boltanski would increasingly come to both critique and exploit conceptions of authorship and subjectivity. On January 11, 1970, Boltanski wrote a letter to critics asking for help, a letter that seemed to blur the distinction between

the artist as an actor in the world and artist as the subject of the work (Fig. 34):

> Dear Sir,
>
> You must help me, you have certainly heard about the difficulties that I have had recently and the very serious crisis that I am currently going through. First of all, I want you to know that everything you have heard about me is false. I have always tried to live an honest life and I think, by the way, that you know my work; you doubtless know that I devote myself to it entirely, but the situation has now reached an intolerable level and I don't think I can stand it for very long, that's why I'm asking you, begging you, to respond *as quickly as possible*. I'm sorry to disturb you, but I absolutely have to get out of this situation.
>
> C. Boltanski.[24]

The letter illustrates how Boltanski used the "life of the artist" for publicity, both circulating his artwork and solidifying his personal relations to art critics. Although the author and the subject of the artwork should be considered distinct, Boltanski showed that when he used personal material, they could be easily confused. He received several responses, including letters from the critics JoséPierre, Alain Jouffroy, and Pierre Restany. JoséPierre responded:

> my dear Boltanski,
>
> what is happening with you? i was not aware of what was going on . . . but in any case, tell me what i can do for you. if it's possible, i will gladly do it. do not allow yourself to be demoralized by adversity.[25]

JoséPierre's genuinely concerned reply demonstrates the kind of confusion this letter produced. Was the appropriate response a critical interpretation and evaluation of the letter as a work of art or an expression of personal concern to a troubled individual? By sending the letter directly to the critics rather than going through the intermediary of the institution, Boltanski changed the usual circuit through which the critic constructed the image of the author by reference to his work. He thus made visible the instability of the author as constructed in critical reception by collapsing the distinction between the living artist and the artist as represented in his work. Similarly, he voiced an implicit critique of art world operations as mediated by critics with the statement "everything you have heard about me is false," which suggests the confluence of *actualités* and art criticism in sensational rumor.

Figure 34.
Christian Boltanski, *Lettre demandant de l'aide*, 1970. © 2005 Artists Rights Society (ARS), New York/ADAGP, Paris. Photo courtesy of Christian Boltanski.

Boltanski's exploration of the issue of authenticity and personal testimony was not limited to his more ephemeral works, but also addressed in his March 1970 exhibit at the Templon gallery, his first gallery show. For this exhibit, Boltanski lined the walls of the gallery with tin biscuit boxes, his *Boîtes de biscuits* (Fig. 35). According to Boltanski's statement on the project, "each box was to contain a moment of [his] existence" and each was labeled with a precise date.[26] While his statement suggested an intimate view of his life and the metal box evoked the archival preservation of specimens or souvenirs, the objects actually contained inside were balls of mud, scraps of paper, and other debris. These contents revealed little about his past and frustrated the expectations raised by the work. Critic Catherine Millet, in her review of the exhibition, described this frustration: "Even if the facts that Boltanski uses as pretexts for his work

Figure 35.
Christian Boltanski, *Boîtes de biscuits*, 1969. Installation at Templon Gallery, 1970. © 2005 Artists Rights Society (ARS), New York/ADAGP, Paris. Photo courtesy of Christian Boltanski.

come from his most private life, his personality by no means emerges for the public."[27]

In fact, Boltanski underscored the way the institution and public united in desperately seeking to find – or create, if necessary – a version of artistic identity that was ultimately illusory. A photograph documenting the biscuit boxes, which Boltanski staged, highlights the way these works examined the construction of the figure of the artist (Fig. 36). The one open tin reveals a lump of unformed dirt that appears to have no meaning. Juxtaposed with the unformed dirt, Boltanski's face is reflected in the box at the top of the stack, contrasting material and image, stasis and ephemerality. His looming shadow contains the boxes, as if to show that their association with his persona – suggested here through literal proximity – gives them meaning. The boxes by themselves, without the statement that emphasized their link to the life of the artist, would mean little. But at the same time, the surface of the box, like a fun-house mirror, deforms the reflection of the artist, suggesting the distortion that takes place when we try to fix an illusion of the artist through his work.

In the years that followed, Boltanski's work increasingly employed more formal devices of museum display in order to focus attention on the institutional systems for exhibiting the artist and on the question of the artist's biographical relation to his work. From 1970 to 1973, he frequently used vitrines to re-present his earlier work. For

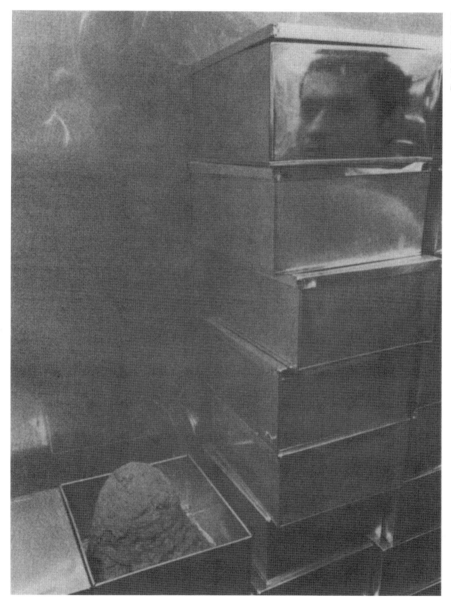

example, a 1970 *Vitrine de référence* displayed Boltanski's letter asking for help, some of his *pièges* (sharp, trap-like objects from 1970), sugar cubes and balls of mud, pages from the *Recherche et présentation*, and other mail art pieces (Fig. 37). By displaying his work in museum formats, Boltanski demonstrated how the institution could change the status of objects.

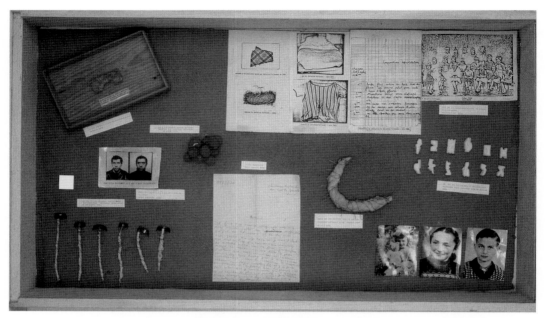

Figure 37. Christian Boltanski, *Vitrine de référence*, 1970. © 2005 Artists Rights Society (ARS), New York/ADAGP, Paris. Photo courtesy of Christian Boltanski.

Exhibiting his mail art – a form that was seen to be quintessentially outside the museum – in the vitrines dramatically altered its nature, for example. Boltanski sent his last mail art works in December 1970 and began displaying them in his vitrines directly thereafter. Thus enshrined, they were taken out of circulation, fixed as part of his career that was over, and relegated to the past. Whereas the mail art works were mass-produced, ephemeral objects, constructed as such to avoid attaining the value and the authority of the individual art object, their placement in the vitrines emphasized their fragility and rarity so that each mail art piece took on the aura of a protected object in the museum display case. Although Boltanski's *Recherche et présentation* was valueless as mail art and, like most of his work from the 1968 to 1970 period, had not sold, it suddenly began selling when it was repackaged in his vitrines and shown in large state-sponsored exhibitions.

Significantly, in the choice of material included, Boltanski's vitrines created a notably partial picture of his work. The vitrines erased the collaborative projects from the period immediately around 1968 from his history and instead directed attention to the individual artist. The vitrines also gave this reconstitution of works the appearance of an untouchable history, as if it were sealed in tombs. The combination of museum form and private material seemed to create a transparent presentation of the

MUSÉE SOCIAL

5, RUE LAS CASES, PARIS-VIIᵉ - 4ᵉ ÉTAGE

DISPERSION A L'AMIABLE

DU CONTENU DES 3 TIROIRS DU SECRÉTAIRE
DE

CHRISTIAN BOLTANSKI

ORIGINAUX - LETTRES - DOCUMENTS ET OBJETS DIVERS

LE LUNDI 5 JUIN A 20 HEURES

artist's "true self." Acting as an institution of art, similar to the institutions of literature described by Foucault that constituted the image of the author, the vitrines appeared to present the artist and his oeuvre as a coherent whole, seemingly resolving the contradictions and creating links between the heterogeneous elements in his works, rendering drafts, notes, and artwork as equal manifestations of the author's creativity. Yet this coherence was simultaneously proposed and withheld by the vitrines.

Just before he displayed the vitrines, which demonstrated how such coherence was created, Boltanski held a *Dispersion à l'amiable*, a "private auction" that appeared to do the opposite: rather than reconstituting his career, he scattered the objects that had constructed his artistic identity (Fig. 38). Michel Durand, a friend of Boltanski, acted as an auctioneer at the parodic auction of "the contents of Christian Boltanski's three desk drawers." "Originals, letters, documents, and various objects" were sold at ridiculously low prices. The general emphasis of the auction was not to sell Boltanski's "artwork," but rather the materials that helped to establish his identity as an artist. The objects can be grouped into several different categories: 1) a c.v., diplomas, texts published in magazines, reviews of his work, correspondence with critics and curators, contracts and administrative letters – all of which referred to the processes by which an artist's career was validated by various educational, critical, and institutional factions of the art world; 2) corrections of a narrative published on exhibition invitations, photos of work used to print brochures, and negatives used to reproduce his mail art – items that referred to the distribution and promotion of his work; 3) three

pieces of pipes belonging to Boltanski in 1969 and 1970, and a photo of Boltanski in 1961 – items supposedly belonging to or attesting to the "life of the artist"; and 4) unpublished texts and unrealized works from 1969 to 1971 – pieces that were not considered part of Boltanski's oeuvre. At the auction, Boltanski rid himself of "non-art" pieces that would not be shown in the vitrines and sold the items that had helped to establish his artistic reputation. The timing of this auction seems significant: it was held just before Boltanski was featured in two large, state-sponsored exhibitions, the Expo '72 in France and the Documenta 5 in Germany – exhibitions intended to consolidate his place in the art world. Boltanski's auction thus resisted the apparatus constructing artistic identity that he was about to enter at a new level. At the Expo '72 and the Documenta 5, Boltanski would exhibit the *Vitrines*, which appeared to lay out his career as somehow self-constituted or independent of these art world dealings and processes. Although he staged his dispersal at the auction, he simultaneously enshrined in vitrines works that manifested the "death" of the artist, staging his entombment for the large-scale museum exhibitions.

Critics had responded to the combination of private, autobiographical themes and museum forms in his earlier work by interpreting them as representations of the artist's self. They observed different personalities: Millet and Poinsot both described Boltanski's emotionally charged attempts to preserve his past with his mail art; Gatellier and Borgeaud, among others, viewed his activity of making the balls of mud as "fanatic;"[28] JoséPierre perceived a troubled individual in the letter asking for help. But when Boltanski put these works side by side in vitrines, he underscored how contradictory were the visions of the artist that the different projects suggested. In this way, he forced the viewer to acknowledge what usually went unnoticed: how the vitrine functions in the museum to emphasize coherence, using the artist or some other category as a classification to unify a group of objects. Yet Boltanski's works challenged the notion of the vitrine as containing the artist's coherent oeuvre. Inside the vitrines, the inconsistency of the characters that were suggested by his work became visible, and it could be seen that he had been playing different roles. The "sentimental Boltanski" who was trying to preserve his childhood past; the "fanatic Boltanski" who feverishly made thousands of balls of mud; and the "suicidal Boltanski" who sent the letters to critics asking for help – all these projects suggested multiple and contradictory personae, so that the vitrine seemed to impose a coherence that the contents refused. The vitrines mocked the name of the artist as classification by showing his multiple and contradictory personalities

and laid bare the process by which observers and institutions constitute an artist by defining him through an oeuvre.

In other words, what seems to be an obsessive and even retrograde turn to the individual personality of the artist in the works Boltanski produced between 1969 and 1971 actually demonstrates a much more skeptical and ironic perspective on the role of an artist and his function within institutions. This critique thus constitutes a continuity with the political questions raised in the art world protests of 1968, which sought to undermine notions of specialization and individual artistic genius. At the end of these years, Boltanski was on the threshold of major national and international success. How did this critical examination of the function of museums, cultural institutions, and the artistic roles they demanded play out in the major state exhibitions in which he would take part? In the next two sections, I consider the ways critics and curators adopted, transformed, and often distorted his work's critique. I begin by examining the exhibition of his work at the Documenta 5 exhibition, held in Germany in 1972, at which dominant interpretations of Boltanski were to crystallize, and then return to the Expo '72 to show how the French museum in particular made use of Boltanski's newly "personal" works. Curators came to feel that Boltanski's displays of private images and memories could help remake the museum by representing the kind of experience that 1968 protesters felt had been excluded by the museum's national and elite mode of address. These curators saw his images as familiar, approachable expressions of individual experience – a means for reconstructing the museum as accessible and inclusive. But putting the work to this use necessitated overlooking the elements of Boltanski's work that remained critical of the museum and skeptical of its ability to represent and communicate personal meaning.

THE DOCUMENTA 5 AND THE FAMILY ALBUM

In the prominent contemporary art exhibition Documenta 5, Boltanski displayed the vitrines that he had been producing over the last several years, as well as another work that referenced private life, the *Album de photos de la Famille D., 1939–1964*, an anonymous photo album, which was to become one of his most celebrated works. Though I will suggest that these works continued his critique of museums with representations of personal memorabilia, the works were met with varied critical responses at the time. The Documenta 5 curatorial team presented Boltanski's work in two opposing ways: on the one hand, as private and inaccessible in the section of the exhibition called "individual mythologies" where the

vitrines were taken to espouse the kind of authenticity that they were intended to critique; on the other, in a catalog essay, the *Album de photos de la Famille D.* was framed as universally comprehensible (Fig. 39). At the Documenta 5, the critical potential of Boltanski's personal materials could still be recognized, for instance, by critic Jean Clair in his comments on the exhibition. Nonetheless, the Documenta 5 would consolidate a powerful new interpretation of Boltanski's art that would work to obscure its critical potential and would dominate his reception up to the present.

The Documenta 5 exhibition "Questioning Reality – Image Worlds Today," held June through August 1972, was conceived as a school of seeing, which sought to investigate dominant modes of representation and vision. According to Harald Szeeman, the director, the Documenta 5 began with the premise that ordinary images taken to be neutral (what it called "representations of reality") in fact conveyed social and political ideology; it thus aimed to demonstrate how these images functioned and how they affected their audience. The exhibition thus sought to criticize and alter common representations and cultivate critical audiences – and in this way it can be viewed as representative of the struggles of the museum after 1968 to make itself more responsive to the call for engagement with the world outside its walls and with new audiences.[29]

The exhibition implied a fundamental contrast between realism (exhibited in both the "reality of representation" and the "reality of the represented" categories that structured the museum's displays) as transparent and accessible, and "individual mythologies" as subjective, inaccessible, and private.[30] The first section, the "reality of representation," showed non-artistic images common in society: kitsch, comics, political propaganda, advertising, nationalist iconography, and pictures from the mass media. The exhibition organizers claimed that these systems of images, although often understood as reality, actually carried social and political ideology. In turn, the "reality of the represented" section displayed caricature, pornography, activist graphics, and photorealism – all of which were seen as interventions into the "reality of representation." For example, caricature and activist graphics exposed the ideology underlying political propaganda and nationalist iconography. The "reality of representation" was shown on the first floor and basement level of the Neue Galerie, providing viewers with grounds for analysis, so that when they went on to the "reality of the represented" on the second floor, they could understand how the images in the "reality of the represented" section critiqued and intervened in the systems of representation shown on the floors below.[31]

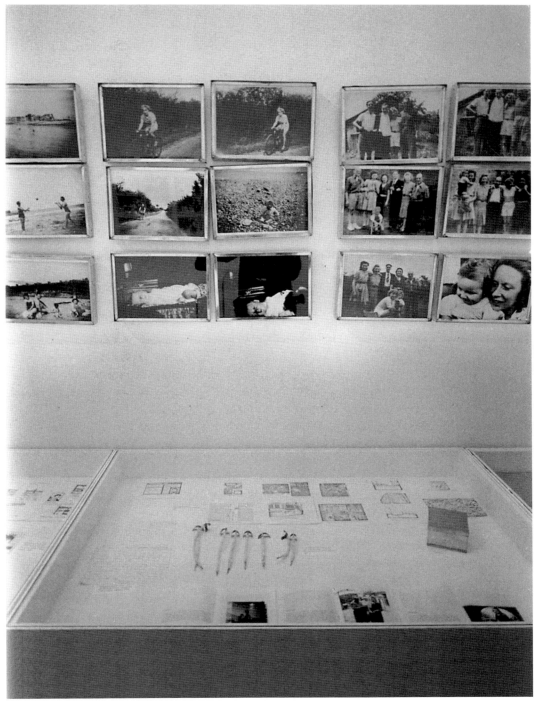

Figure 39. Christian Boltanski, *Vitrine de référence*, 1971, and *L'Album de photos de la Famille D., 1939–1964*, 1971. Installation at the Documenta 5 exhibition, Kassel, 1972. © 2005 Artists Rights Society (ARS), New York/ADAGP, Paris. Photo © André Morain.

Unlike the works in the "reality of the represented" section, which were seen to intervene in dominant systems of representation, the images in the "individual mythologies" section of the exhibition were viewed as entirely private symbolism. Here, Boltanski's work was juxtaposed with objects from the Museum Waldau, Bern, that were made by and belonged to the mentally ill and which were presented in scientific-looking vitrines similar to those used by Boltanski (Figs. 39–40). Literature on the exhibition compared individual mythology makers with children, who had not yet developed the ability to use conventional visual languages, or with the mentally ill, who had lost this capacity. (This conception of individual mythologies drew on notions of *Art Brut*, originally articulated by artist Jean Dubuffet, who lauded the artwork of children, the naive, and the psychotic – those he considered less subject to cultural norms and conventions – and believed that they produced more spontaneous, authentic, and idiosyncratic self-expressions.)[32] As Szeeman explained: "Individual mythology is when an individual is making his own system of signs, which holds [meaning] for himself. Maybe from the outside it doesn't hold [meaning] or looks crazy. . . . Of course he hopes others will understand it someday."[33]

In this context, Boltanski's *Vitrines de référence* were presented, like the objects made by the mentally ill, as entirely disengaged from popular systems of representation.[34] Indeed, Boltanski's traps and knives in ethnographic-style vitrines resembled the glass cabinet containing small knives and tools of the mentally ill. Yet by comparing Boltanski's vitrines with objects made by persons with mental illnesses, the exhibition suggested that Boltanski's work was a personal statement that was inaccessible to the public and foreclosed its participation in the overall project of the exhibition: critiquing popular images and modes of vision. Although Szeeman was correct to emphasize that the personal meaning of Boltanski's material was not communicated, these difficulties in understanding his work were not due to hermetic language or symbolism. After all, his work employed a commonly understood system of communication – museum formats – such as labels and vitrine display cases. By frustrating the viewer's attempts to read these modes of display in their customary manner, Boltanski drew attention to how they were usually intended to work and to the effects they had on audiences' interpretation.

The Documenta 5 contained another section, "museums by artists," which Szeeman hoped would provoke reflection on the museum institution, and Boltanski's vitrines could have just as easily been fit there. A number of artists' museums were displayed in the entrance to

Figure 40.
Objects belonging to the mentally ill, from the Museum Waldau, Bern. Installation at the Documenta 5 exhibition, Kassel, 1972. Photo © AndréMorain.

the Neue Galerie: Marcel Broodthaers's *Département des Aigles*, Marcel Duchamp's *Boîte en valise*, Herbert Distel's *Twentieth-Century Museum*, Claes Oldenburg's *Mouse Museum*, and Ben Vautier's *Armoire*. Curiously, this section was not described in the general literature that explained the other components of the exhibition. As a result, the section that reflected on how the museum presented the work remained largely separate from the rest of the exhibition project. Yet the presence of the *Boîte en valise*, which would have been familiar to an art world audience as a reflection on museum display, would have immediately made clear the idea behind the section.

Although conceived in the 1930s, Duchamp's *Boîte en valise* served as a prototype for many works in the 1960s, because it underscored the functions of the museum. As a portable collection of miniature copies of Duchamp's work that were signed, collected, displayed, and labeled, the *Boîte en valise* imitated the museum. In it, the artwork was not portrayed as simply the product of a great mind, but was shown to be established as art by the conventions and authority of the museum, the catalog, and its reproductions. Although juxtaposing Boltanski's work with the *Boîte en valise* could have underscored his critique of the museum, the Documenta exhibition treated personal material and reflection on the museum in separate sections, so that Boltanski's multifaceted work was only seen as subjective and private, removed from social and institutional politics, and not as addressing the critiques of the museum that other works in the exhibit were thought to convey.

It is unclear why Boltanski's work was not presented in the "museums by artists" section of the exhibition since Boltanski and Szeeman had discussed the museal aspects of Boltanski's works in the planning for the

exhibition. In a letter dated April 15, 1972, Boltanski wrote:

> Dear Szeeman,
>
> I am writing you because I want to modify a bit the presentation of my work in Kassel. I think, as you earlier suggested, that I will place the album of photography in the general context of "my practice" and that I must struggle against the notion of this piece as one with no importance. The only thing interesting for me being the life of the individual and his persistence in always repeating the same thing. I would like to take up again the idea of the Museum, putting in a room several reconstitutions in modeling clay, biscuit boxes, booklets, etc. so that the photo album installed on only one wall would appear as a repetition among those that have come before and those that will come after.[35]

Boltanski's obsession with similarity and repetition demonstrates his need to show coherence in his practice in this sort of large state-sponsored exhibition. Further, his solution was to employ museum formats such as drawers, boxes, and vitrines that created precisely this appearance of unifying traits in a museum venue. The *D. Family* photo album images, the "album of photography" that he mentions in this letter and that spanned an entire wall, seemed to present a difficulty in creating a sense of coherence because they were not presented in vitrines; he therefore feared that they would be seen as unimportant and peripheral to his oeuvre. A reproduction of the exhibition installation depicts his vitrines beneath the family album photos (see Fig. 39). In his vitrines, Boltanski created a miniature retrospective, displaying samples and miniatures of works that had been sent to critics and curators and exhibited in museums and galleries, including: a small version of a *Boîte de biscuits* (resembling those in the 1970 Templon exhibition); several knifelike *pièges* (like those from his 1970 ARC exhibition); and his mail art work *Recherche et présentation de tout ce qui reste de mon enfance 1944–1950*. The placement of the vitrine in the "museums by artists" section would have revealed how the vitrine form constituted the artist's oeuvre and even seemed to evoke his personality, underscoring Boltanski's critical investigation of the museum. Instead, its placement in the "individual mythologies" section – alongside work considered "outsider art" and made by patients with mental illnesses – demonstrates Szeeman's desire to hold onto spaces of subjectivity that were unaffected by cultural institutions.

Boltanski's institutional critique was, however, made explicit at the exhibitions in French provincial history and ethnography museums that

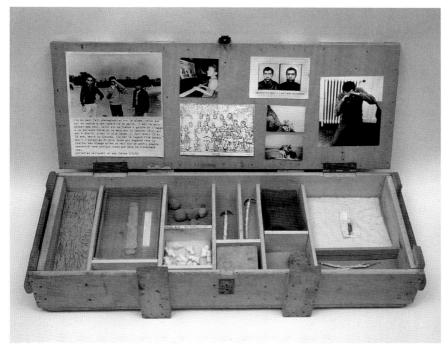

Figure 41.
Christian Boltanski, Exhibition
Traveling Crate, 1972. © 2005
Artists Rights Society (ARS),
New York/ADAGP, Paris. Photo
© Centre Georges Pompidou. Photo:
Adam Rzepka, courtesy of Christian
Boltanski.

overlapped with the Documenta 5, in which he joined with Jean Le Gac.[36] In presenting his vitrines in an art exhibition and provincial ethnography museums, Boltanski's aim was to make visible how museum modes of display shaped the interpretation of the objects. His project clearly referenced Duchamp's *Boîte en valise*: samples of Boltanski's work were sent in a traveling crate, which created a display of his work like a miniature museum (Fig. 41). The inside of the lid displayed pieces of Boltanski's mail art: *Boltanski et ses frères* (a photograph of Boltanski standing with his brothers); a family photograph which appears to have been mailed; the class picture from the *Recherche et présentation de tout ce qui reste de mon enfance 1944–1950*; two photographs of Boltanski taken three months apart, two photographs from the *D. Family* photo album, and one photograph from Boltanski's *Reconstitution des gestes* (in which he reenacted childhood memories). The lower portion of the case exhibited several of Boltanski's "traps" – thin tools with hooks and razor blades and a board with pins jutting out; balls of clay, one inside a mesh case; mini sugar-cube "sculptures"; and a partially wrapped lock of Boltanski's hair. Although little documentation exists of the provincial museum installations, the vitrines shown at the Documenta 5 displayed these same elements in addition to a miniature *Boîte de biscuits* and the letter asking for help.

Boltanski thus appears to have exhibited essentially the same materials in both the provincial museums and the Documenta 5.

Whereas in the art museum the vitrine was expected to function as a retrospective display of his oeuvre, demonstrating the themes and major characteristics of his work, in the provincial museum, organized on more ethnographic lines, the work could be seen as fragments from an individual's life and work, evaluated by standards such as function and age, which replaced authorship as the guarantee of authenticity. In the invitation to the exhibition, Boltanski and Le Gac explained:

> Our work is an effort to find in our present day the means to transmit and conserve the artistic experiment we are conducting: [a] mental journey, marked with vestiges (photos, objects, fragments of texts…) that we are trying to save from indifference and from everyday wear. It was natural that we would dream of presenting this type of activity in museums, which aim to go back in time by classifying and documenting history.
>
> It also seemed to us that the elements of our work could be viewed in an egalitarian mode, in comparison with other testimonies of human activities, and thus it was interesting to seek this comparison inside authentic museums that have the purpose of maintaining the memory of things and the motivations for their development.[37]

In the ethnographic museum, then, Boltanski and Le Gac were acutely aware of the different constructions that the institution would place on the materials that were put on display. In the ethnographic museum, the materials of personal life were made to seem representative of a culture and time. When displayed in the art museum, however, Boltanski's combinations of letters, drafts, and reproductions of works seemed to provide an ambiguously coherent view of an individual artist.

While the Documenta 5 organizers overlooked this component of Boltanski's work, at least one critic, Jean Clair, saw the simultaneous staging of the work in the "individual mythologies" exhibit and the ethnographic museum to be a critical commentary. Clair was one of the team of six curators who organized the concurrent Expo '72 in France and was also the editor of the influential contemporary art journal *Chroniques de l'art vivant*. In "Du *Musée imaginaire* à l'imaginaire muséal" Clair saw the placement of Boltanski's and Le Gac's work in the "individual mythologies" section of the Documenta 5 as part of an "art history without names" (an art history without individual artist-creators) and explored the artwork's questioning of the construction of artistic identity:

Forms, entities, visual signs are arranged here in an order that excludes the intervention of the singular individual, the signatory artist.... Formerly the organizing principle of a certain [artistic] process, origin and unifier of [the artwork's] meaning, source of coherence, recognized and showered with praise as such, [the] individual distinguished from the mass of non-artists, unique "author" of the singular work...His personal intentions, which seem so particular and irreducible, are nonetheless abolished within the profusion of similar projects by children, the mentally ill, naïve painters, mystics....Boltanski's traps come close to the tools indefinitely repeated by a psychotic...Le Gac's texts and photos are mixed up with the inscriptions and nomenclatures of A.S.[38]

In Clair's view, the Documenta 5 juxtaposed artworks with naive objects made by untrained children and the mentally ill to remove the artist from his privileged position at the top of the aesthetic hierarchy. Furthermore, this juxtaposition challenged the idea of the authority of the artist that was traditionally taken to endow the work with meaning. Clair looked elsewhere for the works' significance, but to no avail:

But what code can be applied to "artistic" work to decipher its meaning? The ambiguity is the same as that which resulted from exhibiting the works of Le Gac and Boltanski, as was recently done, in an ethnographic museum or a museum of science and technology. Such places are linked to a certain form of culture.... [It is] as if the role of the museum were to transmit that abstract culture, general, and absolute, which poses knowledge as an entity with no complement: a pure intransitivity. If visiting the Musée de l'Homme teaches me something indefinite, it is sure that seeing the works of Boltanski or Le Gac in the same museum teaches me definitively nothing.[39]

Although his intentionally abstract terminology remains obscure, I think at least the central point would have been clear: the ethnographic museum provided a tangible representation of how ethnographic knowledge was organized, and by emulating the forms of the museum, Boltanski's work suggested that ethnographic knowledge would be conveyed. The ethnographic museum could successfully frame factual material, but when Boltanski's personal material was presented in the same format, it was empty of meaning, "as if at the threshold of knowledge, [it] only affirms the desire for that knowledge: the hollow form of the lure."[40] Whereas the ethnographic museum suggested that value and significance were inherent in the objects and the museum was a transparent means

Figure 42.
Christian Boltanski in front of his installation at the Documenta 5 exhibition, Kassel, 1972. © 2005 Artists Rights Society (ARS), New York/ADAGP, Paris. Photo © André Morain.

of communicating their content, Boltanski tested the limits of these structures: he used private material that could not be interpreted within that kind of framework. Although ethnographic museums may have attempted to portray collective culture, Boltanski blocked the museum's form of communication and showed that the personal content of the materials was lost.

In this reading, Clair saw Boltanski's exhibits in the Documenta 5 and in provincial museums as dismantling the authority of the artist and the status of the artwork in the museum. Clair, however, was essentially alone among the critics of the time to have noted the critical strands in Boltanski's project.[41] Further, the power of Boltanski's work to frustrate the viewer – to suggest content would be conveyed and yet deny fulfillment – was an ongoing theme that was also explored in his *Album de photos de la Famille D., 1939–1964*, although here, too, this strategy was apparently not recognized by critics.

As opposed to the implied "subjectivity" of the vitrines when situated in the "individual mythologies" section of the Documenta 5, and the criticism they were perceived to express when shown in the ethnographic museum, Hans Hein Holz's Documenta catalog essay renders the *D. Family* photo album much more universal and uncritical (Figs. 42–3). In "Kritische Theorie des ästhetischen Zeichens," Holz argued that photographs of family rituals and events, like those in

Figure 43. Christian Boltanski, *Vitrines de référence*, 1971, and *L'Album de photos de la Famille D., 1939–1964*, 1971. Installation at the Documenta 5 exhibition, Kassel, 1972. © 2005 Artists Rights Society (ARS), New York/ADAGP, Paris. Photo © André Morain.

Boltanski's *Album de photos de la Famille D., 1939–1964*, provided a new language for expressing private experience. In fact, Holz assumed that people's experiences and photographs were similar enough that they could identify with the depicted activities and project their own experiences into the photos.[42] Boltanski's statement on the *D. Family* album, which was reprinted in the Documenta 5 catalog, seemed to reinforce this idea:

> In July of '71, I asked one of my friends, Michael D…to entrust me with the photo album his parents possessed. I who knew nothing about them, wanted to try to reconstitute their life by using these images which, taken at all the important moments, would remain after their death as proof of their existence. I could discover the order in which the photographs had been taken and the relations that existed between the persons represented in them. But I realized that I could go no further, because these documents appeared to belong to the memories common to any family, that each person could recognize himself in these vacation or birthday photographs. These photographs did not teach me anything about the *D. Family*…, they returned me to my own memories.[43]

The *D. Family* album, therefore, appeared to enable the individual viewer to recall personal memories while gesturing toward a collective experience. It is this rhetoric, which emphasized the universal appeal of Boltanski's work rather than the privacy emphasized in the "individual mythologies," that would make the *D. Family* album famous and that would set the terms for Boltanski's critical reception in the decades that followed. The appeal of this for museums lay in the way it seemed to respond to the demands of 1968, pointing the way for museums to negotiate between individual and collective experience.

Boltanski's explanations of the way the *D. Family* photographs worked resembled ideas from *Photography: A Middle-Brow Art*, a 1965 text on which his brother Luc Boltanski collaborated with Pierre Bourdieu, but with the key difference that Christian Boltanski's approach ignored their primary emphasis, the role of class difference in photography.[44] Christian Boltanski's statement suggested that the family album was universally accessible to viewers. Bourdieu, however, argued that family photos manifested class rivalry and the struggle for distinction. The ordinary photos of each social class represented its own rituals and values, expressing the aesthetics of what Bourdieu termed the *habitus* – the values and tastes that had been internalized by the taker as a member of a certain social class. Because photographs captured subjects and behaviors that were socially established, the photography in family albums was stereotyped, showing the same kinds of people, objects and places; the particular choice of subjects and manner in which they were represented, however, would only seem appropriate to members of the same social class.

Bourdieu further contended that ordinary photography was a private production for private use: it expressed the relationship between the photographer and the object or person photographed and had no intentions of universality. In family photographs, persons were photographed in terms of their roles within the family so that the image signified generational succession and reinforced the group's sense of unity. The person in the image was thus reduced to a pure sign, and the viewer needed to have enough knowledge of family history to be able to decode it.

Bourdieu described how family albums were used for creating social memory and integrating new members into the family:

> The family album expresses the essence of social memory. There is nothing more unlike the introspective "search for lost time" than those displays of family photographs with their commentaries, the ritual of integration that the family makes its new members undergo. The

images…evoke and communicate memory of events which deserve to be preserved because the group sees a factor of unification in the monuments of its past unity or – which amounts to the same thing – because it draws confirmation of its present unity through moments of its past; this is why there is nothing more decent, reassuring, and edifying than a family album; all the unique experiences that give the individual memory the particularity of a secret are banished from it, and the common past, or, perhaps, the highest common denominator of the past, has all the clarity of a faithfully visited gravestone. Because while seeming to evoke the past, photography actually exorcises it by calling it such, it fulfills the normalizing function that society confers on funeral rites, namely at once recalling the memory of the departed and the memory of their passing, recalling that they lived, and that they are dead and buried and that they continue on in the living. Like the *churinga*, those objects of decorated wood or stone that represent the physical body of a particular ancestor which, amongst the Aranda, each generation solemnly presents to the living person held to be the reincarnation of that ancestor, and which are periodically brought out for inspection and reverence, family photographs which are handed down from generation to generation constitute the generally accessible substitute for this capital of precious goods, family archives, family jewels and family portraits, which owe their sacred character to the fact that by physically attesting to the great age and continuity of the line they consecrate its social identity, always inseparable from permanence over time.[45]

While Bourdieu argued that family photos were only interesting to viewers who were sufficiently steeped in family history to be able to decipher them, Holz believed that the images could speak to all viewers, providing them with a language for making sense of everyday family history. But neither of these views fully encompasses the experience of viewing the *D. Family* pictures when displayed anonymously on the wall of a museum. Scanning across the rows of images we can discern events, such as a bride and groom at their wedding altar and vacation trips to the beach (Figs. 42–5). But the majority of the photographs show family members standing in static poses or seated at a table for a meal. We can see that the characters are smiling and laughing, but do not know why, because we do not know the event the photo was taken to depict and that would give the photograph its meaning. The family photographs do not create the familial bonds Bourdieu described, because we cannot access the story of the common past that they represent.

Figure 44.
Christian Boltanski, *L'Album de photos de la Famille D., 1939–1964* (detail), 1971. © 2005 Artists Rights Society (ARS), New York/ADAGP, Paris. Collection of the FRAC Rhône-Alpes, housed at the Musée d'Art Moderne, Saint-Etienne. Photo courtesy of Christian Boltanski.

Figure 45.
Christian Boltanski, *L'Album de photos de la Famille D., 1939–1964* (detail), 1971. © 2005 Artists Rights Society (ARS), New York/ADAGP, Paris. Collection of the FRAC Rhône-Alpes, housed at the Musée d'Art Moderne, Saint-Etienne. Photo courtesy of Christian Boltanski.

Figure 46.
Christian Boltanski, *L'Album de photos de la Famille D., 1939–1964* (detail), 1971. © 2005 Artists Rights Society (ARS), New York/ADAGP, Paris. Collection of the FRAC Rhône-Alpes, housed at the Musée d'Art Moderne, Saint-Etienne. Photo courtesy of Christian Boltanski.

Without the oral history that usually accompanies family photos, the pictures are opaque. The images do not tell about subjects' personal lives, they merely show details: this family visited their relatives and went to the beach for their holidays (Figs. 46–7). Rather than conveying some kind of personal experience, the images merely provide descriptive information with an aura of truth, creating a feeling of nostalgia that is devoid of direct content. The subjects of the photographs – activities such as holiday boating trips – as well as the frequency with which the photographs were taken, reveal that the family belonged to the middle class.[46] At the same time, however, images were selected with few specifics of time or place and details were cropped out of the pictures, eliminating many of the particularities of this family's history so that it might appear more similar to other families' photographs and encourage viewers' identification. Furthermore, the photographs in the exhibition were not displayed as they would be in a family album, which usually follows a chronology and includes individual labels for the pictures. Here, the uniform size and framing, as well as the absence of captions and jumbled chronology, equalize the significance of each element and draw attention to the way subjects repeat, so that the depicted lives become combinations of ritual events, such as birthdays, vacations, and picnics. We can identify familiar subjects and events, yet we can never recuperate the personal memories

that presumably once were associated with the photographs. Although Boltanski's statement on the project was taken to reinforce the idea of universal identification with the photos, I would argue that it also evokes the inevitable limitations on the viewer. As Boltanski put it, "These photographs did not teach me anything about the *D. Family*..., they returned me to my own memories." Boltanski's statement suggests the way the audience is frustrated by the photographs: we can never inhabit or possess others' memories as represented by the photographs, we can only use them as a point of return to our own past.

The series of photographs was likely to produce conflicting responses. On the one hand, the unfamiliarity of the individuals makes them seem anonymous, distant, even boringly stereotypical and repetitive. On the other, because a visual narration can be traced, with the characters growing up over time, the viewer is likely to experience a strong sense of nostalgia and identification. Photos show two brothers visiting their grandfather and playing on the beach when they are young, returning to their grandfather's home on vacations, and visiting him again as young men (Figs. 46–7). The viewer may feel mixed emotions about the passage of time when he sees images of people's lives laid out across a wall, feeling both the happiness of the events and sadness that they are gone. Encountering ritualized occasions that he may expect to experience but that have already passed for this family may suggest to him that in the future his own history might similarly be regarded as a series of frozen moments of inexplicable or lost detail. Because he cannot access the meaning of the photographs, he may try to create meanings or to project his own.

In view of this account, the *D. Family* images point to the limitations of Bourdieu's model, for they could solicit a cross-class identification that he would have argued against. Although the images did not fulfill the expected function of telling about the family's history, their very inability to disclose this history could entice viewers of all social strata to project meanings into them, forming sentimental, nostalgic attachments with images of a middle-class past. Nostalgia was the medium through which a new collective identification could become possible. In the museum, the middle-class family history in photographs took on the status of patrimony – and beckoned the viewer to participate in it. Just as for Bourdieu the photos served to integrate individuals into the family when displayed in the home, so they were to integrate individuals into the patrimony when displayed in the museum, offering the viewer, through the process of identifying with them, the opportunity to participate in collective culture. The viewer of the *D. Family* photos was thus encouraged to orient his personal history through the terms of the one he saw,

Figure 47.
Christian Boltanski, *L'Album de photos de la Famille D., 1939–1964* (detail), 1971. © 2005 Artists Rights Society (ARS), New York/ADAGP, Paris. Collection of the FRAC Rhône-Alpes, housed at the Musée d'Art Moderne, Saint-Etienne. Photo courtesy of Christian Boltanski.

projecting his memories into the photos and desiring a past like this, thereby making an ambiguous middle class a new point of collective identification. His identification with the photos, however, was not necessarily based on what they represented or on his actual commonality of experience, but largely depended upon an imaginary projection into the photographs, facilitated by the exemplary status accorded to the work by its representation within a museum.

Holz, however, did not address the tenuousness of the viewer's identification and of the supposed collectivity the images represented. By asserting that viewers understood and identified with family photographs, he not only suggested that there was a public for this new art, but also avoided addressing the more politically sensitive issues of the form, meaning, content, or class specificity of the work. Given this context, it is no surprise that the idea of individual response and universality, popularized at the Documenta 5, became the dominant interpretation of Boltanski's work and promoted his appeal for both museums and audiences as well.

REINVENTING THE MUSEUM: THE EXPO '72

Concurrently with the Documenta 5, Boltanski displayed his *Vitrines* in the Expo '72 in Paris, the first major state-sponsored exhibition of contemporary art to be held in France following '68. This exhibit was

curated in part by Jean Clair, who had advanced some of the most perceptive interpretations of Boltanski's critique of the museum – particularly in his essay on Boltanski's display of the *Vitrines* in the Documenta 5 and French provincial museums. However, in his catalog essay and book for the Expo '72, Clair advanced a nearly opposite interpretation. He asserted that Boltanski's works successfully recaptured personal memories and expressed the subjectivity of the artist demonstrating the continued vitality of these concepts for the museum. What could account for this sharp critical turn in Clair's work? In the space remaining, I will investigate Clair's writing on the Expo '72 in order to bring out the political pressures on curators to rebuild the museum in France and the ways this pressure shaped what could and could not be seen in Boltanski's work.

The concept for the exhibition *Expo '72, 12 Ans d'art contemporain en France* came from President Pompidou: a survey of the French avant-garde from 1960 to 1972. Prior to this, French museum exhibitions of contemporary art had been oriented toward art from the World War II period, such as works by Picasso and Dubuffet, whereas the contemporary art market increasingly gravitated toward American Pop Art and Minimalism.[47] Several critics and curators from the national art collections were appointed to the organizational committee: François Mathey, Jean Clair, Daniel Cordier, Maurice Eschapasse, Serge Lemoine, and Alfred Pacquement. They selected approximately seventy-two artists for the exhibition, and this list was then submitted to the president for his approval. Soon after the plans for the Expo '72 were underway, the government decided that this team of curators and administrators would thereafter oversee a permanent contemporary art center and collection, which was eventually dedicated in 1977 as the Pompidou Center. In 1972, faced with the task of organizing a major retrospective of recent art and eventually a new museum, the curators had to plan for new cultural policies and practices in France, and they could not avoid addressing the protests launched by artists against the museum in 1968 and its aftermath.

The curators' stated aim for the exhibition was to present the most representative trends and artists from the last twelve years. They used broad, thematic concepts to organize the artists' work, such as: "kinetic art and Op Art" (which featured GRAV, Jesús Rafaël Soto, and Pol Bury, for example); "monochrome painting and *nouveau réalisme*" (Jean Degottex, Yves Klein, and Niki de Saint-Phalle); "the *affichistes*" (François Dufrêne, Raymond Hains, and Jacques de la Villeglé); "nature and technology" (César and Jean Tinguely); "the individuality of the artist"

(Christian Boltanski, Jean Le Gac, and Ben Vautier); "the relation of the canvas to its support" (Simon Hantaï and Claude Viallat); and "photo-realism and political figuration" (Jacques Monory, Gérard Gasiorowski, the Malassis, and Erró).[48]

Many artists, however, believed that the Expo '72 marked a return to the systems they had opposed in 1968: a selection process in which they had no voice, the construction of a hierarchy based on traditional notions of talent, the co-option of artists in the service of those in power, and the display of work in a traditional art exhibition format, focused on unique objects created by individuals. There was a huge outcry among artists and critics, with many groups such as the activist Front des Artistes Plasticiens (FAP) and the artists associated with the Salon de la Jeune Peinture, as well as independent artists and writers such as Daniel Buren, Bernard Borgeaud, Gilles Aillaud, Michel Journiac, and Gina Pane, denouncing the exhibition.[49] Many artists feared this attempt to organize art in the service of the power embodied by the president. As discussed in the previous chapter, in 1968 artists and students organized sit-ins to attempt to take the control of universities, art schools, and exhibition spaces away from state administration. In 1972, many artists' groups saw the state bureaucracy re-asserting its control over art world affairs and using art to mask the political functioning of the state.

On May 16, the day before the exhibition was to open, police were dispatched to control the crowds of protesters who had gathered out front. The Malassis, a group of painters known for their political iconography, removed their paintings from the exhibition and used them to repel the police (Fig. 48). The intervention of the police seemed to confirm the feeling that the government was trying to control artistic expression and raised the question of why the state was trying to organize the avant-garde and should have such an investment in protecting it, while suppressing oppositional voices.[50] This exhibition created a rift in the artistic community between those who participated and those who did not. Although many artists expressed ambivalence about participating in the state show, they were also frustrated by the lack of other possible venues in which to exhibit their works.

Boltanski did not voice his opinions in these debates but instead sought to find ways of displaying his work critically within the exhibition. He presented several *Vitrines de référence* that displayed earlier works; a set of three drawers with reconstitutions of objects from his childhood; and *Les 62 Membres du Club Mickey en 1955*, a collection of photos of child members of the Mickey Mouse Club sent to a fan magazine.[51] Jean Clair, one of the curators, discussed Boltanski's work in the exhibition

catalog as well as in *Art en France: Une Nouvelle Génération*, his influential book on the state of contemporary art in France. Clair focused on the *Recherche et présentation*, the *Vitrines*, and a work, curiously, that was never shown at the Expo '72, the *Album de photos de la Famille D*. In contrast to his writing on the Documenta 5, here Clair promoted a more traditional view of the artist's subjectivity and the representation of the past that seemed to partake of a new Romanticism.

In *Art en France: Une Nouvelle Génération*, Clair explained that the central problems that contemporary artists faced were finding ways to express the self and to retrieve the past. It was particularly difficult to access and represent the singularity of one's experiences when they were perpetually suppressed by systems of representation, languages, signs, and codes:

> because all language, whether verbal, musical, plastic, choreographic, etc. uses a certain repertory of coded signs (words, sounds, colors, steps, etc.) whose nature is arbitrary, using such languages for expressive ends is to exclude the singularity of that which we wish to convey: it is to intertwine the particularity of one's intentions with the abstract generality of language.[52]

He considered how photography – which was taken to be a document, trace, or an authentic image – served as a representation of the past. Interweaving the theories of Marcel Proust, Maurice Blanchot, Jacques Lacan, and André Bazin, Clair explained that when one looked at a photograph of a person he felt a twinge of death, because he would see the represented person frozen in the photo. The subject would not only seem immobile and lifeless, but the appearance captured in the photo would also show that time had passed.[53] The link between signification and being was figured as metonymy: what was represented and desired was never there; one could have a realistic image of a loved one, but not the person himself.[54] Because one could not really preserve a personal past with photographs or other representations, the problem then became how to remember or recall personal memories.

Clair praised Boltanski's work because he believed it found a way to address this problem and to retrieve the past and memory, focusing particularly on Boltanski's *Recherche et présentation de tout ce qui reste de mon enfance 1944–1950*, the notebook in which he had supposedly documented objects from his early childhood. In speaking of the photographs and texts Boltanski collected to represent his life, Clair claimed that the dates that accompanied the photos contradicted one another and the characters in the photographs were never the same from one image

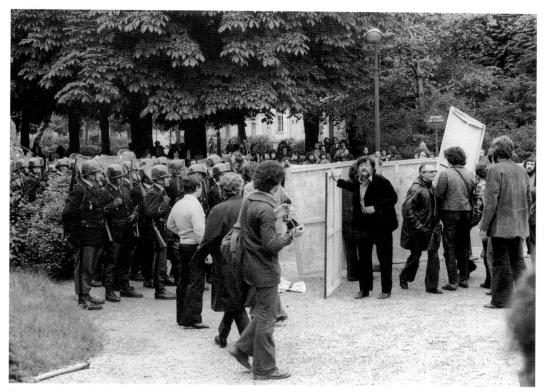

Figure 48. Protests and police intervention at the *Expo '72, 12 Ans d'art contemporain en France*, 1972. © André Morain.

to the next. Clair argued that the images were bits from others' lives and that "Christian Boltanski" was a mythic personality that the artist had created that could refer to anyone. By systematically combining the information he presented in his work, Boltanski caused his own personality to disappear: "the singular 'I' of a chronicle is substituted with the impersonal 'he' of history."[55]

Clair also quoted Boltanski's statement that accompanied the exhibition of the *D. Family* album in the Documenta 5: "These photographs did not teach me anything about the *D. Family* . . . , they returned me to my own memories," yet he read the statement in a different way. If Boltanski's reconstitution of "personal" memories showed us an anonymous identity, then by reconstituting others' memories (those of the *D. Family*) Boltanski expressed himself: "the reconstitution of others' memories brings back the personal subjectivity of the one who creates it, brings forth the 'I' we thought was lost."[56] Clair explained that Proust had analyzed this contradiction: when we look at others, more than seeing them, we project our notions about them, and thus reflect ourselves.

Although he claimed that Boltanski had projected himself into the photographs, Clair did not address whether the viewer was also prompted to do so. Moreover, Clair suggested that one could not invent a new artistic language that would escape systems of signs and symbols, but Boltanski had found a process for the artist to reveal himself through such systems, using the museum to probe deeper into his own artistic subjectivity.

In "Une Avant-garde clandestine," written during the show, Clair saw this work as emblematic of a "new Romanticism," a cult of the individual. Here he reiterated the themes from the catalog and obliquely responded to the political controversy surrounding the exhibition. Clair highlighted leading contemporary French artists, Boltanski among them, as a new "clandestine avant-garde."[57] He explained that all of these artists' works manifested the essential trait of secretiveness: Annette Messager's and Christian Boltanski's reconstitutions of past events and gestures, Jean Le Gac's photographs and texts illustrating "Joycian epiphanies," Jacques Monory's blue memory paintings, Gérard Gasiorowski's Proustian recollections, and Jean-Marie Bertholin's objects relating to personal life events. Contrary to usual notions of the avant-garde, he argued, their practice exhibited the following traits: 1) a quest for the subjective expression of the individual: "the absence of all political and ideological commitment... instead, the cult of the individual, the me, the singular... a new Romanticism... [that is] cold and distanced... but nonetheless containing the values of Romanticism: the search for the unique, a cult of memory and emotion..." and 2) a link with French patrimony, the museum: "an unexpected relation to cultural patrimony, expressed as a fascination with the museum, library, and archive, apparently in extreme opposition to the vandalism and iconoclasm so dear to a certain counter culture." He saw this practice "deeply linked to a certain French cultural reality, to a certain patrimony, a certain configuration of knowledge in France, which is dominated by the archive, the library, and the museum... it is not in the least an international current and remains without equal in Germany or in the U.S.A."[58]

Written during the Expo '72 that Clair had helped to curate, the statement was obviously politically motivated and made several important claims. Given the controversy surrounding the exhibition, it was important for him to show that Boltanski's use of personal forms of preserving memory was subjective, private, and correspondingly, apolitical. Clair grouped the artists together, even though they did not consider themselves as a movement, and argued that their common characteristics, linked to the French cultural tradition, created a distinctly French art, suggesting a new national school and a nationally sponsored avant-garde.

Further, Clair's reference to vandalism and iconoclasm brought up the specter of 1789 and the commune, and showed that, once again, in the wake of a French political uprising, the status and place of the art museum had come to the fore. (The basis of the French national museum in preservation was unthinkable without the history of vandalism associated with revolutions. The Louvre had been established, among other things, to preserve patrimony over and against destruction.) Although Clair concurrently saw Boltanski's use of vitrines as a critical investigation of the museum in the Documenta 5 and ethnographic museum exhibitions, here he argued for what he took to be this artistic generation's attachment to the museum and patrimony in order to help resuscitate the importance of state culture after 1968. Clair's texts, written during his curatorship of the Expo '72, addressed the fundamental issues with which the administrative team had been struggling: how to come up with a new state policy for the museum, following upon 1968's rejection of previous attempts to democratize art. The demonstrations and boycotts surrounding the Expo '72, however, are testimony to the failure of Clair's sense that this new Romanticism had provided a way to re-imagine traditional museum concepts, such as the artist's individuality and genius.

Another reason that the Expo '72 failed to satisfy protesters' demands was that it focused on artists who had largely exhibited at or were affiliated with prominent galleries; in this respect especially, it would reveal itself to be far from the revolutionary artists' politics of 1968. Gallery exhibitions, press releases, and critical reception had generated enough visibility that the artists selected for the show were already somewhat familiar on the Parisian scene. Yet the state of the French art market in the late 1960s and early 1970s had been generally quite depressed, and while galleries did provide a means for artists to show recent work, these opportunities tended to be few and far between and usually favored artists who were more established. The availability of gallery space was also limited by the art market's increasing tendency to favor American work over contemporary art produced in France. Despite this unpromising state of affairs, artists had mixed feelings about the Expo '72, which provided increased publicity for artists' work and thereby energized the market for contemporary art. Whereas in 1968, some activists had proposed grants and scholarships from the state as a possible alternative to the market, in 1972 it was actually the state that redirected and helped to invigorate a market for contemporary French art. Before 1972, the major state apparatus for supporting contemporary art was the FNAC, or Fonds National d'Art Contemporain, which had funds for purchasing, but not exhibiting, contemporary art. Boltanski's own archival records of

his work show that he had sold nothing related to his collaborative work in alternative venues from 1968 to 1971. The rapid increase in the value of Boltanski's art and the unprecedented demand for his work during and directly following the Expo '72 and the Documenta 5, however, demonstrated how the museum presentation of Boltanski's work was instrumental in its promotion. Only a few pieces that he had shown in gallery and museum exhibitions prior to 1972 had sold. Some of the *Boîtes de biscuits* were purchased by Templon and two were purchased by the Fonds National d'Art Contemporain in 1971. The Fonds National d'Art Contemporain also purchased three of his *Essais de reconstitution* in modeling clay in 1971. Sonnabend bought four of Boltanski's *Vitrines de pièges*, which had been shown at the Musée Municipal d'Art Moderne in 1970, and also purchased his *Sucres taillés* in 1971. In contrast, two *Vitrines de référence* shown at the Expo '72 were purchased by private Paris collectors during the exhibition; another three *Vitrines de référence* and *Les 62 Membres du Club Mickey en 1955* were purchased by Sonnabend, presumably during or directly following their exhibition at the Expo '72. Several of Boltanski's works presented at the Documenta 5 were purchased by the German collector Peter Ludwig. Whereas previously the state had, with the intermediary of the FNAC, assisted Boltanski through the purchase of several individual works, it was the promotion and validation of the Expo '72 and Documenta 5 that made his work saleable to major international dealers, curators, and collectors. As plans for the Pompidou Center progressed, the state organization of culture continued to aid the market for French artists' work. Rather than giving artists grants so that they could continue to work, as some had hoped in 1968, the government purchased works from artists and their galleries to display in state-sponsored exhibitions, thus providing publicity and increasing the market for certain types of contemporary art in France.

As plans for the Pompidou Center were developed and enacted in the years following the Expo '72, Boltanski's work continued to experience critical and curatorial favor. Following the negative reactions to the Expo '72, many French curators came to emphasize a different aspect of his work, drawing on the interpretation of the *D. Family* photo album that was popularized by the Documenta 5. In 1976, the year before the Pompidou Center opened, Boltanski's work was displayed in a traveling group exhibition that was organized within a newly forming network of contemporary art institutions in France. In a highly publicized interview, which was reprinted in the catalog, Boltanski took up the rhetoric that had made the *Album de photos de la Famille D.* famous and linked it to his ongoing photographic projects:

I never tried to speak about myself, or to tell about my own memories of childhood. I always wanted to tell stories that are common to all.

When I exhibited a photographic album, I realized that in fact we all have the same photographs, that these albums were catalogs of family rituals, such as marriage, vacation, first communion, and their function was to reinforce family cohesion. The spectators recognized themselves in these photographs, saying "I was at that beach"; or "that looks like my uncle"; or "me too, I had a white outfit like that when I was young…."

My goal is to show a person a mirror in which he could see himself and in which I could recognize myself too, if I looked at myself. Each person would make out his own image and the one holding the mirror would no longer exist.…

Everyone has made a photograph or could make one, it is a medium that is known and accessible to all. In this series of images titled photographs, what interested me was to show images that are generally considered beautiful, that everyone, more or less, has taken, or wishes to take.[59]

Thus French art institutions and Boltanski himself continued to promote the themes originating in 1972: Boltanski was an artist who effaced his individuality so that others could identify with his work, and the family album was the basis for a new, broadly accessible and democratic point of collective identity.[60] Even though Boltanski was aware that his work offered this possibility for viewers' identification and was willing to promote it, the images themselves continued to work against the statements he used to frame them.[61] By limiting the amount of personal information the images conveyed, and thereby permitting only a partial, largely fictional identification on the part of the viewer, Boltanski's photographs ultimately frustrated the use to which curators attempted to put them.

Despite this, the possibilities for identification that Boltanski's photographs and memorabilia seemed to promise provided curators with a means to respond to activists' demands for an inclusive, accessible form of art that would reach out to new audiences. However, the curators' interpretation of Boltanski's photographs – ordinary images in which viewers could see their own lives reflected – would only appear to realize the aims of those who saw art that emerged from popular practices as the form that spoke to the broadest possible audience. Moreover, the curators' assertion that the work represented the collective implied that the work could represent national identity. This interpretation constructed the viewer's

process of identifying with Boltanski's work as an apolitical negotiation of an individual within the national collective. Furthermore, the argument that the meaning of the work remained in the familial sphere – that the work triggered the viewer's memories of his own past and that he had thus an individual and unique response – could make the work appear to be outside politics, ideology, or class struggle. Whereas in 1968, revolutionaries had widely rejected the museum as patrimony and as the preservation of a history that was the domain of the elite, by 1972, Boltanski's work was imagined by museum curators to take the place of elitist history, with photographs of personal memories and everyday life replacing the fine-art objects that Malraux had once sought to democratize through photography. Because Boltanski's photographs and memorabilia seemed to respond to the democratizing aims of '68 and simultaneously reinforced state cultural goals, it appeared to be the ideal artwork for reconstructing museums in France. The history tracked through the opening sections of this chapter – the political aspirations indicated by Boltanski's adoption of alternative venues and media, his challenges to authorial identity, and his ethnographically based critiques of art museums' strategies of display and legitimization – all this was to be soon lost from view as museums' interpretations gained prominence.

4 ANNETTE MESSAGER'S IMAGES OF THE EVERYDAY

THE FEMINIST RECASTING OF '68

From 1971 to 1974, Annette Messager created over one hundred notebooks and collection albums in which she pretended to document her daily life.[1] Inside the notebooks, which constituted her first major series, Messager claimed to describe her daily activities and chores, such as caring for children, cooking, shopping, and knitting. She drew diagrams with pen and ink and colored pencils, sometimes pasting in clippings from magazines that she labeled in pen (Figs. 49–50). Beginning in 1973, Messager exhibited her notebooks in horizontal display cases or hung their individual pages on walls of museums.

Her works employed practices similar to those in the work of her colleague and partner Christian Boltanski, such as collections of photographs and ordinary objects. Both artists seemed to make use of fragments of personal, everyday materials in constructing their work, images and forms for preserving memories (including notebooks, scrapbooks, and family photo albums), and displayed their works in comparable manners, mounting series of small images on museums' walls and displaying objects in the sort of vitrines typically encountered in ethnographic museums. These affinities were noted by critics as early as 1972, and the artists' work was often shown together and described in similar terms.[2] But the critics who highlighted the similarities of their work frequently overlooked the different meanings of the everyday materials and subjects displayed by the artists. In this chapter, I concentrate on a moment in the early 1970s in which museums attempted to incorporate everyday subjects as a response to the challenge of 1968 to broaden their approaches and audiences. However, as curators tried to use artists' images of everyday, personal experience to remake the museum, the previously unrepresented experiences depicted in these works posed new challenges. In particular, women artists influenced by contemporary feminist debates sought to broaden the politics of the everyday beyond the way it was conceived in '68, recognizing the ways that the everyday was fertile ground for social transformation but also a terrain with particular difficulties for women. Messager's work from the early to mid-1970s shows the ways that depictions of women's everyday experience created continued friction with museums' efforts to use the everyday as a means of universal appeal to consolidate a national audience. Tracing

her career through these years demonstrates both the promise and limitations that the representation of everyday experience had for women artists, audiences, and for the museum itself.

THE POLITICS OF EVERYDAY LIFE POST-1968

> Everyday life weighs heaviest on women.... Some are bogged down by its peculiar cloying substance, others escape into make-believe, close their eyes to their surroundings, to the bog into which they are sinking and simply ignore it; they have their substitutes and they are substitutes; they complain – about men, the human condition, life, God, and the gods – but they are always beside the point; they are the subject of everyday life and its victims or objects and substitutes (beauty, femininity, fashion, etc.) and it is at their cost that substitutions thrive. Likewise they are both buyers and consumers of commodities and symbols for commodities (in advertisements, as nudes and smiles). Because of their ambiguous position in everyday life – which is specifically part of everyday life and modernity – they are incapable of understanding it.[3]
>
> Henri Lefebvre, *Everyday Life in the Modern World* (1968)

The notion that everyday life contained a revolutionary potential took on a privileged position in French political discourse of 1968. Although the idea of revolution evoked past associations of the French people rising up to overthrow the government, the revolution of everyday life was to be a different breed: accomplished without violence or military action, but rather through creative action or political activism undertaken by a collective. In contrast to one kind of Marxist model, which had viewed social revolution as originating in the sites of work and the social relations implicated in them, the everyday model of revolution was to widen the field of sites of social change, seeing revolutionary potential in the most basic lived relationships of the workplace, street, and home.

As discussed in Chapter 2, this enthusiasm for the everyday in 1968 led to visions of transforming the art world by breaking down the barrier between museums and everyday life. In strategies that ranged from staging events, to producing posters for the streets, to reconsidering the ordinary objects of ethnography, art world activists and theorists sought to conceive art anew, bringing it out of the confines of the art museum and seeing it in hitherto unrecognized objects and practices. For some of these activists, these practices had an expansive intent, rupturing the elitist tradition of the art museum in favor of working-class traditions and nonwestern perspectives. But other, more idealistic activists saw the

Figure 49.
Annette Messager, *Cahiers* and *Albums collections*, 1971–74. © 2005 Artists Rights Society (ARS), New York/ADAGP, Paris. Photo courtesy of Annette Messager.

Figure 50.
Annette Messager, *Cahiers* and *Albums collections*, 1971–74. © 2005 Artists Rights Society (ARS), New York/ADAGP, Paris. Photo courtesy of Annette Messager.

everyday as transcending divisions, such as class and race; in their view, the spontaneous activities in the streets, the posters, and the happenings would speak to all who encountered them equally, uniting and transforming the entire community in a spirit of festival.

In this utopian vision of unleashing individual creativity in a spirit of play and festivity, activists were influenced by Henri Lefebvre's theory of

the politics of the everyday, but notably overlooked some of its complexity. For Lefebvre, the everyday was the zone in which the contradictions caused by bureaucracy and consumption – whose routines had transformed people into passive consumers – were lived, experienced, and could therefore be grasped and overcome. But Lefebvre perceived that these contradictions and routines were lived and experienced unevenly. In particular, women, in Lefebvre's view, as they fulfilled traditional roles, were so immersed in the everyday – as the main consumers of advertising and products and as the primary material for the publicity of consumer culture – that they could not recognize the broader patterns that bound them to their everyday roles. For Lefebvre, the revolution of the everyday was one in which women played little part.

Yet women were more able than Lefebvre acknowledged to recognize the contradictions and institutions that structured their everyday life. In the early 1970s, a new French feminist movement, the *Mouvement de Libération des Femmes* (MLF), began to explore women's everyday life, finding in their daily routines of domestic labor and childcare grounds for dissatisfaction and political mobilization. In part, this newfound awareness grew out of their discontent with what they saw as the incomplete nature of the revolutionary activity of 1968, in which male activists had relegated them to traditional roles and neglected their specific needs.[4] Even though female activists had a range of activities in '68 – participating in political groups, trade unions, strikes, and sit-ins – revolutionary labor tended to be divided by gender, with women taking the positions of cooks, secretaries, and childcare providers.[5] A poem titled "Where are the women?" written in 1970 as people were taking stock of the unfulfilled aspirations of '68, interrogated this division of revolutionary labor in 1968:

> where are the women
> while you remake the world to your own model?
> a red world, a black world
> in the evening around the table?
> they are cooking,
> laying the table
> putting food on the table
> filling the plates
> while you remake the world to fit yourselves.[6]

This stanza's references to the red world and black world evoke the red and black flags of communism and anarchism that were frequently

carried by activists in the 1968 protests. Despite the claims of these groups that they would remake the world, the home front remained decidedly familiar.

The response of women in the *Mouvement de Libération des Femmes* to their recognition of the burdens of the everyday was twofold.[7] For some, finding a way to escape the everyday rituals that perpetuated traditionally feminine roles seemed necessary for emancipation. As they shunned their everyday routines, such as applying makeup and doing housework, the everyday became a site where these women could enact personal and political transformation. For other feminists, the opportunities for political transformation in the everyday came from acknowledging exactly those kinds of routines and rituals as sites of work and creativity that had not previously been recognized. In other words, the everyday was seen by feminists at the time as fertile ground for politics, but as a particularly complicated site, one with transformative possibilities but that also perpetuated oppression.

The reception of the documentation of the everyday in Messager's notebooks has followed two main perspectives. On the one hand, French feminist critics have viewed her notebooks in light of feminist debates on the everyday, seeing them as taking the side of the debate that celebrated and revalued traditionally feminine labors and experiences.[8] On the other hand, many French curators who had weathered the 1968 protests of art institutions ignored the feminist debates altogether, overlooking the gendered aspects of Messager's work, and praising it as an accessible representation of the everyday with which all could identify.[9] But neither interpretation acknowledged the specific references that her work was invoking. Rather than simply depicting everyday activities and chores in the abstract, Messager's work documented the ways that these everyday labors were taught exclusively to girls in the national education curriculum and then reinforced in the mass cultural products, such as in magazines that were aimed at the female market. By recovering these curricular and mass media sources, I hope to shift the discussion of Messager's notebooks to suggest that her work, in addition to celebrating women's experiences, provides a more complicated analysis of the liberatory potential of everyday life. Although her notebooks recognize the value of everyday labors, they acknowledge everyday life as a site in which subjectivity is formed and constrained and offers varied possibilities and limits to different groups of people – posing particular challenges for women.

By referencing both national education and advertising in the feminine press, Messager was examining two institutions that shaped women's

roles and everyday routines that were rapidly changing as the effects of consumer culture spread and the modernization of housework followed. In her use of materials from the girls' educational curriculum, as well as publications for women, Messager managed to evoke both a sense of women's skills and creativity and a sense of the restrictions that everyday life held for them, locating her work within both strands of feminist debates and creating a complex, nuanced exploration of these problems that neither took just one side nor reconciled the two. In the next sections, I explore Messager's treatment of her everyday sources and discuss the ways critics and curators wrestled with the challenges they posed as they tried to respond to protesters' demands and bring everyday images into art museums. If the museums looked to utopian, collective models of the everyday to renew themselves and make themselves relevant to all, how would artwork that concentrated so deeply on women be received?

WOMEN'S EDUCATION AND THE EVERYDAY

The notebooks that Messager produced in the early 1970s – notebooks and albums filled with drawings, diagrams, and descriptions of daily domestic chores – did not emerge from her own private experience or represent an "individual mythology" of her own creation. Instead, these works had their sources in the home economics and childcare lessons taught to girls in the 1950s and 1960s when they attended primary and secondary school – lessons that have since largely been relegated to the national education archives after decades of struggle by feminist critics of education. These feminist critics joined the concentrated attack on the education system begun by activists in 1968, focusing their attention on the limitations that the curriculum seemed to place on girls. Although in its conception in the 1880s, when free primary school was made universal and mandatory, the French education system was intended to promote a unified culture through a standardized curriculum, these activists noted the way the school system in practice often tracked students according to gender and class.[10] Parts of the curriculum were divided according to gender; they were also divided into pre-baccalaureate (university preparatory) and technical streams.[11] In the pre-baccalaureate sequence – which contained a majority of students from the upper and middle classes – the girls' curriculum was similar to the boys', although girls often learned "domestic science" instead of hard science and domestic crafts rather than industrial arts. In the technical education sequence,

into which students from the working classes were generally channeled, girls were prepared for work in the home and boys for work in industry. Girls learned domestic arts – housekeeping and childcare – whereas boys learned industrial and fine arts.

In the early 1970s, when Messager was creating her notebooks, girls' home economics lessons were gradually being eliminated, sparking debates among feminists on the value of the traditional girls' curriculum. Because society described home economics as a vocation yet refused to see it as work, feminists debated whether they should re-value home economics as a profession or whether they should prepare girls for the paid work positions that men had traditionally occupied. Many groups of scholars, feminists, and government officials were seeking to remove home economics education from the curriculum, because contemporary girls were not able to compete in the working world. At that time, large numbers of young women were unemployed – 52% of the total persons actively looking for work in France were women and two-thirds of these women were younger than age twenty-five. Many scholars and administrators blamed that unemployment on inadequate education and career information.[12]

Other French feminist activists, in contrast, aimed at drawing attention to and valorizing women's domestic work whose importance had never been acknowledged. For example, a special 1974 issue of the feminist journal *Les Cahiers du GRIF* titled "Housework is work," included "The Homemaker's Timetable" – studies that revealed the incredible number of hours French and Belgian women from different social strata spent doing daily housework and caring for children.[13] In the same issue, "Ordinary Life" provided surveys of women's activities over twenty-four-hour periods, underscoring the daily domestic labor done in addition to jobs outside the home. The *Mouvement de Libération des Femmes* also circulated tracts with extensive lists of women's daily chores stating, "It's not called work!"[14] highlighting the ways in which women's domestic labor had been ignored. Messager's notebooks included materials that were central to debates about the curriculum, but expressed various relations to the material, ranging from a critique of the perpetuation of traditional work for girls to a valorization of the work of female homemakers.

Indeed, Messager's notebooks directly engaged contemporary feminist debates over the teaching of women's domestic tasks, an engagement that explored the problems and possibilities represented by both sides. For example, the page titled "Le Lavage" ("Laundry") from her 1974

notebook *Ma Vie pratique* ("My Practical Life") repeated detailed and didactic textbook instructions on doing laundry properly (Fig. 51). It read: "To wash a wool garment, I use warm water and a bit of soap. I squeeze the wool but don't scrub it. I rinse it several times, always with water the same temperature. I squeeze the wool and ring it out by hand and lay it flat to dry."[15] Messager's mechanical repetition of the tasks implied utter immersion in daily routine and clearly related to the strand of feminist thinking that denounced the ways the curriculum trained women into domestic roles. At the same time, the elaboration of the detailed skills and processes learned made visible the value – the intensity of the labor, the care, and skill – of the domestic aspects of many women's daily life.

In its more critical mode, Messager's repetition of tasks from the home economics curriculum can be compared to ideas being explored concurrently by the sociologist Luc Boltanski (Christian Boltanski's brother).[16] Luc Boltanski, like his contemporaries Michel Foucault and Louis Althusser, saw the curriculum as a means for dominant social classes to structure and control students' lives by regulating daily practices.[17] I want to examine this connection at some length here, for it helps to make clearer how her work critiqued the ways the curriculum regulated students' daily activities.

Since its inception in the 1880s, the housekeeping curriculum had been promoted by the state as a means for bringing happiness and health to all homes. In his 1969 study, *Prime Education et morale de classe*, Boltanski sought to expose the ideology underlying this codification of housekeeping practices. He argued that the housekeeping curriculum had formed part of a systematic project to regulate the habits of the working classes. In the late nineteenth century, popular opinion characterized the working class as immoral, disorderly, and free from collective constraints. In response, educational programs were organized to teach moral lessons, housekeeping, and hygiene, in order to acculturate the working class to the middle-class values of order, work, and economy. The schools instilled *enseignement ménager* and *puériculture*, housekeeping and childcare lessons, by teaching rationalized attitudes and practices to be adopted in daily life. Because the familial sphere was considered "women's domain," these housekeeping courses for girls supplied a means to control the private life of the working classes. The factory and office workday had been timed, organized, and rationalized since the nineteenth century, and the housekeeping classes provided a corresponding way to structure the private life of the working classes by regulating domestic labors:

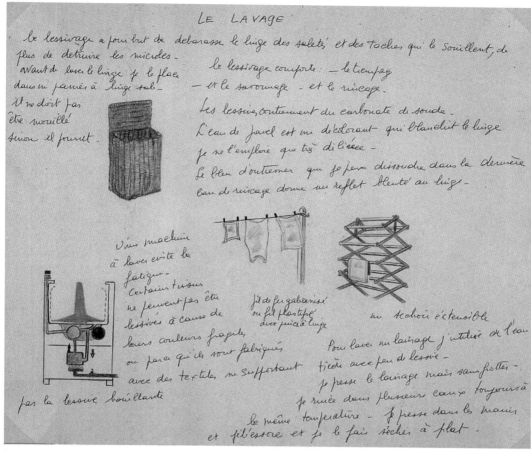

Figure 51. Annette Messager, "Le Lavage," detail from *Ma Vie pratique*, 1974. © 2005 Artists Rights Society (ARS), New York/ADAGP, Paris. Photo: André Morain, courtesy of the FRAC Bourgogne.

Not public life which occurs in factories, offices, and administration, which for a long time, since the beginning or middle of the [nineteenth] century, has been made uniform, standardized, constricted in space and time, confined in workplaces, delimited by work schedules. What needed to be regulated henceforth was private life, the multiple activities that are done in the privacy of the home, done behind the walls of individual houses. The "habitual manners of behaving," [which were] governed by custom, passed on by tradition, had to be replaced by rules.[18]

This structuring of private life was manifest in home economic textbooks, which provided rationally organized chronologies of daily activities, with precise amounts of time allotted for each child-rearing and housekeeping

task (Fig. 52). Beyond teaching rules of housekeeping, hygiene, and child-care, the lessons encouraged students to adopt methods of order and discipline in their daily life. Most importantly, the lessons compelled students to regulate their own behavior, accomplishing what Boltanski called "a total transformation of spirit, a peaceful and internal revolution."[19]

Boltanski's analysis of the home economics and childcare curriculum provides an important perspective on the class-component of education, yet his analysis of women's role in the curriculum is limited. For him, women as homemakers enter into his model simply as the means for transmitting middle-class values to the working class. He does not consider how the home economics classes – because they were taught to and carried out by women – shaped the subjectivity of women in particular. Messager's work, in contrast, not only enacted the "rationalization of behavior" that Boltanski noted, but also showed how women's training shaped their subjectivity. Messager represented the ways in which the behaviors taught in school were internalized at the level of the individual woman and, despite the reality of class differences, became common to some degree to all French women.

Messager's notebook *Ma Vie pratique* (1974) evoked the systematization of daily behaviors that Boltanski observed. In fact, the sources for pages such as "La Peau-rôle-hygiène" ("The Skin-role-hygiene") can be located in a 1958 girls' applied science textbook (Figs. 53–4).[20] Messager's handwritten text, mimicking the language of the textbook, explains:

Skin has numerous functions
Through the skin gases are exchanged: the blood gives off carbonic gas
 and is enriched with oxygen, also I perspire by the skin.
The skin eases the work of the kidneys
the skin is the organ of touch
the skin prevents the entry of germs

One must keep the skin very clean in order to permit respiration and transpiration. If I don't wash grime forms on my skin. It is composed of debris from the epidermis, dust, and oils produced by glands situated at the base of hairs. The grime blocks respiration through the skin and blocks pores.

In order to avoid the development of parasites on the skin:
− lice eggs called nits stuck to hair
− fleas that can transmit the plague
− scabies, animals that resemble spiders, dig tunnels into the skin and
 cause itching…
− microscopic fungi that cause hair loss − tinea

	Ménage	Cuisine	Lavage	Couvert Vaisselle	Divers
8 h 00 - 9 h 00		Mise en route du braisé à la cocotte minute Préparation salade			
9 h 45		Potage, Crème prise en pots			
9 h 45 - 11 h 30	Ménage journalier				
11 h 30 - 12 h 00				Couvert	
12 h 00 - 13 h 00 13 h 00 - 13 h 30					Repas Détente
13 h 30 - 14 h 15				Vaisselle Rangement Balayage	
14 h 15 - 16 h 30			Lavage	Passer la toile dans la cuisine après le lavage.	
16 h 30 - 17 h 00					Courses pour le lendemain
17 h 00 - 18 h 30	S'occuper des enfants et de leurs devoirs, s'il y a lieu. Possibilité de faire quelques points de couture pendant ce temps ou de tricoter. S'il n'y a pas d'enfants, possibilité d'entreprendre une autre activité ménagère.				
18 h 30 - 19 h 15		Préparation du repas		Couvert	
19 h 15 - 20 h 15					Repas
20 h 15 - 21 h 00				Vaisselle Rangement Balayage	
21 h 00 - 21 h 30					Coucher des enfants
21 h 30 - 22 h 00	Rangement				Toilette
22 h 00 - 22 h 15					Coucher

Figure 52.
Daily Timetable for the *Ménagère*. Ginette Mathiot and Nelly de Lamaze, *Manuel d'éducation ménagère* (Paris: Istra, 1965) 31. Courtesy of the Musée National de l'Education, I. N. R. P., Rouen.

Care for cleanliness: I must take a shower each day. At this time, I should also change my undergarments. The face should be washed morning and night (without makeup). Hands that become dirty from touching objects must be washed very often and before every meal. Hair must be brushed every day and I wash my hair at least once a week to remove the dust and grease that forms [on it].[21]

Messager's notes began with scientific descriptions of the functions of the skin, such as "through the skin gases are exchanged: the blood gives

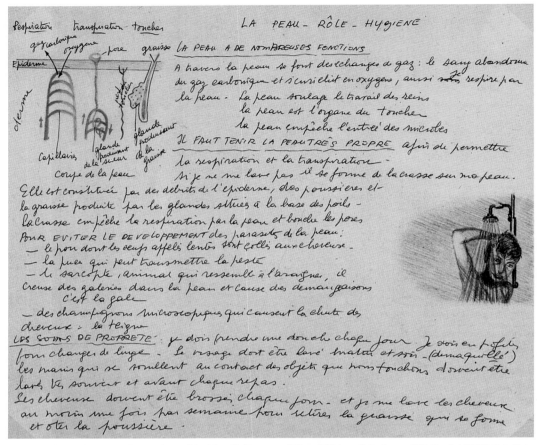

Figure 53. Annette Messager, "La Peau-rôle-hygiène," detail from *Ma Vie pratique*, 1974. © 2005 Artists Rights Society (ARS), New York/ADAGP, Paris. Photo: André Morain, courtesy of the FRAC Bourgogne.

off carbonic gas and is enriched with oxygen." But her text quickly moved to listing the health hazards that would ensue without proper hygiene – "In order to avoid the development of parasites on the skin: – lice eggs called nits stuck to hair – fleas that can transmit the plague" – and then to the vigilant self-care that it was demanded she practice: "I must take a shower each day.... The face should be washed morning and night.... Hands...must be washed very often and before every meal." Messager's text evokes the regulation of daily practices that Luc Boltanski described. The scientific and clinical discussion of the functions of the skin quickly turn into didactic instructions aimed at developing daily routines. The descriptions of the skin written in the objective third person are transformed and expressed as personal directives ("I must take

LA PEAU : RÔLE, HYGIÈNE

■ **LA PEAU A DE NOMBREUSES FONCTIONS.**
À travers la peau (4) se font des *échanges de gaz* : le sang abandonne du gaz carbonique et s'enrichit en oxygène; ainsi *nous respirons par la peau*.
La peau *soulage le travail des reins* (comment ?).
La peau est *l'organe du toucher* (p. 36).
Enfin, la peau *empêche l'entrée des microbes*.

■ **IL FAUT TENIR LA PEAU TRÈS PROPRE.**
• **Afin de permettre la respiration et la transpiration.** — Lorsqu'on ne se lave pas, il se forme de la *crasse* sur la peau. La crasse est constituée par des débris d'épiderme, des poussières et la graisse produite par les glandes situées à la base des poils (4). La crasse *empêche la respiration* par la peau et *bouche les pores*.
• **Afin d'éviter le développement des parasites de la peau :** — le *pou* dont les œufs, appelés *lentes*, sont collés aux cheveux;
— la *puce* qui peut transmettre la *peste*;
— le *sarcopte*, animal minuscule voisin de l'araignée; il creuse des galeries dans la peau et cause des démangeaisons : c'est la *gale*;
— des *champignons microscopiques* qui causent la chute des cheveux, c'est-à-dire la *teigne*.

■ **LES SOINS DE PROPRETÉ.**
• **Soins généraux.** — *Pour tenir la peau toujours propre*, il serait souhaitable de prendre une *douche* chaque jour. Il est toujours possible, au moins une fois par semaine, d'asperger le corps avec une éponge et de le savonner. On en profite pour *changer de linge*.
• **Soins particuliers.** — *Le visage* doit être savonné matin et soir.
Les mains, qui se souillent au contact des objets que nous touchons, doivent être lavées soigneusement et surtout avant les repas.
Les cheveux doivent être brossés chaque jour et lavés au moins une fois par semaine pour enlever la graisse qui retient les poussières.

Travaux personnels

1. **Faites deux schémas** indiquant les modifications subies par le sang :
1er schéma : le sang circule au contact de la paroi des alvéoles pulmonaires (voyez p. 56 (2));
2e schéma : le sang circule dans l'un de nos organes (ci-contre). Indiquez le trajet suivi par le sang; coloriez le sang.

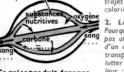

un capillaire
substances nutritives — oxygène
carbone — sang
sang
Ce qui se produit dans nos....

2. **Le savez-vous?** Pourquoi ne doit-on pas utiliser la coiffure d'un camarade? — La transpiration permet de lutter contre la chaleur : pourquoi?

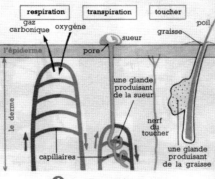

respiration | transpiration | toucher
gaz carbonique — oxygène
l'épiderme — pore — sueur — graisse — poil
le derme
une glande produisant de la sueur
nerf du toucher
capillaires
une glande produisant de la graisse

④ **La coupe de la peau:**
Quelles sont les deux couches qui constituent la peau ? Où se trouvent les vaisseaux sanguins ? — Pourquoi le sang devient-il rouge clair près de la surface de la peau ? Qu'est-ce qui produit la sueur ? — Qu'existe-t-il à la base d'un poil ? — Pourquoi faut-il tenir la peau très propre ?

⑤ **Le meilleur moyen de faire sa toilette.**
Si l'on ne dispose pas d'installation de douche, comment peut-on faire sa toilette ?

RÉSUMÉ
1. **Le rôle du sang :**
a) C'est grâce au sang que nos organes peuvent fonctionner :
— les globules rouges transportent l'oxygène;
— le sang approvisionne nos organes en substances nutritives et les débarrasse des déchets;
b) Les globules blancs du sang assurent la défense de l'organisme contre les microbes.
2. **Il faut tenir la peau très propre :**
— pour que la respiration par la peau et la transpiration s'effectuent normalement;
— afin d'éviter le développement des parasites de la peau (pou, puce, sarcopte ...).
3. **Le meilleur moyen de tenir la peau toujours propre est de prendre une douche chaque jour.**

Figure 54.
"La Peau: rôle, hygiène." Marcel Orieux and Marcel Everaere, *Sciences appliquées, Classe de fin d'études, Ecoles urbaines de filles* (Paris: Hachette, 1965) 61. Courtesy of the Musée National de l'Education, I. N. R. P., Rouen.

a shower each day"), enacting the moment at which inculcation took place. These directives are reinforced by the illustrations, which move from diagrams of the layers of the skin to a sketch of a child washing in the shower. That such bodily practices were taught and followed illustrated the extent to which schools were responsible for shaping girls'

Figure 55.
Student's *Cahier de couture* (cover),
Lycée Marie Curie, approximately
1950. Courtesy of the Musée National
de l'Education, I. N. R. P., Rouen.

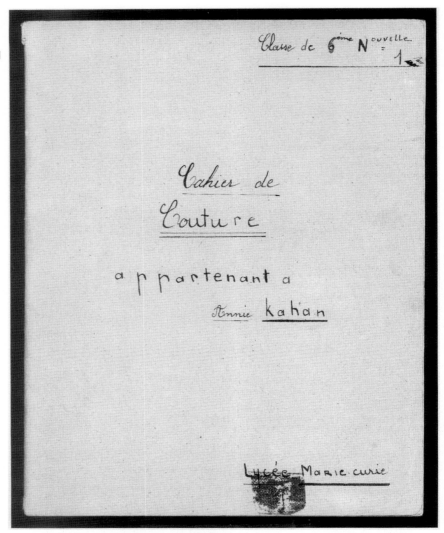

daily routine and bodily discipline. And Messager's representation of
this process in a form evoking personal memory – the notebook or scrap-
book – made the institution's stamp on the intimate life of the subject
clear.

Similarly, Messager's notebook of needlework exercises, *Mes Travaux
d'aiguille* ("My Needlework") (1972), provided an account of how a girl's
quotidian activity was shaped by rationalizing educational practices.
Such needlework exercises had been part of the national curriculum
since public education had become mandatory for girls in the 1880s.[22] An

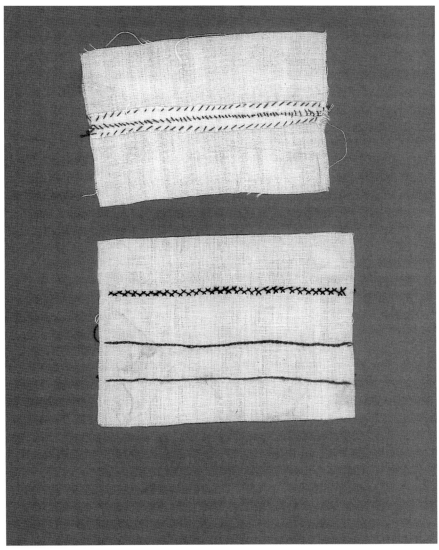

Figure 56.
Student's *Cahier de couture* (detail),
Lycée Marie Curie, approximately
1950. Courtesy of the Musée National
de l'Education, I. N. R. P., Rouen.

example of a girl's needlework album from approximately 1950, currently
located at the Institut National de Recherche Pédagogique, demonstrates
that needlework albums contained an explanation of how to make vari-
ous stitches and small samples of each stitch (Figs. 55–6). Messager's 1972
album repeated the form of these exercises and also provided a carefully
drawn diagram of each stitch (Figs. 57–8). Although these exercises were
labeled as her own ("my needlework") her use of "my" did not individual-
ize the stitching, but merely followed the structure of school exercises. By

Figure 57. Annette Messager, *Mes Travaux d'aiguille*, 1972. © 2005 Artists Rights Society (ARS), New York/ADAGP, Paris. Collection of the Musée de Grenoble. Photo courtesy of Annette Messager.

making pieces that might seem individualized but actually represented a practice that was mandatory for all girls, Messager illustrated how the educational system organized girls' most basic tasks and constrained their possibilities for individual self-expression.

In line with feminists who saw the teaching of home economics as a means of preparing girls for menial roles, Messager's notebooks *Ma Vie pratique* and *Mes Travaux d'aiguille* enacted ways that the social order was incorporated into individual behavior. By selecting statements, such as "I must take a shower each day" or labels such as "my needlework," Messager isolated the moments at which educational directives were absorbed and expressed in the behavior of the individual. From this perspective, it appeared that women across social classes shared, though unevenly, quotidian experiences that had been perpetuated through the education system for their subjection. At the same time though, grouping together these documents of women's daily hygiene practices, household labors, and domestic arts, could be seen to produce a detailed catalogue of women's work and traditional skills that gave them dignity and respect. Both readings are possible, and in the mid-1970s, both readings would be advanced.

LA COUTURE RABATTUE

LE POINT DE DEVANT

la longueur de mon aiguille est d'environ
4 cm. J'enfile toujours le fil par le côté
détaché de la bobine.
Les principales variétés des points d'aiguille
sont celles dessinées au dessus.

— mes travaux d'aiguille —
Album - collection n· 7

Figure 58.
Annette Messager, *Mes Travaux d'aiguille* (detail), 1972. © 2005 Artists Rights Society (ARS), New York/ADAGP, Paris. Collection of the Musée de Grenoble. Photo courtesy of Annette Messager.

The dual modes of critiquing and displaying attachment in Messager's work seem particularly crucial coming at a time when traditions were changing due to feminist challenges, and equally significantly, the encroachments of consumer culture. These changes were particularly noteworthy in relation to women's housework. Messager documented this separate and currently modernizing women's culture, which stood

in opposition to the promotion of standards of national culture that had been the aim of the education system and the museum.

While schools in the 1970s often used textbooks from the 1950s and 1960s and thus taught an older mode of domestic skill, the home economics curriculum was slowly being phased out of the girls' curriculum. Women's magazines, however, whose subscriptions had massively increased in the 1950s and 1960s, had come to represent another primary place where housekeeping skills were promoted. But the treatment of the arts of homemaking in these texts represented a profound transformation. In the 1960s and early 1970s, women's magazines came to emphasize rationalized order and efficiency through the use of commodities – modern appliances and gadgets, standardized recipes, prefabricated products – instead of the moral lessons and specific skills that were taught in the school curriculum. The model housewife in their pages was an efficient manager of the home, rather than a traditionally creative domestic artist.[23] This transformation in the representation of housekeeping practices met with different responses from feminists, from lament for the effacement of traditional skills, to anger that the role of woman as housekeeper was being perpetuated, to a new insistence on valuing women's household labor: if women were managers in the home, why not treat them on a par with male managers in the public sphere?

Some went even further, not only insisting that traditional women's work be recognized as labor, but also expanding their vision of it to see it as a unique culture, one that was under threat from the forces of modernization and commodification. For example, critic Pascal Lainé feared that the skills taught in home economics classes were being effaced, transformed into hobbies and thereby robbed of their dignity, and replaced by a new ethic of mere consumption:

> Feminine civilization, with its own techniques, traditions, language, models of behavior, is among a number of "local" cultures in the process of being liquidated. It is easy – under the pretext of modernism and "liberalism" – to make fun of young women's traditional education: sewing, cooking, etc. And undoubtedly the woman today legitimately aspires to "other things." However the woman's profession, domestic artisanship, and techniques of maternity constitute a veritable "culture," with its own system of value and its scale of mastery. Don't speak of the degraded vestiges that we can still find in bourgeois society: tiny works of embroidery and tapestry are nothing but a distorted, recent by-product of ancient modes of feminine production. All the arts of housekeeping today are limited to knowing how to shop.[24]

Figure 59. Annette Messager, "La Cuisson des aliments," detail from *Ma Vie pratique*, 1974. © 2005 Artists Rights Society (ARS), New York/ADAGP, Paris. Photo: André Morain, courtesy of the FRAC Bourgogne.

In contrast to the "artisanship" and "culture" of traditional feminine household arts, the contemporary housekeeping techniques promoted by women's magazines were based on acquiring housekeeping gadgets that required no specific skills to operate.

Lainé's description of feminine culture as a "local culture" (ironically, one created and perpetuated in part by the national school system) that was in the process of being liquidated by Western modernism, echoed the ethnographic approach to modernizing traditional cultures exemplified by Claude Lévi-Strauss in *Tristes Tropiques*.[25] And like Lévi-Strauss and the ethnographers, anthropologists, and museum curators influenced by him, Lainé saw this local culture as a feature to be preserved. Within this framework, Messager's albums can be seen as constructing the kind of archive that would preserve a vanishing women's civilization, making

visible the skilled and detailed labor in household work that had frequently gone unnoticed. Yet her work also goes further in the manner that Lévi-Strauss argued was necessary for documenting modernizing culture: it does not merely lament a vanishing order but rather examines the changes that were occurring in the present.

One of her albums, *Ma Vie pratique*, for instance, was an encyclopedic inventory of home economics lessons from the 1950s and 1960s. In the various notebook entries, Messager pretended to document her rigorous methods of housekeeping, health, and hygiene, analyzing her daily chores in handwritten instructions, and including textbook passages and textbook-style illustrations with bright, diagrammatic colors. For example, "La Cuisson des aliments" ("Cooking Food"), one page from the album, described how to use a pressure cooker and how to cook meat, fish, dried and fresh fruits and vegetables, and represented each method schematically in diagrams (Fig. 59). The notes described the health benefits of certain methods. For example: "Boiled meat is easy to digest. The heat makes the food either softer or harder, and it becomes more savory and easier to digest, and further, it's sterilized."[26] In contrast, *Mon Livre de cuisine* ("My Cookbook"), was filled with *fiches cuisine*, recipe cards published in women's magazines, such as *Elle* in the 1960s and 1970s (Fig. 60). These clipped-out cards had a picture of the prepared dish on one side and the simple recipe on the back. Both *Ma Vie pratique* and *Mon Livre de cuisine* were based on the idea of women as housekeepers and cooks. Yet unlike *Ma Vie pratique*, the recipe cards in *Mon Livre de cuisine* did not promote principles of cooking in careful diagrams, but were simple recipes – often called "grandma's recipes" in an effort to lend them the aura of tradition – clipped out of magazines and glued into notebooks or copied over word for word. Whereas "La Cuisson des aliments" illustrated the steps involved in each task, emphasizing the tradition and science of housekeeping, the recipe cards merely showed the final product, displaying the finished dish in an effort to entice the reader into purchasing the merchandise whose ads appeared on the pages of the magazine. The learning, the detail, and the labor represented in *Ma Vie pratique* all vanished into a vision of a ready-to-be-consumed meal. Whereas "La Cuisson des aliments" described a number of techniques to be used at the discretion of the housekeeper, the *fiches cuisine* provided a simple, generic model leaving little room for the housekeeper's discrimination, and thus little recognition of her skill. Viewed in this light, Messager's albums would seem to reinforce Lainé's comment that homemaking skills were being effaced and transformed. Where the domestic arts had gained dignity

Figure 60.
Annette Messager, *Mon Livre de cuisine* (detail), 1972. © 2005 Artists Rights Society (ARS), New York/ADAGP, Paris. Photo: author.

from the rhetoric of health, order, and moralistic progress that surrounded their skills, now, it seemed, "All that remains are 'grandma's recipes,' produced by the major food companies" – mere publicity for brand-name products.[27]

Feminists and critics like Lainé, who advocated women's traditional domestic arts, could also see in Messager's 1974 series *Les Gestes quotidiens* ("Daily Gestures") an illustration of how new appliances and their promotion in women's magazines were radically reducing women's housekeeping skills and range of expertise.[28] In *Ma Vie pratique*, the curricular lesson on laundry included the hygienic and physical benefits of doing this household task properly, and outlined the series of necessary steps in texts and drawings, including putting dirty laundry in a hamper, using the proper detergent for the fabrics, using a washing machine if possible, and properly hanging the clothing to dry on a clothesline or drying rack (see Fig. 51). In *Les Gestes quotidiens*, however, the descriptions and diagrammatic illustrations of *Ma Vie pratique* that emphasized the integrity of the labor and the woman performing it as she created a narrative of the tasks were replaced by photos clipped from magazines portraying mechanical gestures: stirring a pot, covering food with plastic wrap, wiping up a spill, or turning the knobs of gadgets (Figs. 61–2). No longer processes with detailed steps, household chores in *Les Gestes quotidiens* are constructed as simple repetitious movements with photographs depicting the same gesture – wiping stains on walls or windows, covering bowls and plates with plastic wrap – over and over again. Further, the handwritten notes supplementing the images of *Ma Vie pratique* evoked the process by which the information was learned and internalized so that it would be invoked as the housekeeper accomplished her tasks. The photographs in *Les Gestes quotidiens*, however, were clipped directly from magazines and emphasized the simplicity of the tasks and the "ready to use" quality of the products and appliances, which required less coordination and discretion on the part of the homemaker.[29] The immersion of the woman in her tasks (even if not wholly positive) visible in *Ma Vie pratique*, is absent in *Les Gestes quotidiens*; she is no longer even a whole woman, but merely a series of interchangeable hands.

The role of women's magazines and their advertising in saturating the everyday existence of their readers was not lost on Lefebvre, who noted the rapid influx of American-style commodities in the 1960s in *Everyday Life in the Modern World*.[30] He believed that women's magazines were the perfect object through which to study this transformation of the everyday, because of their intense focus on the new domestic commodities and their promulgation of the step-by-step behaviors needed to use them. The increased repetition and mechanization of household gestures that they displayed, Lefebvre believed, were a quintessential image of the broader restructuring of the everyday in which work and leisure had been so quantified and structured that no room remained for individual

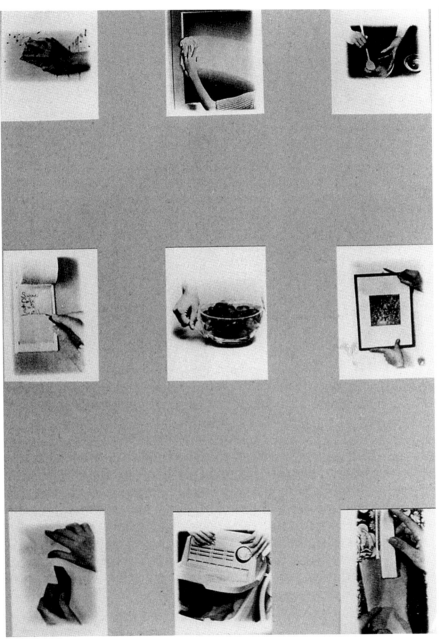

Figure 62.
Annette Messager, *Les Gestes quotidiens* (detail), 1974. © 2005 Artists Rights Society (ARS), New York/ADAGP, Paris. Photo: author.

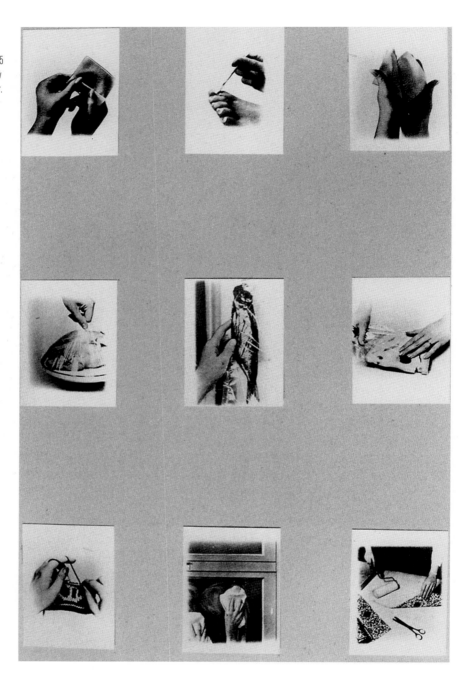

Figure 63.
Annette Messager, *Mes Collections d'expressions et d'attitudes diverses* (detail), 1974. © 2005 Artists Rights Society (ARS), New York/ADAGP, Paris. Photo: author.

creativity, turning people into passive consumers. The consumerist ethic that Lefebvre noted would have profound effects on not only women's practices in the home but also their subjectivities and bodies.

As an example of the influence of this consumer society on subjectivity, Lefebvre described how one day his wife brought home a new laundry detergent and exclaimed, "This is an excellent product," with her speech and behavior unconsciously imitating the advertising for the product.[31] The force of this unconscious immersion was a striking example of the difficulty women would have in attaining a critical perspective on the

everyday. Like Lefebvre, Messager explored the way women emulated
everyday gestures from the media, but also took the idea further, in *Mes
Collections d'expressions et d'attitudes diverses* ("My Collection of Various
Expressions and Attitudes,") to show how even women's emotions had
become saturated with these representations (Figs. 63–4). In this series,
Messager collected mass-media representations of women and catalogued
them by activities or emotional states – "on the telephone," "at the
beach," "fatigue," "sadness," "fear," "jealousy," "happiness," and so forth.
The series "tears," for example, contains highly staged representations of
women in distress: one woman holds her head in her hands, another
leans her head on folded arms, and another covers her face (Fig. 63). In
the center of the page, Messager drew herself in a similarly cliché pose –
with her eyes closed, her head thrust back, and one hand held to her fore-
head. Another series of her *"expressions diverses"* presented photographs
of couples embracing, which surrounded various sketches of Messager
embracing a man, being kissed by him, and leaning against his shoulder
(Fig. 64). By portraying herself within these stereotypes, Messager acted
out how advertising had influenced her.[32] Yet her drawn activities appear
exaggerated and highly unnatural, providing a parody of the stereotypes
and rising above the media immersion, signaling a critical perspective
that Lefebvre would have thought women could not attain.

In the album *Avant-après* ("Before and After") (1972–73), Messager
drew together the influence of stereotypes in advertising and the

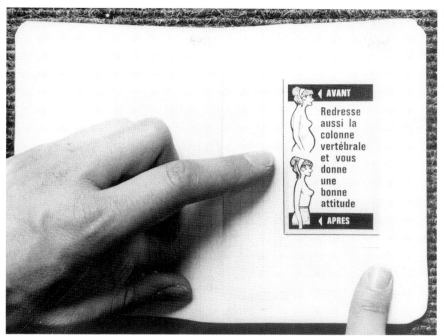

consumption of commodities in investigating the impact of products aimed at modifying women's bodies. Although Lefebvre studied the effects of advertising and commodities on behavior, he did not address products aimed at altering the physical self. In *Avant-après*, Messager collected advertisements that represented consumers before and after using certain products (Fig. 65). The ads primarily featured double pictures of women before and after losing weight, improving posture, increasing bust size, losing facial hair, rejuvenating skin, and remedying varicose veins. She parodied the format with two images of herself, obviously taken one after the other. In the "before" she frowned and in the "after" she smiled, looking at the camera (Fig. 66). In the album *Les Tortures volontaires* ("The Voluntary Tortures") (1972–73), Messager assembled images of women using various beauty treatments (Figs. 67–8). The pictures portrayed women with electric wires and coils strapped to their bodies, and pads, tapes, and creams applied to their skin. Other women were seated in various sauna or exercise contraptions or used rollers and elaborate dryers on their hair. The products seem to offer the possibility of standardizing the physical body in line with stereotypes from advertising.

Although the equipment would seem extreme, these advertisements were frequently run in *Elle* and *Marie-Claire*. In their very extremity, these images convey strikingly the way that commodities worked directly on

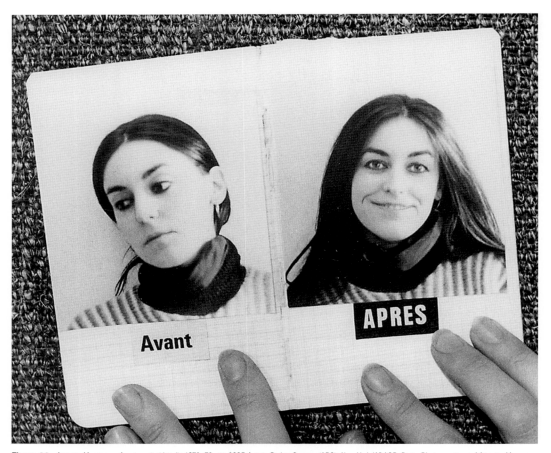

Figure 66. Annette Messager, *Avant-après* (detail), 1972–73. © 2005 Artists Rights Society (ARS), New York/ADAGP, Paris. Photo courtesy of Annette Messager.

the bodies of women and evoked the extent to which women's selves were constructed by popular images and social expectations. Images in *Les Tortures volontaires*, for example, were clearly targeted at women – men were not being asked to transform their bodies in the same ways. And as women's bodies were transformed, so were their subjectivities: for instance, the clichés of falling in love, embracing a man, and leaning on his shoulder were all romantic fantasies from the feminine press embodied in stereotypical – but familiar and repeated – postures and poses. By presenting herself within the advertisements and media images, Messager evoked how they were internalized. By selecting and cataloging the repetition of clichés, and exhibiting them in display cases, she denaturalized the images and offered them for inspection.

Despite its engagement with contemporary politics – both the feminist debates over women's changing roles in society and the analysis of

Figure 67. Annette Messager, *Les Tortures volontaires*, 1972–73. © 2005 Artists Rights Society (ARS), New York/ADAGP, Paris. Photo courtesy of Annette Messager. Collection of the IAC – FRAC Rhône-Alpes, Villeurbanne.

the politics of the everyday – Messager's early work was seldom shown and written about by feminists.[33] In fact, feminist art criticism was not widely established in France in the early 1970s, and few women artists achieved mainstream success. Although a number of other women artists were active, some even employing domestic materials (Milvia Maglione's 1975 *Many Hours of Work*, for example, a wall-hanging incorporating kitchen utensils, bears some resemblance to Messager's domestic themes and subjects), their creation never attained the same level of recognition that Messager's eventually did.[34] Even though Messager's work came to receive far more mainstream attention than these other women artists, it received less critical attention than that of her male colleagues. However, as the seventies got underway, Messager's work found a more favorable terrain within which it could gain more attention. Beginning in the early 1970s, French cultural policy started to change dramatically under the leadership of the Pompidou government; prominent art museums began to look to art of the everyday in response to the 1968 critiques in order to reestablish their relevance and revitalize their mission. It was within this political and cultural shift that Messager's work first came to be exhibited in French museums. She participated in several group exhibitions in 1973 and was given a solo exhibition in 1974. Although Messager's art

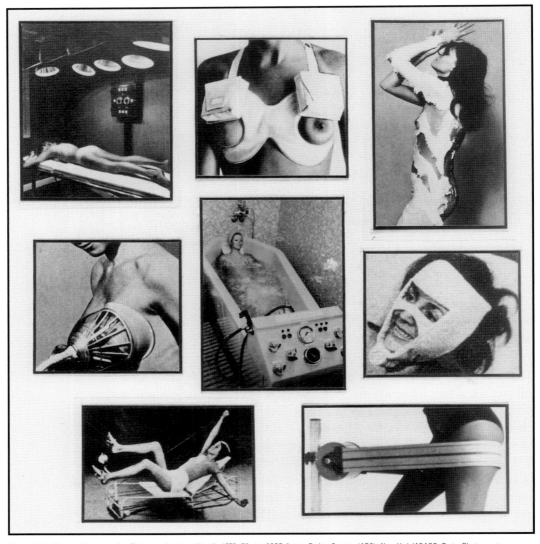

Figure 68. Annette Messager, *Les Tortures volontaires* (detail), 1972–73. © 2005 Artists Rights Society (ARS), New York/ADAGP, Paris. Photo courtesy of Annette Messager. Collection of the IAC – FRAC Rhône-Alpes, Villeurbanne.

critiqued the teaching of traditional women's work, these critical aspects were downplayed by museum curators and critics as they heralded her notebooks as a representation of everyday experience that had been traditionally excluded by the museum. Whether they saw this new everyday as a means of revaluing traditional women's work or saw it more simply as a means of engaging a wider audience and democratizing the museum, critics and curators would overlook the works' more pointed critique

Figure 69. Annette Messager, *Cahiers* and *Albums collections*, 1971–74. Installation at the *Annette Messager collectionneuse* exhibition, Musée d'Art Moderne de la Ville de Paris, 1974. © 2005 Artists Rights Society (ARS), New York/ADAGP, Paris. Photo courtesy of Annette Messager.

of the institutions that had structured women's subjectivity and their experience of everyday life.

MESSAGER'S *VITRINES*: EXHIBITING THE DAILY LIFE OF WOMEN

In the 1974 *Annette Messager collectionneuse* exhibition at the Musée d'Art Moderne de la Ville de Paris, Messager displayed over one hundred of the notebooks and albums that she had been producing during the early 1970s. Some of her notebooks were opened up to specific pages and displayed in vitrines, whereas others were taken apart so that the individual pages could be hung on the walls (Fig. 69). The curator, Suzanne Page, emphasized the careful documentation of tasks in these notebooks as a valorization of women's labor and creativity that had been denigrated in society and the art world. The numerous albums conveyed the idea of an encyclopedic collection of domestic knowledge from home economics lessons and housekeeping chores that had constituted the traditional education and work for girls and women up into the 1970s as well as the new consumerist version of that work. By employing pseudo-ethnographic strategies of cataloging skills, gestures, and crafts, and displaying them within ethnographic vitrines, Messager's work enabled these images and experiences to be seen as women's culture rather than overlooked as part of the trivialities of everyday experience.

In the French art world of the early 1970s, Pagé was one of the few women who occupied prominent curatorial positions. She saw that women artists were not well supported by art institutions and wanted to open up the Musée d'Art Moderne de la Ville de Paris to women's work: "Feminists began to announce themselves in an aggressive way at that time. But there were not many in museums.... There was great contempt for women's art. And in the market it didn't exist. I showed a lot of women artists' work... because of this."[35] The very act of putting these examples of women's creative activities into an art museum in the mid-1970s was extremely novel in France and made a strong, if implicit, argument for recognizing the aesthetic value of these activities.[36] Pagé herself was aware of the historical importance of the show, asserting that its significance was that Messager "showed women's ways of doing things, like recipe cards... What was great was that she was showing these things. It was courageous to show herself as she was."[37] Pagé's emphasis on the importance of simply showing women's work reflects how great a prejudice existed against women's activities. The designation of practices such as Messager's as "non-art" – part of home economics, or domestic arts, rather than industrial or *beaux-arts* within the school system – would have normally functioned to bar such everyday "women's work" from the museum. Messager's temporary occupation of the museum drew attention to how artistic institutions usually excluded women's traditional practices, associating them with the practical needs of everyday life rather than the artistic realm. Even if the "typical" audience for art would find Messager's collections unusual or improper, Pagé thought that the work would particularly appeal to women of Messager's generation, who could appreciate it based on their common practices as well as their experiences in the national school system. In line with feminists who wanted women's domestic labor valued as work, bringing women's domestic materials into the public space of the museum implied attaining for women's work a degree of recognition similar to that of the work that regularly occupied the public sphere.

Even though Pagé managed to exhibit Messager's notebooks, she could not convince the museum's curators to purchase them. She explained: "Here, curators were scandalized by the work. I wanted to purchase one of her works, but they completely refused. They considered her work to be of no interest, undignified, having nothing to say in a museum. Poorly made. This was still a generation of curators who believed that abstract painting was what we should put in the museum."[38] She explained that it was not yet established practice to exhibit commonplace, everyday materials in French art institutions, and Messager's albums were seen as

popular, feminine craft work that was inappropriate for the museum. The museum curators saw it as work without meaning, overlooking the work's interrogation of the divisions between the public and the private or domestic. Messager's exhibition, which brought women's daily housework into the museum, was a way of crossing a barrier to the public sphere that did not exist for men whose education specifically prepared them to occupy that realm. Pagé's perspective on the exhibition highlights this project of reclamation and celebration; however, her interpretation downplays the aspects of Messager's work that were critical of the institutions of feminine acculturation – such as the home economics curriculum or women's magazines – that limited women as much as they offered opportunities for a particular culture to develop.

Yet other feminist critics at the time cautioned against a celebration of women's traditional work. In "Le Soft Art et les femmes," for example, feminist critic Aline Dallier reminded readers that women's production of utilitarian and domestic works, such as needlepoint, had grown out of a historical situation in which women often did not have access to the materials and spaces of high art.[39] Under these circumstances, the project of attempting to eliminate the derogatory label "*ouvrages de dames*," or "women's work," that was frequently given to traditionally feminine aesthetic practices could only go so far: simply to celebrate this kind of work was to lose track of the way it had been forced on women and had been used to delimit their activities throughout the centuries. For Dallier, the celebration of women's traditional work could not be the political end; instead, the work gained political value only insofar as it could be used to gain access to experiences of oppression, to "recall experiences that are both despised and controlled in the service of a new liberty."[40]

In fact, by preserving women's work through ethnographic methods that presented it as a kind of subculture, Messager not only engaged in a task of preservation and celebration as Pagé held, but also displayed the kind of awareness of limitations that Dallier appreciated. Invoking sources from the curriculum, Messager proposed a critique of the nationalizing, standardizing roles of both the public education system that had been established in the 1880s and persisted to the 1970s as well as the museums that took up the nationalization of culture.

In the 1880s, the Third Republic had established free and mandatory primary education. With the primary school curriculum, culture was supposedly nationalized – all students across France learned the same lesson on the same day, and the intended effect was one of national unity.[41] But the curriculum also divided girls' and boys' education. Messager's work brings out the ways that the effort to create national culture systematically

marginalized women, rendering them not fully part of the national culture that was taught in schools and exhibited in national museums, but relegating them through the home economics curriculum to domestic and everyday tasks. By representing women's tasks within ethnographic vitrines, which were traditionally used for non-artistic, utilitarian objects, and foreign, non-French cultures, Messager emphasized this exclusion of women's distinct subculture from the national culture. In her recognition of the origins of this marginalization in primary and secondary education, Messager took the 1968 critiques of national culture a step further than the activists who castigated the museum and the university for perpetuating class biases in the name of preserving universal and national culture. Messager illustrated how biases began much earlier, in primary and secondary school curricula, creating a gendered subculture to which women had been relegated, and which the '68 protests had by and large ignored.

CINQ MUSÉES PERSONNELS: THE EVERYDAY IN THE MUSEUM

This neglect of women's specific experiences would be played out by critics who celebrated Messager's work as an instance of a more utopian transformation of the museum through the everyday. This tendency is strikingly illustrated in the critical writings of Gilbert Lascault, an ambitious, young curator and critic at the *Chroniques de l'art vivant*. Lascault was also sympathetic to the idea of using everyday, utilitarian objects, such as those found in ethnographic museums, to transform the art museum and represent experiences and constituencies that had been previously excluded. The contradictions in his texts are worth exploring at some length, because they represent the contest between the '68 aims of opening up and revolutionizing museums and the institutional pressures to maintain museums' national status. That these played out in the work of an influential and sympathetic individual shows the difficulties that museums and their would-be reformers faced.

The French government, which was greatly increasing the arts budgets and planning for a new modern art museum, was grappling with how to define the role of the museum and its place for contemporary art. These plans had been complicated by the fact that artists since 1968 had repeatedly protested state and city art exhibitions and demanded more democratic venues for their work. In 1971, the curators of the Paris Biennial tried to accommodate the demands artists had been making since 1968 by abolishing selection and opening up the exhibition to a broad cross-section of contemporary art. This new curatorial plan was

rejected, however, and it was never entirely clear whether the curatorial team had quit on its own or had been dismissed by the City of Paris and the Ministry of Cultural Affairs. In any case, it was clear that the new critics and curators who were hired for the project would have to work within the government's traditional exhibition structure and procedures of juried selection.

The issues of the representation of the museum and the government's selection of artists were raised again in the summer of 1972, when the government organized the Expo '72. The exhibition, as discussed in Chapter 3, was designed as a survey of the most recognized contemporary artists in France, yet was largely unsatisfactory to the public. Many artists and members of the art world raised critiques that had been voiced forcefully in May 1968. They saw the government promoting an elite stable of avant-garde artists that represented the interests of those in power and suppressing oppositional voices. Protesters called for more democratic venues for art that would represent the diversity of contemporary practice. The women's movement, for example, protested the fact that only two women artists were included in the exhibition.[42]

By 1973, the French government was greatly increasing the budget for the new museum project, but curators and state officials were still struggling to define the new museum and its relation to the public. Because the canon and traditional notions of *beaux-arts* had been attacked as elitist, the question for the future of the French museum remained: what new forms could provide a more democratic, inclusive, collective representation of the nation? And furthermore, how were curators to negotiate the balance between calls for an art of the everyday – an art that was politicized and socially situated – and the demand that the museum be accessible to all? Lascault faced this task when curating his exhibition *Cinq Musées personnels* for the Musée de Grenoble in the spring of 1973.[43] His text is particularly revealing because, in arguing that Messager's work constituted a personal museum, it highlighted the unresolvable tension between these two aims.

In *Cinq Musées personnels*, Messager's work was shown alongside the work of four other artists: Jean-Marie Bertholin, Christian Boltanski, Joel Fisher, and Thomas Kovachevich. In his catalog essay, Lascault presented these artists as exploring private experiences with materials and formats used in ethnographic museums, evoking those museums' treatments of utilitarian and everyday objects. Boltanski exhibited photographs representing the past and various projects under vitrines. Kovachevich displayed small, sealed packages enclosed in a vitrine, which emphasized the inaccessibility of the personal contents. Similarly, Bertholin showed

containers made out of cardboard and iron that would have to be destroyed to reveal their contents. Fisher displayed geometric forms made out of organic materials: hair, paper, and the artist's clothing. Messager exhibited stuffed birds, which she called her *pensionnaires*, and fictional diaries that described how she treated the birds as children by dressing and pretending to teach them. In notebooks and collection albums, she displayed drawings and clippings about men, marriage, and maternity (Figs. 70–1). Lascault described the artists as making "primitive" projects and notations to reflect personal experiences. Yet he also recognized the artists' staging of museum processes, calling the works "personal museums" and the artists, "ethnographers of themselves." He saw the works as ethnographic because they were composed of non-art materials, and some were displayed in vitrine cases which were common to ethnographic museums.

Lascault's concept of personal ethnography in this essay and exhibition was first of all a response to the protests that had been raised concerning previous attempts to democratize culture – typified, for Lascault, by Malraux's efforts to democratize art and create national culture through the *musée imaginaire* of masterworks. Lascault responded to the protests of 1968 in *Cinq Musées personnels* by rejecting Malraux's model of art history, and especially its emphasis on the great works of the past, which Malraux had believed contemporary artists were destined to incorporate into their own pieces. Instead, Lascault argued, contemporary artists were turning to ethnographic, "non-art" forms:

> In *Les Voix du silence*, André Malraux asserts that every important artist's vision is based on the paintings and statues of his predecessors; his practices rely on previous artists' practices, integrating or opposing them. Today this is no longer true. Certain producers of art (among the five exhibited in Grenoble, at least four) prefer to frequent ethnological museums.... Today many artists are fascinated by that which is situated, in dominant Western conceptions, the furthest from the aesthetic.[44]

Because the personal ethnographies did not appear to refer to the canon, Lascault saw them as being outside the politics and ideology of the *beaux-arts* tradition that had been rejected in the streets in 1968 and again by critics and artists in 1972. The types of quotidian, non-art materials that were used in the personal ethnographies had been seen by critics, such as the young Jean-Marc Poinsot, as "anti-art" and "anti-institutional," but Lascault argued, in implicit response, that these artists' work was not hostile to the museum or *beaux-arts* tradition, but merely outside it.[45]

Figure 70.
Annette Messager, *Les Pensionnaires*, 1972, and the *Cahiers* and *Albums collections*, 1971–73. Installation for the *Cinq Musées personnels* exhibition at the Musée de Grenoble, 1973. © 2005 Artists Rights Society (ARS), New York/ADAGP, Paris. Photo courtesy of the Musée de Grenoble.

Figure 71.
Annette Messager, *Le Mariage de Mademoiselle Annette Messager* (detail), 1971. © 2005 Artists Rights Society (ARS), New York/ADAGP, Paris. Photo courtesy of Annette Messager.

Lascault walked a delicate line: although he wanted to contend that these five artists avoided the politics of the canon – and therefore fulfilled the revolutionaries' demands – as a curator he could not dismiss the artistic tradition of the museum and the museum's social function as a representation of the nation.[46] Implicit in these tensions, and explicit later in his essay, was Lascault's struggle with the notion of the universal

humanist subject that underlay the very idea of the art of the museum as a universal representation of the nation.

In the second half of his *Cinq Musées personnels* catalog essay, Lascault focused on the nature of the subject represented in these personal, "auto-biographical" museums, using this as an opportunity to rethink the role of the museum:

> Thus, all of these personal museums do not constitute, by any means, monuments to those who produced them. They by no means refer to a psychological subject, to a person equipped with qualities, faculties, to a totality, master of himself and of the universe. Nor are they the property of a legal entity capable of distinguishing what is his and what belongs to others. The personal museums present themselves rather as an immense investigation of sexual difference, differences in age, the relations between the interior of my body, its surface, and the external universe.[47]

These projects did not represent humanist subjects whose experiences were coherent and therefore understandable and accessible, but rather fragmentary subjects whose experiences were contradictory and confusing. These collections of everyday, non-artistic objects, he claimed, brought into the museum experiences that had hitherto been excluded, revealing differences of sex and age, for example, in a way that questioned the presumed universality of the artist and viewer. Lascault challenged the humanist conception of knowledge upon which the museum had been based: that the meanings of art objects were self-evident and the audience's understanding of them complete, because the objects manifested universal experiences. His text described the confusion of the viewer confronted with a series of objects that evoked a wide range of varying experiences and that did not immediately allow for the spectators' identification. These personal ethnographies, Lascault asserted, "want to provoke questions about the limits of the hidden and the shown...the private and the public. Where are [my] desires located or not located? In which objects (that I gather together or invent) can I recognize myself and where am I led astray?"[48] Here he was wrestling with the implications of this exploration of difference within the museum. Once new experiences and voices took their place in museums, the former notion of the universal human subject that was addressed and represented in works of art no longer held. Lascault was therefore going two steps beyond Malraux, both bringing in everyday and ethnographic objects that had been previously excluded from the museum and recognizing their social specificity. At this moment,

then, Lascault was fulfilling for the art world the visions of thinkers from Michel de Certeau (who called for the museum to resist flattening out differences in its incorporation of new materials and perspectives) to spokespeople for the feminist movement who desired that new histories, new experiences, and the political issues that these entailed could come to occupy public space, institutions, and discourse.[49]

At the same time as this moment in which he acknowledged the truly radical nature of this recognition of difference, Lascault began retreating from these implications. Suddenly the collective "we" became prominent in his text, as he postulated an audience that was able to identify with the personal ethnographies and overcome their seeming foreignness. By describing the personal ethnographies as "[v]ague information which speaks from beyond us, that paradoxically, allows us to catch a glimpse, within ourselves, of that which is the least linked to our particular culture,"[50] Lascault failed to imagine that the audience might contain viewers for whom the objects on display were not extremely foreign. However, he implied that despite the initial foreignness of the ethnographic objects, the collective "we" would always be able to recognize elements of them within themselves. This move to transform objects that presented difference into objects that revealed commonalities attempted to universalize the significance of the objects, a move not unlike Malraux's vision of great art as a collective celebration of shared values.

Furthermore, in the *Cinq Musées personnels* catalog essay Lascault went to great lengths to deradicalize the critical content of the artists' personal ethnographies:

> These producers of art don't want…to put art in the streets.…Some [observers] will read at first sight an attack on the museal institution, a derision. But this critical function (voluntary or not) that the personal museums fulfill, is undoubtedly not the essential part.[51]

These projects were not political, Lascault contended, but remained in the realm of the individual. Lascault's emphasis on the personal nature of the projects suggested that contemporary practice had shifted away from political protest to introspective exploration. Each viewer, for example, could examine and identify with aspects of Boltanski's childhood memories or Messager's diaries of daily life. The museum, Lascault argued, had become the very place to explore the new conception of the individual subject, and ethnography provided a democratic mode of exhibition. The museum no longer needed to be overturned; instead, Lascault found it responsive to new demands.

Lascault's project was progressive in that it sought to respond to the '68 critiques of the museum as elitist by now proposing that everyday objects be brought into the museum. Lascault drew on language popularized in '68 concerning the accessibility of the everyday objects of ethnography. But in doing so, he overlooked the fact that Messager's images had their sources in specifically feminine realms – the girls' curriculum and the women's press – and thus her work would not have been equally accessible to all viewers, but would particularly resonate for women who consumed these images in the schools and in the home. Further, Messager's detailed, drill-like repetition of the lessons suggested that the everyday could be a site of order and control, and not simply a site of revolutionary promise.

Lascault celebrated the entrance of Messager's everyday materials into the museum, but downplayed the gendered dimension of that gesture. He analyzed Messager's representations of everyday experiences and collecting practices in the same general terms as those of her male colleagues – and his argument became one of the important interpretations of her work. Lascault himself was not unaware of a potential feminist meaning in Messager's work. In fact, in an article in the *Chroniques de l'art vivant* that he wrote the same year as the exhibition, he interpreted her collections as an expression of feminine creativity.[52] However, as a curator in a public institution in the early 1970s, his aim to renew the viability of the museum was paramount, and the aspects of Messager's work that would not have universal resonance were quickly passed over. By universalizing her materials as new sources for art (and evoking a more utopian vision of the everyday), his interpretation lost sight of the issues that informed feminist debates on the everyday in the wake of '68 – the very debates within which her materials situated themselves.

Overall, I have emphasized how Messager's work critiqued the ways in which women's everyday life was shaped by cultural institutions, such as the education system and the feminine press, which trained women into domestic roles. Recognizing the complex ways that Messager was addressing the issues of women's everyday life in the 1970s is crucial to achieve a more complete picture of French feminist art, which has often been seen as simply arguing that women's work should be salvaged and celebrated as an expression of feminine experience.[53] Messager's rich and nuanced analysis of the politics of the everyday shows how this complexity was overlooked within the broad trends in French cultural politics after 1968. In the early 1970s, bringing everyday objects into the museum was often seen as a solution for restoring democratic values and universal appeal to the museum after the strong challenges of 1968.

Yet Messager's work illustrates that the idea of the everyday – though a source of great promise – was never universal and was by no means straightforwardly liberatory.

Messager's work of the early 1970s could only with difficulty be fit into the rhetoric of universal appeal. The work's gendered specificity, Lascault found, had to be swiftly pushed aside when it was brought into the institution of the museum. It is perhaps for this reason that her work enjoyed less institutional support than Boltanski's. Whereas Boltanski's work was consistently promoted as universal and took off, receiving a series of prominent exhibitions in national museums and commercial success, Messager's depictions of women's everyday experience could not be so easily made to inhabit the position of universality as Boltanski's did. Thus, her projects were sometimes dismissed as "women's work." Although she would consistently participate in group shows in France and abroad, the 1974 exhibition was her last solo exhibition in a French museum in that decade, and few museums purchased her work. Moreover, she was not commercially represented by a gallery in Paris until 1978. In the next chapter I will explore the way this dynamic between the particular social identities referenced in the artists' work and the universal impulse of the museum played out as the Pompidou Center opened and dramatically changed the cultural landscape in France. Whereas differences in social class in Boltanski's work could be pushed aside in mainstream criticism, the gender differences in Messager's work could not be overlooked so easily and evoked how representations of masculinity continued to function as the basis of the museum's universal, while representations of femininity remained overly specific, unable to serve the museum's continued desire to consolidate a national audience.

5 INSTITUTIONALIZING '68

THE POMPIDOU CENTER

■■

On January 31, 1977, to great fanfare and great controversy, the President of France, Valéry Giscard d'Estaing, opened a new museum of modern art in Paris, as part of a complex of cultural institutions that was named the Pompidou Center, after the former President who had conceived plans for it eight years earlier. The building that housed the new museum was unlike anything in Paris: glass walls created a transparent sheath that opened up the interior to viewers on the street, while escalators and brightly colored pipes wound around the exterior as if the structure had been turned inside out (Fig. 72). Its exhibition spaces, too, marked a break with conventions of museum display: movable walls and panels made the interior flexible, changeable, a far cry from the stately – and static – rooms of the Louvre. Whether drawn in by the sights visible through the building's transparent skin, by the notoriety of the architecture itself, or by a desire to experience the excitement and spectacle of the museum, crowds flocked to the center. Indeed, the center attracted record numbers of visitors, welcoming over 20,000 per day.[1] In the years since its creation, it has become a prototype for museum development around the world: blockbuster shows and pedagogical tools such as recorded tours, innovative buildings and exhibition spaces, lively interiors filled with temporary exhibits and engaging activities – all blossomed in the Pompidou.

Transparent, open, flexible, crowded, user-friendly: at first glance, it might seem that the planners and cultural policy makers who had set out in the early 1970s to design the Pompidou as the first cultural center to respond to the May '68 demands that the museum be radically transformed had realized their aims. And in many respects, themes recognizable from the political agendas of '68 can be seen at play in the new center. The planners obviously did not take up the most extreme suggestion to emerge from the '68 protests: that the museum be abolished. Instead they focused on the call to democratize the museum. However, in attempting to institutionalize this demand, the center transformed and de-radicalized the terms of democratization. In 1968 and the years immediately following, concepts of everyday life had generated the crucial politically radical and anti-elitist strategies advocated for transforming art and democratizing the art world. By the time the

Pompidou Center was opened in 1977, however, the grounds for democracy and accessibility had shifted; the '68 activists' concept of an art of the everyday – that is, an art grounded in spontaneous creativity, the politics of the streets, the working classes, and later, feminism – had been winnowed down by the center to a view of the everyday as popular entertainment, mass media, and commodity culture, seen as the new common ground in which the French audience could find itself. To this end the planners constructed the building as an entertainment center: the museum's exhibitions leaned heavily on the familiar images of Pop Art; its entrance halls dazzled visitors with dynamic art displays that riveted the attention of all who entered; escalators whisked viewers from floor to floor alongside the glass wall, providing a changing view of the Parisian streetscape and finally depositing them at the top floor where they could take in spectacular views of the city while enjoying coffee at the museum café; when it was time to go, viewers could stop off at the museum shop prominently located near the entrance hall to purchase a souvenir of the visit. The experience of art was thus rendered part of a broader complex of spectacular leisure activity and opportunities for consumption. Artists themselves employed the imagery of mass culture and entertainment in ways that challenged the framing of their work as an accessible spectacle, continuing the critical focus on the museum and its audience from a decade earlier. However, the museum itself, seeking to enhance its status and promote its responsiveness, could not highlight and in some cases even accommodate these continued challenges.

DEMOCRACY, PRESTIGE, AND ENTERTAINMENT

In 1969, no less a figure than the President, Georges Pompidou, declared the importance of renewing a French cultural center to establish the prominence of France on an international art scene that was dominated by the United States: "I passionately wanted for Paris to possess a cultural center like those that the United States has sought to construct."[2] (Pompidou himself would not live to see the center that was to realize his dream, dying of leukemia in 1974.) The way that Paris had slipped behind had been made emphatically clear by the 1968 protesters who saw French art institutions as hopelessly out of date and out of touch with everyday life and the political issues of the present, as well as the vital international contemporary art movements that were increasingly centered in the United States. Though President Pompidou and the protesters of 1968 did not share political sympathies, they did agree that the French museums were in need of modernization if they were to retake their – in Pompidou's view at least – rightful place at the forefront of world

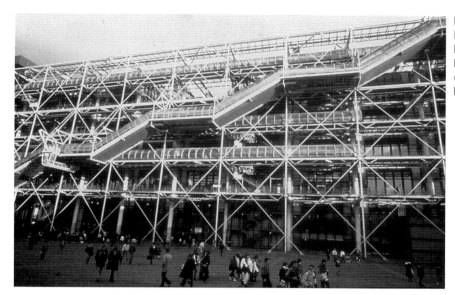

Figure 72.
Renzo Piano and Richard Rogers, The
Pompidou Center, pictured in the
late 1970s. Photo: D. Gliksman,
© MNAM-CCI Documentation
Photographique des Collections.

culture. In constructing the new cultural center, the government-appointed planners could not simply produce more and larger versions of what had come before.[3] Faced with the difficulty of responding to the varied, sometimes contradictory, and sometimes intractably hostile demands of 1968, the planners focused on the call to create a democratic, accessible, politically responsive art museum. The complex that emerged from these concerns, Beaubourg, officially named the Centre National d'Art et de Culture Georges Pompidou, contained four cultural institutions: the updated Musée National d'Art Moderne (MNAM), public library (BPI), Center for Industrial Creation (CCI), and Institute for Musical Research (IRCAM), under the direction of Pontus Hulten, Jean-Pierre Seguin, François Mathey, and Pierre Boulez, respectively. The Pompidou Center was the first and most ambitious wide-ranging cultural program that France had undertaken since the *maisons de la culture* were established under Malraux in the 1960s. Unlike those institutions, which had as their mission the democratization of a restricted vision of French artistic excellence, the Pompidou Center was intended to respond to the 1968 vision of a different kind of democracy, one that engaged with the everyday politics of the street and the people. In its location, architecture, programs, and curatorial mission, the Pompidou was to be a newly vital, democratic kind of cultural institution.[4]

The Pompidou Center was an enormous undertaking with an immense new budget that generated an appropriately huge controversy (over 900 million francs were spent on the center from 1971 to 1977).[5]

The project was subject to numerous attacks focusing on the architecture, the gentrification of the neighborhood that its construction entailed, the centralized location of the museum in Paris, the concentration of arts funding in the capital, and, despite the planners' efforts, the bourgeois nature of the museum. The rhetoric of democratization in which the government couched its discussions of the location, architecture, programming, layout, and budgets of the center was thus useful to respond not only to the critiques of a few years earlier but also to the vociferous contemporary criticism. But in the process of actualizing these democratic intentions, the aims themselves became transformed by the center, and despite the center's many successes, the resulting effects often failed to live up to the fullest promise of the rhetoric.

The location of the center was the government's first step towards producing the new kind of cultural institution that the protesters in 1968 had demanded. During the early stages of the project, President Pompidou argued that locating the center in the working-class neighborhood of Beaubourg would be a sign of its accessibility to all people and would thus remedy the class bias of the museum. Indeed, the central location and extended opening hours (10 A.M. to 10 P.M.) made the center more easily available. As Claude Mollard, the Secretary General of the center put it: "The President of the Republic himself wished for the center to be established in a working-class neighborhood and open to a very broad public: the cultural events should not remain in spirit the privilege of a small, elite [group]."[6] Yet despite these very real moves towards accessibility, the government's vision of democracy as an expansion of access to great works of art simply repeated problematic elements of previous cultural policy such as Malraux's *maisons de la culture*. Simply making art physically accessible, the revolutionaries of '68 argued, was not enough to achieve true cultural democratization. The *maisons de la culture* model and the *beaux-arts* tradition it contained would simply force bourgeois culture and its values on the entire population; new forms of art based on the public's interests and needs were required for true democratization. These specific objectives of creating art and museums that would empower marginalized social groups were downplayed in the planning for the Pompidou, however, as democratization was once again treated largely as a question of location and physical access.

One of the practical reasons that the government chose Beaubourg as the location of the center was to facilitate the razing and renovation of parts of the neighborhood. The Beaubourg area had served no particular purpose since 1936, when slum housing at the site was destroyed, and was used as a parking lot in the 1960s. The construction of the center

thus seemed to the government an ideal opportunity to rejuvenate a shabby neighborhood situated in a prime location. To this end, one of the reasons the building design by Richard Rogers and Renzo Piano was selected out of the 681 competition entries for the center was that it included plans for developing the surrounding area by adding parks and pedestrian zones and improving primary routes to the center.[7] Once the construction of the center had begun, it was linked with other renovations in the neighborhood, including the demolition of the pavilions at Les Halles, a longstanding working-class marketplace, and the construction of the underground shopping forum and RER metro station, which, it was hoped, would draw tourists.[8] The areas directly north and west of Beaubourg were also renovated.

The effects of these renovations for the project of democratization were, at best, mixed. Although the intent was to place the center in a working-class neighborhood to facilitate access by local residents, the gentrification caused by the construction of the center and transformation of the area would force many working-class residents out.[9] The government made some efforts to limit real estate speculation in the neighborhood, yet Mollard admitted that the state could neither prevent nor control gentrification. Thousands of people visited the center each day – many of them tourists – but not necessarily the members of the working class whose inclusion the location of the center had been intended to promote. A 1977 survey of the center's visitors showed that roughly 35% were students, 28% were from the middle class, 26% from the upper class, and only 6% from the working class. Geographically, 70% of the visitors were from Paris and its suburbs and 20% from the provinces, whereas 11% were foreign tourists.[10]

Finally, the claims that the Pompidou was broadening outreach were problematic in that the project called for massive expenditures to be used once more to create another museum for Paris. Indeed, the Pompidou Center's annual operating budget for 1977 was 138,408,000 francs, more than the total state budget for the national museums (which were concentrated in Paris), and the *musées classés* and *musées contrôlés* (which were located primarily in the provinces).[11] Clearly, the construction of the center exacerbated the immense discrepancy in cultural resources allocated to Paris and the provinces. Indeed, provincial museums could not possibly compete with the center. The inaugural *Marcel Duchamp* exhibition at the Pompidou cost 1.5 million francs, for example, and the *Paris-New York* show, also held in 1977, cost over 3.1 million.[12] Michel Guy, the former Minister of Culture, claimed that Beaubourg would fulfill an important role as a "center of decentralization" where resources

could be gathered together and then transmitted to the provinces.[13] This promise was not entirely fulfilled, although some efforts were made. The Musée National d'Art Moderne located in the Pompidou Center created numerous exhibitions that traveled to provincial cities. Furthermore, traveling exhibitions curated by the MNAM helped to circulate and promote French art abroad. However, even these efforts at extension remained fundamentally similar to Malraux's *maisons de la culture:* high culture was disseminated from the capital, but the MNAM did not aid the development of regionally based art or institutions. Even though provincial museums' resources increased after 1977, because of their relatively small budgets many could not afford to organize large-scale exhibitions on their own, and they were thus inclined to take traveling shows curated by the center. In this respect the Pompidou proved to follow the pattern of Malraux's *maisons de la culture*, dispensing culture from the capital to the provinces.

Some members of the art world argued that reinvigorating the market was a way of encouraging outlets for French art through private channels. The Pompidou Center was, as observers at the time noted, expected to serve "as a catalyst for reinstating Paris as the center of the world, or at least the European, art market."[14] And to an extent this project was successful. Whereas no galleries were established near the modest MNAM when it had been located at the Palais de Tokyo in the 1960s, roughly thirty galleries moved to surround the Pompidou Center, making the neighborhood one of the major art centers in Paris. The critic Nancy Marmer described the transformations in the neighborhood thus:

> [F]or the past three or four years…[the Beaubourg area] has been in the metamorphic, traffic-disrupting, ear-splitting process of becoming a high-rent location for editorial offices, publishing houses, architects, and boutiques. Most notably, it has become the prime area for a growing throng of galleries, so many of which have moved to or newly opened in the quarter that good space and tolerable rents are now said to be impossible to find. And all in anticipation of the excitement to be generated by Beaubourg, and to take advantage of the irresistible craving to possess art that is presumably about to be stimulated by the visual arts program of the center.[15]

By drawing galleries to the neighborhood, the Pompidou was expected to open new channels for the development of French art. Others, however, such as the PSU (*Parti Socialiste Unifié*) raised concerns that

the conglomeration of public and private support formed by the new institution of the Pompidou Center along with the gallery networks from which they purchased work and the presses such as Flammarion that published museum catalogs aided a select few artists while neglecting many others, flattening out the texture and diversity of the contemporary art scene.[16]

Another fundamental way that plans for the Pompidou Center claimed to address the question of transforming the museum's contemporary role was through the architecture of the building: openness, flexibility, and an engagement with the outside world were to replace the "museum-cemeteries," dead spaces filled with collections that looked toward the past and were out of touch with the present that many art world activists had complained of in 1968. The architecture of the Pompidou Center appeared to express the aspirations of those '68 activists who argued that art lived in the everyday activities of the street and its political events and happenings. By creating flexibility within the museum space and dissolving borders between the street and museum, the architecture was to open itself up to the street as the site of spontaneous creative expression. The building – essentially a large box with moveable panels on each floor – was described as "flexible" and "polyvalent." The modifiability of the spaces was intended to make the museum not "dead" or frozen in time but "living" and "adaptable to the interests of the public."[17] In addition, the transparency of the glass façade was to encourage exchange between the internal activities and exterior surroundings, preventing the seclusion of the museum and promoting cultural diffusion. The location of the entrance of the building on a public square was also seen to represent the building's "openness to the city."[18]

The industrial aesthetic of the center, which was fundamentally a glass box with pipes, ducts, and escalators on the exterior of the building, was strikingly different from previous French museums and elicited controversy and criticism from different constituencies and perspectives. Some donors and traditionalists asserted that the center did not look like a museum should, while others objected to it on nationalist grounds – the building was not designed by a French architect and did not represent a "French style." Others simply complained that the center was a "factory," an ugly and industrial blemish amid the historic buildings of Paris. Despite the museum's efforts to construct itself as a "place for everyone," it ended up dramatizing the impossibility inherent in imagining a universal public.[19]

To more progressive critics and members of the art world, this new design had not managed to break out of the museum-cemetery model.

For example, in his 1974 article in *L'Express*, Pierre Schneider criticized the center as "a transparent coffin" cut off from daily life and lived experience:

> Changing walls into movable panels, printed guides into cassettes, and guards into hostesses, only modifies the appearance but not the essence. The basis is immutable: it's the museum, which has conformed to society's conception of the role of art since the advent of the bourgeoisie.[20]

Schneider's complaint and those of others were prompted by the way the MNAM was incorporated into the new center. This museum, which had been the focus of specific protests in 1968, was relocated in the Pompidou, and although new acquisitions and displays differentiated it from its 1960s version, its core collection, which had drawn such ire, remained intact. Mollard conceded that the museum's structure was indeed more traditional than that of the other institutions within the Pompidou, but the center's layout was supposed to compensate for it. For example, the "openness" of the building was meant to encourage people who came for the museum to become interested and involved in other aspects of contemporary culture that were also housed in the center such as the Institute for Musical Research, the free exhibitions, the Center for Industrial Creation, and the public library.[21]

The center's architectural efforts to promote vitality, openness, and accessibility, though not universally acknowledged to be a success, were repeated in the museum's programming. To try to overcome the general public's lack of background in art and consequent feelings of intimidation and exclusion, the center and its exhibitions were designed to resemble mass cultural entertainment, which was supposedly available to all. (This notion had a pedigree in cultural policy: even Malraux, though he disdained the contemporary mass media, had seen it as a natural tool of democratization and had sought to use its technologies, such as photography, as a means to spread experience of the elite treasures of French art museums.) In this effort, the center's planners were responding to long-standing and varied criticisms of the operations of the museum. The planners had, for example, been well aware of Bourdieu's famous study *The Love of Art* (1966), which described the class bias of the museum, perpetuated by public schools that presupposed a general knowledge of culture that was never formally taught, but was available only to middle-class and upper-class children who had gained a cultural education through their upbringing.[22] The lack of information in museums to help working-class

audiences understand the works merely reinforced their feelings of exclusion from culture. The more welcoming manner of American museums, with their cafés, bookstores, and guided tours that were designed to draw in and help inexperienced viewers rather than overwhelm them, could assist in making up for early familial disadvantages and the failure of the school system to provide equal access to comprehensive art education (the primary culprits, according to Bourdieu, through which unequal access to culture reproduced the social hierarchy). But the Pompidou Center planners were also cognizant of the critiques Bourdieu faced in 1968 from many student protesters and even some directors of the *maisons de la culture*, who decried his emphasis on "high art," the museum, and academic preparation as elitist, a model of democratization that merely imposed a predetermined set of art objects and interpretations on diverse audiences that might or might not find them relevant to their lives. These protesters called for new forms of art and education suited to the public's interests and needs, though they did not provide a clear sense of what form they would take.

The center's planners and museum's curators, in other words, needed to balance calls on the one hand for more interpretive aids to make contemporary art accessible to the public, with their own fears, on the other hand, of being accused of imposing elitist objects, interpretations, and thus "ideologies" on spectators.[23] The compromise they struck between the contradictory demands to teach the canon to make it accessible, and to level the canon altogether, involved multiple approaches. De-emphasizing the traditional canon, they cast the Pompidou Center as "a building for information, culture, and entertainment."[24] The building contained a library and a museum, but many of the center's visitors came for the kinds of sites and activities that Bourdieu had approved of as a means to draw in visitors, such as the café, store, and view of the city from the top floor. While high art was shown, the curators downplayed the scholarly background that was necessary to understand it to make it seem accessible to all. Free exhibitions were designed with an eye to amusement and interaction. The museum's collection prominently featured works of Pop Art that were embedded in the vocabulary of the mass media and advertising, evoking a resonance with contemporary, urban culture with which the curators contended all could identify. The consumption of culture was thus promoted as a form of entertainment. In fact, Mollard himself described the center as entertaining and fun, a space of leisure and games.[25] No longer the quiet, contemplative, reverential museum that had been attacked in '68, the center was crowded with people pouring in.

AN INFORMATION CENTER

In an implicit response to both Bourdieu and the '68 critiques, the museum changed its pedagogical focus and tactics: planners saw its task as appealing to a public in order to spark its interest in art, rather than considering the public's interest and respect art's mere due. To this end, instead of seeing the center's mission as teaching the appropriate academic background for art and cultivating viewers' cultural sensibility, planners instead tried to strike a much less didactic tone, emphasizing "providing information" that the viewer could sample at will.

In the interest of furnishing "information," the center began publishing immense exhibition catalogs, inexpensive museum guides (called *Le Petit Journal*), and specialized reviews associated with the three departments of the center.[26] But the institution that would perhaps have the greatest impact in this direction was the "public information library" or BPI. The BPI's founder, Jean-Pierre Seguin, sought to bring down barriers that had previously excluded the general public from such institutions. Unlike other Parisian research libraries, no academic affiliation was necessary and there were no admission fees. Furthermore, the library remained open past regular working hours – until 10 P.M. on weekdays and weekends. Even more unusual, the public had the freedom to browse the open-access bookshelves. In addition, significant numbers of library staff were stationed in the reading rooms to assist with reference questions. In fact, half of the entries to the Pompidou Center were for the BPI; long waiting lines for entrance to the library then (and now) indicate how much this resource was needed in Paris. The library collections were intended to feature information about current events and the contemporary world, providing general rather than specialized coverage in order to reach a broad public. In keeping with the interdisciplinary and mass media emphasis of the center, the BPI collections featured contemporary audiovisual material covering a range of subjects. This equipment, extremely novel in France at the time, included an audio language lab, photographic image archives, and recent musical recordings, which, in the words of the library staff, were all readily available for "consultation and relaxation."[27]

One clear indication of the way the Pompidou Center was conceived as an information center was the presence in the planning stages of a media wall, a wall of electronic signs and projection screens that featured prominently in the architects' presentation drawings for the main façade.[28] The wall, intended to diffuse social and cultural information, sought to exemplify the kind of engagement with politics that earlier protesters had demanded. Indeed, the presentation drawings seemed to

go out of their way to highlight a sense of engagement with the politics of the streets by depicting images of soldiers in the Vietnam War, thus recalling a major impetus for the 1968 protests. The presence of the media wall in the planning stages indicates the way the Pompidou Center was conceived as a "live center of information" rather than a cultural temple.

However, this invocation of recent political upheaval proved to be too much for the center's planners to stomach, and the media wall was never built. In an interview published concurrently with the opening of the center, architects Rogers and Piano explained that the media wall, which was to express the function of the center as a transmitter of social and cultural information, was not completed because of its possible political usage and ramifications:

> The building was conceived as a tool (for diversified evolving activities) whose exterior should have been the contact surface... a surface of screens – TV screens, movie screens, written messages, newsreels.... In reality this proved very difficult, and not for technical reasons, because the building, as it is, can be used to that end at any time.... The difficulties are of a political nature. Clearly it's very interesting to talk about information, but right away there are those that ask themselves: what type of information? The center would have become an information center in the heart of Paris, a small, independent and autonomous O.R.T.F. [broadcasting service]. And the beginnings of a center for free information that the students could have occupied and put to highly effective use was something very threatening.[29]

The planners of the center, Rogers explained, were afraid "to end up with, despite themselves, a monument whose consequences they could not control, notably the political ones."[30] Thus, despite the real accomplishments of its library and publications, the Pompidou stopped short of embodying the fullest possible imagining of a politically engaged center for information, as some types of information were deemed potentially too volatile to include. Though the center's planners wanted to respond to '68, they did not want to repeat '68 by triggering unsanctioned broadcasts and occupations.

ENTERTAINMENT: LEISURE AND GAMES

According to Piano, it was Rogers who came up with the solution to the dilemma of responding to without repeating '68, when he "immediately thought... of an alternative proposition, of a large building that would

not be a monument, but a festival, a large urban toy."[31] The language of festivals and play in Rogers' description recalls both Lefebvre's and the Situationists' notions of the everyday as a site for new, creative politics, but the way this was carried out in the execution of the building would have been unlikely to satisfy these theorists. Instead, in the name of increasing access to "culture," artworks within – especially those presented in the entrance hall – were often framed as spectacular games and popular entertainment.

In framing the center as a toy, the architects evoked the approach taken up by Pontus Hulten, the first director of the new Musée National d'Art Moderne, who profoundly shaped the form of the center as well as the museum's exhibitions and programming. (By 1973, when he became the MNAM's director, Hulten had already established his international reputation as the director of the Moderna Museet in Stockholm.)[32] Hulten favored staging activities and sensational events, as well as multiplying the number of exhibitions, in order to draw in large (and especially young) audiences, to integrate the museum into its urban environment, and to desacralize the idea of culture. Rather than making a museum as solemn as a cathedral, Hulten chose to make a fun fair, a museum that would not intimidate people but rather show them that culture was a vigorous part of daily life.

To this end, Hulten wanted the center's expansive entrance hall to show playful, dynamic works of art that would draw in the public and encourage them to "participate" in the cultural life of the center.[33] For example, in 1977, repeating a strategy he had used with success in the Moderna Museet, Hulten commissioned the artists Jean Tinguely, Niki de Saint-Phalle, and Bernard Luginbühl to create an immense installation in the hall; the result was the *Crocrodrome*, an immense, mechanized sculpture composed of giant gears and outdated industrial parts covered in plaster, creating a giant moving crocodile that opened and closed its jaws when operated (Fig. 73). The project also included a school of fish, a teddy bear, and a giant pinball machine. This sort of massive, environmental installation became typical for the center's foyer; because the installation was directly accessible to visitors, Hulten saw it as inviting public participation. In fact, Tinguely's mechanized and animated sculptures were frequently exhibited in the entrance hall, because their movement was seen by curators as a means to attract viewers' attention.

In his introductory wall plaque, Hulten described the *Crocrodrome* in terms that recall the '68 rhetoric of rendering art democratic by joining it with everyday life: the *Crocrodrome* was, in his words, a "joyful art, freed from the constraints of the commercial object, dynamic, active,

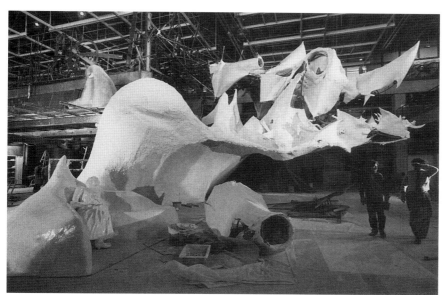

living in symbiosis with a public which is no longer an 'audience' but an integral part. A new world where the lines separating Life and Art have entirely disappeared."[34] Tinguely's project statement was also displayed, which characterized the work as the "phantom of functionalism, the Anti-Center." Implying that the clanking machinery of the sculpture grated against the smooth functionalism of the center, Tinguely asserted that "the *Crocrodrome* was not unproblematic."[35] Although Tinguely claimed the work was a provocation, his terms were perhaps better applied to sculptures that he had created in the 1960s, such as the self-destructing machines, composed of urban detritus and rusted, noisy moving parts that burst into flame, which suggested a cynical view of industrial progress and the consumption of mass-produced commodities. But the *Crocrodrome*, with its whimsical animal characters and built-in pinball game, was playful and amusing and did not appear to elicit the critical interpretation the artist ascribed to it.

In essence, Hulten's goal in displaying this kind of work was to try to spark the general public's interest in art rather than to teach in-depth culture. But in such attempts to attract a broad public, other types of cultural experience were sacrificed, notably the kind of understanding of art that Bourdieu had hoped to advance. The educational mission was not absent from the center: in addition to the library and publications, the museum did offer children's classes designed to sensitize a new generation of museum visitors to contemporary art, and it featured some

docent-led tours. But by and large, the educational aura of the museum directed by Hulten was overshadowed by the effects of the center's entertainment objectives. Although high art remained on display upstairs in the museum, the framing it received from such lighthearted, whimsical entrance hall displays could lead viewers to experience it in a distracted, almost touristic fashion. Mere participation in the museum, in the sense of attendance, became a source for satisfaction, in much the same way that the notion of "access" had been a touchstone for Malraux. But the question of the value of the public's experience was elided, and the full political objectives behind the call for a democratic museum were not achieved.

Ultimately, the measure of the center's success became quantitative – with the government boasting about the number of people who entered the building, whatever their purpose – rather than qualitative – focused on the content of their experience. As Jean Baudrillard, probably the most famous critic of the center saw it, the crowds that flocked to the museum could not be seen as a triumph in which culture was brought to life in the presence of new audiences. Instead,

> This new museum presents itself in such a way as to try and salvage the humanist myth of culture, but in truth what one is witnessing in Beaubourg is the death of culture, and in reality the masses are blithely being invited to come along and help mourn its passing. And they come in their hordes. This is the supreme irony of Beaubourg: the masses come thronging in, not because they are drooling over the idea of having access to culture – of which they have supposedly been deprived for centuries – but because, for the first time, they have in their thousands the opportunity to join in a massive act of mourning over a culture which they have basically always loathed.[36]

But despite his invocation of the crowd's resistant capacities in this quotation, Baudrillard feared that the Pompidou Center was an extreme example of the "supermarket of culture" in which people poured through the museum as voracious consumers of its superficial pleasures.

FROM POPULAR TO POP: THE MUSEUM AND ITS AUDIENCE

The crowds flocking to Beaubourg, enjoying its café and store, and browsing and sometimes buying in the surrounding galleries, certainly signaled that in at least one significant sense the new center was popular. But the

strategies it used to achieve this popularity involved changes in the notion of the popular that altered the terms in which it had been invoked in earlier critiques of the museum. In the first place, the center's planners did not strive to foster a culture of "the people" – emerging from and instrumental for the disenfranchised classes – a concept that had been vital in the 1968 artists' protests and the *atelier populaire*.[37] And apart from making audiovisual and recording equipment available to artists, significant space, resources, and programs were not devoted to encouraging contemporary visual artists' creation. Instead, the center promoted a "popular culture" measured by the number of people addressed, along the lines of the model supplied by mass culture and entertainment. The '68 concept of popular culture as grounded in the working class was thus effectively depoliticized and transformed into a mass cultural vision that was seen to affect and appeal to all classes in the same way, a *lingua franca* that all could share equally.

Pop Art, which formed a considerable part of the MNAM's new acquisitions, was appealing to curators like Hulten in part because it seemed to offer a connection to the everyday reality of its audience. The Pop vocabulary of urban objects, advertising, and mass-produced commodities was seen as a way to make advanced art accessible to museum-goers whose interests were increasingly rooted in mass culture. Pop Art thus seemed to address the complaint that museums presented academic, "dead" art, and an elitist vision of culture. In addition, developing a focus on this style seemed to serve the aim of restoring the French – and especially Parisian – art worlds to a place of international preeminence. For Hulten, trying to constitute the MNAM simultaneously as a new kind of museum, one that responded to the 1968 critiques with a broadly democratic stance and appeal, and as a museum that restored French greatness, a focus on Pop Art seemed ideal for both purposes.

Upon Hulten's arrival in 1973, the museum at the Pompidou gave signs of a new direction. In reaction to the collections and exhibitions of the MNAM of the 1960s, which had focused on the Ecole de Paris (French and foreign-born artists working in Paris), the Pompidou's exhibitions would stress "internationalism," especially Paris's role in the development of major artistic movements of the twentieth century. Making this possible was the fact that the museum finally obtained an independent budget for the acquisition of artwork, which allowed curators to circumvent the institutions that had prevented the purchase of contemporary and international art at the former MNAM.[38] The curators used the inaugural exhibitions to acquire important examples of Dadaism, Surrealism, Constructivism, Abstract Expressionism, Pop Art, and

Figure 74.
Pop Art and *Nouveau Réalisme* in the *Paris-New York* exhibition, Musée National d'Art Moderne, Paris, 1977. Photo: Jacques Faujour, © Bibliothèque Kandinsky, Centre de Documentation et de Recherche du Musée.

Minimalism – movements that were underrepresented or almost entirely absent from the MNAM's collection.

Hulten conceived the 1977 exhibition *Paris-New York* as a means of setting forth this new internationalism.[39] As Romy Golan has argued, Hulten accepted that Paris had lost to New York its status as the capital of the western art world. The *Paris-New York* exhibition was to redress that loss, and, like the creation of the Pompidou Center itself, was to put Paris back at the center of the international art world.[40] The enormous 729-page exhibition catalog, written mostly by the center's curators, detailed interactions between French and American artists, critics, gallery owners, and curators, creating a picture of continuous artistic exchange spanning the period from 1905 to 1968. A disproportionate share of the catalog – six chapters – was devoted to European and American Pop Art, which was also emphasized in both the *Paris-New York* show and the installation of the MNAM's permanent collection in the new Pompidou space.

But why Pop? Unlike the other major, recent artistic movements – Lyrical Abstraction, in which French painting styles and aesthetic debates had few parallels to American Abstract Expressionism, and American Minimalism, which had no counterpart in France – Pop Art could, at least superficially, be argued to have developed simultaneously and collaboratively on both sides of the Atlantic. To this end, the *nouveaux réalistes* (including Jean Tinguely, Niki de Saint-Phalle, Arman, and César), who worked in France, were presented as the aesthetic contemporaries and

Figure 75.
(from left) Nina Kandinsky, Pontus
Hulten, Michel d'Ornano, and
Claude Pompidou view Jean
Tinguely's *Méta-matic no.19*, 1959,
at the opening of the *Paris-New York*
exhibition, Musée National d'Art
Moderne, Paris, 1977. Photo: Jacques
Faujour, © Bibliothèque Kandinsky,
Centre de Documentation et de
Recherche du Musée.

colleagues of the American Pop artists (particularly Robert Rauschenberg,
Jasper Johns, Andy Warhol, and John Chamberlain) (Fig. 74). Further-
more, the way the "parallels" between the works were concretized was
through the influence of the Dadaist Marcel Duchamp, perhaps the
foremost twentieth-century example of a native French artist who had
had tremendous influence in America, whose retrospective was held at
the Pompidou just before the opening of the *Paris-New York* show.[41]
Duchamp's use of mass-produced objects in his famous "readymades"
was presented as evidence of a freedom from "aesthetic preoccupations"
which Hulten claimed could "reconcile Art and the People."[42] Hulten
drew a direct connection between Duchamp and this generation of 1950s
and '60s artists who incorporated mass-produced images and industrial
objects in their work.[43]

Hulten's catalog essay primarily treated the works in the exhibition as
revelations of "artistic exchange," but another current emphasized the
use the artists made of materials and images from everyday life. Hulten
saw similarities between Tinguely, Saint-Phalle, Rauschenberg, and Johns
in their use of material from everyday life and ironic reactions to gestural
abstraction. In his catalog commentary on Tinguely's *Méta-matic no. 19*
(1959), a machine with a metallic arm that made painted marks on paper
clipped to an easel, Hulten downplayed the latter interpretation in favor
of the former (Fig. 75). This is in many ways a surprising interpretive

choice – after all, it did not take much stretching to read Tinguely's sculpture, in which with the push of a button the viewer could set in motion the repetitive production of "original" abstract paintings, as a parody through mechanization of the idea of the abstract painter's revelation of his innermost creative expression in his work. But in the *Paris-New York* catalog entry, Hulten emphasized instead the connection to the readymade:

> The drawing machine is an invention whose significance is as fundamental…as that of the "readymade"….
>
> We have often emphasized a certain irony with regard to *tachisme*, [which was] dominant in Paris in 1959…. The "méta-matic" idea encompasses much more than a simple ironical commentary on *tachisme*. As in the case with the self-destructing work, it is about a work becoming an object of metaphysical meditation and whose aesthetic context is enlarged.[44]

The interpretation of Tinguely's sculpture as a cynical critique of abstraction was de-emphasized in favor of "metaphysical meditation" and an enlarged aesthetic field – that is, the idea that anything can be art. By highlighting the connection to an art form drawn from the everyday, Hulten fit Tinguely's sculpture into the new museum's emphasis on everyday materials as a point of connection and inclusiveness for a broad audience.[45]

In framing the *nouveaux réalistes* in the *Paris-New York* show, the catalog furthermore leaned heavily on the terms of its major promoter, Pierre Restany, an extremely influential, entrepreneurial figure. Restany had celebrated the new realism movement as a rejection of the individualist gestures of abstract painting in favor of a positive embrace of "the city, the street, the factory, mass production."[46] The *Paris-New York* catalog quoted Restany at some length, emphasizing the artists' immersion in the world around them:

> What we are in the process of discovering, in Europe as much as in the United States, is a new source of nature, of our contemporary nature, [which is] industrial, mechanical, promotional…. That which is the reality of our everyday context is the city or the factory…. The direct appropriation of the real is the law of our present [time].[47]

As early as 1961, when he argued that "the Neo-Realists consider the world a painting, the large, fundamental work from which they

appropriate fragments of universal significance,"[48] Restany had set in motion the understanding of the new realists as appealing to common experience, the reality of urban life and mass culture, which enhanced their appeal for the Pompidou museum's curators. By including Tinguely's clanking machines, Arman's accumulation of military gas masks, César's compressed junkyard cars, Raysse's neon signs, Hains' advertising posters, and Saint-Phalle's papier-mâché female figures decorated with plastic trinkets, the curators intended to draw a continuum between their collection and the outside world.

Despite the curators' efforts to display this recent work, the *Paris-New York* exhibition, as well as installations of the MNAM's new acquisitions, sparked considerable criticism that the center promoted American art, which already dominated the international art market, rather than providing French artists – especially the young generation – much-needed opportunities for exposure. Some artists and critics feared that Hulten did not know contemporary French art well enough to devise groundbreaking exhibitions.[49] Others were alarmed at seeing a state-sponsored museum attempt to cultivate American sponsorship and donors through the establishment of the Beaubourg Foundation (later renamed the Georges Pompidou Art and Culture Foundation) that met in New York.[50] In particular, critics singled out the French-born Dominique de Menil, a contemporary art collector (and well-known patron of the arts) living in Texas, who had become an important donor to the center. Her gifts of American art, which included pieces by Jackson Pollock, Larry Rivers, and Andy Warhol, were featured in the center's early exhibitions, in some critics' views to the detriment of French work. The critic Pierre Schneider, for example, described the strong presence of postwar American work in the *Paris-New York* exhibition as resulting from an "aesthetic Marshall Plan" while "those who had the misfortune to paint in Paris during the years '45–'60 are almost [entirely] eliminated."[51] While curators were trying to present Paris in dialogue with New York, thus broadening the too-narrow focus on Paris of the former MNAM, and simultaneously making a case for Paris's ongoing importance in the international artistic mainstream, a number of critics and artists, who were keenly aware of how Paris had been eclipsed by New York, feared the center's approach was merely reinscribing the hierarchy.

But the reason for the failure to include the most current French art in the new museum may lie less in the national origins and locations of its director and major donors, and more in the continued atmosphere of controversy that swirled around contemporary French art. After the blowup at the Expo '72, administrators and curators feared more demonstrations and protests by artists and the public; hence the decision to cut

off the time period covered in the *Paris-New York* exhibition in 1968. The curators' decision to highlight new realism was a "safe" choice – it had been the most internationally recognized art movement based in France in the 1960s. For this reason, the museum faced the criticism that it was simply following the market's dictates rather than taking the opportunity to support new art or to seek out new voices.[52] Although the *Paris-New York* show displayed more recent and international work than had been presented in most Paris museums, it included little work from 1968, and nothing that directly engaged the debates and artistic practices that developed in its wake. In this show, curators steered clear of art produced in the aftermath of '68, while framing their exhibition with a rhetoric of engagement with everyday life through its use of popular imagery that seemed like a response to that era's calls to make art and the museum reach out to all people.

ARTISTS AND MASS CULTURE: QUESTIONING COMMON GROUND

But to what extent did artists and their work uphold the museum's framing of everyday life and mass culture as common ground for its audience? Even the new realists' artwork did not express the same uniform enthusiasm as the museum establishment suggested. In addition to the works' playful efforts to invite viewer participation, they often provided a darker read of the mass culture that was pulling spectators in. With their assemblages of gas masks, rusted gears, and junked cars, the new realists seemed to challenge the observer to feel uncomfortable with the waste and disfunctionality of modern consumer society. Other artists of the '68 generation would draw attention to the different ways that various members of the audience might experience the so-called common ground of everyday images and the mass cultural realm. As the work of members of the '68 generation became prominent in the new art scene, however, it was cast as amenable to the new mass cultural direction of the museum. For Boltanski and Messager, success within the new art scene that had sprung up around the Pompidou was linked to an interpretation of their work that emphasized their images' connections to mass culture as a shared experience, while the more critical interpretations that their work evoked often went unspoken.

Boltanski was one French artist whose recent work gained prominence in the development of the art establishment and gallery scene with an exhibition in 1974 at the Centre National d'Art Contemporain (CNAC), a show in 1976 at the Sonnabend Gallery, and a slide show presentation in

1976 at the Musée National d'Art Moderne at the Palais de Tokyo, before the new museum in the Pompidou Center could be occupied. His work was also purchased by the Pompidou in 1977 with the newly established budget for acquiring photography. Messager's first solo gallery exhibition in Paris was held in 1978 at the Galerie Gillespie-Laage, one of the new spaces that opened in the area surrounding the Pompidou Center, though her work was not purchased by the center until 1979. Her work was gaining greater recognition at major international exhibitions, the 1976 Venice Biennial and the 1977 Documenta 6 in Kassel, Germany. However, some instructive differences can be found in the degree to which the artists were incorporated into the new museum and the art establishment that had sprung up around it. Boltanski's and Messager's exhibitions in the mid- to late 1970s throw into relief the possibilities and limitations of the museums' program for democracy and inclusiveness.

Significantly, in his work for his exhibition and presentation at the Sonnabend Gallery and the MNAM, Boltanski turned away from his earlier images of personal memory and daily life, explaining, "Someone who shows an old photo or a trace, it's become reassuring, we tell ourselves, yes, I understand, I've got something from it. . . . I don't know why but from that moment on I can no longer do the thing, it's no longer interesting."[53] Instead he concentrated on exploring the kinds of mass media images that the planners of the Pompidou were trying to tap into as a way to make the museum accessible and appealing. His new work represented images of standardized beauty, the kinds of clichés that he saw structuring advertising and therefore, in an ad-saturated world, much of the aesthetic sensibility of the new audiences that the museum was reaching out to.

Boltanski's color photographs, titled *Images modèles* or "model images" – evoked the typical subjects and compositions of popular photography. The models were repeated in not only the subject matter – such as children, flowers, and pets – but also the composition – which ranged from posed snapshots to evocations of the picturesque (Figs. 76–7). In a 1975 interview, Boltanski himself noted that he was playing on the culturally established notions of what would make pretty pictures, describing the way that certain conventions had become well-known and widely accessible:

> Everyone has made a photograph or could make one, it is a medium that is known and accessible to all. In this series of images . . ., what interests me is to show images that are generally considered beautiful, that everyone, more or less, has taken, or wishes to take. Current amateur

Figure 76. Christian Boltanski, *Images modèles*, 1975. © 2005 Artists Rights Society (ARS), New York/ADAGP, Paris. Collection of the Musée National d'Art Moderne, Paris. Photo courtesy of Bob Calle.

photography seems important to me because it contains...a notion of aesthetics that is culturally established (every person who looks at photographs that he has taken asks himself if one thing is prettier than another).[54]

But on the other hand, this description overlooked a crucial difference in the way these photographs could be experienced. The hobby and amateur models that Boltanski emulated in his pictures carried specific associations and references to social class. Ten years earlier the sociologist Pierre Bourdieu and his research team – which included Christian's brother Luc – in studying a working-class camera club in Vincennes, had suggested the way working-class hobby photographers rejected aesthetic foundations for their practice, instead imitating the myriad commercial and casual images that they saw around them in various forms of a media. The authors of this particular study, Robert Castel and Dominique Schnapper, described the organizer of the working-class camera club confessing: "I supply formulas, tiny little formulas"; such formulas, the authors argued, were what the participants in the camera club expected and desired to emulate.[55] Consequently, pictures of "pretty," often sentimental subjects such as flowers, monuments, landscapes, and

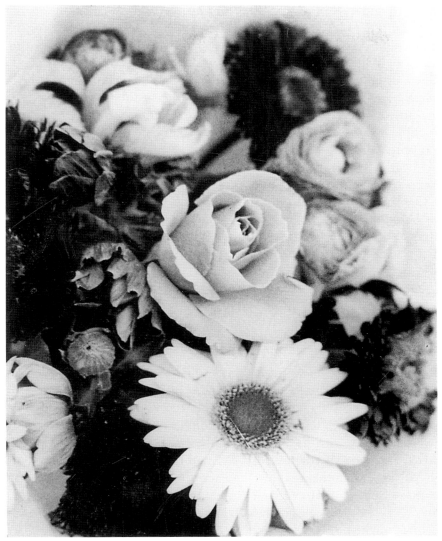

Figure 77.
Christian Boltanski, *Images modèles*
(detail), 1975. © 2005 Artists
Rights Society (ARS), New
York/ADAGP, Paris. Collection of the
Musée National d'Art Moderne, Paris.
Photo courtesy of Christian Boltanski.

children, frequently drawn from advertising and commercial sources, dominated their pictures.[56] Middle-class hobby photographers with more aesthetic training and experience disdained such images, the authors suggested. One member of a middle-class camera club explained: "You come across clichés particularly among the beginners: hackneyed subjects."[57]

Boltanski's *Images modèles* evoked the formulas of the working-class camera club photographs described by Castel and Schnapper. They

included "pretty" subjects such as bouquets of flowers and portraits of children (Figs. 76–7). The images also manifested hackneyed rules of composition: a swan swam in a pond, seen through the branches of a tree; a curving path extended off into the distance. Boltanski also included "amateur" pictures, slightly different from his hobby pictures, resembling snapshots of events of family life, taken with few rules of composition and little use of the technical capacities of the camera. They depicted, for example, two people posing at the shore, a close-up of a boy whose face was obscured by shadow because the picture was shot into the sun, and an image of a majorette marching by in a parade with her legs accidentally cropped out of the picture.

On the invitation for the slide show of the *Images modèles* at the MNAM, Boltanski highlighted this strategy of adopting conventions of the beautiful in terms that recall the working-class camera club hobbyists that Castel and Schnapper had described:

> I make photographs; I have perfected my technique and I try to conform to the rules of this art that is so difficult. I am now tackling color photography, which lends itself particularly well to subjects I am fond of: all that expresses the beauty of simple things and *joie de vivre*.[58]

But Boltanski's statement may be more slippery than it appears. Indeed, Boltanski's clichéd language ("the beauty of simple things and *joie de vivre*") both in his invitation and elsewhere, as well as his slavish adherence to techniques and rules, suggest this work continued his earlier investigation of identification and distance on the part of the viewer. In a separate statement Boltanski asserted that he was using photography as "a medium that is known and accessible to all" and that he strove to make images "that everyone, more or less, has taken, or wishes to take."[59] These accessible and familiar images evoking affection and good feelings might be seen as parallels to his earlier practice of displaying family photographs, such as the *D. Family* photo album, which was seen as a point of collective identification. But here Boltanski's language and images seem too exaggerated to be taken seriously, signaling a marked parodic distance on the part of the artist.

In fact, the *Images modèles* continued the *D. Family* project's quest to complicate the museum's efforts to ground itself on work that was supposedly accessible to all. The *Images modèles*, however, presented an even starker choice between identification and recognition of distance than the *D. Family* pictures offered; with their extremely hackneyed quality, they almost dare the viewer to try to sentimentalize them. Most of the

Images modèles were not taken as records of personal events; stripped of the emotional or nostalgic appeal that the *D. Family* photos presented, it became easier for viewers to recognize the aesthetic formulas and clichés that they might despise.[60] These color compositions, the hackneyed images of a hobby photographer, seemed to purposely refuse the nostalgia and identification triggered by the *D. Family's* aging black-and-white family photographs. Although his representations of poor-quality contemporary photographs seemed, on the one hand, to evoke a familiar practice that allowed Boltanski to tease viewers and critics with the possibility that he was reaching for commonality and universality, on the other hand, they deflected an emotional pull and the spectator's will to identify with them. But it was the former possibility that the gallery and museum presentations of the photographs exploited as they framed the images in their promotional materials, quoting Boltanski as offering the audience "pretty pictures" that could be understood by all.

For the museum, Boltanski's images made perfect sense as part of an effort to construct itself as engaged with the reality of everyday life, reaching out to a democratically conceived audience with terms that all could appreciate. And for Boltanski, invoking these notions of a new aesthetic common ground in popular images and mass media reinforced his work's timeliness and relevance and thus proved useful for his career. On the other hand, however, the museum's framing of the images could not contain all their possible meanings. Indeed, the parodic aspect of Boltanski's *Images modèles* allowed him to continue his investigation of the relation of art to the museum's audience. The tension between a universal or common appeal and the class-based aesthetics from which he drew his sources in the *Images modèles* opened up the possibility that the museum audience itself would be split in its reaction to the photos, seeing them as an ironic parody or a straightforward evocation of standard conceptions of the beautiful, varying with the viewer's experience and aesthetic education.

Furthermore, Boltanski's portrayals of working-class practices and aesthetics challenged art institutions and their audiences to examine their efforts to broaden the range of art in the museum. The extremely clichéd nature of his images seemed likely to prompt sneers and scorn; his stereotyped view of working-class aesthetics could invite condescension and disdain. These reactions would dramatically display the class-based nature of the museum and its audience and reveal the very real social divisions that continued to exist – even in the self-consciously striving-to-be-democratic Pompidou Center.

Messager's work with mass cultural themes from the mid- to late 1970s achieved more recognition than her previous work in the French art scene. However, like Boltanski's insistence on class differences, Messager's work also challenged the art establishment's assumption of mass culture as common ground. In her case, rather than social class, the focus of her critique grew out of its exploration of the gender differences in the audiences' experience of mass culture. She continued to employ feminine imagery and materials and to use them to examine the situation of women. In celebrating her new work as an instance of appeal to common experience, then, the art establishment did not necessarily live up to the most radical challenges that emerged out of 1968. The particularly feminine concerns of Messager's early work could not be fit into this model, and the aspects of her contemporary work that explored the particular effects of media on the everyday lives of women went largely unheralded within the mainstream. In the quest to find common ground, the museum missed the opportunity for a recognition of difference that would radically remake its sense of its audience.

In her 1978 show at the Galerie Gillespie-Laage, Messager exhibited pieces that brought together the feminist strands of her work with an analysis of media that could seem to speak to everyone. *Le Feuilleton*, or *The Serials*, focused on media clichés, but also represented concerns with traditionally feminine aesthetics of "prettiness" and mass media images that were aimed at women, taking as sources the cliché subjects and characters represented in European romance and melodramatic photo novels and Hitchcock movies and posters.[61] In this series, Messager combined realistically drawn and photographic images into composites that were approximately the size of movie posters. Although the various scenes were combined into one, the characters and scenes remained separated by bold diagonal cuts through the image – a technique Messager borrowed from movie posters and photo novels. For example, "Accident" displayed an image of doctors in surgical scrubs and masks above an image of a car on the road, whereas "Nightmare" depicted a sleeping couple beneath an immense image of a woman's eyes peering out in fear (Figs. 78–9). Some of the images were taken from the mass media, such as the look of alarm in "Nightmare," which appears to have come from a horror movie. Other images, however, represented Messager's friends and family – the sleeping couple in "Nightmare," for example, was Messager and Boltanski. The drawn areas of the images were typically black and white, whereas the photographs were shaded with bright, unreal colors that added to their commercial appearance and "feminine" appeal.

Figure 78.
Annette Messager, "L'Accident,"
detail from *Le Feuilleton*, 1978.
© 2005 Artists Rights Society
(ARS), New York/ADAGP, Paris.
Photo courtesy of Annette Messager.

The German critic Klaus Honnef, responding to an earlier exhibition of the series at the Rheinisches Landesmuseum, Bonn, picked up on the continuities between *Le Feuilleton* and Messager's earlier interest in traditionally feminine materials and aesthetics. He compared *Le Feuilleton* with Agnes Varda's film *Le Bonheur* ("Happiness"): both featured harmonious images and delicate colors. Honnef quoted a film critic describing Varda's attachment to "pretty things" and applied it to Messager's images to suggest that they were work "that only a woman could have made."[62] In

a 1977 statement, Messager, too, described her work of this period as feminine: "I wanted to make evident this so despised, so 'feminine' prettiness. Not the beautiful, the sublime, the strong, the tough, the powerful, but on the contrary all the archetypes of the pretty, the tender, the delicate, the sweet."[63]

But despite the fact that Honnef described Messager's aesthetics as feminine, he emphasized more the aspects of her work that he felt had universal significance, explaining that she represented "a reality that exists exclusively in collective representations. The material basis of this reality is the happy, agreeable, conflict-free world of advertising, commercial cinema, and the popular press."[64] He elaborated, "In her serials, that which appears to be false, silly, and in poor taste, is in reality the precise description of the collective unconscious."[65] Although the artificial colors of *Le Feuilleton* suggested "feminine prettiness," along with mass cultural styles, Honnef continued to underscore the latter: Messager represented universally familiar advertising clichés that had become a shared unconscious or imaginary.

When her show opened at the Galerie Gillespie-Laage in Paris, critics occasionally responded to the gender issues in her work. The critic Sylvie Dupuis, for instance, saw Messager juxtaposing dramatic images that suggested stories like those of *Nous deux* and *Bonnes Soirées*, popular serials aimed at a feminine audience. In placing herself and her family into the pictures, Dupuis suggested, Messager "mix[ed] therein her identities as woman and artist, her private life,"[66] and raised questions about how the clichés of mass culture were absorbed and enacted in women's lives.

More frequently, though, critics continued to describe her work as appealing to common experience. Invoking an unproblematic "we," the photography critic for *Le Figaro*, Michel Nuridsany, for example, described Messager's combinations of paintings and drawings as "the image of our universe, cluttered with fictions, where mythologies govern us more surely than adequate concepts of truth or reality."[67] "These subtle compositions indicate that our reality is never simply lived as it is," he elaborated, "but perceived 'secondhand,' and devitalized, banalized, normalized."[68] Nuridsany also quoted explicitly Honnef's interpretation of Messager's clichés as representing a collective unconscious.[69]

Such critical responses illustrated how Messager's work was incorporated into the new world of French art, as the rhetoric of common experience overshadowed possible gendered interpretations. But in exploring what the framing of Messager's art reveals about the limitations of the newly constituted art institutions, the circumstances of the exhibition itself are just as important as what the critics said. It is significant,

Figure 79.
Annette Messager, "Le Cauchemar,"
detail from *Le Feuilleton*, 1978.
© 2005 Artists Rights Society
(ARS), New York/ADAGP, Paris.
Photo courtesy of Annette Messager.

for instance, that Messager was shown in a gallery in the orbit of the
Pompidou, not in the center itself. Although *Le Feuilleton* obtained more
attention than Messager had previously received, and particularly more
mainstream attention, her range of exhibitions still contrasted notice-
ably with Boltanski's, for example. While Boltanski strove to maintain

the critical edge in his work, resisting easy identification on the part of the audience, he simultaneously promoted the work's universality, and it was very easily accepted as building an audience on a ground of shared experience, perhaps because the class differences he evoked were more easily overlooked than the gender differences Messager explored. Boltanski received opportunities to exhibit at the Expo '72, the CNAC in 1974, and to present work at the MNAM in 1976. Messager's work achieved more success to the extent that she invoked the common rhetoric of mass culture; however, to highlight gender within her work might have seemed partial, representative of a special group identity rather than a universal subject. This may help to explain why she – and other women artists – had a harder time entering the new national museum as it consciously strove for the broadest possible appeal.[70] Hence, Messager's more overtly feminist pieces tended to be taken up in alternative spaces or shown outside the country – at the 1977 *Frauen Machen Kunst* exhibition, held at Galerie Magers, Bonn, for example, which adopted a specifically and overtly feminist agenda.[71] One important exception to this in the French context was the solo show organized by Suzanne Pagé in 1974 at the Musée d'Art Moderne de la Ville de Paris, which sought to foreground the feminist aspects of Messager's work directly. However Pagé's willingness to address these issues was unusual among curators in Paris at that time, and her selection of artists was markedly different from that of the primary state museum at the Pompidou.

The different career trajectories and exhibition opportunities of Messager and Boltanski thus illustrate the ways in which the new museum fell short of achieving its aims of becoming universally accessible and democratic. Not only was there little room to criticize the idea of the museum's shared appeal – a criticism that both artists tried to make – but many constituencies felt the need to develop independent art institutions because they were still not accepted into the mainstream ones. European women artists in the German exhibitions *Frauen Machen Kunst* and *Künstlerinnen International* and in the French group exhibitions *Utopie et féminisme* and *Féminie-dialogue*, for example, saw it necessary to organize exhibitions for women artists because many women were still not able to enter the major channels of the art world.[72] The French ecomuseums, organized in the 1970s to exhibit the cultural traditions of specific social and ethnic groups, also sought to address the demands that grew out of 1968 and gained momentum in the 1970s. Often located in parks, natural areas, or sites of local industries that were significant to the groups, ecomuseums were used to demonstrate community traditions, such as agricultural or manufacturing methods. The ecomuseums

sought to further group members' progressive awareness of their particular identity through presenting their culture and inviting their members to participate in the operations of the museum, thus "liberat[ing] individuals from the quest for identification" in museums.[73] In this way, the ecomuseums hoped to transform the public from passive consumers into "actors" or even "authors." Significantly, however, the ecomuseums developed in the domains of "popular traditions" and ethnography. In the 1970s, few moves were made to open up French art museums to represent diverse populations and their cultures; instead, the MNAM continued to try to reach the public on the basis of common experience.

Many of the revolutionaries of '68 envisioned art and exhibitions that would address the different needs of various social groups – and the Pompidou Center made gestures of incorporating these goals by, for example, locating in a working-class neighborhood. In addition, it made very real strides toward openness with its libraries, extended opening hours, and expanded contemporary collections. Despite these advances, by 1978 the museum still maintained the aspiration that it could reach out to all audiences on the basis of a common visual language. But this time, instead of drawing upon the humanist rhetoric invoked in the cultural policy of the 1960s and early 1970s, museum curators treated mass media images and entertainment-style exhibitions – the very types of representations that Malraux had opposed and that '68ers such as Lefebvre had treated with suspicion as tools of oppression – as the grounds for accessibility and commonality. The museum downplayed the traditional canon, promoted entertainment, and presented the sorts of mass media representations that were familiar to broad audiences, basing its claims of accessibility and democratic representation on the numbers of people it attracted. Artists like Boltanski and Messager challenged the concept of mass media and popular images as a commonly shared milieu to a certain extent by evoking differences of social class and gender, but also allowed their work to gain exposure by referencing them. Although the Pompidou Center made efforts to adopt a more democratic approach, it nonetheless retained familiar models of its museum audience. Rather than imagining an audience that could accommodate differences, the center sought to be an emblem of the entire nation, one which represented collectively shared meanings for the public.

6 AMERICA AND EUROPE POST-POMPIDOU

SUSTAINING THE POLITICAL MISSION OF THE MUSEUM

The year 1968 constituted a dividing line: prior to the upheavals of May and June, the humanist universal upon which museums had been based could be, for the most part, agreed upon. In the aftermath of '68, previously shared assumptions and values could no longer be taken to ground a national cultural policy without prompting debate. As artists, curators, and policy makers struggled to determine new paths for art and the museum in exhibitions that culminated in the construction of the Pompidou Center, their decisions participated in a debate over the scope of the art museum and the ways in which the nation should be represented. But the Pompidou Center, as I have suggested, was by no means able to resolve these conflicts. In conclusion, I want to examine the recent endeavors of curators, artists, and critics to address these issues in European and American contexts. Looking both at the direction of cultural policy in the decades following the Pompidou's opening and at exhibitions from the 1980s and 1990s, I trace the fates of some of the challenges of 1968 along with institutional and artistic responses to them. While some have continued to promote the museum as an emblem of a coherent and unified nation, others have sought to make it a space that more truly represents the nation's diversity and complexity.

In France, national art institutions have made several attempts in recent exhibitions to mobilize art and museums in the service of the nation, specifically, through reworking the art and legacy of the post-1968 decade. The most publicized responses to these exhibitions have been critics' xenophobic calls to return to "pure," national cultural traditions, which, I argue, constitute the end of a line of thinking that rejected the '68 contestation in favor of representation of a unified nation. At the same time, this chapter insists on a less-noted danger: even those who supported the contestation of '68 and developed serious responses to it have lost sight of some of its most important challenges. As museums in Europe and the United States in the 1980s and 1990s faced calls to democratize and diversify their collections and audiences that resembled the ones facing French museums in '68, the French experience

seemed to have laid the groundwork for a response. Artists such as Boltanski and Messager, whose work had been celebrated in France for its seeming accessibility and outreach, gained wide attention in the international art scene. However, these recent patterns of interpretation have obscured the artists' most radical criticisms of the museum rather than truly engaging them. This chapter analyzes the successes and limitations of these various strategies, delineating the challenges remaining for contemporary museums that seek to address the imperatives of inclusion and representation.

Culture was one of the centerpieces of François Mitterrand's Socialist government of the 1980s. The Socialists budgeted unprecedented expenditures for art; by 1986, they had achieved 1% of the national budget, more than double what it had been for Malraux.[1] The best-known products of these expenditures were Mitterrand's *grands projets*, such as the pyramid at the Louvre, the Opera at the Bastille, and the new *Bibliothèque Nationale*, which were intended to demonstrate the government's commitment to French culture and to enhance Paris's place on the contemporary cultural map. The culmination of the Socialists' cultural project, although it has received less media attention than the *grands projets*, was the creation of the Fonds Régionaux d'Art Contemporain (FRACs), collections of contemporary art stationed throughout the provinces. Formed as a response to the perceived over-commitment of cultural funds to the Parisian capital – a frequent complaint in the years following '68 and surrounding the construction of the Pompidou Center – the FRACs, developed under Mitterrand's Minister of Culture, Jack Lang, recalled Malraux's goal of decentralizing art with the *maisons de la culture*, which had sought to distribute reproductions of a canon of great masterworks of the past throughout the provinces. But in many ways the FRACs were intended to improve upon the inadequacies of Malraux's earlier attempts to decentralize art. In contrast to the nationally centralized administration and fairly standardized programming of the *maisons de la culture*, FRACs had regionally based administrative committees that were to help promote local and regional art (although these were still governed by a centralized administration). The FRACs were staffed by young curators and focused exclusively on contemporary art to help France support new artistic trends. With new budgets and structures for acquiring art, the FRACs purchased large numbers of works from French art galleries, massively inflating the French art market of the 1980s. Many of the artists, including Boltanski and Messager, who had been gradually rising to prominence in the 1970s began selling significant amounts of work during this period; Messager has said that this was the first time she

was able to live from the sale of her artwork.[2] The FRACs thus brought contemporary artists in France new levels of recognition; for example, along with providing material support, the FRACs facilitated the loans of artists' work for exhibitions and helped the French art market operate on an unprecedented scale, attracting increased attention both in France and abroad.

Although the FRACs constituted an admirable commitment to contemporary art, they were not without problems. Despite the geographic diversity of the FRACs' locations and administrative teams and the devotion of one-third of acquisitions to regional art trends, a significant increase, the FRACs still purchased through gallery circuits that tended to favor similar stables of nationally and internationally recognized artists.[3] Furthermore, the FRACs' mission facilitated the acquisition of contemporary art, but did not necessarily include sufficient exhibition space. As a result, the FRACs lent work to other institutions for exhibitions and organized small shows themselves, but were frequently forced to keep large portions of their collections in storage.[4] In their conception and their execution, the FRACs demonstrate the continued attempt to find a way to achieve some of the aims voiced in and following '68 – making art available to a broad audience and representing a more accurate picture of the nation as a whole – but they faced some of the same problems that the previous decades' efforts to revolutionize art and the museum had encountered. In particular, the Socialists, trying to draw parallels between their government and the Popular Front of 1936, frequently drew upon the Popular Front rhetoric celebrating giving each person access to art[5] – a notion that had been popular in cultural planning in the post-World War II period and adopted by Malraux. This rhetoric assumed culture was relevant to all and thus had unifying effects. This hearkening back to the Popular Front foreclosed questions raised in '68, about, for example, what work could be pertinent and of interest to different audiences and communities. The FRACs, in the end, did not sufficiently reflect on how to build diverse art collections and reach diverse audiences.

At the same time as the Socialists were investing heavily in contemporary "high" art through the FRACs, they also became known for sponsoring numerous popular festivals, organized under Jack Lang, that were aimed at cultivating a populist atmosphere in the cities where they were held. For example, the annual street festival, the *Fête de la musique*, was initiated in June 1982. The name of the festival, a pun on the command *"faites de la musique"* – "make music" – suggests the way it was intended to tap the spirit of '68, exhorting people to take to the streets and spontaneously create music in a festival of democratic participation. But the

Fête de la musique, a government-sponsored call for improvisation, did not share the oppositional politics of '68 street "happenings"; in attempting to institutionalize the spontaneity of '68, much of the political force was lost.

In fact, in the 1980s the memory of May '68 was becoming a matter for nostalgia. As Kristin Ross has argued, during that decade May '68 came to be seen as playful, "a merry month of youthful, free expression and libertarian goodwill, a benign transformation of customs and lifestyles."[6] This framework erased the way students', workers', and other activists' protests converged around a critique of the state, capitalism, the Vietnam War, and French social, cultural, and political institutions. For the ten-year commemoration of May '68, footage of protests, strikes, and police violence were aired on TV; however, these broadcasts were not repeated in 1988.[7] Stripped of their larger contexts and arguments, the events of '68 were reduced to a handful of stock phrases and graffiti slogans, and cast as a drama of personal liberation and generational conflict. This 1980s version of '68 was taken to prefigure the "narcissistic individualism" of the later decade: what had appeared at the time to be a wide-ranging critique of the institutional and social structures of France came to appear a youthful stage of individual development in publications such as Patrick Rotman and Hervé Hamon's 1987 *Génération*, which cultivated the idea of a common identity for people of "the '68 generation."[8] The very real political challenges of 1968, then, became in popular discourse like so many other features of youth: desirable as signs of energy and vitality but a little embarrassing and unserious.

In the mid- to late 1990s, the French government led by President Jacques Chirac, of the neo-Gaullist RPR party, recycled and reinterpreted the period of the 1960s and 1970s in ways that might seem surprising, given the history of controversy and unrest traced here. In a series of commemorative events that were designed to celebrate the legacy of the right's grand figures of cultural policy, Chirac promoted the idea of government cultural planning while at the same time reducing expenditures for art (which had been vastly expanded under Mitterrand and Lang in the 1980s). Herman Lebovics has argued that in 1996, Chirac's government, which was mired in a lackluster economy, commemorated the legacy of the first Minister of Culture, André Malraux, with conferences, exhibitions, postage stamps and so forth, in order to camouflage the effect of the fiscal austerity of the mid-1990s on the arts.[9] While the arts were being officially celebrated, the reductions in government spending on art exacerbated the crisis in the already suffering art market.[10]

Even more striking was the Chirac government's recycling of the legacy of former President Georges Pompidou. For the 1999 exhibition *Georges*

Pompidou, Homme de culture, held at the Galerie Nationale du Jeu de Paume during the renovation of the Pompidou Center, Chirac himself wrote the introduction to the exhibition catalog. Positioning himself as part of the cultural lineage of Pompidou, he explained that he had known Pompidou well and "had worked beside him in serving the state." Chirac termed the 1970s "the Pompidou years," which, he claimed:

> embody a certain idea that is also a certain image of France. That of a France moving [forward], rich with its best traditions and resolutely turned toward the future and youth, careful to understand its period and singularly, the art of its time, because this, as Georges Pompidou believed, is the best testimony that man can give of his dignity.[11]

While making an argument for supporting contemporary art, Chirac nonetheless evaded the controversies that had marked the development of Pompidou's projects and advanced instead a conservative humanist conception of art as the most dignified testimony of "man." Both the exhibition and catalog highlighted the development of Beaubourg as an example of President Pompidou's benevolent and exemplary patronage of modern art. Chirac described how "the Statesman . . . wanted to reconcile the Republican institution with current art."[12] Notably, Chirac neglected to mention the controversy over the center and the exhibition which formed part of its planning, *Expo '72, 12 Ans d'art contemporain en France*, whose selection of artists provoked protests by artists and critics that were severe enough that the administration called in police to stop them. In Chirac's essay, Expo '72 was a straightforward revelation of an art scene that simply needed to be revealed to the nation, not forged and contested; the "great exhibition of 1972 . . . under his impetus, was to make France discover contemporary creation."[13] Both the exhibition and its catalog thereby effaced the political controversies surrounding the center, especially the Expo '72, by aligning art with the state, claiming for the center an ability to speak to the French nation.

Another commemorative event of the mid-1990s brought to the fore the controversies that Chirac was pushing aside. In 1997, the Musée National d'Art Moderne (MNAM) at the Pompidou Center celebrated the twentieth anniversary of the center and the fiftieth anniversary of the MNAM with a major reinstallation of its collections. The resulting exhibition, *Made in France*, featured works by French artists and international artists who had worked in France over the last fifty years. *Made in France*, designed by the director of the MNAM Germain Viatte, echoed the 1972 exhibition organized by the center's curators, *Expo '72, 12 Ans d'art contemporain en France*, in seeking to promote the importance of

France as a cultural center and a supportive environment for international artists. *Made in France* was used in the service of party and national aims in various ways. At the opening of the exhibition, artists were asked to wait by their works in order to shake hands with President Chirac for publicity and press photographs – photographs taken to suggest that the artists supported and had been supported by Chirac's government (Fig. 80). Outside, an illuminated French flag several stories high flew from the side of the Pompidou Center. The effort to recapitulate and rework the 1972 exhibition that was to define the status of art in the nation demonstrates the continued preoccupation with mobilizing art, artists, and institutions in the service of the nation and state.

Like its 1972 predecessor, the show provoked controversy, but this time the cultural terms had changed. The exhibition, however, did not seek out controversy: in fact, the categories around which it was organized seemed designed to steer clear of making any definitive statement about French art. Viatte chose not to organize the exhibit chronologically, feeling that this would not, as one critic remarked, illustrate the "diversity of contemporary creation."[14] Instead, the artworks (all created in France in the twentieth century) were grouped together thematically in rooms. For instance, the room with the theme "transformation of the object" displayed the work of artists often associated with *nouveau réalisme*: Arman, César, Christo, Raymond Hains, and Daniel Spoerri; "origins and singularity" included works by Gaston Chaissac, Jean Dubuffet, Annette Messager, and Niki de Saint-Phalle; and "space and color" featured work by Daniel Buren, Sam Francis, Henri Matisse, Nicolas de Staël, and Claude Viallat. The concepts Viatte used were deliberately open and playful. However, they were criticized as bland efforts to render the art safe; the critic Alain Cueff, for instance, contended that the "grandiose and eternal values that they convey are obviously unsuitable for making sense of the complexity and anxiety that feed modern art."[15] The vagueness of the categories de-emphasized the contestatory nature of many of the works, without adding significantly to their meaning.

The politics of the exhibition, then, centered on asserting the place of France – and Paris – within the art world. As the exhibition brochure explained: "This is an occasion to recall the diversity of the collections, and through them, the always unparalleled situation of Paris and of the French scene as an international melting pot of artistic creation."[16] In order to combat the notion that France was cut off from international artistic movements, publicity for the exhibition emphasized foreign-born artists working in France. Clearly, the choice of the English-language title "Made in France" suggested the notion of selling a French product in

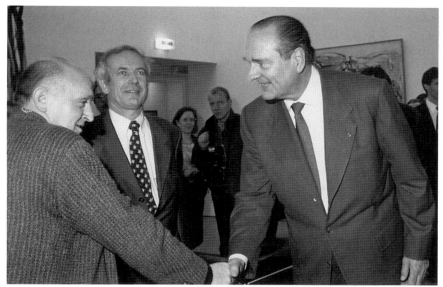

Figure 80.
President Jacques Chirac and Museum Director Germain Viatte (center) greet artists and other notables at the opening of the *Made in France* exhibition, Musée National d'Art Moderne, Paris, 1997. Photo: Sylvie Biscioni, © Bibliothèque Kandinsky, Centre de Documentation et de Recherche du Musée.

an international – particularly Anglophone – market; the concurrent *Rendezvous* exhibition organized by the Pompidou Center and the Guggenheim Museum in New York reinforced this view. *Made in France* thus had a dual political resonance; as Cueff asserted, "the institutional promotion of French art has remained divided between the hope of a re-conquest beyond [French] borders and the nationalist affirmation of an identity."[17]

The controversy that erupted around *Made in France* focused on the international emphasis within the show, and was largely sparked by the response of one critic, Jean Clair, who castigated the exhibition's internationalism and broadened his criticism to mount an attack on contemporary French art institutions more generally. Clair was a well-known and powerful figure within the French art world, and so his attack on these institutions came as a surprise to many. In the 1970s, he had been one of the major advocates of young French artists of the '68 generation as the director of the contemporary art review *Chroniques de l'art vivant* and as curator during the development of the Pompidou Center.[18] In the early 1970s, Clair had demonstrated an acute awareness of the politics of the museum, but by the mid-1990s he had adopted an ultra-nationalist, xenophobic position on culture and museums. Arguing that French museums should not support foreign artists or influences, Clair voiced a cultural position that in many ways paralleled the perspectives of the *Front National* party, known for its anti-immigration agenda. In 1996,

Clair had published an interview in *Krisis* (a journal of the extreme right) in which he lamented that contemporary French art "no longer exists," so his attack on contemporary French art institutions was not without warning. In *Krisis*, Clair's interview appeared as part of a debate on contemporary art that was organized by editor Alain de Benoist (who has been criticized for publishing anti-Semitic articles and works by the leaders of the *Front National* party).[19] Members of the French art world mobilized against Clair's statement, holding heated debates on television and at the Paris Ecole des Beaux-Arts, and filling French newspapers and art reviews with responses. When Clair published his commentary on *Made in France*, then, it set the terms for the controversy that followed.

These battles demonstrate the ways in which museums continue to be sites where larger political struggles are fought – in this case, as in the 1970s, the question of how the nation should be constituted and represented. The trajectory that Clair's writings take stands as an example of the way, by the late 1990s, one response to the challenges of 1968 was to try to retreat to an earlier "golden age" of blood and soil, where art represented the nation wholly and unquestioningly. Clair's writings, in other words, show the danger of suppressing the controversies that were brought to life in 1968.

In Clair's response to the 1997 exhibition, "De *L'Art en France* à *Made in France*," he named the 1972 art exhibition *12 Ans d'art contemporain en France* – with its efforts to promote an international, more open, contemporary art museum – as the starting point for a degeneration away from a pure French national culture.[20] The underlying problem with the exhibition for Clair was not that it functioned as an emblem of the nation, but that it emblematized the wrong kind of nation. Although this critique shared an element with the 1968 critiques of the museum (a museum that was dominated by bourgeois art and did not reflect the population of France), Clair took this criticism in the opposite direction. He criticized the Pompidou Center specifically, and French art institutions in general, for not supporting French artists and instead focusing on internationalism. In a reminiscence of his time in the United States, Clair glorified a connection to the nation of one's birth through what he called maternal language:

> No doubt, one takes great pleasure in speaking several languages, in slipping into several logical systems. But one can write, I believe, only in one's native language. The network of linguistic relations, woven during the first months of life…is so fine and fragile…that [one] must, in order to be able to express with words the most precise inflections of

sensitivity, have preserved the treasure of the first moments, the richness
of which the subsequent mastery of other languages will never approach.

As with language, so with art. A painting is also born of maternal
language, of an old connection to a land of birth....

The eye has developed from a certain light, a certain outline of forms, a
certain boundary of the horizon, a certain occupation of the ground –
and the tradition which has developed there.[21]

Clair implied that foreigners and immigrants could never truly speak the
artistic language of France, or share the same sensitivity to and ability to
represent the national landscape. Furthermore, his concept of maternal
language suggested that there was only one French national artistic lan-
guage. By implication, people in other countries might speak French (or
share certain artistic elements with France), but the language and painting
within France remained distinct, because it was inflected by a particular
connection to the landscape and soil. Clair initially avoided using the
term nation, but used instead terms that since the fascist era had been
politically loaded, such as "soil" and "native land," rendering his ultimate
advocacy of "nationalist" art even more unsettling.

Clair contended that the lack of international attention given to con-
temporary French art was due to the failure of art institutions and admin-
istrators to promote a "nationalist" style. Only the European countries
that had developed nationalist art after the Second World War had come
to international recognition: "other countries in Europe...developed
an art that we cannot call anything other than 'nationalist.' They are
Germany, Italy, and Great Britain. They are also the three and only Euro-
pean countries whose art met international recognition in the 1980s."[22]
He also reproached French artists and art institutions for their postwar
preoccupation with American art: "France was ironic about national val-
ues and ridiculed traditions and local attachments only to open up to
the charms of American abstraction."[23] This overemphasis on art abroad,
Clair believed, was compounded by the exhibitions of the Pompidou
Center. In reaction to the overly centralized (and nationalized) art insti-
tutions in France, the Pompidou Center had come to emphasize inter-
national art at the expense of the national school:

[T]he State has compromised itself in a scandal, which is the lack of
recognition of the French art that it was supposed to "promote"....

These "people in charge" would not have acted differently from the brave
mail carrier in *Jour de fête*, who, head spinning with the continuous

achievements of the Americans, mounting his bike and pedaling like a madman, tries to match their feats. It is true that the scene of his accomplishments, the small village buried in its groves and criss-crossed paths, the one described by Flaubert, Maupassant, and Gracq, will have in the meantime closed its shutters and put its school on sale.[24]

In sum, Clair suggested that since foreign artists could never truly represent France, state funds should not be supporting them, but rather the French artists who could. Furthermore, French institutions should not take interest in international art or seek to emulate American success on the international art scene. France, Clair claimed, needed to close its shutters (by implication, its borders) and look inward, supporting its own school of art.

In the 1997 essay, Clair argued that artistic languages were not universal, but rather rooted in a specific place: "painting...isn't a means of universal expression...that is because it remains attached to a precise place."[25] By rejecting the universal, Clair was not following the critiques of '68; in fact, he was reaching back even beyond the universal humanism espoused by Malraux to concepts of soil and homeland that were more reminiscent of Vichy.[26] Clair's text represents an extreme, xenophobic instance of the problems that result from taking the museum to represent a singular, national identity and culture. As we have seen in Chapters 3 and 4, there was a moment in Clair's career in the early 1970s when he showed support in his own writing and the selections he published as editor of the *Chroniques de l'art vivant* for Boltanski's critical investigations of the museum as well as the specifically feminine issues engaged by Messager's work. But in 1972, in the aftermath of the controversy surrounding the *Expo '72, 12 Ans d'art contemporain en France* exhibition, Clair turned away from the artists' challenges to the universal museum and began to promote their work as part of an apolitical, nationally sponsored avant-garde with an attachment to French patrimony and the museum. The far-right, ultra-nationalist position given voice in his 1997 article can be seen as the logical, if dangerous endpoint of the rejection of the 1968 cultural critique on behalf of representations of a unified nation.

Clair's rightward trajectory is a striking instance of the path implied by the explicit, wholehearted renunciation of the artistic debates of '68. But there are other, less obvious consequences to the way even those in the art world who responded to the 1968 aims of inclusion and representation have lost sight of some of the most significant challenges. In conclusion, I consider two recent exhibitions of Messager's and Boltanski's

work, one in Europe and the other in the United States. While seeking to create activist and inclusive displays, these exhibitions reveal the way that 1968's challenges to the relation of the individual to the state and the personal to the collective have not been fully recognized and acted upon. Although there are important differences in the concept of the museum and the nation in Europe and the United States, in both contexts the two artists' work has been adapted to serve strikingly similar functions.

In the Documenta 11 exhibition in Kassel, Germany, Messager's work was celebrated as bringing into the museum new, untold stories, but at the same time this significance was diverted through the lens of universal meaning that effaced the political specificity of these stories. In the United States, on the other hand, curators heralded Boltanski's *Lessons of Darkness* exhibition through a lens of individual meaning; though on the surface this rhetoric may seem to recognize individual and social difference, in fact it relied on an equally universalizing assumption that all individuals could or would react to the work in the same way. By analyzing how these important and politically engaged exhibitions nonetheless repeat earlier patterns and mistakes, I aim to suggest new directions for museums in the contemporary moment.

The 2002 Documenta 11 exhibition, with its activist intent and efforts for outreach, can be seen as embracing the aims of 1968 more than any other recent art exhibition. This was the first Documenta exhibit curated by a non-western artistic director, Nigerian-born Okwui Enwezor, and it sought to be truly global in both the scope of the exhibition and the public it addressed. One of the exhibition's primary goals was to represent and respond to the oppression in the contemporary world caused by economic policies as well as ethnic, ideological, and national conflicts. In a series of four international conferences and in the selection of works featured in the Documenta 11 exhibition, the curators sought to give voice to stories that were often suppressed. The artwork depicted the experiences of refugees, political prisoners, undocumented workers, and numerous victims of rape, torture, and other forms of violence caused by current political and military conflicts. Like many 1968 artistic activists, the Documenta 11 artists and curatorial team went to great lengths to address contemporary political issues, to reach out to new audiences, and to include previously marginalized voices.

Annette Messager's installation *Articulés-désarticulés (Articulated-Disarticulated)* (2002), which filled an entire room of the exhibition, was praised by critics for evoking intense feelings of personal suffering and providing a powerful depiction of daily life erupting into the horrific

(see Figs. 3–4). The room was filled with soft sculptures resembling mar-
ionettes and stuffed animals, which conjured human presences. The
figures' bodies were deflated and distorted; some had drooping, dan-
gling limbs and others were splayed open, suggesting dismemberment
and mutilation. In the exhibition guidebook, Nadja Rottner described
Messager's work as helping viewers understand "the dark and more vio-
lent side of humanity," and as "standing in for a larger human condi-
tion of suppression and oppression" as it was enacted in everyday life.[27]
Yet by describing the work as referencing a "larger human condition of
suppression and oppression" this essay generalized the represented vio-
lence – both its perpetrators and its victims – and obscured the power
differentials that the work sought to expose. The represented experi-
ences of violence, in fact, were not ones that were equally shared among
humanity; closer inspection of the work reveals depictions of violence
directed at women in particular. Not only did Messager's soft materials
and fabrics connote femininity, but her sculptural figures often suggested
female bodies. The mechanized clusters of figures, for example, conjured
a mother with her children clutching her for protection or a woman being
raped, indicating the kinds of threats and violence endured by women
as a result of larger political conflicts. The kinds of violence experienced
by Messager's figures created striking parallels with victims' stories high-
lighted in other sections of the exhibition and referenced sites of conflict
in the contemporary world. To the degree that these references were
brought into the museum, the exhibition was true to its aims. How-
ever, for the exhibition to have been wholly successful in achieving its
activist goals, the catalog materials that framed its displays should not
have collapsed the work into a general or universal "human condition,"
but should instead have recognized the strength in the historical speci-
ficity in Messager's work and the other work in the exhibition.

The idea that spectators can identify with common human experiences
in such images of violence and personal suffering – even when these
images are extremely upsetting – implied that Messager's work addressed
a community characterized by the fundamental similarity of its members
and lost sight of the diversity of both the work's meaning and its audi-
ences. In fact, Rottner's interpretation repeats the pattern of Messager's
earlier critical reception. Messager's work was deemed most successful
when it was understood as illustrating fundamentally human experience,
not the experiences of particular groups – an interpretation that implied
the artwork and museum could represent and reach out to all. But is its
audience equally subject to violence and personal suffering? After all, if
violence is at issue, there must be at least one axis of social division, that

between victims and oppressors. It should not be necessary to imply that such a work is equally representative of all audiences; its power grows out of the ways the particular violence depicted resonates with specific groups – in this case women and refugees – who are currently subjected to oppression and struggling to make their voices heard. Curators should not be afraid of such specificity; rather than fearing losing influence and meaning by abandoning the universal, museums and curators can find a new source of relevance by attending to the specificity of their works of art and audiences. Refusing to gloss over particular identities, histories, and social circumstances, even though it may implicate museums and viewers in uncomfortable ways, can render the museum a more engaged and vital institution.

For more than two decades, American museums have been widely pressured by the left, especially feminist and multicultural movements, to pay more attention to the multiplicity of their audiences. Activist groups such as the Guerilla Girls have waged high-profile campaigns to encourage museums to purchase and display works by women and people of color. With these critiques in the 1980s and 1990s, therefore, museums in the United States faced challenges that were in many ways reminiscent of the French art activists' critiques of the museum in 1968, with calls for the museum to become accessible, politically engaged, and to speak to diverse audiences. At the same time, American museums were under siege by cultural conservatives, especially the Christian right, who found allies in Congress and local governments hoping to win support by cutting back cultural funding and closing controversial exhibitions.[28] As a result, American museums experienced these so-called "culture wars" in a situation of increasing scarcity of public funds, unlike French museums, which benefited from increasing government largesse. The combination of political pressures and financial needs from these cutbacks prompted museums in the United States to take the need for greater audience appeal seriously and also to revisit the role that they played in shaping local, national, and community histories.

One response to American museums' increasing interest in institutional self-reflection was the promotion of artists such as Fred Wilson, who used the museum itself as a medium, taking apart its narratives and exposing its assumptions by rifling through storage rooms, re-curating displays, and developing new signage and object labels. Wilson, for example, in his 1992 *Mining the Museum* exhibit at the Maryland Historical Society, Baltimore, re-exhibited busts of three white historical figures from the collection on podiums along with a corresponding set of black podiums that were empty in order to interrogate the racial politics and

history of the community and museum. Additionally, he displayed oil painting portraits, asking why people of color, unlike their white counterparts, remained anonymous.[29] By foregrounding the collection strategies of the museum, Wilson questioned how objects came to be acquired and what history was considered important enough to preserve, criticizing the absence of the history and accomplishments of black Americans.

At the same time as museums engaged in self-examination through their exhibitions of artists who questioned their strategies of collection and display, they also sought to engage in outreach to broaden their audiences through the display of personal and everyday materials. In the American context, one of the most powerful means to try to achieve this appeal was the rhetoric of individualism, in which museums promoted art that promised to address historical exclusions and injustices while permitting individual viewers to draw connections to their personal and everyday lives. With this strategy, museums sought to provide individual access to historical injustices, but in a more democratic mode, one in which viewers were enabled and inspired to come to their own interpretations of the artwork. Although the opening up of museums to previously underrepresented histories has been a welcome step, this rhetoric of individually determined meaning can abdicate and efface museums' responsibility to address the difficult issues they raise. In the United States, in other words, instead of cultivating the notion of universal symbolism as was done in the European context, the rhetoric of individualism has fostered the idea of a nation of individuals in which museums can nonetheless reach out to all on the basis of their fundamental commonalities.

Boltanski's exhibitions of the late 1980s and 1990s have been an exemplary instance of this pattern. Drawing on the framework of interpretation established in the 1970s, contemporary American curators have promoted the idea of Boltanski's private images as triggering viewers' memories of their individual experiences; at the same time, they have also seen his work as a mirror that can evoke great historical tragedies. As I mentioned in the introduction, this explanation was established by the groundbreaking 1988 and 1989 *Lessons of Darkness* exhibition, curated by Lynn Gumpert and Mary Jane Jacob. In her catalog essay, Gumpert contended that the aging black-and-white family photographs in Boltanski's work constituted an immediate way to access the memory of lives lost during the Holocaust (see Fig. 1). Gumpert described his use of photographs as a way of obliquely referencing that which we cannot approach. Citing Siegfried Kracauer, she explained: "Kracauer concludes that we cannot look at actual horrors directly because they would

paralyze us, and that we can only watch images of them: 'the reflections of happenings which would petrify us were we to encounter them in real life.'" She sees in Boltanski's work a way to remember such horrors:

> Boltanski's work, like the film screen of Perseus' polished shield, serves as a mirror reflecting the mass extinctions in the concentration camps....What is reflected in Boltanski's work...are not at all literal depictions of the Holocaust. Instead, he approaches the atrocities obliquely, indirectly, through photographs of children that testify to the death since they became adults of their childhood....Ultimately, Boltanski's work, while broaching the theme of death, also evokes life itself....In excavating his memories of childhood and his notions of death, he succeeds in presenting us with reflections of ourselves. Looking at the life and "death" of Christian Boltanski in the polished shield of his work, we see our own – and survive.[30]

This interpretation is then generalized to argue that much of Boltanski's oeuvre references the Holocaust. However, the evidence from Boltanski's work may not be as clear-cut as she suggests: although several of Boltanski's works such as *La Maison manquante* (1991) and *Lycée Chases* (1988) (*The Missing House* and *Chases High School*) directly reference the period of the Holocaust and its victims, many works simply repeat photographs that Boltanski has been using since the early 1970s, such as the school-children of Dijon, child members of the Mickey Mouse club, and unidentified photographs clipped from tabloids. But perhaps more telling, in terms of what it reveals about the politics of art, of museums, and of interpretation, is the series of slippages in her argument: Boltanski evokes the horrors of the Holocaust through pictures of children, which evoke death by representing childhood lost as the children become adults; this transmutes into a claim that Boltanski represents his own life and death, and this into the proposition that we can thus "see our own" life and death and "survive." One is left with the question of what kind of content about the Holocaust is conveyed. If Boltanski does not reference or represent the Holocaust and if we see ourselves in his work – isn't the specific history being lost?

Gumpert's interpretation is a commendable, thought-provoking effort to address the memory and trauma of the Holocaust. However, the interpretation that the work's meaning is determined by the spectator promotes the viewers' connection to the work while avoiding the difficult issues of the work's content. It claims that the work provides a means for viewers to respond to oppressive history in the present, yet it uses viewers'

emotional identification with private representations of childhood to gloss over viewers' distance from the traumas that are supposedly represented. In fact, such accounts of Boltanski illustrate the risks of using representations of the private to support political needs they cannot meet. Though this seems like an appealing solution to museums because they may claim the difficult content is referenced, the actual contribution is lessened by the fact that the content may not always be there.

Furthermore, the idea that Boltanski's images trigger each viewer's memory implies that audiences have different interpretations, but also share a fundamental similarity. Yet Boltanski's images have a social specificity; they are largely images of white, middle-class Europeans from the 1940s to the 1970s with which all audiences might not identify. Rather than contending that all viewers can identify with them, museums need to recognize important reasons why viewers may not – the ethnicity, race, gender, religion, social class, and so forth depicted in the works and of the individuals who make up its audience. Instead of trying to collapse the individual into a shared human identity with a common point of identification that is never discussed, museums would be more productive and truly responsive if they embraced individual differences as a starting point of discussion.

This book has sought to write artists' challenges to the museum as a collective representation of the nation back into the history of the post-1968 decade, even though critics, curators, policy makers – even presidents – from 1968 to the present have tended to write it out. The post-1968 period was not only a turbulent time, but also the controversial origin of the most pressing cultural debates of the present, debates which are far from resolved. The seriousness of the controversy then and now is an important reason, I believe, why art historians have been reluctant to address the political significance of the art of this period. The questions of how to represent the nation, how to determine the grounds for collective expression – if indeed such grounds are possible – and how to relate the personal to the collective are issues that the art world is still struggling to address. Thus, we need to return to and understand the challenges and possibilities that artists, critics, and curators have sensed over the decades, but that have been lost from view. In doing so, the ways in which the universal and national appeal of the museum have been claimed only through exclusions and suppressions may be perceived and once again contested.

Although their familiarity may seem a perfect example of outreach to all, representations of personal and everyday life are not a means to overcome conflict, but are precisely the means to engage extremely pressing

political issues. Exhibitions of the private and everyday, in other words, make museums sites of political struggle, not community consensus. But this should not be seen as a failure to achieve the goals of democracy and outreach that were voiced so powerfully in 1968. Instead, attending to the challenges and difficulties raised as the private and everyday are put on display provides a new point of entry to discuss the divisions in contemporary society. By embracing debate and conflict, museums can find their most important challenge, but also their most vital power.

NOTES

1. MUSEUMS AS POLITICAL CENTERS

1 The curator Mary Jane Jacob made connections between Boltanski's work of the 1970s and his current work: "The poor material he used . . . increased [his work's] power . . . the poverty of his means had an inverse relation to their beauty and emotive impact. . . . [B]y appropriating mementos of others' lives and presenting them as if they were his own, he could both depersonalize and generalize their content, allowing each of us to share in the remembrances and to see in them our own experiences. He created art that could be completed by a viewer reading the work according to his or her own life." Mary Jane Jacob, "Introduction," *Christian Boltanski: Lessons of Darkness*, ed. Lynn Gumpert and Mary Jane Jacob (Chicago: Museum of Contemporary Art; Los Angeles: The Museum of Contemporary Art; and New York: The New Museum of Contemporary Art, 1988) 11–13. Her co-curator Lynn Gumpert described: "In excavating his memories of childhood and his notions of death, he succeeds in presenting us with reflections of ourselves" (84). The *Lessons of Darkness* exhibition was held in Chicago, Los Angeles, New York, Vancouver, Berkeley, and Toronto in 1988 and 1989.

2 She writes: "Boltanski's work . . . serves as a mirror reflecting the mass extinctions in the concentration camps." Gumpert, *Lessons*, 84. For her interview with Boltanski, see pages 53–4. Béatrice Parent, curator at the Musée d'Art Moderne de la Ville de Paris where Boltanski's work was also being shown, explained: "Boltanski wants to 'implicate' the spectator, so that he recognizes himself in the work that confronts him. . . . History is frozen, the unnamable history of the death camps, the history we hide from ourselves, but keep in our memories. Fixed in these hard and violent photographs, in this very emotional theatricalization, history suddenly returns like a landslide, like memories long buried rushing back to consciousness." Béatrice Parent, "Light and Shadow: Christian Boltanski and Jeff Wall," *Parkett 22* (December 1989) 62. For more recent discussions of this interpretation, see, for example, Lynn Gumpert, *Christian Boltanski* (Paris: Flammarion, 1994) and Gerald Fox, *Christian Boltanski* (Chicago: Home Vision Arts, 1997).

3 See Heike Ander and Nadja Rottner, eds., *Documenta 11 Platform 5: Exhibition Catalogue* (Ostfildern-Ruit: Hatje Cantz, 2002) 412–15 and Nadja Rottner, "Annette Messager," *Documenta 11 Short Guide*, ed. Christian Rattemeyer (New York: Distributed Art Publishers, Inc., 2002) 160. See also "Annette Messager Documenta 11," *Kunstforum International* 161 (August–October 2002) 270–3.

4 Kristin Ross, *May '68 and Its Afterlives* (Chicago: University of Chicago Press, 2002) 3. Ross explains: "Among the insurrections that were occurring across the globe in the 1960s – notably in Mexico, the United States, Germany, Japan, and elsewhere – only in France, and to a certain extent in Italy, did a synchronicity or 'meeting' between intellectual refusal of the reigning ideology and worker insurrection occur" (4).

5 Jean-Pierre Le Goff, *Mai 68, L'Héritage impossible* (Paris: La Découverte, 1998) 43–7.

6 Carol Duncan, *Civilizing Rituals: Inside Public Art Museums* (New York: Routledge, 1995) 22.

7 Pierre Nora, *Realms of Memory*, trans. Arthur Goldhammer (New York: Columbia University Press, 1996 (orig. 1992)).

8 I am not suggesting that this was the first such struggle over museums in French history; the role of museums had been a focus of interest at moments of political upheaval from the French revolution onward. For recent studies of the ways governments foregrounded arts policy and support for living artists to advance their political platforms, see, for example, Marie-Claude Chaudonneret, *L'Etat et les artistes* (Paris: Flammarion, 1999) and Chantal Georgel and Geneviève Lacambre, *1848 La République et l'art vivant* (Paris: Réunion des Musées Nationaux, 1998). For historical criticisms of the museum, see, for example, Anne-Laure Charrier, *Visiteurs du Louvre* (Paris: Réunion des Musées Nationaux, 1993).

9 On the '68 activism in the art world, see Jean Cassou, *Art and Confrontation*, trans. Nigel Foxell (London: Studio Vista Limited, 1970 (orig. 1968)). See also the extensive archives of tracts, films, photographs, and posters at the Bibliothèque de Documentation Internationale Contemporaine (BDIC), Nanterre and the Bibliothèque Nationale, Paris.

10 Whereas the cultural policies created under André Malraux in the 1960s and by the socialist government in the 1980s have been the focus of much interesting literature, the 1968 activism in the art world and the 1970s cultural policies that were created in response have received far less attention. There are, however, several sources that provide revealing accounts of the cultural politics of the period. See Pierre Gaudibert, *Action culturelle: Intégration et/ou subversion* (Paris: Casterman, 1972); Francis Jeanson, *L'Action culturelle dans la cité* (Paris: Seuil, 1973); Pierre Cabanne, *Le Pouvoir culturel sous la Ve République* (Paris: Olivier Orban, 1981); Jeanne Laurent, *Arts et pouvoirs en France de 1793 à 1981* (Saint-Etienne: Université de Saint-Etienne, 1982); Catherine Millet, *L'Art contemporain en France* (Paris: Flammarion, 1987); and Brian Rigby, *Popular Culture in Modern France* (New York: Routledge, 1991).

11 This strategy of using family pictures as a touchstone has been so widely adopted that only a few examples can be mentioned. Some of the best-known American practitioners are Lorie Novak, Clarissa Sligh, and Sally Mann. On the prevalence of family photographs in contemporary North American artistic displays, for example, see Marianne Hirsch, *Family Frames: Photography, Narrative, and Postmemory* (Cambridge: Harvard University Press, 1997) and Marita Sturken, "Personal Photographs in Cultural Memory," *The Familial Gaze*, ed. Marianne Hirsch (Hanover: Dartmouth College, 1999).

12 See François Pluchart, "L'Histoire universelle de Boltanski," *Combat* 20 December 1971, 11; Alfred Pacquement, "Christian Boltanski," *Les Lettres françaises* 1418 (12–18 January 1972) 26; and Gilbert Lascault, *Cinq Musées personnels* (Grenoble: Musée de Grenoble, 1973) n.p. for early articulations of these interpretations. For subsequent readings that continue this pattern of interpretation, see, for example, Andreas Franzke, *Christian Boltanski: Reconstitution*, trans. Laurent Dispot (Paris: Chêne, 1978); Musée d'Art Moderne Villeneuve d'Ascq, *Collages, Collections des musées de province* (Colmar: Musée d'Unterlinden, 1990); and Philippe Dagen, "L'Ecole fantôme de Christian Boltanski," *Le Monde* 24–5 August 1997, 15.

13 For universalizing interpretations of Messager's work across her career, see, for example, Jacques Darriulat, "Annette Messager, Collectionneuse," *Combat* 27 May 1974, 9; Michel Nuridsany, "Annette Messager: L'Univers du feuilleton," *Le Figaro* 7 November 1978, 30; Bernard Marcadé, "Je ne crois pas aux fantômes mais j'en ai peur," *Annette Messager chimères* (Calais: Musée de Calais, 1982–83) 59–62; and Carol S. Eliel, "'Nourishment You Take' Annette Messager, Influence, and the Subversion of Images," *Annette Messager*, ed. Sheryl Conkelton and Carol S. Eliel (New York: Museum of Modern Art, 1995) 51.

14 Nadja Rottner, for example, described Messager's work as helping viewers understand "the dark and more violent side of humanity," and as "standing in for a larger human condition of suppression and oppression" as it was enacted in everyday life. Rottner, "Annette Messager," 160.

15 The Conceptual Art movement is vast and the writing on it is equally vast. For their treatment of Conceptual Art in wide-ranging European and American contexts, the work of Charles Harrison, Lucy Lippard, Anne Rorimer, and Benjamin Buchloh has been particularly important. See Charles Harrison, *Conceptual Art and Painting* (Cambridge: MIT Press, 2001); Lucy Lippard, "Escape Attempts," *Reconsidering the Object of Art 1965–1975*, ed. Ann Goldstein and Anne Rorimer (Los Angeles: Museum of Contemporary Art, 1995) 16–41; Anne Rorimer, *New Art in the 60s and 70s: Redefining Reality* (London: Thames and Hudson, 2001); and Benjamin Buchloh, "From the Aesthetic of Administration to Institutional Critique (Some Aspects of Conceptual Art 1962–1969)," *L'Art conceptuel, Une Perspective* (Paris: Musée d'Art Moderne de la Ville de Paris, 1990) 41–53. See also the recent anthology, Michael Corris, ed. *Conceptual Art: Theory, Myth, and Practice* (New York: Cambridge, 2004).

16 Delphine Renard, "Entretien avec Christian Boltanski," *Boltanski* (Paris: Musée National d'Art Moderne, Centre Georges Pompidou, 1984) 72–3; Démosthène Davvetas, "Christian Boltanski," *Flash Art* 124 (October–November 1985) 82; Gumpert, *Lessons*, 54. In 1993, Boltanski explained: "Much of my early work is about the Holocaust, but I would never have spoken about it in these terms, or pronounced that word. Early pieces . . . deal with the Holocaust, but the subject matter is displaced and hidden. I could only begin talking about it much later." Leslie Camhi, "Christian Boltanski: A Conversation with Leslie Camhi," *Print Collector's Newsletter* 23.6 (January–February 1993) 202. "I was born at the end of the war. My mother was a Christian, and my father, who was Jewish, had been hunted by the Nazis. Most of my parents' friends were survivors of the Holocaust, and even though I have never talked directly about the

Shoah, those years of horror are undoubtedly, in one way or another, always present in my work." Quoted in Gloria Moure, *Christian Boltanski, Advent and Other Times* (Barcelona: Polígrafa, 1996) 105.

17 In 1989, Boltanski contended: "My work is not about the camps, it is after the camps. The reality of the Occident was changed by the Holocaust. We can no longer see anything without seeing that. But my work is really not about the Holocaust, it's about death in general, about all of our deaths." Georgia Marsh, "The White and the Black: An Interview with Christian Boltanski," *Parkett* 22 (1989) 39. In 1997, he asserted: "My work is about the fact of dying, but it's not about the Holocaust itself. . . . I don't think [my work] is about Jewish history. I often get this kind of misunderstanding with my work. Of course it is post-Holocaust art, but that is not the same as saying that it is Jewish art. I hope my work is general. . . . I know nothing about Jewish culture and religion; I've almost never been to a synagogue. If I had to choose a religion I would choose the Christian religion. It would suit me better because it's more universal than Judaism." Tamar Garb, "Interview with Christian Boltanski," *Christian Boltanski* (London: Phaidon, 1997) 22–3.

18 On the problem of Boltanski's identity, see Daniel Soutif, "Et in Boltanski ego," *Voyages immobiles* (Nantes: Le Passeur, 1994) 47–70, as well as his playful reconstruction of Boltanski's career, which was written as if pulling documents, works, and exhibition announcements from an archival box, in Daniel Soutif, "An Attempt to Reconstruct Christian Boltanski," *Christian Boltanski*, ed. Danilo Eccher (Milan: Charta, 1997) 30–177. In her review of the *Lessons of Darkness* exhibition, Nancy Marmer discusses the contradictions in Boltanski's ostensibly autobiographical artwork, as does Didier Semin. See Nancy Marmer, "Boltanski, The Uses of Contradiction," *Art in America* 77.10 (1989) 168–80, 233, 235 and Didier Semin, "Boltanski: From the Impossible Life to the Exemplary Life," *Christian Boltanski* (London: Phaidon, 1997) 44–91.

19 Michel Foucault, "What Is an Author?" *Language, Counter-Memory, Practice*, trans. Donald F. Bouchard and Sherry Simon (Ithaca: Cornell University Press, 1977 (orig. 1969)) 113–38. Roland Barthes, "The Death of the Author," *Image, Music, Text*, trans. Stephen Heath (New York: Noonday Press, 1977 (orig. 1968)) 142–8. For the debates on authorship in the *Cahiers du cinéma* of the 1960s, see John Caughie, *Theories of Authorship* (New York: Routledge, 1981).

20 Abigail Solomon-Godeau has raised doubts about Boltanski's Berlin installation, *La Maison manquante* (1991), as a site of historical commemoration, in "Mourning or Melancholia: Christian Boltanski's Missing House," *Oxford Art Journal* 21.2 (1998) 1–20. Ernst van Alphen has argued that Boltanski engages the history of the Holocaust yet does not make literal representations; with his portrait-based work, Boltanski creates a "Holocaust effect" by emphasizing the depicted subjects' absence rather than their presence. Ernst van Alphen, "Nazism in the Family Album: Christian Boltanski's *Sans Souci*," *The Familial Gaze*, ed. Marianne Hirsch (Hanover: Dartmouth College, 1999) 32–50. Richard Hobbs has pursued allusions to the Holocaust in Christian Boltanski's work and that of his brother, Luc Boltanski, see Richard Hobbs, "Boltanski's Visual Archives," *History of the Human Sciences* 11.4 (1998) 121–40. On the presentation of Boltanski's work in the exhibition *After Auschwitz: Responses to the Holocaust in Contemporary Art*, see Sue Hubbard, "After Auschwitz: Responses to the Holocaust," *Contemporary Art* 3.1 (Winter 1995) 10–14.

21 Luc Boltanski, *Prime Education et morale de classe* (Paris: Ecole Pratique des Hautes Etudes and Mouton, 1969). Boltanski's approach to the medical establishment as a means of social control was indebted to Michel Foucault, *Naissance de la clinique* (Paris: Presses Universitaires de France, 1963). See also Louis Althusser, *Lenin and Philosophy and Other Essays*, trans. Ben Brewster (New York: Monthly Review Press, 1971 (orig. 1969)).

22 See Gilbert Lascault, "Les Travaux de la femme," *Chroniques de l'art vivant* 33 (April 1973) 14–16 and Sheryl Conkelton, "Annette Messager's Carnival of Dread and Desire," *Annette Messager*, ed. Sheryl Conkelton and Carol S. Eliel (New York: Museum of Modern Art, 1995) 9–49. For additional feminist interpretations, see Günter Metken, *Annette Messager Sammlerin, Annette Messager Künstlerin* (München: Städtische Galerie im Lenbachhaus, 1973) 3–6; Aline Dallier, "Le Soft Art et les femmes," *Opus international* 52 (September 1974) 49–53; and Margarethe Jochimsen et al., *Frauen Machen Kunst* (Bonn: Galerie Magers, 1977) n.p.

23 Henri Lefebvre, *Everyday Life in the Modern World*, trans. Sacha Rabinovitch (New York: Harper and Row, 1971 (orig. 1968)).

24 See "Work, Politics, and Power" and "Home Life" in Claire Laubier, *The Condition of Women in France: 1945 to the Present, A Documentary Anthology* (New York: Routledge, 1990) 113–67. For overviews of the French Women's Liberation Movement, see Claire Duchen, *Feminism in France: From May '68 to Mitterrand* (London: Routledge, 1986); Isabelle de Courtivron and Elaine Marks, *New French Feminisms: An Anthology* (New York: Schocken Books, 1981); and Françoise Picq, *Libération des femmes: Les Années-mouvement* (Paris: Seuil, 1993).

25 See, for example, Darriulat, "Annette Messager, Collectionneuse," 9; Nuridsany, "Annette Messager: L'Univers du feuilleton," 30; Marcadé, "Je ne crois pas aux fantômes," 59–62; and Eliel, "Nourishment," 51.

26 Thomas Crow, *The Rise of the Sixties* (New York: Harry N. Abrams, 1996) 150, 179.

27 Blake Stimson, "The Promise of Conceptual Art," *Conceptual Art: A Critical Anthology*, ed. Alexander Alberro and Blake Stimson (Cambridge: MIT Press, 1999) xl.

28 See, for example, Francis Parent and Raymond Perrot, *Le Salon de la Jeune Peinture, Une Histoire 1950–1983* (Paris: Jeune Peinture, 1983) and Geneviève Dreyfus-Armand and Laurent Gervereau, *Mai 68, Les Mouvements étudiants en France et dans le monde* (Paris: Bibliothèque du Musée de l'Histoire Contemporaine, 1988).

29 Mary D. Garrard, "Feminist Politics: Networks and Organizations," *The Power of Feminist Art*, ed. Mary D. Garrard and Norma Broude (New York: Abrams, 1994) 90–1 and Simon Taylor, "The Women Artists' Movement: From Radical to Cultural Feminism, 1969–1975," *Personal and Political: The Women's Art Movement, 1969–1975*, ed. Simon Taylor and Natalie Ng (East Hampton: Guild Hall Museum, 2002) 13.

30 Erika Doss, *Twentieth-Century American Art* (Oxford: Oxford University Press, 2002) 196–7 and Mary Schmidt Campbell, *Tradition and Conflict: Images of a Turbulent Decade 1963–1973* (New York: The Studio Museum in Harlem, 1985) 45–68.

31 Francis Frascina, *Art, Politics, and Dissent: Aspects of the Art Left in Sixties America* (Manchester: Manchester University Press, 1999) 111.

2. DISMANTLING ART INSTITUTIONS: THE 1968 EXPLOSION OF SOCIAL AWARENESS

1 Keith A. Reader, *The May 1968 Events in France* (London: St. Martin's Press, 1993) 1–20.

2 Kristin Ross, *May '68 and Its Afterlives* (Chicago: University of Chicago Press, 2002) 4.

3 Fisera notes that universities were massively overenrolled – with attendance increasing from 357,000 students in 1964–65 to more than 550,000 in 1967–68; over two-thirds would leave before graduating. Vladimir Fisera, ed. *Writing on the Wall. May 1968: A Documentary Anthology* (New York: St. Martin's Press, 1978) 5, 19.

4 Ibid., 13–14.

5 These factory occupations hearkened back to the Popular Front activities of the 1930s, much like the students' barricades evoked the memory of the Paris Commune.

6 Fisera, *Writing on the Wall*, 38.

7 Michel de Certeau, *The Capture of Speech and Other Political Writings*, trans. Tom Conley (Minneapolis: University of Minnesota Press, 1997 (orig. 1968)) 3.

8 "Fermeture de l'Ecole jusqu'à nouvel ordre."

9 The paintings were shown at the Alsthom factory in Belfort, at the Berliet factories in Bourg-en-Bresse, in the streets of Perrouges and Besançon, and in the "MJC" (youth community centers) of Besançon and Lons-le-Saunier. Francis Parent and Raymond Perrot, *Le Salon de la Jeune Peinture, Une Histoire 1950–1983* (Paris: Jeune Peinture, 1983) 73–4.

10 Ross, *May '68 and Its Afterlives*, 3. For collections of tracts and other ephemeral sources, see the holdings at the Bibliothèque de Documentation Internationale Contemporaine, Nanterre, as well as the

compilations and publications of the Bibliothèque Nationale, Service de l'Histoire de France, *Les Tracts de Mai 1968* (Paris: IDC, 1987) and *Les Affiches de Mai 68* (Paris: Bibliothèque Nationale, 1982).

11 In addition, as a result of the protesters' emphasis on collective action and authorship, as well as the fluid, nonhierarchical, participatory organization of the groups that made up the protest movements, it can be difficult to recount the history of the protests with anything like the traditional historical narrative with clearly defined leaders.

12 Jean Clair, *Art en France: Une Nouvelle Génération* (Paris: Chêne, 1972).

13 See, for example, the following surveys of contemporary art in France: François Pluchart, *Pop Art et Cie.* (Paris: Martin Malburet, 1971); Suzanne Pagé and Catherine Thieck, *Tendances de l'art en France 1968–1978/9* (Paris: ARC, 1979); and Claude Gintz, *Vingt-cinq Ans d'art en France 1960–1985* (Paris: Jacques Legrand, 1986).

14 Pierre Cabanne, *Le Pouvoir culturel sous la Ve République* (Paris: Olivier Orban, 1981) 219–20. Apparently the closure was precipitated by critic Pierre Restany, best known for his writing on the *nouveaux réalistes* of the early 1960s.

15 André Malraux, *Le Musée imaginaire* (Paris: Gallimard, 1954). On Malraux's writing about art, see Herman Lebovics, *Mona Lisa's Escort: André Malraux and the Reinvention of French Culture* (Ithaca: Cornell University Press, 1999) 79–82.

16 Malraux developed his optimistic view of the possibilities of photographic reproduction – particularly the idea that photographs could bring images of things previously unseen to mass audiences – from Walter Benjamin's "The Work of Art in the Age of Mechanical Reproduction" essay. See Walter Benjamin, "The Work of Art in the Age of Mechanical Reproduction," *Illuminations*, trans. Harry Zohn, ed. Hannah Arendt (New York: Schocken Books, 1968) 217–52.

17 Texts from the meeting of the Assemblée Nationale, November 18, 1959. Cited in Pierre Gaudibert, *Action culturelle: Intégration et/ou subversion* (Paris: Casterman, 1972) 29–30, "rendre accessibles les œuvres capitales de l'humanité et d'abord de la France, au plus grande nombre possible de Français, assurer la plus vaste audience au patrimoine culturel" so that "n'importe quel enfant de seize ans, si pauvre soit-il, puisse avoir un véritable contact avec son patrimoine national et avec la gloire de l'esprit de l'humanité."

18 In fact, in planning for the *maisons de la culture*, Malraux employed a number of cultural "*animateurs*" who had been active in the popular education and popular culture movements. See Brian Rigby, *Popular Culture in Modern France* (New York: Routledge, 1991) 39–68. In 1934, Malraux had participated in the planning and programming for the first *maison de la culture* in Paris. In 1936, several more *maisons de la culture* were established in Rouen, Reims, Nice, Cannes, Tunis, and Algiers. The idea of the *maisons de la culture* originated with the institutions that had been created in the Soviet Union shortly after the 1917 revolution and continued to operate in the 1960s. See Lebovics, *Mona Lisa's Escort*, 116.

19 Lebovics, *Mona Lisa's Escort*, 46–9, 85, 122, 203.

20 Emile Biasini, *Action culturelle, An I* (Paris: Ministère d'Etat des Affaires Culturelles, October 1962) 15, trans. in Lebovics, *Mona Lisa's Escort*, 123.

21 Pierre Bourdieu and Alain Darbel, *The Love of Art* (Stanford: Stanford University Press, 1990 (orig. 1966)). Bourdieu directed the study and wrote the text whereas Darbel designed the sampling strategy and mathematical models for the visitor surveys.

22 Ibid., 15.

23 Ibid., 44.

24 Ibid., 44.

25 Ibid., 111.

26 Ibid., 111.

27 Ibid., 113.

28 Atelier Populaire, *Posters from the Revolution Paris, May 1968* (London: Dobson Books, Ltd., 1969) n.p. The critiques of the *maisons de la culture* and Malraux's cultural policy were wide-ranging. In an anthology of activist texts that he published in 1968, for instance, Jean Cassou, the former director of the Musée

National d'Art Moderne, lamented the very limited role given to contemporary curators and cultural institutions: "The only obligation . . . is to preserve the testimonies of the past, and perhaps even more to preserve the opportunity they provide for self-glorification." He complained that museums provided no sense of art as alive or as containing revolutionary potential. Jean Cassou, *Art and Confrontation*, trans. Nigel Foxell (London: Studio Vista Limited, 1970 (orig. 1968)) 8–9. Raoul Vaneigem, a member of the Situationist International, advocated a more direct approach, calling for making love in the *maisons de la culture* as a passionate antidote to the cultural and mental stagnation they had fostered. Raoul Vaneigem, *Traité de savoir-vivre à l'usage des jeunes générations* (Paris: Gallimard, 1967) 55.

29 Cited in Raymonde Moulin, "Living Without Selling," *Art and Confrontation*, ed. Jean Cassou, trans. Nigel Foxell (London: Studio Vista Limited, 1970 (orig.1968)) 135.

30 Many of the directors of the *théâtres populaires* and the *maisons de la culture* had been active in the popular culture and popular education movements and thus tended to be sympathetic to the '68 protesters' call for more democratic art institutions.

31 Cited in Francis Jeanson, *L'Action culturelle dans la cité* (Paris: Seuil, 1973) 119–22, trans. in Rigby, *Popular Culture*, 136–7, "la simple 'diffusion' des œuvres d'art . . . apparaissait déjà de plus en plus incapable de provoquer une rencontre effective entre ces œuvres et d'énormes quantités d'hommes et de femmes qui s'acharnaient à survivre au sein de notre société mais qui, à bien des égards, en demeuraient exclus: contraints d'y participer à la production des biens matériels mais privés des moyens de contribuer à l'orientation même de sa démarche générale. . . .
Quelle que soit la pureté de nos intentions, cette attitude apparaît en effet à une quantité considérable de nos concitoyens comme une option faite par des privilégiés en faveur d'une culture héréditaire, particulariste, c'est-à-dire tout simplement bourgeoise."

32 Ibid., 120, "une conception entièrement différente qui ne se réfère pas *a priori* à tel contenu préexistant mais qui attend de la seule rencontre des hommes la définition progressive d'un contenu qu'ils puissent *reconnaître*."

33 Ibid., 120, "se libérant toujours mieux des mystifications de tous ordres qui tendent à le rendre en lui-même complice des situations réelles qui lui sont infligées."

34 The statement ended by calling for the budget for cultural affairs to be increased from 0.43% to 1.0 % of the national budget. The 1969 budget for cultural affairs however, was not increased, and funding for the *maisons de la culture* declined. Several municipalities that had been hostile to the *maisons* withdrew funding, making it difficult for the state to finance them fully. A number of the directors who were part of the Villeurbanne committee were forced to leave their posts. Cabanne, *Le Pouvoir culturel*, 236–7.

35 See Jean Jamin, "Les Objets ethnographiques sont-ils des choses perdues?" *Temps perdu, Temps retrouvé*, ed. Jacques Hainard and Roland Kaehr (Neuchâtel: Musée d'Ethnographie, 1985) 61–2; Jean François Leroux-Dhuys et al., *La Muséologie selon Georges Henri Rivière* (Paris: Bordas, 1989); Georges Henri Rivière, "De l'objet d'un musée d'ethnographie comparé à celui d'un musée des beaux-arts," *Cahiers de Belgique* (November 1930) 310–13; and Nina Gorgus, *Le Magicien des vitrines, Le Muséologue Georges Henri Rivière*, trans. Marie-Anne Coadou (Paris: Fondation Maison des Sciences de l'Homme, 2003).

36 Part of the reason for this was that the Musée de l'Homme was a "research museum" run under the umbrella of the Ministry of Education, rather than the Ministry of Culture, and maintained by leftist professors whose personal politics tended toward colonial independence. Christian Boltanski, Interview with the author, January 14, 2004.

37 de Certeau, *The Capture of Speech*, 33.

38 Yve-Alain Bois, "Better Late than Never," *Rendezvous: Masterpieces from the Centre Georges Pompidou and the Guggenheim Museums* (New York: Solomon R. Guggenheim Foundation, 1998) 44.

39 The term "School of Paris" remains loosely defined. However, the term usually encompasses painters of international origin, as well as French artists who made their careers in Paris. Cassou's primary acquisitions included large numbers of works by Matisse, Picasso, Braque, and Rouault, and his exhibitions favored fauvism and cubism. See Kathryn Anne Boyer, "Political Promotion and Institutional Patronage: How New York Displaced Paris as the Center of Contemporary Art, ca. 1955–1968," dissertation, University of Kansas, 1994, 133. For more information on how the Ecole de Paris was promoted as a French

tradition, see Sarah Wilson, "La Vie artistique à Paris sous l'Occupation" and "Les Peintres de tradition française," *Paris 1937-Paris 1957: Créations en France* (Paris: Centre Georges Pompidou, 1981) 147–62 and 163–74. See also Laure de Buzon-Vallet, "L'Ecole de Paris, Eléments d'une enquête," in *Paris-Paris* (Paris: Centre Georges Pompidou, 1981). For a discussion of Cassou's presentation of French art in the 1960 exhibition *Les Sources du vingtième siècle*, see Sandra Persuy, "Les Sources du XXe siècle," *Les Cahiers du MNAM* 67 (Spring 1999) 30–63.

40 Bois, "Better Late than Never," 45.

41 Most of the works were not displayed until the CNAC was merged with the MNAM for the opening of the Pompidou Center in 1977. Jeanne Laurent, *Arts et pouvoirs en France de 1793 à 1981* (Saint-Etienne: Université de Saint-Etienne, 1982) 161.

42 Catherine Millet, *L'Art contemporain en France* (Paris: Flammarion, 1987) 136.

43 Gaudibert, *Action culturelle*, 144.

44 For example, Ross notes that philosophers including Lukács, Heidegger, and Lefebvre himself took up the subject of the everyday in the 1930s, but treated it as a "negative category," in terms of banal repetition. See Kristin Ross, "French Quotidian," *The Art of the Everyday: The Quotidian in French Postwar Culture*, ed. Lynn Gumpert (New York: NYU Press, 1997) 19–21 and Alice Kaplan and Kristin Ross, "Introduction," *Yale French Studies* 73 (1987) 1–4.

45 In 1958, Lefebvre broke with the Parti Communiste Français (which continued to support Stalinism), but continued to explore Marxist issues in his work.

46 Kristin Ross, "Lefebvre on the Situationists: An Interview," *October* 79 (Winter 1997) 69–72.

47 Members from the Lettrist International joined with Cobra and the International Movement for an Imagist Bauhaus in the First World Congress of Free Artists in 1956 and in the Situationist International in 1957. Situationists were undoubtedly influential in the May and June events in France, yet the scope of their influence is still highly debated. See, for example, Thomas F. McDonough, "Rereading Debord, Rereading the Situationists," *October* 79 (Winter 1997) 3–14 and Reader, *The May 1968 Events*, 51–3.

48 Michèle C. Cone, "'Métro, Boulot, Dodo': The Art of the Everyday in France 1958–1972," *The Art of the Everyday: The Quotidian in French Postwar Culture*, ed. Lynn Gumpert (New York: NYU Press, 1997) 47–8.

49 Victoria Scott, "La Beauté est dans la rue: Art and Visual Culture in Paris 1968," M. A. thesis, University of British Columbia, 2000, 44–5, 77–8.

50 Millet, *L'Art contemporain en France*, 23.

51 Tronche and Gloaguen, *L'Art actuel en France*, 55.

52 Ibid., 191.

53 See, for example, "The Avant-Garde of Presence," *Internationale situationniste* 8 (January 1963) 3–14.

54 Michel Ragon, "The Artist and Society," *Art and Confrontation*, trans. Nigel Foxell (London: Studio Vista Limited, 1970 (orig. 1968)) 34.

55 Ibid., 28.

56 Reproduced in Tony Godfrey, *Conceptual Art* (London: Phaidon, 1998) 103.

57 Millet, *L'Art contemporain en France*, 175.

58 See, for example, the definitive text by Pierre Restany, "A quarante degrés au-dessus de dada," *Le Nouveau Réalisme* (Paris: Union Générale d'Editions, 1978 (orig. 1961)) 281–5. For a retrospective summary of the movement, see Pierre Restany, "Nouveau Réalisme," *Manipulated Reality: Object and Image in New French Sculpture*, ed. Edith A. Tonelli (Los Angeles: Frederick S. Wight Art Gallery, UCLA, 1985) 9–16.

59 See Jill Carrick, "Le Nouveau Réalisme: Fetishism and Consumer Spectacle in Post-war France," dissertation, Bryn Mawr College, 1998 and "Phallic Victories? Niki de Saint-Phalle's *Tirs*," *Art History* 26.5 (2003) 700–29. See also Bruce Altshuler, *The Avant-Garde in Exhibition: New Art in the 20th Century* (New York: Abrams, 1994) 192–219.

60 Although *ateliers populaires* were established throughout France, the most famous one was located in the building of the Ecole des Beaux-Arts in Paris.

61 Geneviève Dreyfus-Armand and Laurent Gervereau, *Mai 68, Les Mouvements étudiants en France et dans le monde* (Paris: Bibliothèque du Musée de l'Histoire Contemporaine, 1988) 160–91. Parent and Perrot chronicle the political and aesthetic debates within the *atelier*, indicating some of the members: Gilles

Aillaud, Edouardo Arroyo, Pierre Buraglio, Gérard Fromanger, Julio Le Parc, Bernard Rancillac, Guy de Rougement, Gérard Tisserand, Philippe Vermès, and Christian Zeimert. Parent and Perrot, *Le Salon de la Jeune Peinture*, 76–81.

62 *Atelier populaire présenté par lui-même* (London: U. U. U. [Usines Universités Union], 1968) 12, "développement d'une culture populaire . . . issue du peuple et au service du peuple."

63 Cited in Moulin, "Living without Selling," 131.

64 *Atelier populaire présenté par lui-même*, 29, "travailleurs français, immigrés, unis."

65 Ibid., 60.

66 Rigby, 149. In addition to the posters, tracts and newspapers pasted on walls were also used as alternative means to distribute information.

67 "L'intox vient à domicile."

68 "La police vous parle tous les soirs à 20h."

69 "Sois jeune et tais-toi."

70 "La police s'affiche aux beaux-arts, les beaux-arts affichent dans la rue."

71 Dominique Bozo, "Introduction," *La Collection du Musée National d'Art Moderne*, ed. Agnès de la Beaumelle and Nadine Pouillon (Paris: Centre Georges Pompidou, 1987) 11. See also Laurie Monahan, "Cultural Cartography: American Designs at the 1964 Venice Biennale," *Reconstructing Modernism: Art in New York, Paris and Montreal 1945–1965*, ed. Serge Guilbaut (Cambridge: MIT Press, 1990) 369–416.

72 Pierre Gaudibert, "The Cultural World and Art Education," *Art and Confrontation*, ed. Jean Cassou, trans. Nigel Foxell (London: Studio Vista Limited, 1970 (orig. 1968)) 143.

73 Ibid., 142.

74 Cabanne, *Le Pouvoir culturel*, 119. Gaudibert, "The Cultural World," 149.

75 Ibid., 143. The contemporary art dealer Daniel Cordier described in 1964 how the Academy's influence and outdated teaching at the Ecole des Beaux-Arts worked against contemporary art: "For nearly a century, the government has persecuted the creators of living art through its outdated teaching at the Ecole des Beaux-Arts, its choice of award winners who walk away with all the official commissions, the absurd mediocrity of the official shows, and the Museum of Modern Art's irresponsible purchasing policy – all sorry examples of the confused standard or bald indifference of the men in power." Daniel Cordier, "Letter to the Editor," *Arts Magazine* 38.10 (September 1964) 7.

76 Moulin, "Living without Selling," 126–7.

77 Cordier, "Letter to the Editor," 6.

78 Ibid., 6. Cordier also chastised French collectors for their conservative taste: "Where can one find French private collections of Impressionist, Cubist, Surrealist, or abstract paintings comparable to those which are the pride of Switzerland, Germany or America? . . . the real tastes of French collectors are for Dunoyer de Segonzac, Brianchon, Buffet, Brayer, etc., a traditional painting devoid of lyricism and authenticity, but which is absolutely 'safe.'"

79 Tract courtesy of Philippe Vermès archives,
 "1. L'OFFRE: émane de l'artiste
 2. LA DEMANDE: est régie par un critère esthétique de l'objet d'art et par un critère spéculatif qui constitue à parier sur le bon cheval, la valeur de l'artiste étant consacrée par le processus suivant:
 a. stockage de la production entière de certains artistes par les marchands
 b. certaines de ces œuvres sont présentées dans des musées jusqu'à ce qu'elles prennent de la valeur. Le stock est alors vendu progressivement vendu (*sic*) à des collectionneurs.
 c. les collectionneurs revendent ces œuvres en vente publique. La valeur de l'artiste est alors reconnue selon le principe de l'offre et de la demande.
 Le marché de l'œuvre d'art est comparable à celui des valeurs boursières (panique des hausses, effondrement des cours . . .)
 Donc l'artiste subit les conséquences d'un système sur lequel il ne peut pas agir et dans lequel la qualité de son travail n'intervient pas
 PARCE QU'IL EST ENTRE LES MAINS DES SPECULATEURS.
 3. MECANISMES DU MARCHE:

a. <u>Le contrat</u>
 – exclusivité sur la totalité des œuvres en échange d'un fixe très faible plus un pourcentage sur les ventes
b. '<u>première vue</u>'
 – priorité sur les productions. Les rapports artiste-marchand ne sont pas toujours parfaits, mais:
 – les contrats étant oraux
 – le chantage à l'effondrement de la cote par la vente brutale de tout le stock
 – la complicité dans la fraude fiscale, empêchent toute procédure judiciaire
 Cependant, ces contrats se limitent à 1% du nombre des artistes professionnels
b. (*sic*) <u>Les courtiers</u>
 Intermédiaires qui prélèvent une commission confortable entre l'artiste et les points de vente.
 Le 'droit de suite,' légal, à raison de 3% ne peut pas être réclamé par l'artiste à cause de la clandestinité de la plupart des ventes.
 Il apparaît que l'artiste exploité ne peut s'intégrer à la société à cause de ce marché.
 COMMENT L' ARTISTE PEUT-IL REAGIR?
 – Par le mépris
 – Par l'isolement et la pente du 'peintre maudit'
 – Par la fuite du système et la recherche d'autres moyens"
80 Moulin, "Living without Selling," 123–4.
81 In fact, during May and June, artists boycotted certain galleries while others closed their doors.
82 Ibid., 130.
83 Atelier Populaire, *Posters from the Revolution*, n.p.
84 Moulin,"Living without Selling," 130.
85 Parent and Perrot, *Le Salon de la Jeune Peinture*, 81, "usines, universités, union."
86 Jean Le Gac and Jean Daive, "Jean Le Gac, Détective," *L'Autre Journal* 4 (April 1985) 57.
87 Jean Le Gac, Interview with the author, February 25, 1997.
88 Anne Tronche, "S'il y a quelqu'un ici, il est là," *Gina Pane*, trans. Nicola Coleby (Southampton: John Hansard Gallery, 2002) 58–71. Tronche compares Pane's work to contemporary land art projects by Michael Heizer, Dennis Oppenheim, and Walter de Maria.
89 Lynn Gumpert, *Christian Boltanski* (Paris: Flammarion, 1992) 19.
90 Annette Messager, Interview with the author, February 13, 1997, "Tous les gens qui étaient à Paris . . . on était dans la rue. . . . Bien sûr j'étais tout le temps dans la rue, sur les barricades, enfin beaucoup."
91 Ibid., "C'était le début du féminisme. C'était vraiment une prise de conscience des femmes, qu'elles ne sont pas toujours derrières les hommes. Elles se sont beaucoup organisées en soixante-huit pour les enfants, les bébés, les crèches. C'était très important pour ça."
92 The piece was featured in the 1968 Festival des Arts Plastiques, which, in lieu of a traditional exhibition, asked forty-eight young artists to contribute multiple works to the "Dossier '68." The multiples were sold through the mail and sought to promote distribution that would be different from the usual gallery and museum circuits.
93 Annette Messager, Interview with the author, February 13, 1997, "Je pense que [la Révolution de '68] a vraiment changé les déterminations de beaucoup d'artistes en France. Parce que, enfin pour moi, je ne faisais déjà plus de peinture – à l'école j'avais fait de la peinture – mais c'était sûr que je ne voulais plus faire de peinture."
94 Carol S. Eliel, "'Nourishment You Take' Annette Messager, Influence, and the Subversion of Images," *Annette Messager*, ed. Sheryl Conkelton and Carol S. Eliel (New York: Museum of Modern Art, 1995) 53.

3. CHRISTIAN BOLTANSKI'S PERSONAL MEMORABILIA: REMAKING MUSEUMS IN THE WAKE OF 1968

1 Raymonde Moulin, "Living Without Selling," *Art and Confrontation*, ed. Jean Cassou, trans. Nigel Foxell (London: Studio Vista Limited, 1970 (orig. 1968)) 124, 130–1.

2 Michel Foucault, "What Is an Author?" *Language, Counter-Memory, Practice*, trans. Donald F. Bouchard and Sherry Simon (Ithaca: Cornell University Press, 1977 (orig. 1969)) 138.

3 Roland Barthes, "The Death of the Author," *Image, Music, Text*, trans. Stephen Heath (New York: Noonday Press, 1977 (orig. 1968)) 142–8. For the debates on authorship in the *Cahiers du cinéma* in the 1960s, see John Caughie, *Theories of Authorship* (New York: Routledge, 1981).

4 See, for example, Andreas Franzke, *Christian Boltanski: Reconstitution*, trans. Laurent Dispot (Paris: Chêne, 1978); Delphine Renard, "Entretien avec Christian Boltanski," *Boltanski* (Paris: Musée National d'Art Moderne, Centre Georges Pompidou, 1984) 70–85; and Lynn Gumpert and Mary Jane Jacob, *Christian Boltanski: Lessons of Darkness* (Chicago: Museum of Contemporary Art; Los Angeles: The Museum of Contemporary Art; and New York: The New Museum of Contemporary Art, 1988). Even Jean-Marc Poinsot, editor of *Une Scène parisienne* – the only source that provides an in-depth chronology of Boltanski's activity during this period – has pointed to the fact that the artist and his work have not yet been properly historicized. See Jean-Marc Poinsot, ed., *Une Scène parisienne* (Rennes: Centre d'Histoire de l'Art Contemporain, 1990) 11.

5 The choice to exhibit at the American Center may seem surprising given the anti-American violence that had occurred earlier that year in Paris in opposition to the Vietnam War. However, the American Center was not protested for its association with the Embassy; because the Center was more welcoming to experimental artwork than most Parisian institutions, many young artists exhibited there in the late 1960s and early 1970s.

6 Poster published by the American Center for Students and Artists, 1968. The artists "ne seront pas seulement une présence physique, mais une affirmation par des actes et des objets: ce qu'en d'autres temps on appellerait une œuvre d'art et qui, ici, est plutôt une œuvre à vivre. Plutôt que des spéculations esthétiques, ils proposent, en vertu d'une nouvelle morale, des mécanismes de santé publique. Ils invitent par leur action à mieux se pénétrer de soi, à mieux communiquer, à mieux rêver, à mieux aimer, à être sans faux semblants, sans faux fuyants.... Il ne s'agit pas d'une exposition, mais d'une communication, d'un geste collectif qui n'a de raison d'être que dans la participation, la continuité à vivre.

 L'œuvre d'art traditionnelle est un objet ajouté à la vie; ici c'est la vie qui est...modifiée....L'état d'urgence d'une telle modification de l'art a été ressentie par quelques isolés. Ici, a été tentée la rencontre sans distinction de style, de genre, de quelques-uns de ceux qui en France, ont le plus apporté à ce jeu d'échanges, à cette forme essentielle de communication qui sauvera l'homme d'un anonymat corrosif, anémiant, mortel, que la société de consommation lui prépare."

7 Henri Lefebvre, *Everyday Life in the Modern World*, trans. Sacha Rabinovitch (New York: Harper and Row, 1971 (orig. 1968)).

8 Although the American art market was unquestionably the dominant venue in which emerging artists established their careers, the foundation of the National Endowment for the Arts in 1964, which significantly aided venues for contemporary artists, marked the beginning of a new form of state involvement in American art. But in France there was widespread dissatisfaction with the seeming irrelevance and outdatedness of the gallery scene. Critic Lucy Lippard, in her account of Conceptual Art in the late '60s and early '70s, invokes Charles Harrison on this matter: "The British critic Charles Harrison pointed out that in the late 1960s, Paris and the various European cities were in the position that New York was in around 1939: a gallery and museum structure existed, but it was so dull and irrelevant to new art that there was a feeling it could be bypassed." Lucy Lippard, "Escape Attempts," *Reconsidering the Object of Art 1965–1975*, ed. Ann Goldstein and Ann Rorimer (Los Angeles: Museum of Contemporary Art, 1995) 16–41.

9 Benjamin Buchloh, "Formalism and Historicity – Changing Concepts in American and European Art since 1945," *Europe in the Seventies: Aspects of Recent Art*, ed. Art Institute of Chicago (Chicago: Art Institute of Chicago, 1977) 83–111.

10 Daniel Buren, *Les Ecrits 1965–1990*, ed. Jean-Marc Poinsot (Bordeaux: CAPC, 1990).

11 See Daniel Buren, "Conversation relative à la Biennale de Paris de 1971," *Artitudes* 2 (November 1971) 7–9. At the Venice Biennial in June 1968, Arman was the only artist representing France that left his work on display; Michel Ragon, the curator for the French section, resigned.

12 Gilbert Gatellier, "Les Projets sans fin de Boltanski et de Le Gac," *Opus international* 15 (1969) 44–5, "Le mannequin de Boltanski est un témoin de ses œuvres des dernières années où, dans des sortes d'aquariums de plastique semi-transparent, étaient figés, des personnages de même type, habillés d'oripeaux insoutenables.... Disparus maintenant des mises en scènes statiques, ces personnages se retrouvent, sous forme d'acteurs masqués, dans de courts films de préférence atroces (un monsieur qui crache son sang pendant deux minutes et demie, avec bande sonore . . .)."

13 Ibid., 44, "sans limite d'espace ni de spécialisation culturelle."

14 Ibid., 44, "assemblage séduisant de trois attitudes hétérogènes, qui ne prétendait ni à la fixité ni à la pureté synthétisante d'une œuvre."

15 Lucy Lippard explains that such contradictions are typical in the Conceptual Art of this period: "However rebellious the escape attempts, most of the work remained art-referential, and neither economic nor aesthetic ties to the art world were fully severed." Lippard, "Escape Attempts," 31.

16 Gatellier, "Les Projets sans fin," 44–5, "Boltanski se livre à des travaux de maniaque solitaire, inutiles comme la confection de trois ou quatre mille petites boules d'argile."

17 The statement was published by Templon Gallery in April 1970 and reprinted in Suzanne Pagé and Françoise Chatel, *Boîtes* (Paris: ARC 2, 1977) n.p., "n'ont pour eux que de refléter le temps que j'ai mis à les faire."

18 Gilbert Gatellier, "Opus Actualités," *Opus international* 5 (1969) 54.

19 Moulin, "Living Without Selling," 121–36.

20 Christian Boltanski, *Recherche et présentation de tout ce qui reste de mon enfance 1944–1950* (Paris: Givaudan, 1969) n.p., "On ne remarquera jamais assez que la mort est une chose honteuse. Finalement nous n'essayons jamais de lutter de front, les médecins, les scientifiques ne font que pactiser avec elle, ils luttent sur des points de détail, la retardent de quelques mois, de quelques années, mais tout cela n'est rien. Ce qu'il faut, c'est s'attaquer au fond du problème par un grand effort collectif où chacun travaillera à sa survie propre et à celle des autres. Voilà pourquoi, car il est nécessaire qu'un d'entre nous donne l'exemple, j'ai décidé de m'atteler au projet qui me tient à cœur depuis longtemps: se conserver tout entier, garder une trace de tous les instants de notre vie, de tous les objets qui nous ont côtoyés, de tout ce que nous avons dit et de ce qui a été dit autour de nous, voilà mon but. La tâche est immense et mes moyens sont faibles. Que n'ai-je commencé plus tôt? Presque tout ce qui avait trait à la période que je me suis d'abord prescrit de sauver (6 septembre 1944–24 juillet 1950) a été perdu, jeté, par une négligence coupable. Ce n'est qu'avec une peine infinie que j'ai pu retrouver les quelques éléments que je présente ici. Prouver leur authenticité, les situer exactement, tout cela n'a été possible que par des questions incessantes et une enquête minutieuse. Mais que l'effort qui reste à accomplir est grand et combien se passera-t-il d'années, occupé à chercher, à étudier, à classer, avant que ma vie soit en sécurité, soigneusement rangée et étiquetée dans un lieu sûr, à l'abri du vol, de l'incendie et de la guerre atomique, d'où il soit possible de la sortir de la reconstituer à tout moment, et que, étant alors assuré de ne pas mourir, je puisse, enfin, me reposer."

21 Gatellier, "Les Projets sans fin," 44–5, "pièces du Musée de l'Homme relatives aux cultures disparues," "images dérisoires," "des petits albums où la médiocrité des documents polycopiés . . . accuse la pauvreté des pièces à conviction du souvenir."

22 Catherine Millet, "Boltanski et Le Gac," *Les Lettres françaises* 1 April 1970, 26, "Comment réagir lorsque l'on possède de quelqu'un avec qui l'on a par ailleurs aucun contact personnel, une mèche de cheveux enveloppée comme une relique, quelques photographies de sa petite sœur . . . pour témoigner de son activité et baliser ainsi le temps de sa vie?"

23 Jean-Marc Poinsot, "Les Envois postaux: Nouvelle Forme artistique?" *Chroniques de l'art vivant* 18 (1971) 8. The mailings "relève du privé . . . [qui] souffrirait d'une divulgation au grand public."

24 Letter reproduced in Jennifer Flay and Günter Metken, *Christian Boltanski: Catalogue Books, Printed Matter, Ephemera 1966–1991* (Köln: Walther König, 1992) 24, "Monsieur, Il faut que vous m'aidiez, vous avez sans doute entendu parler des difficultés que j'ai eu [*sic*] récemment et de la crise très grave que je traverse. Je pense d'abord que vous sachiez que tout ce que vous avez pu entendre contre moi est faux. J'ai toujours essayé de mener une vie droite, je pense, d'ailleurs que vous connaissez mes travaux;

vous savez sans doute que je m'y consacre entierrement [*sic*], mais la situation a maintenant atteint un degré intolérable et je ne pense pas pouvoir le supporter bien longtemps, c'est pour cela que je vous demande, que je vous prie, de me répondre le plus vite possible. Je m'excuse de vous déranger, mais, il faut absolument que je m'en sorte. C. Boltanski"

25 Ibid., 26, "mon cher Boltanski, que se passe-t-il? je ne suis au courant de rien... mais peu importe, dites-moi ce que je peux faire pour vous. si c'est dans le domaine des choses possibles, je le ferai de tout cœur. ne vous laissez pas abattre par l'adversité."

26 The statement was published by Templon Gallery in April 1970 and reprinted in Pagé and Chatel, *Boîtes*, n.p., "Chaque boîte devait contenir un moment de mon existence..."

27 Millet, "Boltanski et Le Gac," 26, "Même si les faits qui lui servent de prétexte appartiennent à sa vie la plus intime, sa personnalité ne vient en aucun cas s'imposer au public."

28 Bernard Borgeaud, "Qui se souviendra de Christian Boltanski," *Pariscope* 31 March 1971, 57. Gatellier, "Les Projets sans fin," 44–5.

29 Documenta 5, with its massive scope and didactic message, was a groundbreaking exhibition and stands out among the history of the Documentas. Nonetheless, the basic premise as well as the concept of individual mythologies derived from an earlier exhibition held in Paris, *Mythologies quotidiennes*, organized by François Mathey and Gérald Gassiot-Talabot in 1964. Centre d'Art Contemporain Abbaye Saint-André, *La Fin des années 60: D'une contestation à l'autre* (Meymac, Corrèze: Centre d'Art Contemporain Abbaye Saint-André, 1986) 6.

30 Irmeline Lebeer, "Une Ecole de la vision? (Documenta 5)," *Chroniques de l'art vivant* 32 (August-September 1972) 7–8.

31 Irmeline Lebeer, "Documenta 5: Entretien avec Harald Szeeman," *Chroniques de l'art vivant* 25 (November 1971) 5.

32 Jean Dubuffet, *Prospectus* (Paris: Gallimard, 1946) 47–99.

33 Harald Szeeman, Interview with the author, June 6, 1997.

34 The individual mythology section, although making explicit comparisons between Boltanski's vitrines and those from the Museum Waldau, did not address the *Album de photos de la Famille D.* that was also shown in this section.

35 Letter courtesy of Harald Szeeman archives, "Cher Szeeman, Je t'écris parce que je voudrais modifier un peu la présentation de mon travail à Kassel. Je pense, comme tu me l'avais d'ailleurs conseillé, remplacer l'album de photographies dans le contexte général de 'ma démarche' et qu'il faut lutter contre la notion de pièce qui n'a aucune importance. La seule chose intéressante pour moi étant la vie de l'individu et son obstination à répéter toujours la même chose. Je voudrais reprendre l'idée du Musée, mettre dans la salle quelques reconstitutions en pâte à modeler, des boîtes de biscuits, les petits livres, etc. pour que l'album de photos installé sur un seul mur apparaisse comme une redite parmi celles qui sont venues avant et celles qui viendront après."

36 In September, they exhibited in the department of natural sciences at the Musée de Saint-Etienne; in October, at the Musée de Mâcon; in February and March, 1973, at the Musée de Cognac; and in June and July, 1973, at the Musée Rude in Dijon. Claire Legrand, "Chronique," *Une Scène parisienne*, 64–5.

37 Invitation courtesy of Harald Szeeman archives, "Notre travail est une tentative pour trouver dans notre aujourd'hui les moyens de transmettre et de conserver l'expérience que nous faisons d'une activité artistique: parcours mental, jalonné de vestiges (photos, objets, fragments de textes...) que nous nous efforçons de sauver de l'indifférence et de l'usure du quotidien. Il était naturel que nous songions à présenter ce type d'activité dans des musées qui ont précisément pour vocation de remonter le temps en classant et le document et son histoire.

Il nous a également semblé que les éléments de notre travail pourraient être examinés sur un mode égalitaire qui permettait de les confronter avec les autres témoins de l'activité humaine, et donc, il était intéressant de chercher cette confrontation dans d'authentiques musées qui ont la charge de garder la mémoire des choses et des motivations retrouvées qui ont présidé à leur élaboration."

38 Jean Clair, "Du *Musée imaginaire* à l'imaginaire muséal. Cassel: Documenta 5," *Chroniques de l'art vivant* 32 (August–September 1972) 4–5, "Formes, entités, signes plastiques sont ici disposés selon une ordonnance qui exclue l'intervention de l'individu singulier, de l'artiste signataire. . . . Autrefois principe d'ordonnancement d'un certain processus, origine et unité de sa signification, foyer de cohérence, reconnu et encensé comme tel, individu distingué de la masse des non-artistes, 'auteur' unique d'œuvre singulière . . . Son propos personnel, si particulier semble-t-il être, si irréductible paraît-il demeurer, s'abolit au sein d'un foisonnement de propos semblables, tenus par des individus anonymes: les enfants, les malades mentaux, les naïfs, les mystiques. . . . les pièges de Boltanski rejoignent les outils indéfiniment répétés par tel psychotique . . . les textes et les photos de Le Gac se confondent avec les inscriptions et les nomenclatures de A. S."

39 Ibid., 4, "Mais quel code appliquer à l'œuvre 'artistique,' qui déchiffrerait son sens? L'ambiguïté est la même que celle qui consiste à exposer, comme cela s'est fait récemment, les œuvres de Le Gac et de Boltanski dans un musée d'Ethnologie ou dans un Musée des Sciences et des Techniques. De tels lieux sont liés en effet à une certaine forme de culture. . . . Comme si le rôle de ces musées était de transmettre cette culture abstraite, générale et absolue qui pose le savoir comme une entité sans complément: une intransitivité pure. Or, si visiter le Musée de l'Homme m'apprend quelque chose (d'indéfini), il est sûr que voir dans ce même musée les œuvres de Boltanski ou de Le Gac ne m'apprendra définitivement rien."

40 Ibid., 5, "comme si, au seuil d'une connaissance, elle n'affirmait que le désir de cette connaissance: la forme en creux d'un leurre."

41 Gilbert Lascault, writing for Clair at the *Chroniques de l'art vivant*, was the only other critic who took up a similar line of argument concerning the Documenta 5. See Gilbert Lascault, "Eloge de l'accumulation et du bric à brac," *Chroniques de l'art vivant* 35 (December 1972–January 1973) 16–17.

42 Hans Hein Holz, "Kritische Theorie des ästhetischen Zeichens," *Documenta 5* (Kassel: Documenta, 1972) 1: 1–49. See also Christopher Phillips, "The Phantom Image: Photography within Postwar European and American Art," *L'Immagine Riflessa: une selezione di fotografia contemporanea dalla Collezione LAC, Svizzera* (Prato: Museo Pecci, 1995) 142–52.

43 "En juillet 71, je demandais à un de mes amis, Michel D . . . de me confier l'album de photographies que possédaient ses parents. Je voulais, moi qui ne savais rien d'eux, tenter de reconstituer leur vie en me servant de ces images qui, prises à tous les moments importants, resteraient après leur mort comme la pièce à conviction de leur existence. Je pus découvrir l'ordre dans lequel elles avaient été prises et les liens qui existaient entre les personnages qu'elles représentaient. Mais je m'aperçus que je ne pouvais aller plus loin, car ces documents semblaient appartenir aux souvenirs communs de n'importe quelle famille, que chacun pouvait se reconnaître dans ces photos de vacances ou d'anniversaire. Ces photographies ne m'apprenaient rien sur ce qu'avait été réellement la vie de la Famille D . . . , elles me renvoyaient à mes propres souvenirs."

44 Pierre Bourdieu et al., *Photography: A Middle-Brow Art*, trans. Shaun Whiteside (Stanford: Stanford University Press, 1990 (orig. 1965)).

45 Ibid., 30–1.

46 My initial research led me to conclude mistakenly that the social status of the D. Family was upper-middle class. Rebecca J. DeRoo, "Christian Boltanski's Memory Images: Remaking French Museums in the Aftermath of '68," *Oxford Art Journal* 27.2 (2004) 233. Boltanski has since identified the photo album as belonging to his friend, Michel Durand, whose family Boltanski describes as "very middle class" ("très petite-bourgeoise"). Christian Boltanski, Interview with the author, January 31, 2005.

47 Sam Hunter, *A View from the Sixties: Selections from the Leo Castelli Collection and the Michael and Ileana Sonnabend Collection* (New York: Guild Hall of East Hampton, Inc., 1991) 12.

48 "Douze Ans d'art contemporain en France," *Le Petit Journal des grandes expositions* (Paris, Réunion des Musées Nationaux, 1972) n.p.

49 For example, in February 1972 the Front des Artistes Plasticiens organized a discussion titled "De Mai 68 à l'exposition Pompidou," and circulated on May 18 the tract "Les Artistes révoltés contre la politique

totalitaire et technocratique des pouvoirs publics en matière d'art." See Daniel Buren, "Une Exposition exemplaire," *Flash Art, Milan* 35–6 (1972) 24. For newspaper reviews, tracts, and other ephemeral sources, consult the clipping files at the Musée National d'Art Moderne, Paris.

50 Pierre Bourgeade, "Expo Flic, Après les incidents de l'Expo 72," *Combat* 18 May 1972, 14–15. "Art on the Barricades," *Newsweek* 29 May 1972, 46. Michael Gibson, "Art, Dissidents, the Police and the Establishment," *International Herald Tribune* 20–1 May 1972, 9.

51 Little documentation remains of Boltanski's display at the Expo '72, although records and catalogs list the materials he presented.

52 Jean Clair, *Art en France: Une Nouvelle Génération* (Paris: Chêne, 1972) 119, "parce que tout langage, qu'il soit verbal, musical, plastique, chorégraphique, etc. utilise un certain répertoire codé de signes (les mots, les sons, les couleurs, les pas, etc.) dont la nature est arbitraire, user de ces langages à des fins expressives, c'est s'interdire de dire la singularité même de ce que l'on veut dire: c'est entrelacer (inter-dire) la particularité de son propos à la généralité abstraite de tout langage."

53 Boltanski and Clair were working out concerns about the complexity of the relation of personal memory and family photography that would later take hold among theorists, perhaps mostly famously, Roland Barthes. See Roland Barthes, *Camera Lucida*, trans. Richard Howard (New York: Hill and Wang, 1981 (orig. 1980)).

54 Jean Clair, "Nouvelles Tendances depuis 1963," *72: Douze Ans d'art contemporain en France*, ed. François Mathey (Paris: Réunion des Musées Nationaux, 1972) 66–77.

55 Clair, *Art en France*, 124, "qu'au 'je' singulier d'une chronique fût substitué le 'il' impersonnel d'une histoire."

56 Ibid., 126–7, "la reconstitution de souvenirs étrangers, impersonnels, renvoie-t-elle à la propre subjectivité de celui qui la provoque, fait surgir un 'je' qu'on croyait perdu."

57 Jean Clair, "Une Avant-garde clandestine," *Chroniques de l'art vivant* 32 (August-September 1972) 16.

58 Ibid., 16, "L'absence de tout engagement politique ou idéologique... mais au contraire, le culte de l'individu, du moi, du singulier... un nouveau Romantisme... froid et distancié... mais néanmoins investi des valeurs du romantisme: la recherche de l'unique, le culte du souvenir et de l'émotion." "Un certain rapport inattendu à la culture et au patrimoine culturel se traduisant par une fascination pour le musée, la bibliothèque, et l'archive, à l'extrême opposé apparemment, du vandalisme et de l'iconoclastie chers à une certaine contre-culture." He saw this movement "profondément lié à une certaine réalité culturelle française, à un certain patrimoine, à une certaine configuration du savoir en France, précisément dominée par l'archive, la bibliothèque et le musée... n'est en rien un courant international, mais demeure sans équivalent en Allemagne ou aux U.S.A."

59 Christian Boltanski, "Interview with Jacques Clayssen," *Identité/Identifications* (Bordeaux: CAPC Bordeaux, 1976) 23–5, "Je n'ai jamais cherché à parler de moi, ni à raconter mes propres souvenirs d'enfance. Je n'ai voulu que raconter des histoires connues par tous. Quand j'ai présenté un album de photographies, je me suis aperçu que nous avions, en fait, tous, les mêmes photographies, que ces albums n'étaient que le catalogue des rites familiaux, tels que les mariages, les vacances, les premières communions et que leur fonction était de renforcer la cohésion familiale. Les spectateurs se reconnaissaient dans ces photographies, il disaient 'j'ai été sur cette plage'; ou 'on dirait mon oncle'; ou 'moi aussi j'ai eu un costume blanc quand j'étais petit....' Mon désir serait de présenter à l'autre un miroir dans lequel il se verrait et où je me reconnaîtrais aussi, si je m'y regardais. Chacun y distinguerait sa propre image et celui qui tient la miroir n'aurait plus d'existence.... Enfin, tout le monde a fait une photographie ou peut en faire une, c'est un média qui est connu et accessible à tous. Dans cette suite d'images intitulées photographies, ce qui m'intéresse c'est de montrer des images généralement considérées comme belles, que tout le monde a plus ou moins fait ou désiré faire."

60 Other exhibitions and catalogs from this period also popularized this interpretation. See, for example, Franzke, *Christian Boltanski: Reconstitution*, 6–20 (published in French and German in conjunction with Boltanski's 1978 exhibition at the Badischer Kunstverein) and Suzanne Pagé and Catherine Thieck,

Tendances de l'art en France 1968–1978/9 (Paris: ARC, 1979) (published for the 1979 exhibition held at the Musée d'Art Moderne de la Ville de Paris).

61 Although Boltanski's statements appear optimistic about the prospects for preserving the past and sharing common experiences, the work is more skeptical and resists this interpretation. Moreover, his statements must be viewed in light of his ongoing play with artistic identity and critical reception.

4. ANNETTE MESSAGER'S IMAGES OF THE EVERYDAY: THE FEMINIST RECASTING OF '68

1 Prior to this, Messager's works and exhibitions included a limited edition drawing for the "Dossier 68" of the Festival des Arts Plastiques, a small *Maison* and *Mes Bandes dépilatoires* exhibited at the 1970 Salon de Mai, Paris. In 1971 and 1972, Messager sent several mail art works, some of which were based on her notebooks.

2 For example, Jean Clair grouped together Messager's and Boltanski's reconstitutions of past gestures as part of a new French avant-garde, which was characterized by a cult of memory and emotion and an attachment to cultural patrimony and the museum. Jean Clair, "Une Avant-garde clandestine," *Chroniques de l'art vivant* 32 (August–September 1972) 16. Günter Metken, picking up on Clair's description, saw Messager as part of an avant-garde of young artists, including Boltanski, Le Gac, Bay, Bertholin, and the Poiriers. Günter Metken, "Frankreichs stille Avantgarde. Spurensuche und Ethnologie der jungen Generation," *Süddeutsche Zeitung (Munich)* 11–12 August 1973, 107. Marianne Lemoine's catalog for the *Christian Boltanski, Jean Le Gac, Annette Messager* exhibition at the Musée Rude in 1973 described the three artists as trying to express singular experiences and events from their pasts. Marianne Lemoine, *Christian Boltanski, Jean Le Gac, Annette Messager* (Dijon: Musée Rude, 1973) n.p.

3 Henri Lefebvre, *Everyday Life in the Modern World*, trans. Sacha Rabinovitch (New York: Harper and Row, 1971 (orig. 1968)) 73.

4 Aline Dallier, "Le Mouvement des femmes dans l'art," *Les Cahiers du GRIF* 23–4 (December 1978) 140 and Claire Duchen, *Feminism in France: From May '68 to Mitterrand* (London: Routledge, 1986) 7.

5 Claire Duchen, *Women's Rights and Women's Lives in France 1944–1968* (New York: Routledge, 1994) 193–5.

6 Ibid., 202.

7 For overviews of the French women's liberation movement, see Isabelle de Courtivron and Elaine Marks, *New French Feminisms: An Anthology* (New York: Schocken Books, 1981) and Françoise Picq, *Libération des femmes: les années-mouvement* (Paris: Seuil, 1993). See also Joan Wallach Scott, *Only Paradoxes to Offer: French Feminists and the Rights of Man* (Cambridge: Harvard University Press, 1996).

8 Gilbert Lascault, "Les Travaux de la femme," *Chroniques de l'art vivant* 33 (April 1973) 14–16 and Sheryl Conkelton, "Annette Messager's Carnival of Dread and Desire," *Annette Messager*, ed. Sheryl Conkelton and Carol S. Eliel (New York: Museum of Modern Art, 1995) 9–49. For additional feminist interpretations, see Günter Metken, *Annette Messager Sammlerin, Annette Messager Künstlerin* (München: Städtische Galerie im Lenbachhaus, 1973) and Aline Dallier, "Le Soft Art et les femmes," *Opus international* 52 (September 1974) 49–53.

9 Clair, "Une Avant-garde clandestine," 16; Metken, "Frankreichs stille Avantgarde," 107; and Lemoine, *Christian Boltanski, Jean Le Gac, Annette Messager*, n.p.

10 The best-known critique of the class bias of the school system and the ways in which it reinforced social divisions was of course Bourdieu's and Passeron's *The Inheritors*. Their terms were often repeated by the student protesters in 1968 as they targeted educational institutions, as documented by Dreyfus-Armand and Gervereau. Bisseret and Chaton provide early examples of attempts to add gender concerns to these class-based critiques of the university system; Mosconi presents an overview and bibliography of feminist critiques of the education system. See Pierre Bourdieu and Jean-Claude Passeron, *The Inheritors: French Students and Their Relation to Culture*, trans. Richard Nice (Chicago: University of Chicago Press, 1983 (orig. 1964)); Geneviève Dreyfus-Armand and Laurent Gervereau, *Mai 68, Les Mouvements étudiants en*

France et dans le monde (Paris: Bibliothèque du Musée de l'Histoire Contemporaine, 1988); Noëlle Bisseret, "L'Enseignement inégalitaire et la contestation étudiante," *Communications* 12 (1968) 54–65; Jeanne H. Chaton, "L'Education des jeunes filles et des femmes en France," *Convergence* 2.2 (1969) 18–25; and Nicole Mosconi, *Femmes et savoir, La Société, l'école et la division sexuelle des savoirs* (Paris: L'Harmattan, 1994).

11 On the girls' curriculum, see Linda L. Clark, *Schooling the Daughters of Marianne: Textbooks and the Socialization of Girls in Modern French Primary Schools* (Albany: SUNY Press, 1984); Ralph Albanese, Jr., "Images de la femme dans le discours scolaire républicain (1880–1914)," *The French Review* 62.5 (April 1989) 740–8; Françoise Lelièvre and Claude Lelièvre, *Histoire de la scolarisation des filles* (Paris: Nathan, 1991); and Mary Louise Roberts, "Rationalization, Vocational Guidance, and the Reconstruction of Female Identity in Post-war France," *Proceedings of the Annual Meeting of the Western Society for French History*, ed. Norman Ravitch (Riverside: Univ. of California, Riverside, 1993) 367–81. On technical education, see Charles R. Day, *Schools and Work: Technical and Vocational Education in France since the Third Republic* (Montreal: McGill-Queen's University Press, 2001).

12 Annie Decroux-Masson, *Papa lit, Maman coud* (Paris: Denoël/Gonthier, 1979) 15–20, 52. For example, Decroux-Masson sought to change the depiction of gendered work and roles in textbooks. Gender roles became such an area of concern that in 1974 *Les Temps modernes* ran a special series of columns concerning the *"sexisme ordinaire"* in school texts, and around 1976, the Secrétariat de la Condition Féminine set up a task force to investigate how gender roles were portrayed in textbooks. They found that the majority of textbook representations of women portrayed them as wives and mothers in the home, and text exercises were filled with women knitting and sewing. Furthermore, in 1978, the Ministry of Education continued to recommend needlework, embroidery, and knitting as manual work for girls, and *héliogravure*, mechanics, and wood working for boys. The *classes préprofessionnelles de niveau* (CPPN) included childcare for girls and electricity/*bricolage* courses for boys. Despite public pressure in 1979, the Ministry of Education continued to refuse to eliminate the gender imbalances in textbooks.

13 "Faire le ménage c'est travailler." Thérèse Tasmowski, "Le Budget du temps de la ménagère," *Les Cahiers du GRIF* February 1974, 45–9.

14 "On n'appelle pas ça du travail!"

15 "Pour laver un lainage j'utilise de l'eau tiède avec peu de lessive. Je presse le lainage mais sans frotter. Je rince dans plusieurs eaux toujours à la même température. Je presse dans les mains et je l'essore et je le fais sécher à plat."

16 Luc Boltanski, *Prime Education et morale de classe* (Paris: Ecole Pratique des Hautes Etudes and Mouton, 1969). Luc Boltanski's book formed part of a larger study directed by Pierre Bourdieu and carried out by the Centre de Sociologie Européenne. Boltanski's approach to the educational establishment as a means of social control was indebted to Michel Foucault's *Birth of the Clinic*. See Michel Foucault, *Naissance de la clinique* (Paris: Presses Universitaires de France, 1963).

17 Although his examples were taken from the justice system, medical establishment, and military and parochial schools rather than from the national school system, Foucault's notion of discipline, describing how institutions form the behavior of individuals, is one of the most powerful arguments on the structuring of subjectivity by institutions to emerge from this time. Such institutions form individuals not through overt repression but rather through coercive training and discipline: "The chief function of the disciplinary power is to 'train,' rather than to select and levy, or, no doubt, to train in order to levy and select all the more. . . . Discipline 'makes' individuals; it is the specific technique of a power that regards individuals as both objects and as instruments of its exercise. It is not a triumphant power, which because of its own excess can prize itself on its omnipotence; it is a modest, suspicious power, which functions as a calculated, but permanent economy. These are humble modalities, minor procedures, as compared with the majestic rituals of sovereignty or the great apparatuses of the state." Michel Foucault, *Discipline and Punish, The Birth of the Prison*, trans. Alan Sheridan (New York: Pantheon Books, 1977 (orig. 1975)) 170. The other renowned contemporary work on this subject was, of course, that of Louis Althusser, who saw school as one of the ideological state apparatuses that perpetuated the dominant ideology and class

divisions; through forming the students' subjectivities, school also accomplished their subjection. Louis Althusser, *Lenin and Philosophy and Other Essays* (New York: Monthly Review Press, 1971 (orig. 1969)).

18 Boltanski, *Prime Education et morale de classe*, 21–2, "Non pas la vie publique, celle qui s'accomplit dans les usines, les bureaux ou les administrations; celle-là depuis longtemps déjà, le début ou le milieu du [dix-neuvième] siècle, est uniformisée, standardisée, bornée dans l'espace et le temps, enfermée dans les lieux de travail, délimitée dans des horaires de travail. Ce qu'il faut régler, dorénavant, c'est la vie privée, les multiples conduites qui s'exercent dans l'intimité du foyer, derrière les murs des maisons d'habitation. A des 'manières d'agir habituelles' régies par la coutume, transmises par la tradition, il faut substituer des règles."

19 Ibid., 26, "une transformation totale des esprits, une révolution pacifique et intérieure."

20 Marcel Orieux, *Sciences appliquées, Classe de fin d'études, Ecoles urbaines des filles* (Paris: Hachette, 1958) 61.

21 Messager's text explained:

> "La peau a de nombreuses fonctions
> A travers la peau se font des échanges de gaz: le sang abandonne du gaz
> carbonique et s'enrichit en oxygène, ainsi je respire par la peau.
> La peau soulage le travail des reins
> la peau est l'organe du toucher
> la peau empêche l'entrée des microbes

> *Il faut tenir la peau très propre* afin de permettre la respiration et la transpiration. Si je ne me lave pas il se forme de la crasse sur ma peau. Elle est constituée par des débris de l'épiderme, des poussières et la graisse produite par les glandes situées à la base des poils. La crasse empêche la respiration par la peau et bouche les pores.

> Pour éviter le développement des parasites de la peau:
> – le pou dont les œufs appelés lentes sont collés aux cheveux
> – la puce qui peut transmettre la peste
> – le sarcopte, animal qui ressemble à l'araignée, il creuse des galeries dans la peau et cause des démangeaisons . . .
> – des champignons microscopiques qui causent la chute des cheveux-la teigne

> *Les soins de propreté:* je dois prendre une douche chaque jour. Je dois en profiter pour changer de linge. Le visage doit être lavé matin et soir (démaquillé). Les mains qui se souillent au contact des objets que nous touchons doivent être lavées très souvent et avant chaque repas. Les cheveux doivent être brossés chaque jour et je me lave les cheveux au moins une fois par semaine pour retirer la graisse qui se forme et ôter la poussière."

22 Messager herself had made needlework exercises like the *Travaux d'aiguille* in school. Annette Messager, Interview with the author, February 13, 1997.

23 See Claire Duchen, *Women's Rights*, 64–95 and Kristin Ross, *Fast Cars, Clean Bodies. Decolonization and the Reordering of French Culture* (Cambridge: MIT Press, 1995) 3–6, 78. Claire Duchen and Kristin Ross have emphasized the role home economics played in promoting the ideas of order and efficiency in constructing the female citizen, linking the spread of home economics in France in the 1950s and 1960s to the concurrent consolidation of a Fordist regime in the French work world. While the Fordist model led to an increased separation of home and work, ideas from Fordist rationalization and functionalist models were also applied to home economics. Magazines promoted the new conception of the home, managed by the efficient housewife, as the basis of the nation's welfare. Women's magazines, with subscriptions soaring in the 1950s, reinforced women's roles as housewives and played a key role in popularizing the state-led modernization efforts.

24 Pascal Lainé, *La Femme et ses images* (Paris: Stock, 1974) 23, "L'aire de la civilisation féminine, avec ses techniques propres, ses traditions, son langage, ses modèles de comportement, compte au nombre des cultures 'locales' en voie de liquidation. Il est facile de se moquer – sous prétexte de modernisme et

'libéralisme' – de l'éducation ancienne des jeunes filles: couture, cuisine, etc. Et sans doute la femme d'aujourd'hui aspire-t-elle légitimement à 'autre chose.' Cependant le métier de femme, l'artisanat domestique et les techniques de la maternité constituaient une véritable 'culture,' avec son système de valeur propre et son échelle de maîtrise. Ne parlons pas des vestiges extrêmement dégradés qu'on peut trouver encore dans la bonne société bourgeoise: les menus travaux de broderie et de tapisserie ne sont qu'un sous-produit tardif et défiguré des anciens modes de production féminins. Tout l'art de la ménagère, aujourd'hui, se borne à savoir acheter."

25 See Claude Lévi-Strauss, *Tristes Tropiques*, trans. John and Doreen Weightman (New York: Modern Library, 1997 (orig. 1955)).

26 "La viande bouillée [*sic*] est facile à digérer. Sous l'action de la chaleur les aliments sont ramollis ou durcis, ils deviennent plus savoureux et plus faciles à digérer, de plus ils sont stérilisés."

27 Lainé, *La Femme et ses images*, 23, "Il reste que les 'recettes de grand-mère,' ce sont les grandes firmes de produits alimentaires qui les fabriquent."

28 Peemans-Poullet also lamented the loss of traditional *arts ménagers:* she argued that working women were being trained for limited roles at the factory and regretted that they no longer possessed basic domestic skills. Hedwige Peemans-Poullet, "La Division sociale du travail," *Les Cahiers du GRIF* February 1974, 37–41.

29 To the extent that Messager provides glimpses of the personal discretion involved in cooking and cleaning, her work may be compared with that of Michel de Certeau, who examined similar sorts of daily practices. Whereas de Certeau views such activities as sites of creativity and resistance to the rational and institutional structuring of daily life, Messager is more skeptical about the possibility for resistance in everyday tasks and often presents views of the individual as constructed and constrained by social institutions and commercial culture. See Michel de Certeau, *The Practice of Everyday Life*, trans. Steven Rendall (Berkeley: University of California Press, 1984 (orig. 1980)).

30 Lefebvre, *Everyday Life in the Modern World*, 67, 72–4, 85–8.

31 Henri Lefebvre, *Le Temps des méprises* (Paris: Stock, 1975) 34.

32 Whereas Messager's references to the French school curriculum remain more nationally specific, her explorations of the way mass media representations were internalized by women may be compared more broadly with the work of international artists active in the mid-1970s, such as Cindy Sherman's *Untitled Film Stills*. For an account that emphasizes the similarities of French and American artwork of the 1970s, see Thomasine Haynes Bradford, "The Relations of American and French Feminism as Seen in the Art of Annette Messager," dissertation, SUNY at Stony Brook, 2000.

33 For the reviews that did note the feminist critique in her work, see Béatrice Parent, "Annette Messager collectionneuse," *Pariscope* 8 May 1974, 91; Anne Tronche, "Paris IV," *Opus international* 1974, 73; Metken, *Annette Messager Sammlerin*, 3–6; Lascault, "Les Travaux de la femme," 14–16; and Gaëtane Lamarche-Vadel, "Tout sur Annette Messager," *Opus international* 52 (1974) 54–7.

34 For overviews of women artists' work in France in the 1970s see Aline Dallier, "Activités et réalisations de femmes dans l'art contemporain," dissertation, Université de Paris VIII, 1980 and Laura Cottington, Françoise Collin, and Armelle Leturcq *Vraiment Féminisme et art* (Grenoble: Magasin, 1997).

35 "Il y avait un féminisme qui commençait à s'annoncer d'une façon agressive à cette époque-là. Mais il n'y en avait pas beaucoup dans les musées. . . . Il y avait un grand mépris pour l'art des femmes. Et sur le plan du marché, ça n'existait pas. Moi, j'en ai montré beaucoup . . . à cause de ça."

36 The exhibition catalog reproduced Messager's work but included no curatorial essay; as a result, Pagé's interpretation was not circulated beyond the exhibition itself.

37 Suzanne Pagé, Interview with the author, June 5, 1997, "parle effectivement de façons de faire qui sont habituelles aux femmes . . . [comme] les fiches de cuisines. Ce qui est fantastique c'est qu'elle les montre. C'est un courage formidable de s'être montrée telle qu'elle était."

38 Ibid., "Ici, les conservateurs étaient extrêmement scandalisés. Moi, j'ai voulu acheter une œuvre d'Annette Messager. Ça m'a été totalement refusé. Les gens considéraient ça comme absolument sans aucun intérêt, indigne, hors de propos dans un musée. C'était mal foutu. C'était un moment où encore, pour une

génération de conservateurs, il y avait l'idée que ce qu'on met dans le musée c'est de la peinture abstraite."

39 Dallier, "Le Soft Art et les femmes," 49–53.

40 Ibid., 50, "retrouver des expériences à la fois méprisées et maîtrisées, aux fins d'une nouvelle liberté."

41 Sanford Elwitt, *The Making of the Third Republic* (Baton Rouge: Louisiana State University Press, 1975) 170–229 and Eugen Weber, *Peasants into Frenchmen* (Stanford: Stanford University Press, 1976) 303–38.

42 Dallier, "Activités et réalisations de femmes," 135.

43 By 1968, Lascault was Assistant Professor of Literary Science and Ancient Languages at the University of Nanterre, and he contributed to the journals *Les Temps modernes, Critique,* and *L'Arc.* In 1973, Lascault was writing for Jean Clair, one of the chief curators of the Expo '72 and the editor of the influential *Chroniques de l'art vivant.*

44 Gilbert Lascault, *Cinq Musées personnels* (Grenoble: Musée de Grenoble, 1973) n.p., "Dans les *Voix du silence*, André Malraux affirmait que la vision de tout artiste important s'organise à partir des tableaux et statues de ses prédécesseurs; que sa pratique s'appuie sur des pratiques artistiques antérieures, les intégrant ou s'y opposant. Ce n'est plus toujours vrai aujourd'hui. Certains producteurs d'art (parmi les cinq exposés à Grenoble, au moins quatre) préfèrent fréquenter les musées ethnologiques. . . . Aujourd'hui bien des artistes sont fascinés par ce qui se situe, dans les conceptions dominantes de l'Occident, au plus loin de l'esthétique."

45 Jean-Marc Poinsot, "Lieu culturel/Objet culturel," *Chroniques de l'art vivant* (December 1972–January 1973) 13.

46 Lascault, *Cinq Musées personnels,* n.p. Lascault continued on to explain that: "Ces actuels producteurs d'art . . . ne s'intéressent guère aux musées consacrés à la conservation et à l'exposition de tableaux et de sculptures classiques ou modernes. Il ne s'y sont pas formés. Ils ne les ont pas fréquentés. Ils ne les détestent, ni ne les vénèrent. Ni hostiles, ni héritiers face à ce qui, jusqu'ici a été reconnu comme artistique. Indifférents. Etrangers. Ce que la culture dominante en Occident nomme des chefs-d'œuvre, ils ne le copient pas, ne l'agressent pas, ne le ridiculisent pas. Ils ne veulent pas le connaître." "These producers of art . . . are hardly interested in museums consecrated for the conservation and exhibition of classical and modern paintings and sculptures. They were not trained there. They do not frequent them. They neither detest nor venerate them. Neither hostile to nor inheritors of that which, until now, has been recognized as artistic. They are indifferent; strangers to it. They do not copy, attack, or ridicule that which dominant western culture calls masterworks. They do not want to know them."

47 Lascault, *Cinq Musées personnels,* n.p., "Ainsi tous ces musées personnels ne constituent nullement des monuments à ceux qui les ont produits. Ils ne renvoient nullement à un sujet psychologique, à une personne pourvue de qualités, de facultés, à une totalité maîtresse d'elle-même et de l'univers. Ils ne sont pas non plus la propriété d'un sujet juridique capable de départager ce qui est à lui et ce qui appartient à d'autres. Ces musées personnels se présentent plutôt comme une immense interrogation portant sur la différence sexuelle, les différences d'âge, les rapports entre l'intérieur de mon corps, sa surface et l'univers extérieur."

48 Lascault, *Cinq Musées personnels,* n.p., "voudrait provoquer un questionnement sur les limites du caché et du montré . . . de l'intime et du public. Où se situent, où ne se situent pas [mes] désirs? En quels objets (que je ramasse ou invente) puis-je me reconnaître ou m'égarer?"

49 Michel de Certeau, *The Capture of Speech* (Minneapolis: University of Minnesota Press, 1997 (orig. 1968)).

50 Lascault, *Cinq Musées personnels,* n.p., "Information floue qui nous parle plus loin de nous et, paradoxalement, nous fait entrevoir, en nous-mêmes, ce qui est le moins lié à notre culture particulière."

51 Lascault, *Cinq Musées personnels,* n.p., "Ces producteurs ne veulent pas . . . mettre l'art dans la rue. . . . Dans cette mise en scène du musée . . . certains liront d'abord une attaque contre l'institution muséale, une dérision. Mais cette fonction critique que (volontairement ou non) remplissent les musées personnels, n'est sans doute pas l'essentiel."

52 Lascault, "Les Travaux de la femme," 14–16.

53 As French critic Aline Dallier has explained, there was no organized feminist art movement in France, and feminist artists lacked venues to bring their work and concerns before a broad public. As a result, the work of French feminist artists of the 1970s has been often viewed in terms of the much more visible and internationally influential feminist literary theory of the time. Dallier, "Le Mouvement des femmes," 141–5. On the ways in which the work of feminist literary theorists has overshadowed other branches of French feminism, see Duchen, *Feminism in France*, 20–5; and Claire Laubier, *The Condition of Women in France: 1945 to the Present, A Documentary Anthology* (New York: Routledge, 1990) 71–3.

5. INSTITUTIONALIZING '68: THE POMPIDOU CENTER

1 Pierre Cabanne, *Le Pouvoir culturel sous la Ve République* (Paris: Olivier Orban, 1981) 328.
2 Quoted in Claude Mollard, *L'Enjeu du Centre Pompidou* (Paris: 10/18, 1976) 109, "Je voulais, passionnément, que Paris possède un centre culturel comme on a cherché à créer aux Etats-Unis."
3 The initial architectural committee was led by Sébastien Lhoste and François Lombard, and included Jean Leymarie, Blaise Gautier, François Mathey, and Jean-Pierre Seguin. After the selection of the building's design, the directors of the institutions within the center, Jean-Pierre Seguin, Pontus Hulten, François Mathey, and Pierre Boulez, as well as the Center's President Robert Bordaz, greatly influenced the center's activities and mission. Bernadette Dufrêne, *La Création de Beaubourg* (Grenoble: Presses Universitaires de Grenoble, 2000) 23.
4 On the history of the center, see "Beaubourg et le musée de demain," *L'Arc* no. 63 (1976) (a special issue devoted to the center); Catherine Millet, "Notre-Dame Beaubourg," *Art Press* no. 4 (1977) 4–10; Dominique Bozo, "Introduction," *La Collection du Musée National d'Art Moderne*, ed. Agnès de la Beaumelle and Nadine Pouillon (Paris: Centre Pompidou, 1987) 10–31; M. R. Levin, "The City as a Museum of Technology," *Industrial Society and Its Museums 1890–1990*, ed. Brigitte Schroeder-Gudehus, Eckhard Bolenz, and Anne Rasmussen (Langhorne: Harwood Academic Publishers, 1993) 27–36; Bernard Blistène and Lisa Dennison, "Pompidou/Guggenheim: A Dialogue for an Exhibition," *Rendezvous: Masterpieces from the Centre Georges Pompidou and the Guggenheim Museums* (New York: Solomon R. Guggenheim Foundation, 1998) 90–105; and Daniel Abadie et al., *Georges Pompidou et la modernité* (Paris: Centre Georges Pompidou, 1999).
5 Marie Leroy, *Le Phénomène Beaubourg* (Paris: Syros, 1977) 117–21.
6 Mollard, *L'Enjeu du Centre Pompidou*, 114, "Le président de la République souhaitait lui-même que Beaubourg fût implanté dans un quartier populaire et ouvert à un très large public: les manifestations culturelles ne devaient pas rester dans son esprit le privilège d'une petite élite."
7 Ibid., 110–11, 115.
8 Kristin Ross, "Paris Assassinated?" *The End(s) of the Museum* (Barcelona: Fundacio Antoni Tapies, 1996) 136–7.
9 Mollard, *L'Enjeu du Centre Pompidou*, 111, 114.
10 José Freches, "Les Musées de France, Gestion et mise en valeur d'un patrimoine," *Notes et études documentaires* no. 4539–4540 (5 December 1979) 150.
11 The 1977 budget for national museums was 105,543,000 francs, roughly 75% of which was spent in the Ile-de-France region surrounding Paris; the state budget for the 31 *musées classés* and 860 *musées contrôlés*, was 20,032,000 francs, though these also received regional and municipal support. Leroy, *Le Phénomène Beaubourg*, 117–21.
12 Ibid., 119.
13 Nancy Marmer, "Waiting for Gloire," *Artforum* February 1977, 52, "centrale de la décentralisation."
14 Ibid., 53.
15 Ibid., 52.
16 Leroy, *Le Phénomène Beaubourg*, 30–3.
17 Mollard, *L'Enjeu du Centre Pompidou*, 25–6, 80–2.

NOTES TO PAGES 173–180 **237**

18 Ibid., 83.

19 For these debates, consult the Fonds Pierre Restany at the Archives de la Critique d'Art, Châteaugiron, as well as the historical archives of the Bibliothèque Kandinsky, Centre Pompidou.

20 Cited in Mollard, *L'Enjeu du Centre Pompidou*, 281, "un cercueil transparent," "Remplacer les murs par des cloisons mobiles, les guides imprimés par des cassettes, les gardiens par des hôtesses, c'est modifier les apparences, non l'essence. Le fond est immuable: c'est le musée, conforme à l'idée que la société se fait du rôle de l'art depuis l'avènement de la bourgeoisie."

21 Ibid., 288.

22 Pierre Bourdieu and Alain Darbel, *The Love of Art*, trans. Caroline Beattie and Nick Merriman (Stanford: Stanford University Press, 1990 (orig. 1966)).

23 Hulten's curatorial team at the Pompidou Center (1977–1981) included: Françoise Cachin, Isabelle Monod-Fontaine, Jean-Hubert Martin, Germain Viatte, Jean Clair, Christian Derouet, Pierre Georgel, Hélène Seckel, Daniel Abadie, Alfred Pacquement, Alain Sayag, Hélène Lasalle, Jean Lacambre, Henri de Cazals, and Jean-Louis Faure. Catherine Lawless, *Musée National d'Art Moderne, Historique et mode d'emploi* (Paris: Centre Pompidou, 1986) 170.

24 In fact, Roger's first drawings and plans for the center termed it thus. Douglas Davis, *The Museum Transformed* (New York: Abbeville Press, 1990) 41.

25 Mollard, *L'Enjeu du Centre Pompidou*, 68.

26 *Traverses* for the Center for Industrial Creation, *Inharmoniques*, which became the *Cahiers de l'IRCAM* for the Institute for Musical Research, and the *Cahiers du MNAM* for the National Museum of Modern Art.

27 Dufrêne, *La Création de Beaubourg*, 139.

28 Jean-Louis Cohen, "Monuments for a Mass Cult," *Rendezvous: Masterpieces from the Centre Georges Pompidou and the Guggenheim Museums* (New York: Solomon R. Guggenheim Foundation, 1998) 26.

29 Cesare Casati, "Nuovo Oggetto a Parigi," *Domus* January 1977, 18, "Le bâtiment avait été conçu comme 'outil' (pour des activités différentielles, évolutives) dont l'extérieur aurait dû être surface de contact . . . une surface avec des écrans – des écrans de télévision, de cinéma, des informations écrites, des journaux télévisés. . . . En réalité tout cela s'est révélé très difficile, et non pas pour des raisons techniques, car le bâtiment, tel qu'il est, peut être utilisé pour ça à n'importe quel moment. . . . Les raisons des difficultés sont d'ordre politique. Il est évident que parler d'information est intéressant, mais il y a aussitôt ceux qui se demandent: quelle sorte d'information? Le Centre allait devenir un centre d'information au cœur de Paris, une petite O.R.T.F. indépendante, autonome. Et la naissance d'un centre d'information libre, que les étudiants auraient pu occuper et qu'on utilise de manière très efficace, était chose inquiétante."

30 Quoted in Dufrêne, *La Création de Beaubourg*, 107–8, "de déboucher, malgré [eux], sur un monument dont [ils n'auraient] pas contrôlé toute les implications, politiques, notamment."

31 Ibid., 107–8, "a tout de suite pensé . . . à une proposition alternative, à un grand bâtiment qui ne serait pas un monument, mais une fête, un grand jouet urbain."

32 Patrik Lars Andersson, *Euro-Pop: The Mechanical Bride Stripped Bare in Stockholm, Even*, dissertation, University of British Columbia, 2001.

33 In this he was seconded by Robert Bordaz, the first president of the center, who described the hall as a space of "recreation" or "entertainment" ("*distraction*") and as a center of continual life and movement, "foyer constant d'animation et de mouvement." Dufrêne, *La Création de Beaubourg*, 104.

34 Ibid., 143, "un art joyeux, libéré des contraintes de l'objet commercialisable, dynamique, actif même, vivant en symbiose avec un public qui n'est même plus 'public' mais en fait partie intégrale. Monde nouveau où les lignes de démarcation entre la Vie et l'Art ont entièrement disparu."

35 Ibid., 143, "C'est le fantôme du fonctionnel, l'Anti-Centre. . . . Le *Crocrodrome* n'est pas non-problématique."

36 Jean Baudrillard, *L'Effet Beaubourg: Implosion et dissuasion* (Paris: Galilée, 1977) 22–4, translated in Brian Rigby, *Popular Culture in Modern France* (New York: Routledge, 1991) 187–8.

37 Rigby has noted this general transformation in the conception of popular culture in France; his commentary on Beaubourg informs my reading in this chapter. See Rigby, *Popular Culture*, 189–97.

38 By a decree of 27 January 1976, the MNAM was no longer part of the *Réunion des Musées Nationaux*; this gave the museum much more financial and curatorial independence.

39 With Pontus Hulten as the general director, Daniel Abadie, Alfred Pacquement, and Hélène Seckel served as *commissaires* of the exhibition.

40 Romy Golan, "Paris-New York," presentation on the panel "Transatlantic: European and American Art in the 1960s and 1970s," College Art Association Annual Conference, February 2003.

41 Pontus Hulten et al., *Paris-New York* (Paris: Centre Georges Pompidou, 1977) 2–3. See also Robert Lebel, "Paris-New York et retour avec Marcel Duchamp, dada et le surréalisme," *Paris-New York*, ed. Pontus Hulten et al. (Paris: Centre Georges Pompidou, 1977) 76.

42 Here Hulten invoked Apollinaire's well-known 1911 commentary on Duchamp. See Pontus Hulten and Pierre Matisse, *Marcel Duchamp, Notes* (Paris: Centre Georges Pompidou, 1980) xii. This text more fully articulated the interpretation of Duchamp that Hulten had set forth in the *Paris-New York* catalog.

43 This idea was not new; the 1961 *Art of Assemblage* exhibit at the MOMA had posed New York Pop artists as Duchamp's successors, and the French critic Pierre Restany had repeatedly argued that the new realists were "40 degrees above dada," meaning that they shared Duchamp's appropriation of mass-produced objects, yet without the "negativity" or social critique.

44 Hulten, *Paris-New York*, 563, "La machine à dessiner est une invention d'une portée aussi fondamentale . . . que le 'readymade'. . . . On a souvent mis en relief une certaine ironie à l'égard du tachisme, dominant à Paris en 1959. . . . L'idée 'méta-matic' renferme cependant en elle-même beaucoup plus qu'un simple commentaire ironique du tachisme. Comme dans le cas de l'œuvre d'art autodestructrice, il s'agit d'une œuvre devenant objet de méditation métaphysique et dont le contexte esthétique s'élargit."

45 At the Moderna Museet, Hulten had also favored Tinguely's work for its "inclusive" properties, because he believed it offered the possibility for "viewer participation" by pressing a button or by stopping the machine to remove the "completed" abstract painting. Tinguely's sculptures were only occasionally operated at the Pompidou, but Hulten's interest in their interactive qualities is suggestive.

46 Pierre Restany, "A quarante degrés au-dessus de dada," *Le Nouveau Réalisme* (Paris: Union Générale d'Editions, 1978 (orig. 1961)); trans. in Kristine Stiles and Peter Selz, *Theories and Documents of Contemporary Art* (Berkeley: University of California Press, 1996) 308.

47 Cited in Alfred Pacquement, "Nouveau Réalisme et pop'art. Le Début des années 60," *Paris-New York*, ed. Pontus Hulten et al. (Paris: Centre Georges Pompidou, 1977) 584, "Ce que nous sommes en train de redécouvrir, tant en Europe qu'aux Etats-Unis, c'est un nouveau sens de la nature, de notre nature contemporaine, industrielle, mécanique, publicitaire. . . . Ce qui est la réalité de notre contexte quotidien c'est la ville ou l'usine. . . . L'appropriation directe du réel est la loi de notre présent."

48 Restany, "A quarante degrés," translated in Stiles and Selz, *Theories and Documents*, 308.

49 Marmer, "Waiting for Gloire," 58.

50 Cabanne, *Le Pouvoir culturel*, 330–1.

51 Cited in Dufrêne, *La Création de Beaubourg*, 230, "plan Marshall esthétique," "ceux qui ont eu le malheur de peindre à Paris pendant les années 45–60 sont quasiment éliminés."

52 Sociologist Raymonde Moulin, for example, in her study of funding for the arts, saw museum acquisitions reinforcing market trends: "public institutions . . . continue to show solidarity with the tendencies of the art market." "[L]es institutions publiques . . . restent solidaires des tendances du marché." Raymonde Moulin, "Marché de l'art et bureaucratie culturelle," *De la valeur de l'art* (Paris: Flammarion, 1995 (orig. 1981)) 114.

53 Christian Boltanski, Unpublished interview, January 5, 1974. Courtesy of Harald Szeeman archives, "Quelqu'un qui montre une vieille photo ou une trace ou quelque chose c'est devenu rassurant, on se dit, ah je comprends, je tiens quelque chose. . . . Je ne sais pas pourquoi mais à partir de ce moment là le truc ne me semble plus possible à faire, il n'est plus intéressant."

54 Centre d'Arts Plastiques Contemporains, *Identité/Identifications* (Bordeaux: Centre d'Arts Plastiques Contemporains, 1976) 24–5, "Enfin, tout le monde a fait une photographie ou peut en faire une, c'est un média qui est connu et accessible à tous. Dans cette suite d'images . . . , ce qui m'intéresse c'est de montrer des images généralement considérées comme belles, que tout le monde a plus ou moins fait ou désiré faire. La photographie d'amateur actuelle me semble importante car elle contient . . . une notion esthétique culturellement établie (toute personne qui regarde des photographies qu'elle a prises se demande si telle chose est plus belle que telle autre)." Boltanski also described the standardization that had occurred because popular photography emulated magazine photography: "I think that the aesthetic value we give a photograph has developed in recent years: the causes are the generalization of color, the development of specialized reviews that have created standards to which, consciously or not, a good number of amateur photographers refer. Just as the photographed subjects are stereotyped, photographic beauty obeys a very precise framework." "Je crois que la valeur esthétique que l'on donne à une photographie s'est développée ces dernières années: la généralisation de la couleur, le développement des revues spécialisées qui ont créé des standards auxquels se réfèrent, consciemment ou inconsciemment, bon nombre de photographes amateurs, en sont les causes. De même que les sujets photographiques sont stéréotypés, la beauté photographique obéit à un cadre bien précis."

55 Robert Castel and Dominique Schnapper, "Aesthetic Ambitions and Social Aspirations: The Camera Club as a Secondary Group," *Photography: A Middle-Brow Art*, trans. Shaun Whiteside (Stanford: Stanford University Press, 1990 (orig. 1965)) 121.

56 In the catalog of an exhibition of the *Images modèles* in Bonn, the curator Klaus Honnef took up a similar line of argument and stressed the ways that advertising images had influenced the composition and subjects of popular photography. Klaus Honnef and Lothar Romain, *Christian Boltanski/Annette Messager. Modellbilder* (Bonn: Rheinisches Landesmuseum, 1976).

57 Castel and Schnapper, "Aesthetic Ambitions," 108.

58 Christian Boltanski, Letter to Guy Jungblut, August 1975. This text was published on the invitation to the slide presentation *Christian Boltanski-photographies couleurs*, Musée National d'Art Moderne, salle audiovisuelle, May 1976. "Je fais de la photographie; j'ai perfectionné ma technique et j'essaie de me conformer aux règles de cet art si difficile. J'aborde maintenant la photographie en couleur, qui se prête particulièrement bien aux sujets que j'affectionne: tout ce qui exprime la beauté des choses simples et la joie de vivre."

59 Centre d'Arts Plastiques Contemporains, *Identité/Identifications*, 24–5, "un media qui est connu et accessible à tous," "que tout le monde a plus ou moins fait ou désiré faire."

60 For example, the critic Jean-Jacques Lévêque described Boltanski's photos as: "[o]f an honest mediocrity. That is, conformist in their subjects (little cousins on bicycles, the beloved woman, the cat, in sum, all the clichés of happiness) and in their framing and lighting." "D'une honnête médiocrité. C'est-à-dire, conformistes dans les sujets (petits cousins à bicyclette, la femme aimée, le chat, en somme les clichés du bonheur) et dans le cadrage, l'éclairage." Jean Jacques Lévêque, "Christian Boltanski, Galerie Sonnabend," *Les Nouvelles littéraires* February 25, 1976, 26.

61 Annette Messager, Interview with the author, September 21, 1999.

62 Honnef, *The Serials*, n.p., "belles choses . . . que seule une femme pouvait faire."

63 Helena Kontova and Giancarlo Politi, "Post Conceptual Romanticism," *Flash Art International* 78–9 (November-December 1977) 30.

64 Reproduced in Serge Lemoine, ed., *Annette Messager comédie tragédie 1971–1989* (Grenoble: Musée de Grenoble, 1989) 52–3, "une réalité qui existe exclusivement dans les représentations collectives. Le point de départ matériel de cette réalité est le monde gai, agréable, et sans problème de la publicité, du cinéma commercial et de la grande presse."

65 Ibid., 53, "Ce qui a l'air d'être faux, niais et de mauvais goût est en réalité la description précise de l'inconscient collectif."

66 Sylvie Dupuis, "Annette Messager," *Art Press* 24 (1979) 24, "en y mêlant son identité de femme et d'artiste, son intimité."

67 Michel Nuridsany, "Annette Messager: L'Univers du feuilleton," *Le Figaro* 7 November 1978, 30, "l'image de cet univers encombré de fictions qui est le nôtre, où les mythologies nous gouvernent bien plus sûrement que les concepts inadéquats de vérité ou de réalité."

68 Ibid., 30, "Ces compositions subtiles indiquent que notre réalité n'est jamais vécue en tant que telle mais perçue 'de seconde main' et dévitalisée, banalisée, normalisée."

69 Ibid., 30, "ce qui dans ses images feuilletonesques 'a l'air faux, niais, et de mauvais goût est en réalité la description précise de l'inconscient collectif.'" Other reviews in the French press also voiced similar interpretations, such as the November 13 exhibition announcement in *Le Nouvel Observateur* (20). See also Marc Le Bot, "Les Messages d'Annette Messager," *Le Quinzaine littéraire* 13 November 1978, 13.

70 Very few women artists' works did in fact make it into the national museum in the 1970s; Niki de Saint-Phalle was a prominent exception. Raymonde Moulin, *L'Artiste, l'institution, et le marché* (Paris: Flammarion, 1992) 282.

71 Margarethe Jochimsen et al., *Frauen Machen Kunst* (Bonn: Galerie Magers, 1977) n.p.

72 For more information on these exhibitions, see Aline Dallier, "Le Mouvement des femmes dans l'art," *Les Cahiers du GRIF* 23–4 (December 1978) 141–5 and Thomasine Haynes Bradford, *The Relations of American and French Feminism as Seen in the Art of Annette Messager*, dissertation, SUNY at Stony Brook, 2000, 106–7.

73 Dominique Poulot, "Le Patrimoine et les aventures de la modernité," *Patrimoine et modernité*, ed. Dominique Poulot (Paris: L'Harmattan, 1998) 57–64.

6. AMERICA AND EUROPE POST-POMPIDOU: SUSTAINING THE POLITICAL MISSION OF THE MUSEUM

1 Nancy Marmer, "Out of Paris: Decentralizing French Art," *Art in America* September 1986, 125. Although Malraux had sought to increase the ministry's budget, it never rose above 0.49%. Herman Lebovics, *Mona Lisa's Escort: André Malraux and the Reinvention of French Culture* (Ithaca: Cornell University Press, 1999) 103.

2 Annette Messager, Interview with the author, September 21, 1999.

3 Marmer explained that by 1996, more than 10,000 works by 2,500 artists had been bought by the FRACs. However, Raymonde Moulin noted that the FRACs' acquisitions tended to favor particular artists; by 1992, only 15% of purchases had been for the work of women artists. Nancy Marmer, "France '97: The Culture Forecast," *Art in America* December 1996, 30 and Raymonde Moulin, *L'Artiste, l'institution, et le marché* (Paris: Flammarion, 1992) 284–5.

4 On the FRACs' sites, collections, and administration as they developed under Jack Lang, see Marmer, "Out of Paris," 125–37, 155, 157.

5 Ibid., 118.

6 Kristin Ross, "Establishing Consensus: May '68 in France as Seen from the 1980s," *Critical Inquiry* (Spring 2002) 650. See also Michelle Zancarini-Fournel, "1968: Histoire et mémoires," unpublished manuscript presented at the University of Chicago, 1996, 11–17.

7 Ross, "Establishing Consensus," 653.

8 Ibid., 656. Ross explains: "the generation of '68 is born only in the mid-1980s – not, that is, in contestation, but only afterwards, in the collective erasure of any contestatory dimension and in the telling of that story" (672). Hervé Hamon and Patrick Rotman, *Génération* (Paris: Seuil, 1987).

9 Lebovics, *Mona Lisa's Escort*, ix–x.

10 Marmer indicates that the 1997 budget for the Ministry of Culture was decreased 2.9%. Marmer, "France '97," 29.

11 Jacques Chirac, "En mémoire de Georges Pompidou," *Georges Pompidou et la modernité*, ed. Galerie Nationale du Jeu de Paume (Paris: Centre Georges Pompidou, 1999) 14, "incarnent une certaine idée qui est aussi une certaine image de la France. Celle d'une France en mouvement, riche de ses traditions les meilleures et résolument tournée vers l'avenir et la jeunesse, soucieuse de comprendre son époque et

singulièrement l'art de son temps, parce que c'est là, comme le pensait Georges Pompidou, le meilleur témoignage que l'homme puisse donner de sa dignité."

12 Ibid., 13, "l'homme d'Etat... voulait réconcilier l'institution républicaine et l'actualité artistique."

13 Ibid., 13, "grande exposition de 1972... sous son impulsion, devait faire découvrir aux Français la création contemporaine."

14 Laurent Wolf, "Paris," *Le Nouveau Quotidien* 1 April 1997, 20. See also Philippe Dagen, "Le Musée National d'Art Moderne présente cinquante ans de création en France," *Le Monde* 31 January 1997, 26.

15 Alain Cueff, "Commémoration et régression," *Le Journal des arts* March 1997, "valeurs aussi grandioses qu'éternelles qu'ils véhiculent sont à l'évidence impropres à rendre compte de la complexité et de l'inquiétude qui nourrissent l'art moderne."

16 Exhibition brochure for *Made in France* (Paris: Musée National d'Art Moderne, 1997), "C'est l'occasion de rappeler la diversité des collections et, à travers elles, la situation toujours sans équivalent, de Paris et de la scène française comme creuset international de la création artistique."

17 Alain Cueff, "L'Art français sur plusieurs fronts," *Le Journal des arts* January 1997, 3, "La promotion institutionnelle de l'art français est restée partagée entre l'espoir d'une reconquête hors des frontières et l'affirmation nationaliste d'une identité."

18 He is currently the director of the Picasso Museum in Paris; his proper name is Gérard Regnier, though he has used the pseudonym Jean Clair since the late 1960s.

19 For an analysis of the *Krisis* debates and background on the journal editors, see Jacques Henric, "L'Extrême Droite attaque l'art contemporain," *Art Press* 223 (April 1997) 52–65.

20 Jean Clair, "De *L'Art en France* à *Made in France*," *Les Cahiers de médiologie* 3 (April 1997) 121–33. For a compilation of the art community's responses in the press see the unpublished 1997 dossier assembled by the Délégation aux Arts Plastiques, Paris.

21 Clair, "De *L'Art en France*," 123–4, "Il y a sans doute une grande jouissance à pouvoir parler plusieurs langues, à se couler dans plusieurs systèmes logiques. Mais on ne peut écrire, je crois, que dans sa langue maternelle. Le réseau de relations linguistiques, tissées dès les premiers mois de la vie... est si fin et si fragile... qu'il faut, pour savoir exprimer dans des mots les inflexions les plus précises de sa sensibilité, avoir su préserver ce trésor des premiers moments, et dont la maîtrise ultérieure d'autres langues n'approchera jamais la richesse.

Ainsi de la langue, ainsi de l'art. Une peinture naît aussi d'une langue maternelle, d'un rapport très ancien à une terre natale....

L'œil s'est formé à une certaine lumière, à une certaine découpe des formes, à un certain bornage de l'horizon, à une certaine occupation des sols – et la tradition qui s'est développée là."

22 Ibid., 129, "d'autres pays en Europe... développaient un art que nous ne pouvons appeler autrement que 'nationaliste.' C'est l'Allemagne, l'Italie, la Grande-Bretagne. Ce sont aussi les trois et seuls pays européens dont l'art aura connu, dans les années 80, une reconnaissance internationale."

23 Ibid., 129, "la France ironisait sur les valeurs nationales et ridiculisait les traditions et les attachements locaux pour ne s'ouvrir qu'aux charmes de l'abstraction américaine."

24 Ibid., 132, "[L]'Etat s'est compromis dans un scandale, qui est l'absence de reconnaissance de l'art français qu'il était supposé 'promouvoir'....

Ces 'responsables' n'auront pas agi différemment du brave facteur de *Jour de Fête*, qui, la tête tourneboulée par les exploits des Américains n'a de cesse, enfourchant son vélo et pédalant comme un fou, d'égaler leur prouesses. Il est vrai que, théâtre de ses exploits, le petit village enfoui dans son bocage et ses chemins creux, celui qu'avaient décrit Flaubert, Maupassant, et Gracq, aura entre-temps refermé ses volets et mis en vente son école."

25 Ibid., 129, "la peinture... n'est pas... un moyen d'expression universelle... c'est parce qu'elle reste attachée à des lieux précis."

26 Clair was aware of the xenophobic associations of the terms he employed, and began his essay with the disclaimer: "if nazism compromised, perverted, and seemingly contaminated common vocabulary words such as 'homeland,' 'sky,' 'light,' 'soil,' 'village,' 'forest,' but also forms of art as well . . . must [one] resign [oneself] to no longer using them?" "[S]i le nazisme a compromis, perverti, et comme contaminé les mots usuels du vocabulaire comme 'patrie,' 'ciel,' 'lumière,' 'terroir,' 'village,' forêt,' mais aussi les formes de l'art . . . ne faut-il pas se résigner à n'en plus faire usage?" Ibid., 123.

27 Nadja Rottner, "Annette Messager," *Documenta 11 Short Guide*, ed. Christian Rattemeyer (New York: Distributed Art Publishers, Inc., 2002), 160. *Kunstforum International* described the work similarly: "the personal is transformed into a universal statement on humankind, which suffers and causes pain." "wird das Persönliche transformiert zu einer allgemeingültigen Aussage über die Menschheit, die leidet und Leid zufügt." "Annette Messager Documenta 11," *Kunstforum International* 161 (August–October 2002) 273.

28 Perhaps the most famous instance during this period in which an exhibition was the target of the right was the closing of the 1990 *Robert Mapplethorpe: The Perfect Moment* show at the Cincinnati Contemporary Arts Center under charges of obscenity. During the 1990s, too, New York Senator Alphonse D'Amato and North Carolina Senator Jesse Helms criticized contemporary art for its "assault" on "traditional" American values. Their attack was successful: artists receiving NEA grants were forced to sign "decency" clauses, and the NEA vetoed the grants of the famous "NEA 4": Karen Finley, John Fleck, Holly Hughes, and Tim Miller. Erika Doss, *Twentieth-Century American Art* (Oxford: Oxford University Press, 2002) 224.

29 See Lisa G. Corrin, ed., *Mining the Museum* (Baltimore: The Contemporary, 1994) 13–15.

30 Lynn Gumpert, "The Life and Death of Christian Boltanski," *Christian Boltanski: Lessons of Darkness*, ed. Lynn Gumpert and Mary Jane Jacob (Chicago: Museum of Contemporary Art; Los Angeles: The Museum of Contemporary Art; and New York: The New Museum of Contemporary Art, 1988) 83–4.

BIBLIOGRAPHY

Abadie, Daniel, et al. *Georges Pompidou et la modernité*. Ed. Galerie Nationale du Jeu de Paume. Paris: Centre Georges Pompidou, 1999.

Albanese, Ralph, Jr. "Images de la femme dans le discours scolaire républicain (1880–1914)." *The French Review* 62.5 (April 1989): 740–8.

Alberro, Alexander. "Reconsidering Conceptual Art, 1966–1977." *Conceptual Art: A Critical Anthology*. Ed. Alexander Alberro and Blake Stimson. Cambridge: MIT Press, 1999: xiv–xxxvii.

Althusser, Louis. *Lenin and Philosophy and Other Essays*. Trans. Ben Brewster. New York: Monthly Review Press, 1971 (orig. 1969).

Altshuler, Bruce. *The Avant-Garde in Exhibition: New Art in the 20th Century*. New York: Abrams, 1994.

American Center for Students and Artists. *Work in Progress*. Paris: American Center, 1969.

Ammann, Jean-Christophe. "A Few Modest Thoughts on the Prerequisites for Museums and Exhibits of Art . . ." *Museums by Artists*. Ed. A. A. Bronson and Peggy Gale. Toronto: Art Metropole, 1983: 12–20.

Ander, Heike, and Nadja Rottner, eds. *Documenta 11 Platform 5: Exhibition Catalogue*. Ostfildern-Ruit: Hatje Cantz, 2002.

Andersson, Patrik Lars. "Euro-Pop: The Mechanical Bride Stripped Bare in Stockholm, Even." Dissertation, University of British Columbia, 2001.

"Annette Messager: Archiviste de la vie intime." *Les Nouvelles littéraires* 6 May 1974: 150.

"Annette Messager, Documenta 11." *Kunstforum International* 161 (August–October 2002) 270–3.

"Annette Messager." *Le Nouvel Observateur* 13 November 1978: 20.

Applegate, Judith. "Chronicles: Paris." *Art International* 14.9 (November 1970): 7.

"L'Art et les femmes." *Sorcières* 10 (1977): 14–50.

"L'Art français en quête de reconnaissance." *Le Journal des arts* January 1997: 3, 18, 19.

"Art on the Barricades." *Newsweek* 29 May 1972: 46.

Atelier populaire présenté par lui-même. London: U.U.U. (Usines Universités Union), 1968.

Atelier Populaire. *Posters from the Revolution, Paris, May 1968*. London: Dobson Books, 1969.

"L'Autobiographie de Boltanski." *Combat* 23 March 1970: 11.

"The Avant-Garde of Presence." *Internationale situationniste* 8 (1963): 14–22.

Balibar, Renée. *Les Français fictifs: Le Rapport des styles littéraires au français national*. Paris: Hachette, 1974.

Barthes, Roland. *Camera Lucida*. Trans. Richard Howard. New York: Hill and Wang, 1981 (orig. 1980).

———. "The Death of the Author." Trans. Stephen Heath. *Image, Music, Text*. New York: Noonday Press, 1977 (orig. 1968): 142–8.

———. *Mythologies*. Trans. Annette Lavers. New York: Noonday Press, 1972 (orig. 1957).

Baudrillard, Jean. *L'Effet Beaubourg: Implosion et dissuasion*. Paris: Galilée, 1977.

Baumann, Hans D., et al. *Kunst und Medien: Materialien zur Documenta 6*. Kassel: Stadtzeitung und Verlag, 1977.

"Beaubourg 4 mois après." *Art Press* 8 (1977): 24–5.

"Beaubourg et le musée de demain." *L'Arc* 63 (1976) (special issue).

"Beaubourg: Un Débat manqué." *Art Press* 16 (1975): 2, 17–18.

Beaumelle, Agnès de la, and Nadine Pouillon. *La Collection du Musée National d'Art Moderne, Acquisitions 1986–1996*. Paris: Centre Georges Pompidou, 1996.

Bénéton, Philippe, and Jean Touchard. "The Interpretations of the Crisis of May/June 1968." *The May 1968 Events in France*. Ed. Keith A. Reader. New York: St. Martin's Press, 1993 (orig. 1970): 20–47.

Bernège, Paulette. *De la méthode ménagère*. Paris: Jacques Lanore, 1969 (orig. 1928).

Biard, Ida, Béatrice Parent, and Daniel Soutif. *La Galerie des locataires*. Rome: Edizioni Carte Segrete, 1989.

Biasini, Emile. *Action culturelle, An I*. Paris: Ministère d'Etat des Affaires Culturelles, October 1962.

Bibliothèque Nationale. *Les Affiches de Mai 68*. Paris: Bibliothèque Nationale, 1982.

Bisseret, Noëlle. "L'Enseignement inégalitaire et la contestation étudiante." *Communications* 12 (1968): 54–65.

Bissière, Caroline, and Jean-Paul Blanchet. *Les Années 70: Les Années mémoire; Archéologie du savoir et de l'être*. Meymac: Centre d'Art Contemporain, Abbaye Saint-André, 1987.

Blistène, Bernard, and Lisa Dennison. "Pompidou/Guggenheim: A Dialogue for an Exhibition." *Rendezvous: Masterpieces from the Centre Georges Pompidou and the Guggenheim Museums.* New York: Solomon R. Guggenheim Foundation, 1998: 90–105.

Bois, Yve-Alain. "Better Late than Never." *Rendezvous: Masterpieces from the Centre Georges Pompidou and the Guggenheim Museums.* New York: Solomon R. Guggenheim Foundation, 1998: 41–7.

Boltanski, Christian. *Recherche et présentation de tout ce qui reste de mon enfance, 1944–1950.* Paris: Givaudan, 1969.

———. Interview with Jacques Clayssen. *Identité/Identifications.* Bordeaux: CAPC Bordeaux, 1976: 24–5.

———. *Inventaire des objets ayant appartenu à une femme de Bois-Colombes.* Paris: Centre National d'Art Contemporain, 1974.

———. *L'Album photographique de Christian Boltanski 1948–1956.* Paris: Sonnabend Press, 1972.

———. "Présentation et description de 4 photos." *Chorus* 5–6 (1970): 14–17, 34–7.

———. *Quelques interprétations par Christian Boltanski.* Paris: Etablissement Public du Centre Beaubourg, 1974.

———. Unpublished interview. 5 January 1974. Harald Szeeman Archives.

Boltanski, Christian, and Jacques Caumont. "Mythologie Individuelle" (unpublished interview). 30 November 1971. Harald Szeeman Archives.

Boltanski, Christian, and Jeanne Caussé. "Reconstitution." *Revue des deux mondes* November 1992, 76–83.

Boltanski, Christian, and Klaus Honnef. *Recueil de Saynètes comiques interprétées par Christian Boltanski.* Münster: Westfälischer Kunstverein, 1974.

Boltanski, Luc. *Prime Education et morale de classe.* Paris: Ecole Pratique des Hautes Etudes and Mouton, 1969.

Borgeaud, Bernard. "Art Abroad: Paris." *Arts Magazine* 45.3 (December 1970–January 1971): 46.

———. "Les Activités mystérieuses de Jean Le Gac." *Chroniques de l'art vivant* 21 (1971): 13.

———. "Qui se souviendra de Christian Boltanski." *Pariscope* 31 March 1971: 57.

Boudaille, Georges. *Biennale de Paris: Une Anthologie 1959–1967.* Paris: Fondation Nationale des Arts Plastiques et Graphiques, 1977.

Bourdieu, Pierre, et al. *Photography: A Middle-Brow Art.* Trans. Shaun Whiteside. Stanford: Stanford University Press, 1990 (orig. 1965).

Bourdieu, Pierre, and Alain Darbel. *The Love of Art.* Trans. Caroline Beattie and Nick Merriman. Stanford: Stanford University Press, 1990 (orig. 1966).

Bourdieu, Pierre, and Jean-Claude Passeron. *The Inheritors: French Students and Their Relation to Culture.* Trans. Richard Nice. Chicago: University of Chicago Press, 1983 (orig. 1964).

———. *La Reproduction: Eléments pour une théorie du système d'enseignement.* Paris: Minuit, 1970.

Bourgeade, Pierre. "Expo Flic, Après les incidents de l'Expo 72." *Combat* 18 May 1972: 14–15.

Boyer, Kathryn Anne. "Political Promotion and Institutional Patronage: How New York Displaced Paris as the Center of Contemporary Art, ca. 1955–1968." Dissertation, University of Kansas, 1994.

Bozo, Dominique. "Introduction." *La Collection du Musée National d'Art Moderne.* Ed. Agnès de la Beaumelle and Nadine Pouillon. Paris: Centre Pompidou, 1987: 10–31.

Bradford, Thomasine Haynes. "The Relations of American and French Feminism as Seen in the Art of Annette Messager." Dissertation, SUNY at Stony Brook, 2000.

Buchloh, Benjamin. "Formalism and Historicity – Changing Concepts in American and European Art since 1945." *Europe in the Seventies: Aspects of Recent Art.* Chicago: Art Institute of Chicago, 1977: 83–111.

———. "From the Aesthetic of Administration to Institutional Critique (Some Aspects of Conceptual Art 1962–1969)." *L'Art conceptuel, Une Perspective.* Paris: Musée d'Art Moderne de la Ville de Paris, 1990: 41–53.

———. "Le Musée et le monument." *Les Couleurs: sculptures; Les Formes: peintures.* Ed. Centre National d'Art et de Culture Georges Pompidou. Paris: Centre National d'Art et de Culture Georges Pompidou, 1981: 6–25.

Buren, Daniel. "Conversation relative à la Biennale de Paris de 1971." *Artitudes* 2 (1971): 7–9.

———. *Les Ecrits 1965–1990.* Vol. 1–3. Ed. Jean-Marc Poinsot. Bordeaux: CAPC, 1990.

———. *Photo-Souvenirs 1965–1988.* Villeurbanne: Art Edition, 1988.

———. "Une Exposition exemplaire." *Flash Art, Milan* 35–6 (1972): 24.

Cabanne, Pierre. "Les Assassins sont parmi nous." *Combat* 18–19 May 1968: 11.

———. *Le Pouvoir culturel sous la Ve République*. Paris: Olivier Orban, 1981.

Camhi, Leslie. "Christian Boltanski: A Conversation with Leslie Camhi." *Print Collector's Newsletter* 23.6 (January–February 1993): 201–6.

Campbell, Mary Schmidt. *Tradition and Conflict: Images of a Turbulent Decade 1963–1973*. New York: The Studio Museum in Harlem, 1985.

Carrick, Jill. "Le Nouveau Réalisme: Fetishism and Consumer Spectacle in Post-war France." Dissertation, Bryn Mawr College, 1998.

———. "Phallic Victories? Niki de Saint-Phalle's Tirs." *Art History* 26.5 (2003): 700–29.

Casati, Cesare. "Nuovo Oggetto a Parigi." *Domus* January 1977: 5–37.

Cassou, Jean. *Art and Confrontation*. Trans. Nigel Foxell. London: Studio Vista Limited, 1970 (orig. 1968).

———. *Mai 68 affiches*. Paris: Tchou, 1968.

Castel, Robert, and Dominique Schnapper. "Aesthetic Ambitions and Social Aspirations: The Camera Club as a Secondary Group." Trans. Shaun Whiteside. *Photography: A Middle-Brow Art*. Stanford: Stanford University Press, 1990 (orig. 1965): 103–28.

Caughie, John. *Theories of Authorship*. New York: Routledge, 1981.

Celant, Germano. "Record as Artwork." *Flash Art* 43 (December 1973–January 1974): 8–9.

Centre d'Art Contemporain Abbaye Saint-André. *La Fin des années 60: D'une contestation à l'autre*. Meymac, Corrèze: Centre d'Art Contemporain, Abbaye Saint-André, 1986.

Centre d'Arts Plastiques Contemporains. *Identité/Identifications*. Bordeaux: Centre d'Arts Plastiques Contemporains, 1976.

Chanoir, Isabelle. "Les Relations artistiques entre la France et l'Allemagne de 1969 au début des années quatre-vingt." Maîtrise d'Histoire de l'art, Université de Rennes II, 1996.

Charrier, Anne-Laure. *Visiteurs du Louvre*. Paris: Réunion des Musées Nationaux, 1993.

Chaton, Jeanne H. "L'Education des jeunes filles et des femmes en France." *Convergence* 2.2 (1969): 18–25.

Chaudonneret, Marie-Claude. *L'Etat et les artistes*. Paris: Flammarion, 1999.

Chirac, Jacques. "En Mémoire de Georges Pompidou." *Georges Pompidou et la modernité*. Ed. Galerie Nationale du Jeu de Paume. Paris: Centre Georges Pompidou, 1999: 13–14.

"Christian Boltanski ou le stéréotype volontaire." *Opus international* 54 (January 1975): 68.

Clair, Jean. *Art en France: Une Nouvelle Génération*. Paris: Chêne, 1972.

———. "De *L'Art en France* à *Made in France*." *Les Cahiers de médiologie* 3 (1997): 121–33.

———. "Du *Musée imaginaire* à l'imaginaire muséal. Cassel: Documenta 5." *Chroniques de l'art vivant* 32 (1972): 3–6.

———. *Elevages de poussière: Beaubourg vingt ans après*. Paris: L'Echoppe, 1992.

———. "Expressionnisme 70." *Chroniques de l'art vivant* 14 (October 1970): 9.

———. "Notes brèves sur une biennale (Venise 36e)." *Chroniques de l'art vivant* 32 (August–September 1972): 9–10.

———. "Nouvelles Tendances depuis 1963." *72: Douze Ans d'art contemporain en France*. Ed. François Mathey. Paris: Réunion des Musées Nationaux, 1972: 66–77.

———. "Une Avant-garde clandestine." *Chroniques de l'art vivant* 32 (1972): 16.

Clark, Linda L. "Schooling in the Land of Bourbons, Bonapartes, and Republics of Marianne: Recent Trends in the History of Modern French Education." *Trends in History* 3.2 (1982): 49–71.

———. *Schooling the Daughters of Marianne: Textbooks and the Socialization of Girls in Modern French Primary Schools*. Albany: SUNY Press, 1984.

——— "The Socialization of Girls in the Primary Schools of the Third Republic." *Journal of Social History* 15.4 (1982): 685–97.

Clark, T. J., and Donald Nicholson-Smith. "Why Art Can't Kill the Situationist International." *October* 79 (Winter 1997): 15–31.

Clifford, James. *The Predicament of Culture*. Cambridge: Harvard University Press, 1988.

Cohen, Jean-Louis. "Monuments for a Mass Cult." *Rendezvous: Masterpieces from the Centre Georges Pompidou and the Guggenheim Museums.* New York: Solomon R. Guggenheim Foundation, 1998: 18–39.

Combes, Patrick. *La Littérature & le mouvement de Mai 68.* Paris: Seghers, 1984.

Cone, Michèle C. "'Métro, Boulot, Dodo': The Art of the Everyday in France 1958–1972." *The Art of the Everyday: The Quotidian in French Postwar Culture.* Ed. Lynn Gumpert. New York: NYU Press, 1997: 47–64.

Conkelton, Sheryl. "Annette Messager's Carnival of Dread and Desire." *Annette Messager.* Ed. Sheryl Conkelton and Carol S. Eliel. New York: Museum of Modern Art, 1995: 9–49.

Cordier, Daniel. "Letter to the Editor." *Arts Magazine* 38.10 (September 1964): 6–7, 76.

Corrin, Lisa G., ed. *Mining the Museum.* Baltimore: The Contemporary, 1994.

Corris, Michael, ed. *Conceptual Art: Theory, Myth, and Practice.* New York: Cambridge, 2004.

Cottington, Laura, Françoise Collin, and Armelle Leturcq. *Vraiment Féminisme et art.* Grenoble: Le Magasin, 1997.

Crabbé, Brigitte, et al. *Les Femmes dans les livres scolaires.* Brussels: Pierre Mardaga, 1985.

Crane, Susan A., ed. *Museums and Memory.* Stanford: Stanford University Press, 2000.

Crow, Thomas. *The Rise of the Sixties.* New York: Harry N. Abrams, 1996.

Cueff, Alain. "Commémoration et régression." *Le Journal des arts* March 1997.

———. "L'Art français sur plusieurs fronts." *Le Journal des arts* January 1997: 3, 18, 19.

Dagen, Philippe. "L'Ecole fantôme de Christian Boltanski." *Le Monde* 24–5 August 1997: 15.

———. "Le Musée National d'Art Moderne présente cinquante ans de création en France." *Le Monde* 31 January 1997: 26.

Dallier, Aline. "Activités et réalisations de femmes dans l'art contemporain." Dissertation, Université de Paris VIII, 1980.

———. "Annette Messager: Un Langage de plasticienne." *Les Cahiers du GRIF* 13 (October 1976): 44–5.

———. *Combative Acts, Profiles and Voices: An Exhibition of Women Artists from Paris.* New York: A. I. R. Gallery, 1976.

———. "La Critique, les femmes, et l'art." *Opus international* 70–71 (1979): 80–1.

———. "Le Féminisme dans l'art." *Alternatives* 1 (1977): 133.

———. "Le Mouvement des femmes dans l'art." *Les Cahiers du GRIF* 23–4 (December 1978): 141–5.

———. "Le Soft Art et les femmes." *Opus international* 52 (September 1974): 49–53.

Dardigna, Anne-Marie. *Femmes-femmes sur papier glacé.* Paris: François Maspero, 1974.

Darriulat, Jacques. "Annette Messager, Collectionneuse." *Combat* 27 May 1974: 9.

Davis, Douglas. *The Museum Transformed.* New York: Abbeville Press, 1990.

Davvetas, Démosthène. "Christian Boltanski." *Flash Art* 124 (October–November 1985): 82–3.

Day, Charles R. *Schools and Work: Technical and Vocational Education in France since the Third Republic.* Montreal: McGill-Queen's University Press, 2001.

de Baecque, André. *Les Maisons de la culture.* Paris: Seghers, 1967.

de Certeau, Michel. *The Capture of Speech and Other Political Writings.* Trans. Tom Conley. Minneapolis: University of Minnesota Press, 1997 (orig. 1968).

———. *The Practice of Everyday Life.* Trans. Steven Rendall. Berkeley: University of California Press, 1984 (orig. 1980).

de Courtivron, Isabelle, and Elaine Marks. *New French Feminisms: An Anthology.* New York: Schocken Books, 1981.

Decroux-Masson, Annie. *Papa lit, Maman coud.* Paris: Denoël/Gonthier, 1979.

de Diego, Estrella, and Catherine Grenier. *Annette Messager La Procesión va por dentro.* Madrid: Museo Nacional Centro de Arte Reina Sofia, 1999.

Demonet, Michel, et al. *Des Tracts en Mai 68.* Paris: Armand Colin, 1975.

DeRoo, Rebecca J. "Christian Boltanski's Memory Images: Remaking French Museums in the Aftermath of '68." *Oxford Art Journal* 27.2 (2004): 219–38.

Des Nouhes, Chantal. *Guide pratique de la femme au foyer.* Paris: La Pensée Moderne, 1968.

Dialogue. *Féminie 75*. Paris: Unesco, 1975.

———. *Féminie 76*. Paris: Unesco, 1976.

Dickel, Hans. "The Finiteness of Freedom: An Exhibition in Berlin, 1990." *Parkett* 26 (1990): 165–9.

"Documenta 5." *Informationen (Kassel)* July 1972: 14.

Documenta 6. Kassel: Paul Dierichs, 1977.

Doss, Erika. *Twentieth-Century American Art*. Oxford: Oxford University Press, 2002.

"Douze Ans d'art contemporain en France." *Le Petit Journal des grandes expositions*. Paris, Réunion des Musées Nationaux, 1972.

Dreyfus-Armand, Geneviève, and Laurent Gervereau. *Mai 68, Les Mouvements étudiants en France et dans le monde*. Paris: Bibliothèque du Musée de l'Histoire Contemporaine, 1988.

Dubuffet, Jean. *Prospectus*. Paris: Gallimard, 1946.

Duchen, Claire. *Feminism in France: From May '68 to Mitterrand*. London: Routledge, 1986.

———. *Women's Rights and Women's Lives in France 1944–1968*. New York: Routledge, 1994.

Dufrêne, Bernadette. *La Création de Beaubourg*. Grenoble: Presses Universitaires de Grenoble, 2000.

Duncan, Carol. "Art Museums and the Ritual of Citizenship." *The Poetics and Politics of Museum Display*. Ed. Ivan Karp and Steven D. Lavine. Washington, D.C.: Smithsonian Institution Press, 1991: 88–103.

Duncan, Carol. *Civilizing Rituals: Inside Public Art Museums*. New York: Routledge, 1995.

Dupuis, Sylvie. "Annette Messager." *Art Press* 24 (1979): 24.

Eccher, Danilo, ed. *Christian Boltanski*. Milan: Charta, 1997.

Eliel, Carol S. "'Nourishment You Take' Annette Messager, Influence, and the Subversion of Images." *Annette Messager*. Ed. Sheryl Conkelton and Carol S. Eliel. New York: Museum of Modern Art, 1995: 51–85.

Elwitt, Sanford. *The Making of the Third Republic*. Baton Rouge: Louisiana State University Press, 1975.

Englund, Steven. "The Ghost of Nation Past." *Journal of Modern History* 64 (1992): 299–320.

Ferry, Luc, and Alain Renaut. *French Philosophy of the Sixties*. Amherst: The University of Massachusetts Press, 1990 (orig. 1985).

Fisera, Vladimir, ed. *Writing on the Wall. May 1968: A Documentary Anthology*. New York: St. Martin's Press, 1978.

Flay, Jennifer, and Günter Metken. *Christian Boltanski: Catalogue Books, Printed Matter, Ephemera 1966–1991*. Köln: Walther König, 1992.

Forbes, Jill, and Michael Kelly, eds. *French Cultural Studies*. Oxford: Oxford University Press, 1995.

Foucault, Michel. *Discipline and Punish, The Birth of the Prison*. Trans. Alan Sheridan. New York: Pantheon Books, 1977 (orig. 1975).

———. *Naissance de la clinique*. Paris: Presses Universitaires de France, 1963.

———. "What Is an Author?" Trans. Donald F. Bouchard and Sherry Simon. *Language, Counter-Memory, Practice*. Ithaca: Cornell University Press, 1977 (orig. 1969): 113–38.

Fox, Gerald. *Christian Boltanski*. Chicago: Home Vision Arts, 1997.

Francastel, Pierre. *Etudes de sociologie de l'art*. Paris: Denoël/Gonthier, 1970.

Francblin, Catherine. *Jean Le Gac*. Paris: Art Press/Flammarion, 1984.

Franzke, Andreas. *Christian Boltanski: Reconstitution*. Paris: Chêne, 1978.

Frascina, Francis. *Art, Politics, and Dissent: Aspects of the Art Left in Sixties America*. Manchester: Manchester University Press, 1999.

Freches, José. "Les Musées de France, Gestion et mise en valeur d'un patrimoine." *Notes et études documentaires* 4539–4540 (1979): 1–179.

Gaffroy, Marie-Christine. "Le Travail ménager." *Alternatives* 1 (June 1977): 33–9.

Garb, Tamar. "Interview with Christian Boltanski." *Christian Boltanski*. London: Phaidon, 1997: 6–43.

Garrard, Mary D. "Feminist Politics: Networks and Organizations." *The Power of Feminist Art*. Ed. Mary D. Garrard and Norma Broude. New York: Abrams, 1994: 88–102.

Gatellier, Gilbert. "Boltanski au Musée Municipal d'Art Moderne." *XXe Siècle* June 1971.

———. "Les Projets sans fin de Boltanski et de Le Gac." *Opus international* 15 (1969): 44–5.

———. "Opus Actualités." *Opus international* 21 (December 1970): 50–3.

———. "Opus Actualités." *Opus international* 19/20 (October 1970): 154–6.

———. "Opus Actualités." *Opus international* 18 (June 1970): 56–8.

———. "Opus Actualités." *Opus international* 5 (1969): 54.

Gaudibert, Pierre. *Action culturelle: Intégration et/ou subversion*. Paris: Casterman, 1972.

———. "The Cultural World and Art Education." Trans. Nigel Foxell. *Art and Confrontation*. Ed. Jean Cassou. London: Studio Vista Limited, 1970 (orig. 1968): 137–50.

Gaüzère, Mireille. "En suivant la genèse de Beaubourg 1959–1969." *Georges Pompidou, Homme de culture*. Ed. Philippe Tétart. Paris: MNAM, 1994: 93–100.

Geerlandt, Robert. *Garaudy et Althusser*. Paris: Presses Universitaires de France, 1978.

Georgel, Chantal, and Geneviève Lacambre. *1848, La République et l'art vivant*. Paris: Réunion des Musées Nationaux, 1998.

Gibson, Michael. "Art, Dissidents, the Police, and the Establishment." *International Herald Tribune* 20–21 May 1972: 9.

Gintz, Claude. *Vingt-cinq Ans d'art en France 1960–1985*. Paris: Legrand, 1986.

Gitlin, Todd. *The Sixties: Years of Hope, Days of Rage*. New York: Bantam Books, 1987.

Godfrey, Tony. *Conceptual Art*. London: Phaidon, 1998.

Goldmann, Lucien. *La Création culturelle dans la société moderne*. Paris: Denoël, 1971.

Gorgus, Nina. *Le Magicien des vitrines, Le Muséologue Georges Henri Rivière*. Trans. Marie-Anne Coadou. Paris: Fondation Maison des Sciences de l'Homme, 2003.

Gouma-Peterson, Thalia, and Patricia Mathews. "The Feminist Critique of Art History." *Art Bulletin* XIX.3 (1987): 326–57.

Grasskamp, Walter. "Artists and Other Collectors." *Museums by Artists*. Ed. A. A. Bronson and Peggy Gale. Toronto: Art Metropole, 1983: 129–48.

Grenier, Catherine. *Annette Messager*. Trans. David Radzinowicz Howell. Paris: Flammarion, 2001 (orig. 2000).

Guadilla, Naty Garcia. *Libération des femmes: Le MLF*. Paris: Presses Universitaires de France, 1981.

Guilbaut, Serge. *How New York Stole the Idea of Modern Art*. Trans. Arthur Goldhammer. Chicago: University of Chicago Press, 1983.

———, ed. *Reconstructing Modernism: Art in New York, Paris and Montreal 1945–1965*. Cambridge: MIT Press, 1990.

Gumpert, Lynn. *Christian Boltanski*. Paris: Flammarion, 1994.

———. "The Life and Death of Christian Boltanski." *Christian Boltanski: Lessons of Darkness*. Ed. Lynn Gumpert and Mary Jane Jacob. Chicago: Museum of Contemporary Art; Los Angeles: The Museum of Contemporary Art; and New York: The New Museum of Contemporary Art, 1988: 49–86.

Hahn, Otto. "Boltanski." *L'Express* 7–13 November 1977: 19–21.

Hahn, Otto, et al. "Les Dossiers noirs de la Biennale." *Artitudes* 2 (November 1971): 5–9.

Hamon, Hervé, and Patrick Rotman. *Génération*. Paris: Seuil, 1987.

Harrison, Charles. *Conceptual Art and Painting*. Cambridge: MIT Press, 2001.

Heinich, Nathalie. "Un Cas singulier: Entretien avec Harald Szeeman." *Les Médiateurs culturels*. Paris: Les Presses du Réel, 1994.

Henric, Jacques. "L'Extrême Droite attaque l'art contemporain." *Art Press* April 1997: 52–65.

Hirsch, Marianne. *Family Frames: Photography, Narrative, and Postmemory*. Cambridge: Harvard University Press, 1997.

Hobbs, Richard. "Boltanski's Visual Archives." *History of the Human Sciences* 11.4 (1998): 121–40.

Holz, Hans Hein. "Kritische Theorie des ästhetischen Zeichens." *Documenta 5*. Kassel: Documenta, 1972: 1:1–49.

Honnef, Klaus. "Les Images du bonheur: Christian Boltanski, Annette Messager." *Art Press* 2 (1976): 20–1.

———. "The Real, the Truth, and the Beauty. Research into the Work of Annette Messager." *The Serials with Annette Messager Collector, Annette Messager Practical Woman, Annette Messager Trickster, Annette Messager Artist*. Bonn: Rheinisches Landesmuseum, 1978.

Honnef, Klaus, and Lothar Romain. *Christian Boltanski/Annette Messager. Modellbilder*. Bonn: Rheinisches Landesmuseum, 1976.

Hubbard, Sue. "After Auschwitz: Responses to the Holocaust." *Contemporary Art* 3.1 (Winter 1995): 10–14.

Hulten, Pontus, and Pierre Matisse. *Marcel Duchamp, Notes*. Paris: Centre Georges Pompidou, 1980.

Hulten, Pontus, et al. *Paris-New York*. Paris: Centre Georges Pompidou, 1977.

Hunter, Sam. *A View from the Sixties: Selections from the Leo Castelli Collection and the Michael and Ileana Sonnabend Collection*. New York: Guild Hall of East Hampton, Inc., 1991.

Hurtig, Annette. *Annette Messager, Making up Stories*. Toronto: Mercer Union, 1991.

Jacob, Mary Jane. "Introduction." *Christian Boltanski: Lessons of Darkness*. Ed. Lynn Gumpert and Mary Jane Jacob. Chicago: Museum of Contemporary Art; Los Angeles: The Museum of Contemporary Art; and New York: The New Museum of Contemporary Art, 1988: 9–13.

Jamin, Jean. "Les Objets ethnographiques sont-ils des choses perdues?" *Temps perdu, Temps retrouvé*. Ed. Jacques Hainard and Roland Kaehr. Neuchâtel: Musée d'Ethnographie, 1985: 51–74.

Jeanson, Francis. *L'Action culturelle dans la cité*. Paris: Seuil, 1973.

Jochimsen, Margarethe, et al. *Frauen Machen Kunst*. Bonn: Galerie Magers, 1977.

Jouffroy, Alain. "Christian Boltanski: Récit souvenir." *Opus international* 24–5 (May–June 1971): 82–3.

———. *L'Abolition de l'art*. Geneva: Claude Givaudan, 1968.

Kaplan, Alice, and Kristin Ross. "Introduction." *Yale French Studies* 73 (1987): 1–4.

Karp, Ivan, and Steven D. Lavine. *Exhibiting Cultures*. Washington D.C.: Smithsonian Institution, 1991.

Kelly, Michael. "Humanism and National Unity: The Ideological Reconstruction of France." *The Culture of Reconstruction*. Ed. Nicholas Hewitt. New York: St. Martin's Press, 1989: 103–119.

———. *Modern French Marxism*. Oxford: Basil Blackwell, 1982.

Kennedy, R. C. "Chronicles: Paris." *Art International* 15.6 (Summer 1971): 73–6.

Kontova, Helena, and Giancarlo Politi. "Post Conceptual Romanticism." *Flash Art International* 78–9 (1977): 23–36.

Lainé, Pascal. *La Femme et ses images*. Paris: Stock, 1974.

Lamarche-Vadel, Gaëtane. "Tout sur Annette Messager." *Opus international* 52 (September 1974): 54–7.

Lascault, Gilbert. "Boltanski au Musée Municipal d'Art Moderne." *XXe Siècle* 33 (June 1971): 143–5.

———. *Cinq Musées personnels*. Grenoble: Musée de Grenoble, 1973.

———. "Contemporary Art and the 'Old Mole'." Trans. Nigel Foxell. *Art and Confrontation*. Ed. Jean Cassou. London: Studio Vista Limited, 1970 (orig. 1968): 63–94.

———. "Eloge de l'accumulation et du bric à brac." *Chroniques de l'art vivant* 35: 16–17.

———. "Inventaires de Boltanski." *XXe Siècle* 36.43 (December 1974): 180–1.

———. "Les Travaux de la femme." *Chroniques de l'art vivant* 38 (April 1973): 14–16.

Laubier, Claire. *The Condition of Women in France: 1945 to the Present, A Documentary Anthology*. New York: Routledge, 1990.

Laurent, Jeanne. *Arts et pouvoirs en France de 1793 à 1981*. Saint-Etienne: Université de Saint-Etienne, 1982.

Lawless, Catherine. "Entretien avec Annette Messager." *Les Cahiers du Musée National d'Art Moderne* 27 (1989): 111–17.

———. *Musée National d'Art Moderne, Historique et mode d'emploi*. Paris: Centre Pompidou, 1986.

Lebeer, Irmeline. "Documenta 5: Entretien avec Harald Szeeman." *Chroniques de l'art vivant* 25 (1971): 4–7.

———. "Une Ecole de la vision? (Documenta 5)." *Chroniques de l'art vivant* 32 (1972): 7–8.

Lebel, Robert. "Paris-New York et retour avec Marcel Duchamp, dada et le surréalisme." *Paris-New York*. Ed. Pontus Hulten et al. Paris: Centre Georges Pompidou, 1977: 64–78.

Le Bot, Marc. "Les Messages d'Annette Messager." *La Quinzaine littéraire* 13 November 1978: 13.

Lebovics, Herman. *Mona Lisa's Escort: André Malraux and the Reinvention of French Culture*. Ithaca: Cornell University Press, 1999.

Lefebvre, Henri. *Everyday Life in the Modern World*. Trans. Sacha Rabinovitch. New York: Harper and Row, 1971 (orig. 1968).

———. *Le Temps des méprises*. Paris: Stock, 1975.

Le Gac, Jean, and Jean Daive. "Jean Le Gac, Détective." *L'Autre Journal* 4 (1985): 57–60.

Le Goff, Jean-Pierre. *Mai 68, L'Héritage impossible*. Paris: La Découverte, 1998.

Legrand, Claire. "Chronique." *Une Scène parisienne*. Ed. Jean-Marc Poinsot. Rennes: Centre d'Histoire de l'Art Contemporain, 1990: 15–73.

Lelièvre, Françoise, and Claude Lelièvre. *Histoire de la scolarisation des filles*. Paris: Nathan, 1991.

Lemoine, Marianne. *Christian Boltanski, Jean Le Gac, Annette Messager*. Dijon: Musée Rude, 1973.

Lemoine, Serge, ed. *Annette Messager, Comédie tragédie 1971–1989*. Grenoble: Musée de Grenoble, 1989.

Leroux-Dhuys, Jean François, et al. *La Muséologie selon Georges Henri Rivière*. Paris: Bordas, 1989.

Leroy, Marie. *Le Phénomène Beaubourg*. Paris: Syros, 1977.

Lévêque, Jean Jacques. "Christian Boltanski, Galerie Sonnabend." *Les Nouvelles littéraires* 25 February 1976: 26.

Lévi-Strauss, Claude. *Tristes Tropiques*. Trans. John and Doreen Weightman. New York: Modern Library, 1997 (orig. 1955).

Levin, M. R. "The City as a Museum of Technology." *Industrial Society and Its Museums 1890–1990*. Ed. Brigitte Schroeder-Gudehus, Eckhard Bolenz and Anne Rasmussen. Langhorne: Harwood Academic Publishers, 1993: 27–36.

Lippard, Lucy. "Escape Attempts." *Reconsidering the Object of Art 1965–1975*. Ed. Ann Goldstein and Anne Rorimer. Los Angeles: Museum of Contemporary Art, 1995: 16–41.

Made in France 1947–1997, Le Petit Journal. Paris: Centre Georges Pompidou, 1997.

Maingueneau, Dominique. *Les Livres d'école de la République 1870–1914 (discours et idéologie)*. Paris: Le Sycomore, 1979.

Malraux, André. *Le Musée imaginaire*. Paris: Gallimard, 1954.

Marcadé, Bernard. "Annette Messager (Interview)." *Bomb* Winter 1988–89: 28–33.

———. "Je ne crois pas aux fantômes mais j'en ai peur." *Annette Messager, Chimères*. Calais: Musée de Calais, 1982–83: 59–62.

———. "La Vie impossible de Christian Boltanski." *Parachute* 55 (July–September 1989): 4–8.

Marmer, Nancy. "Boltanski, The Uses of Contradiction." *Art in America* 77.10 (1989): 168–80, 233, 235.

———. "France '97: The Culture Forecast." *Art in America* December 1996: 29–33.

———. "The New Culture: France '82." *Art in America* September 1982: 115–23, 181–9.

———. "Out of Paris: Decentralizing French Art." *Art in America* September 1986: 125–37, 155, 157.

———. "Waiting for Gloire." *Artforum* February 1977: 52–9.

Marsh, Georgia. "The White and the Black: An Interview with Christian Boltanski." *Parkett* 22 (1989): 36–40.

Mathey, François, ed. *72: Douze Ans d'art contemporain en France*. Paris: Réunion des Musées Nationaux, 1972.

McDonough, Thomas F. "Rereading Debord, Rereading the Situationists." *October* 79 (1997): 3–14.

Messager, Annette. "4 Identités d'Annette Messager." *Flash Art International* 68–9 (October–November 1976): 32–3.

———. "Art … Art de plaire … Artifice … Art d'aimer et d'être aimée." *Traverses* 7 (February 1977): 152–5.

———. "Dans l'intimité d'Annette Messager Collectionneuse." *Chroniques de l'art vivant* 46 (February 1974): 26–7.

———. *Ma Collection d'expressions diverses*. Copenhagen: Antigranin, 1974.

———. *Ma Collection d'expressions et d'attitudes diverses par Annette Messager collectionneuse*. Antibes: Antiquarium-Arrocaria, 1975.

Metken, Günter. "Das Doppelleben der Annette Messager." *Annette Messager Sammlerin, Annette Messager Künstlerin*. München: Städtische Galerie im Lenbachhaus, 1973: 3–6.

———. "Frankreichs stille Avantgarde. Spurensuche und Ethnologie der jungen Generation." *Süddeutsche Zeitung (Munich)* 11–12 August 1973: 107.

———. *Spurensicherung*. Cologne: Dumont Aktuel, 1975.

Millet, Catherine. "Boltanski et Le Gac." *Les Lettres françaises* 1 April 1970: 26.

———. *L'Art contemporain en France*. Paris: Flammarion, 1987.

———. "Notre-Dame Beaubourg." *Art Press* 4 (1977): 4–10.

Ministère de la Culture. *Politiques culturelles, études et documents 1976–1983*. Paris: La Documentation Française, 1986.

Moissac, Patrick. *Mai 68, La Révolution s'affiche*. La Ferté St-Aubin: Archer, 1998.

Mollard, Claude. *L'Enjeu du Centre Pompidou*. Paris: 10/18, 1976.

Montboron, Julien. "La Perspective postale de Jean Le Gac." *Chorus* 7 (1971): 66–7.

"Monument à une personne inconnue: Six questions à Christian Boltanski." *Art actuel, Skira annuel* 1975, 146–8.

Mosconi, Nicole. *Femmes et savoir, La Société, l'école et la division sexuelle des savoirs*. Paris: L'Harmattan, 1994.

Moulin, Raymonde. *De la valeur de l'art*. Paris: Flammarion, 1995.

———. *The French Art Market: A Sociological View*. Trans. Arthur Goldhammer. New Brunswick: Rutgers University Press, 1987 (orig. 1968).

———. *L'Artiste, l'institution, et le marché*. Paris: Flammarion, 1992.

———. "Living Without Selling." Trans. Nigel Foxell. *Art and Confrontation*. Ed. Jean Cassou. London: Studio Vista Limited, 1970 (orig. 1968): 121–36.

Moure, Gloria. *Christian Boltanski, Advent and Other Times*. Barcelona: Polígrafa, 1996.

Musée d'Art et d'Industrie, Saint-Etienne. *Réalité-réalités*. Saint-Etienne: Musée d'Art et d'Industrie, 1973.

Musée d'Art Moderne Villeneuve d'Ascq. *Collages, Collections des musées de province*. Colmar: Musée d'Unterlinden, 1990.

Musée des Arts Décoratifs. *Ils collectionnent . . .* Paris: Adrien Maeght, 1974.

Nora, Pierre. *Realms of Memory*. Trans. Arthur Goldhammer. New York: Columbia University Press, 1996 (orig. 1992).

Nuridsany, Michel. "Annette Messager: L'Univers du feuilleton." *Le Figaro* 7 November 1978: 30.

Nye, Ruddel B. "Miroir de la vie: The French Photoroman and Its Audience." *Journal of Popular Culture* 4 (Spring 1977): 744–51.

Oliver, Kelly. *French Feminism Reader*. Lanham, Maryland: Rowman and Littlefield, 2000.

Orieux, Marcel. *Sciences appliquées, Classe de fin d'études, Ecoles urbaines de filles*. Paris: Hachette, 1958.

Pacquement, Alfred. "1960–1972, Douze Ans d'art contemporain en France." *Georges Pompidou, Homme de culture*. Ed. Philippe Tétart. Paris: MNAM, 1994: 67–76.

———. "Christian Boltanski." *Les Lettres françaises* 1418 (1972): 26.

———. "Nouveau Réalisme et pop'art. Le Début des années 60." *Paris-New York*. Ed. Pontus Hulten et al. Paris: Centre Georges Pompidou, 1977: 584–608.

Pagé, Suzanne. "Introduction." *Annette Messager: Faire Parade 1971–1995*. Paris: ARC, 1995: 7–9.

Pagé, Suzanne, and Françoise Chatel. *Boîtes*. Paris: ARC 2, 1977.

Pagé, Suzanne, and Catherine Thieck. *Tendances de l'art en France 1968–1978/9*. Paris: ARC, 1979.

Parent, Béatrice. "Annette Messager collectionneuse." *Pariscope* 8 May 1974: 91.

———. "Light and Shadow: Christian Boltanski and Jeff Wall." *Parkett* 22 (December 1989): 52–63.

Parent, Francis, and Raymond Perrot. *Le Salon de la Jeune Peinture, Une Histoire 1950–1983*. Paris: Jeune Peinture, 1983.

Peemans-Poullet. "La Division sociale du travail." *Les Cahiers du GRIF* February 1974: 37–41.

Persuy, Sandra. "Les Sources du XXe siècle." *Les Cahiers du MNAM* 67 (1999): 30–63.

Phillips, Christopher. "The Phantom Image: Photography within Postwar European and American Art." *L'Immagine Riflessa: una selezione di fotografia contemporanea dalla Collezione LAC, Svizzera*. Prato: Museo Pecci, 1995: 142–52.

Piano, Renzo, and Richard Rogers. *Du plateau Beaubourg au Centre Georges Pompidou*. Paris: Centre Georges Pompidou, 1987.

Picq, Françoise. *Libération des femmes: Les Années-mouvement*. Paris: Seuil, 1993.

Pluchart, François. "L'Histoire universelle de Boltanski." *Combat* 20 December 1971: 11.

———. "L'Hiver à Paris." *Artitudes* 4 (February 1972): 2–3.

Poinsot, Jean-Marc. "Envois." *Septième Biennale de Paris*. Paris: Septième Biennale de Paris, 1971: 63–72.

———. "Les Envois postaux: Nouvelle Forme artistique?" *Chroniques de l'art vivant* 18 (1971): 8.

———. "Lieu culturel/Objet culturel." *Chroniques de l'art vivant* December 1972–January 1973: 13.

———, ed. *Une Scène parisienne*. Rennes: Centre d'Histoire de l'Art Contemporain, 1990.

Poulot, Dominique. "Le Patrimoine et les aventures de la modernité." *Patrimoine et modernité*. Ed. Dominique Poulot. Paris: L'Harmattan, 1998: 7–67.

———. "Le Patrimoine universel: Un Modèle culturel français." *Revue d'histoire moderne et contemporaine* 39.1 (January–March 1992): 29–55.

Ragon, Michel. "The Artist and Society." Trans. Nigel Foxell. *Art and Confrontation*. Ed. Jean Cassou. London: Studio Vista Limited, 1970 (orig. 1968): 23–40.

Reader, Keith A. *Intellectuals and the Left in France since 1968*. London: Macmillan, 1987.

———. *The May 1968 Events in France*. London: St. Martin's Press, 1993.

Renard, Delphine. "Entretien avec Christian Boltanski." *Boltanski*. Paris: Musée National d'Art Moderne, Centre Georges Pompidou, 1984: 70–85.

Restany, Pierre. "A quarante degrés au-dessus de dada." Trans. Martha Nichols. *Theories and Documents of Contemporary Art*. Ed. Kristine Stiles and Peter Selz. Berkeley: University of California Press, 1996 (orig. 1961) 308.

———. "Nouveau Réalisme." *Manipulated Reality: Object and Image in New French Sculpture*. Ed. Edith A. Tonelli. Los Angeles: Frederick S. Wight Art Gallery, UCLA, 1985: 9–16.

"La Résurrection de Paris." *Artitudes* 1 (October 1971): 3.

Rigby, Brian. *Popular Culture in Modern France*. New York: Routledge, 1991.

Rioux, Jean-Pierre. "Une Nouvelle Conception de l'Etat face à la culture." *Georges Pompidou, Homme de culture*. Ed. Philippe Tétart. Paris: MNAM, 1994: 61–6.

Rivière, Georges Henri. "De l'objet d'un musée d'ethnographie comparé à celui d'un musée de beaux-arts." *Cahiers de Belgique* November 1930: 310–13.

Roberts, Mary Louise. "Rationalization, Vocational Guidance and the Reconstruction of Female Identity in Post-war France." *Proceedings of the Annual Meeting of the Western Society for French History*. Ed. Norman Ravitch. Riverside: Univ. of California, Riverside, 1993: 367–81.

Rocard, Geneviève, and Colette Gutman. *Sois belle et achète*. Paris: Gonthier, 1968.

Rorimer, Anne. *New Art in the 60s and 70s: Redefining Reality*. London: Thames and Hudson, 2001.

Ross, Kristin. "Establishing Consensus: May '68 in France as Seen from the 1980s." *Critical Inquiry* Spring 2002: 650–76.

———. *Fast Cars, Clean Bodies. Decolonization and the Reordering of French Culture*. Cambridge: MIT Press, 1995.

———. "French Quotidian." *The Art of the Everyday: The Quotidian in French Postwar Culture*. Ed. Lynn Gumpert. New York: NYU Press, 1997: 19–30.

———. "Lefebvre on the Situationists: An Interview." *October* 79 (1997): 69–83.

———. *May '68 and its Afterlives*. Chicago: University of Chicago Press, 2002.

———. "Paris Assassinated?" *The End(s) of the Museum*. Barcelona: Fundacio Antoni Tapies, 1996: 135–50.

Rottner, Nadja. "Annette Messager." *Documenta 11 Short Guide*. Ed. Christian Rattemeyer. New York: Distributed Art Publishers, Inc., 2002: 160.

Schneckenberger, Manfred. *Documenta, Idee und Institution*. Munich: Bruckmann, 1983.

Scott, Joan Wallach. *Only Paradoxes to Offer: French Feminists and the Rights of Man*. Cambridge: Harvard University Press, 1996.

Scott, Victoria. "La Beauté est dans la rue: Art and Visual Culture in Paris 1968." M.A. Thesis, University of British Columbia, 2000.

Semin, Didier. *Boltanski*. Paris: Art Press, 1988.

———. "Boltanski: from the Impossible Life to the Exemplary Life." *Christian Boltanski*. London: Phaidon, 1997: 44–91.

Semin, Didier, and Alain Fleischer. "Christian Boltanski, La Revanche de la maladresse." *Art Press* 128 (September 1988): 4–9.

Solomon-Godeau, Abigail. "Mourning or Melancholia: Christian Boltanski's Missing House." *Oxford Art Journal* 21.2 (1998): 1–20.

Soutif, Daniel. "An Attempt to Reconstruct Christian Boltanski." *Christian Boltanski*. Ed. Danilo Eccher. Milan: Charta, 1997: 30–177.

———. "Et in Boltanski ego." *Voyages immobiles*. Nantes: Le Passeur, 1994: 47–70.

Sowerwine, Charles. *France since 1870, Culture, Politics, Society*. New York: Palgrave, 2001.

Stimson, Blake. "The Promise of Conceptual Art." *Conceptual Art: A Critical Anthology*. Ed. Alexander Alberro and Blake Stimson. Cambridge: MIT Press, 1999: xxxviii–lii.

"Stolo: Entretien avec le maniaque." *L'Humidité* December 1970: 4–5.

Sturken, Marita. "Personal Photographs in Cultural Memory." *The Familial Gaze*. Ed. Marianne Hirsch. Hanover: Dartmouth College, 1999: 178–95.

Sullerot, Evelyne. *La Presse féminine*. Paris: Armand Colin, 1966.

Svestka, Jiri. *Galleries Magazine* 24 (1988): 97–103.

Szeeman, Harald. "Individuelle Mythologien I+II." *Documenta 5*. Kassel: Documenta, 1972: 16.7–86, 16.167–220.

Tasmowski, Thérèse. "Le Budget du temps de la ménagère." *Les Cahiers du GRIF* February 1974: 45–9.

Taylor, Simon. "The Women Artists' Movement: From Radical to Cultural Feminism, 1969–1975." *Personal and Political: The Women's Art Movement, 1969–1975*. Ed. Simon Taylor and Natalie Ng. East Hampton: Guild Hall Museum, 2002: 9–33.

Trehard, Elisabeth, Aline Dallier, et al. "Les Femmes et la création artistique." *Face à femmes* 1 (1977): 127–44.

Tronche, Anne. "Paris IV." *Opus international* 1974: 70–3.

Tronche, Anne, and Hervé Gloaguen. *L'Art actuel en France*. Paris: Balland, 1973.

van Alphen, Ernst. "Nazism in the Family Album: Christian Boltanski's *Sans Souci*." *The Familial Gaze*. Ed. Marianne Hirsch. Hanover: Dartmouth College, 1999: 32–50.

Weber, Eugen. *Peasants into Frenchmen*. Stanford: Stanford University Press, 1976.

Wilson, Sarah, et al. *Paris: Capital of the Arts 1900–1968*. London: Royal Academy of Arts, 2002.

Wilson, Sarah. "La Vie artistique à Paris sous l'Occupation" and "Les Peintres de tradition française." *Paris 1937–Paris 1957: Créations en France*. Paris: Centre Georges Pompidou, 1981: 147–74.

Wolf, Laurent. "Paris." *Le Nouveau Quotidien* April 1 1997: 20.

Yaguello, Marina. *Les Mots et les femmes*. Paris: Payot, 1978.

Zancarini-Fournel, Michelle. "1968: Histoire et mémoires." Unpublished manuscript presented at the University of Chicago, 1996.

INDEX

Note: Page numbers in bold refer to figures.

and Documenta 5, 100, 102, 103, 114–115
and ethnography, 36, 38, 162–163
and Fluxus, 46–47
and mass media, 192
and *Occupation des lieux*, 74–78
and participatory viewing, 78
and photography, 221n16
and Pompidou Center, 6, 168, 174, 175, 178–181,
 184–187, 197
response to conceptual exhibitions, 1, 3, 73, 79,
 84, 102, 123, 162, 191
response to feminist exhibitions and women's
 issues, 125–126, 154, 156, 192, 194
and shared experiences, 196–197, 210–211
museum cafés, 168
museum commissions, 178–179, **179**
museum-dealer-press conglomeration
and narrowing of artist participation, 172–173
Museum of Modern Art, New York (MOMA), 16,
 238n43
museum(s), 211. *See also* art institutions; Bourdieu,
 Pierre; cultural institutions; ethnographic
 museums; *headings beginning with* "Musée" *or*
 "Museum of"; *maisons de la culture*; museum
 audiences; Palais de Tokyo; Pompidou
 Center; Whitney Museum of American Art
and accessibility, 7, 168, 170, 175
and class bias, 30, 32, 34, 158, 174–175
and concept of universality, 8, 26, 30, 32, 35,
 125, 158, 161–162, 196, 199, 209, 211
and contemporary art acquisitions, 39–40
conventions and authority of, 103
critiques of, 5, 6, 26, 29–30, 32–35, 38, 67–68,
 79, 117, 126, 157–158, 168, 185, 206, 211
democratization of, 9, 18, 28–29, 167–171, 180,
 181, 196–197, 212
economic role of, 122
elitism and inaccessibility of, 6, 28, 34–36, 126,
 175
exclusion of contemporary artists, 41
government centralization of, in France, 16
history of, 217n8
"museums by artists" (Documenta 5), 102–103
and national culture, 6, 158, 199–202
patrimony, 29, 31, 32, 34, 39, 124
political mission of, 3, 15–16, 17–18, 167, 206
role in historical upheavals, 217n8
and social diversity, 5–6, 32, 33, 199, 209
as symbol of national identity, 15–16, 167
museums, American, 16, 211

Museum Waldau, Bern, Switzerland, 102, 228n34
My Collection of Various Expressions and Attitudes
 (Messager). *See Mes Collections d'expressions et
 d'attitudes diverses*
Mythologies quotidiennes (exhibition), 228n29

Nanterre campus, University of Paris. *See* Paris,
 University of
"narcissistic individualism," 202
National Endowment for the Arts (U.S.), 226n8,
 242n28
"nationalist" art, advocacy of, 205, 207–208
NEA. *See* National Endowment for the Arts (U.S.)
"NEA 4," 242n28
Neue Galerie, 100, 102–103
New Left, 15
new realism. *See nouveaux réalistes/nouveau réalisme*
New York School
 imposition of, on Europeans, 56
Nightmare (Messager). *See Cauchemar, Le*
Nora, Pierre
 on collective memory and identity *(lieux de
 mémoire)*, 5
Nous deux (serial), 194
nouveaux réalistes/nouveau réalisme, 47–48, 52, 204.
 See also Arman; Christo; de Saint-Phalle,
 Niki; Hains, Raymond; Klein, Yves;
 Restany, Pierre; Spoerri, Daniel
 and Expo '72, 116
 in *Made in France* exhibition, 204
 in *Paris-New York* exhibition, **182**, 182–185,
 238n47
Nuridsany, Michel
 criticism on Messager, sources in mass culture,
 194, 240nn67–69

objets témoins, 37
Occupation des lieux (collaborative project), 75–80,
 77
occupations (sit-ins), 19, **25**, 75, 229n5
Odéon theater. *See* Théâtre de l'Odéon
Oldenburg, Claes, 103
Ono, Yoko, 45
Op Art, 116
Opera at the Bastille, 200
oppression
 women's (*see* Mouvement de Libération des
 Femmes)
"origins and singularity" (theme, *Made in France*
 exhibition), 204